THE COMPLETE IDIOT'S GUIDE TO

Photography Like a Pro

Third Edition

by the editors of Petersen's PHOTOgraphic™ Magazine *and Mike Stensvold*

ALPHA

A member of Penguin Group (USA) Inc.

ALPHA BOOKS

Published by the Penguin Group

Penguin Group (USA) Inc., 375 Hudson Street, New York, New York 10014, U.S.A.

Penguin Group (Canada), 10 Alcorn Avenue, Toronto, Ontario, Canada M4V 3B2 (a division of Pearson Penguin Canada Inc.)

Penguin Books Ltd, 80 Strand, London WC2R 0RL, England

Penguin Ireland, 25 St Stephen's Green, Dublin 2, Ireland (a division of Penguin Books Ltd)

Penguin Group (Australia), 250 Camberwell Road, Camberwell, Victoria 3124, Australia (a division of Pearson Australia Group Pty Ltd)

Penguin Books India Pvt Ltd, 11 Community Centre, Panchsheel Park, New Delhi—110 017, India

Penguin Group (NZ), cnr Airborne and Rosedale Roads, Albany, Auckland 1310, New Zealand (a division of Pearson New Zealand Ltd)

Penguin Books (South Africa) (Pty) Ltd, 24 Sturdee Avenue, Rosebank, Johannesburg 2196, South Africa

Penguin Books Ltd, Registered Offices: 80 Strand, London WC2R 0RL, England

International Standard Book Number: 1-59257-356-8
Library of Congress Catalog Card Number: 2004115800

07 06 05 8 7 6 5 4 3 2

Interpretation of the printing code: The rightmost number of the first series of numbers is the year of the book's printing; the rightmost number of the second series of numbers is the number of the book's printing. For example, a printing code of 05-1 shows that the first printing occurred in 2005.

Printed in the United States of America

Note: This publication contains the opinions and ideas of its authors. It is intended to provide helpful and informative material on the subject matter covered. It is sold with the understanding that the authors and publisher are not engaged in rendering professional services in the book. If the reader requires personal assistance or advice, a competent professional should be consulted.

The authors and publisher specifically disclaim any responsibility for any liability, loss, or risk, personal or otherwise, which is incurred as a consequence, directly or indirectly, of the use and application of any of the contents of this book.

Most Alpha books are available at special quantity discounts for bulk purchases for sales promotions, premiums, fundraising, or educational use. Special books, or book excerpts, can also be created to fit specific needs.

For details, write: Special Markets, Alpha Books, 375 Hudson Street, New York, NY 10014.

Publisher: *Marie Butler-Knight*
Product Manager: *Phil Kitchel*
Senior Managing Editor: *Jennifer Bowles*
Acquisitions Editor: *Tom Stevens*
Development Editor: *Jennifer Moore*
Production Editor: *Jan Lynn*

Copy Editor: *Molly Schaller*
Cartoonist: *Chris Eliopoulos*
Cover/Book Designer: *Trina Wurst*
Indexer: *Angie Bess*
Layout: *Angela Calvert*
Proofreading: *Donna Martin*

Contents at a Glance

Contents

Foreword

Photography as an art form should be a simple process of observing an image, reacting to that image, and then doing something about what you have learned from the experience of viewing the image. When I was a young boy my father turned me on to the "magic" of photography—it was a moment in my life that I will never forget.

I recently spent some time in the darkroom of Edward Weston, and I was astonished at the simplicity of his working environment. There was no enlarger, no gadgets of any kind—just a naked light bulb, some trays, chemicals, and a cutting board. If Weston, one of our greatest treasures, could work so simply, then the subjects taught in this book should suffice in getting us all on the road to creating fine images, and through them, changing the world.

—Graham Nash

Los Angeles, California

Introduction

Me and my camera, we go just about everywhere together. In fact, that's the first key to getting good photographs. You gotta have a camera to take pictures. Sure, sometimes it's a pain to take the camera, but it hurts a lot more to miss great pictures because you didn't have a camera. And I've done that.

I love photography. It's a blast to go out exploring with my camera. I love to bring back good pictures of what I see for others to enjoy. I'm not always successful, of course. Even the big-name pros miss once in a while. But it's fun to be out there trying. I love to look at good photos in magazines and books, and especially in galleries and museums, where I can marvel at the beauty of original prints. And I love to play with photo equipment. Hopefully, you'll start to feel the same way as you go through this book.

Photography is one of humankind's most popular activities. You can't go anywhere without seeing people taking pictures. But most people who take pictures aren't photographers. In fact, most aren't interested in *photography*—they're just interested in recording the people and events in their lives for future enjoyment. And there's nothing wrong with that. But you can get a lot more out of photography than a shoebox full of snapshots.

You might be afraid that photography is very complicated. After all, colleges and universities offer degrees in it. And it's an art, for gosh sakes! Well, there is a lot to photography, but it's not all that complicated. And the best thing is, you don't have to know everything about it to make good photographs! While Ansel Adams and many other great photographers mastered every technical and artistic nuance, there are famous pros today who appreciate the convenience and especially the speed of the automatic modes on their pro cameras. Some of them don't understand Ansel's Zone System, but they create some magnificent photographs nonetheless.

Don't get me wrong: These pros do know photography. They're good. They know when to override the automation in their cameras. But the automation makes their jobs a lot easier, and they appreciate that. But you don't need a fancy pro camera to make good pictures, nor do you need Ansel's knowledge. You can make excellent pictures with a point-and-shoot camera, and that's largely what this book is about.

You can also make better pictures, quite easily, with a more "serious" camera, and you'll learn about that, too. (For the record, I love Ansel's photos—he was my first photographic "hero"—and I do know how to use his Zone System. But I'm one of those who uses his pro cameras in auto mode much of the time.)

One of the great things about photography is that you don't have to deal with any more of it than you want. If you want to point-and-shoot, that's fine. If you want to do photography as a serious hobby, processing your own film and making your own prints, that's fine, too. If you want to be a black-and-white fine art photographer, that's wonderful—but beyond the scope of this book. Appendix B provides some books to check out if you're interested in specific aspects of photography.

If you have a point-and-shoot camera and find it a bit intimidating, I'll go over the camera and its features—and how to use them—in Part 1 of this book. Perhaps you feel comfortable with the mechanics of using your camera but have lots of questions: What film should I use? Where should I get it processed? Why didn't my flash pictures come out? What happens if the battery dies partway through the roll? What is this Advanced Photo System? What's with these new digital cameras? I have lots of answers.

If you simply want to learn how to make your pictures more interesting, Chapters 13 and 14 will show you how. If, on the other hand, you've just been bitten by the photo bug, want to get serious about shooting, but don't know where to start or how, you'll find what you need to know in this book. By the time you've finished this book, you'll have the answers to your questions. You'll know how to make good photographs, with minimal hassle, with any camera. You'll know, rather than just *hope*, that your pictures will come out right when you shoot. You'll get better vacation photos, more exciting candid pictures of the kids, and more attractively posed family-reunion shots. You'll gain a new appreciation for your camera—and maybe even a desire to go out and shoot pictures just because the light is really great.

There's a whole new world waiting for you and your camera. This book will help you find it.

How to Use This Book

I've long been meaning to write the darned-good American novel, but this isn't it. This is an information book, not a story you need to read from start to finish. The book is put together with a simple-to-more-advanced approach, but each section can stand on its own. If you're interested in a specific topic or have a specific question, check the table of contents or the index and go right to it.

This book is divided into five parts:

Part 1, "Cameras: Tools of the Trade," tells you what photography is all about and introduces you to the basic tool of photography, the camera. You'll learn how to choose the best camera for you and how to use it.

Part 2, "Other Vital Stuff," introduces you to all the other gear that photographers use and shows you what it can do for you.

Part 3, "How to Make Better Photos With Any Camera, Right Now," shows you how photographers see and how to use light to make better pictures.

Part 4, "How to Photograph …," shows you how to take better pictures of your favorite subject matter.

Part 5, "Extras! Extras!" introduces you to special effects and digital imaging.

I've also included two appendixes. Appendix A tells you how to buy photo equipment. Appendix B lists some great photo books, if you want to learn more about specific subjects.

Extras

In addition, as you flip through this book, you'll see the following boxes to give you helpful information.

Hot Tip
Easy tips for shooting better photos.

Whazzat Mean?
Definitions and explanations of key photographic terms.

Photo Fact
Facts, sketches, and anecdotes.

Watch Out!
Warnings about practices to avoid.

Acknowledgments

I'd like to thank all the folks who made this book possible—those listed here and those whose names I've managed to miss: the staff at Alpha Books; all the *PHOTOgraphic Magazine* staff members and photo industry people with whom I've worked over the past 30-plus years; photographers Renee Chodor, Lynne Eodice, Keith Ewing, Jay Jorgensen, Karel and Carol Kramer, Ron Leach, and Leslie Soultanian for providing thousands-of-words worth of pictures; the photo equipment

manufacturers for their great products (and the product photos); my friends Duchess Dale, David Knell, Betty Rockwell, and Kate Rogowski for their insightful questions; and especially *PHOTOgraphic Magazine*'s editor, Ron Leach, for steering the project my way and for reviewing the manuscript for technical and political correctness.

Special Thanks to the Technical Reviewer

The Complete Idiot's Guide to Photography Like a Pro was reviewed by an expert who double-checked the accuracy of what you'll learn here, to help us ensure that this book gives you everything you need to know about photography. Special thanks are extended to Ron Leach, editor of *Petersen's PHOTOgraphic Magazine*, the leading how-to publication for photo enthusiasts. A 21-year veteran of the photographic industry, Leach has previously edited a magazine for professional photographers, an international gymnastics publication, and a trade magazine for corporate agriculture. He also taught journalism courses at the University of Michigan and spent a year as an investigative reporter for the *Ann Arbor News*.

Trademarks

All terms mentioned in this book that are known to be or are suspected of being trademarks or service marks have been appropriately capitalized. Alpha Books and Penguin Group (USA) Inc. cannot attest to the accuracy of this information. Use of a term in this book should not be regarded as affecting the validity of any trademark or service mark.

Part 1

Cameras: Tools of the Trade

Welcome to the wonderful world of photography! It's a pastime that can provide joy for a lifetime, for you and for others, through the doing and through the pictures you create. Photography can be whatever you want it to be: simply a means to record the people and events in your life, a hobby, a passion, an art, or even a career. You can enjoy the photography of others at museums, in books, and by joining a camera club if you're the sociable sort. You can learn specifics and get some great photos by joining a photo tour or workshop, or you can go out on your own and shoot pictures of whatever you want for your own enjoyment. It's all up to you. No matter what your interest, you'll need to know about photography's most fundamental tool, the camera. The first part of the book provides the basics you need to know.

You and Your Camera

In This Chapter

♦ What is photography, anyway?

♦ Point-and-shoot cameras make it easy

♦ "Serious" cameras let you do more

♦ It takes more than a camera

♦ Photograph or snapshot?

If you're reading this book, you probably have a camera. And it's probably a point-and-shoot camera. There's a lot you can do with a point-and-shoot camera, and I'll show you how to get the most out of yours. But I'll also cover the autofocus 35mm single lens reflex (SLR) "serious" camera. It has a fully automatic mode that makes it as simple to use as any point-and-shoot camera, and it offers a lot more for those who want to go beyond pointing and shooting. But you can make good pictures with any camera, and that is the underlying theme of this book.

Your camera is truly a wondrous device. It records—at the touch of a button—people, places, and events for future enjoyment. You can take your camera with you wherever you go and bring back memories to enjoy

again and again—magical moments to share with family and friends. With a little knowledge (which you'll get from reading this book) and a little practice (which you'll have to gain on your own), you can even create art with your camera—photos that will bring enjoyment to all who view them.

The key element here is *you*. Cameras don't shoot pictures; people do. Wondrous though it is, the camera is just a tool. It's up to you to use the tool effectively. I'll show you how.

Before we get down to details (beginning in Chapter 2), let's see just what photography is all about.

Ready, Aim, Shoot

You know I know you're not a complete idiot. You picked up a book called *The Complete Idiot's Guide to Photography Like a Pro* because you want to make better photographs with minimal hassle. You want to improve those family photos, add light to your dark indoor photos, learn what all those other little buttons on your camera do, take more exciting vacation pictures, capture shots of your daughter's hockey game that aren't blurry … you get the picture!

You might be a point-and-shooter who has no interest in photography as art or even as a serious hobby—you just want to make better pictures of family and friends. Maybe you figure (correctly) that by learning a little more about lighting, lenses, and your camera in general, you can keep those same family members and friends from mysteriously vanishing every time you start to set up the slide projector or pull out the old photo album.

On the other hand, maybe you do want to get serious about photography and just don't know where to start or how.

Either way, you'll find what you need in this book.

Photo Philosophy 101: What Photography Is

I know you're eager to get started making better pictures, but we can't have a book on photography without defining what photography is, now can we? Everybody knows what *photography* is: It's taking pictures with cameras, right?

Well, yes. But photography is more than just that.

The word *photography* comes from the Greek words for "light" (*phos*) and "drawing" (*graphe*). So, literally, photography is "drawing with light." Traditionally, it has been done on film, using cameras and lenses, and some purists today still consider that the only legitimate way to do it. But you can make a photograph without a lens (by using a pinhole camera, for example) and without film (by using a digital camera). There are many ways to draw with light, and by the literal definition of the word, they all qualify as photography.

Whazzat Mean?

Literally "drawing (*graphe*) with light (*phos*)," **photography** is generally considered to mean the recording of images on light-sensitive media, using a camera.

But Is It Art?

Is photography art? For some time, the traditional art establishment didn't think so, largely because cameras made it possible for Just Anybody to take a picture—and Just Anybody's pictures weren't very good. But as a growing number of talented artists began to make creative photographs and as a growing number of painters took it up, photography began to gain acceptance as art. Some folks even started to look for "art" in lowly snapshots!

At last recognized as artists, serious photographers began battling among themselves. Some believed in "straight" photography, sharp and objective; others preferred "pictorial" photography, highly stylized and often fuzzy. Should photography show only "reality," only "truth," only the world as it is? Or should it show things as interpreted by the artist's imagination and craft? Well, there's room for everything—including the topic of this era's hot photographic debate, digital imaging.

Straight photography takes a sharp, realistic approach to the image.

You can make whatever kinds of photographs you like: sharp, literal renditions of the world's facts and marvels; manipulated, abstract impressions of things most others don't see; computer-enhanced images; even simple snapshots. Will your work be art? That lies in your vision and in your ability to show it in your photographs—and, of course, in the eye of the beholder.

Pictorial photography takes an ethereal, painterly approach to the image.

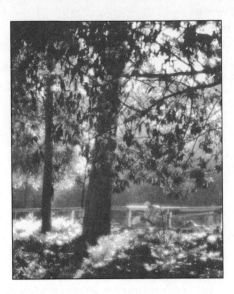

In recent years, many technological advances have made it much easier to make photographs, and with today's cameras and films, it's not difficult to go out and bring back well-exposed, sharp images. But your most important piece of photographic "equipment" is your mind—your eye and knowledge. If you'd sent legendary landscape photographer Ansel Adams and an untalented snapshooter out with snapshot cameras, which one do you suppose would have come back with the better pictures? Hint: His initials are AA. Ansel couldn't have produced the same images with the snapshot camera that he produced with his "serious" cameras, but the snapshooter wouldn't have stood a chance against Ansel's keen eye.

Photography is both an art and a craft. To make good photographs, you have to develop a good eye, and you have to know the equipment and techniques so you can capture on film (or memory card, if using a digital camera) what you see. I'll help you out on both counts. But you don't have to become the next Ansel Adams to enjoy your pictures and the process of making them.

Photo Fact

Pictorialism originated as an attempt to justify photography as art by making photos more like paintings. (This is the opposite of *photorealism*, where painters try to make their work as lifelike as possible.) Although pictorialism has died out as a movement, photography has not lost its claim to art. The essence of art—adding emotional and intellectual content to the mere recording of "what is there"— can be done through a straight approach, as well as through a pictorial approach, as the work of Ansel Adams, Edward Weston, and all the great photographers demonstrates.

There's More Here Than Meets the Eye

To many, photography is simply a means to record the people and events in their lives and the lives of their loved ones. To others, it's an art, a science, a pastime, a passion, even a career.

Even if you aren't a photographer, you benefit from the wonders of photography. Photographs enable us to see things we couldn't see otherwise: things too tiny, or too fast; places we can't go ourselves, such as faraway lands, the moon, other planets, and even the imaginations of photo-artists. It's a wonderful experience just viewing stunning photographs in magazines and books (or better still, in museums and galleries, where you can marvel at the beauty of original prints). And, of course, collecting photos and photo equipment is a great hobby.

Many are led into photography by their other passions. For example, some of the top bird photographers started taking pictures to record their beloved avian subjects. Many great sports photographers became such through their love of sports. The top travel photographers love to travel. If you have a special interest, combine it with your interest in photography and watch what happens.

And the reverse happens, too. Once you begin carrying your camera around, you never know what new fields might capture your interest. For example, I developed an interest in birds long after I became a photographer.

Photography helps make the world a better place. Photojournalists alert us to things needing attention. Their powerful images drive the message home to people everywhere far more graphically than pages of words could. Photography makes us aware, and inspires us to do something about things that aren't right.

Photography makes it possible for us to see things we couldn't see otherwise. For example, a balloon bursts too quickly for the naked eye to see, but the camera can capture the event, as in this photo.

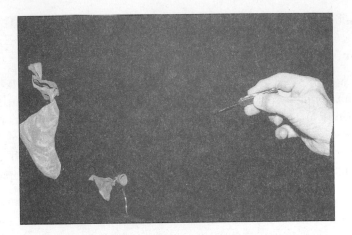

For example, Nick Ut's famous photo of a little Vietnamese girl fleeing a napalm attack with her clothes burned off and John P. Filo's shot of the Kent State student on her knees before a slain fellow student awakened us to the horrors of war, and Ansel Adams's beautiful scenic shots led to environmental awareness and the establishment of national parks.

This book introduces you to the tools and techniques that photographers use to make good photographs. But you have to shoot pictures to become good at shooting pictures—just reading about it isn't enough. So when you read about a camera feature, a technique, or an idea that intrigues you, go out and use it until you master it. The practice will pay off, whether it's the ability to quickly load a new roll of film just as junior is getting ready to blow out the birthday cake candles, or the know-how to turn a boring snapshot of two people into an intimate portrait of a loving couple.

Perhaps the most important thing to keep in mind as you enter the wonderful world of photography is that *photography is fun*. It's great to come back with great pictures, but the doing—going out, looking, discovering, and figuring out how to record your vision—is fun, too. Enjoy it!

Congratulations! You've just aced Photo Philosophy 101. Now, on to the camera.

From Pinhole to Point-and-Shoot

The first cameras didn't take pictures. Or more precisely, they didn't *record* them. The first cameras consisted of a dark room with a tiny hole in the ceiling. Why was the hole in the ceiling? Because the first photographic "subjects" were solar

eclipses. The ceiling-to-floor setup was devised by the fifth-century Chinese to enable people to view eclipses indirectly, so they wouldn't suffer eye damage. (Charlie Brown and Linus would use this same basic technique 1,500 years later!)

Later, the hole would be moved to one of the walls. The tiny hole projected an image of what was outside in the daylight onto a white surface on the opposite wall, where people in the room could view it. But of course, no objects outside were as bright as the sun, so their images weren't very bright—or very sharp, for that matter. And they were upside down. But these dim, fuzzy images were the beginning of the process that led to the soap-bar–sized automatic wonder you take pictures with today.

Not much more happened in the area of camera development for about a thousand years. Then, in the 1500s and 1600s, some people in Europe got serious about it and made several major advances. The first step was giving the thing an impressive scholarly sounding Latin name: *camera obscura*. (This exotic term simply means "dark room.") Soon, devices were designed to duplicate the effects of the dark room on a smaller scale, and the dark room became a dark box, adding the benefit of portability. The image produced by the tiny hole was still quite dim, though, and making the hole bigger to let in more light and make the image brighter made the image even fuzzier. So the pinhole was replaced with a lens. The lens had a bigger opening (called an *aperture*) to let in more light; this solved the problem of reduced sharpness by focusing the light on the opposite wall of the dark box.

Whazzat Mean?

The **aperture** is the opening in the lens that lets light into the camera. In today's cameras, the lens contains a *diaphragm* that lets the camera (or photographer) change the size of the aperture to control the amount of light reaching the film.

At this point, the camera was portable and produced reasonably bright and sharp images, but it still didn't record them. And, unlike what happened with the dark room, it was hard to squeeze the folks who wanted to view the images into the little dark box. So a mirror was added to reflect the image up to the top surface of the box, and the top surface was replaced with a ground-glass viewing screen. Now the user could not only view the projected image on the ground glass, but also could put a sheet of tracing paper on the ground glass and trace the image, recording it for all to enjoy.

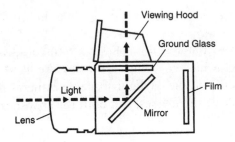

The basic elements of the camera developed in the 1600s are still in use today: the light-tight box, the lens, the ground-glass viewing screen (or viewing hood), and the reflex mirror.

But Wait ... There's Something Missing!

So we've had the basic components of the camera since the 1600s (the light-tight box, the lens, a ground glass for viewing the image, and even a reflex mirror), but what was lacking for another 200 years was a light-sensitive material to permanently record the images the camera produced. In the early 1800s, when a Frenchman named Joseph Nicéphore Niépce put some of this new light-sensitive material into the light-tight box, the photographic camera was born.

Incidentally, early "films" weren't very sensitive to light—the first exposure with Niépce's camera took eight hours!

After that, things started to evolve relatively quickly. Niépce became the first to produce negative images on light-sensitized paper. Within the next 12 years, Frenchman Louis-Jacques-Mandé Daguerre gave us the daguerreotype, the first commonly used photographic process. Englishman William Henry Fox Talbot originated the negative-positive process, a refined form of which is still used today. And Englishman Frederick Scott Archer invented the wet-collodion process, which reduced exposure times from minutes to seconds.

Photo Fact
Think using today's cameras is tough? Think about Mathew Brady, famed Civil War photographer. Brady and his aides didn't carry his equipment in a pocket or even a camera bag, but in wagons. They didn't buy their film at the local convenience store. They had to make their "film"—glass plates coated with a light-sensitive emulsion—in the dark on location, because it had to be exposed before the emulsion dried. And they couldn't handhold their cameras—the devices were too big, and exposure times typically ran several seconds, requiring a sturdy camera stand. Not quite today's automatic "pocket" camera!

Here Comes Mr. Kodak

Enter Mr. Kodak (whose name really was Mr. Eastman—"Kodak" was a name George Eastman dreamed up for his new company because he liked the sound of it). Kodak gave us flexible roll film and the daylight-loadable cameras in the late 1880s, photography became available to the masses, and both the snapshot and the photographic industry were born.

Cameras, Cameras, Cameras!

In the century-plus since George Eastman gave us flexible film and the first point-and-shoot camera, lots of technology has developed. Today, there are many types of cameras and more than 100 different kinds of films available in daylight-loadable rolls and cartridges. Why so many? Because there are many different types of photography and photographers.

♦ *Point-and-shooters* want cameras that are simple to use and films that produce good pictures even when not exposed perfectly.

♦ *Professional wildlife photographers* need cameras that accept high-magnification lenses to get great close-ups of those skittish beasts and films that can accurately record nature's colors and details.

♦ *Photojournalists* need hardy cameras that can take a lickin' and keep on clickin' and films that won't go bad when subjected to harsh conditions.

♦ *Portrait photographers* need cameras they can hook up to studio flash systems and films that reproduce skin tones beautifully.

♦ *Architectural and still-life photographers* need cameras with complex adjustments to keep things properly aligned in their photos and large films that can record every minute detail.

♦ *Private eyes* need small, silent cameras and films that don't require a lot of light.

You get the picture. Different films and different cameras for different needs.

Watch Out!

Don't feel overwhelmed by all these camera and film choices. Throughout this book, I'll remind you of what you minimally need—the easy stuff. You don't have to buy every gadget or learn every trick to get a good picture. But you'll want to know about the extras so you can decide which ones you might want to try.

Don't Panic!

Faced with so many choices in the equipment and material available to you, you may have a strong urge to say "Aarrgghh!" Go right ahead. But you don't have to deal with all those types of cameras and films. For most readers of this book (and you know who you are), there are only four types of cameras and one type of film you need to consider: 35mm point-and-shoot, Advanced Photo System, autofocus 35mm SLR, and digital cameras; and color-print film. We'll go into each of these four cameras in detail in Chapters 2 through 5 and in Part 5.

The Four "Easy" Cameras

What is a point-and-shoot camera? It's one that doesn't require you to set anything. Just switch it on, point it at the subject, and push the button. You don't have to worry about focusing, exposure, or even flash—if flash will produce a better picture, the camera will automatically fire it.

Of course, even point-and-shoots require a little more than that. Even if they have autofocus, you at least have to let them know what you want them to focus on. All but the single-use point-and-shoot cameras must be fed film (or memory cards, with digital cameras) and batteries before they'll make pictures, and all cameras must be held properly if those pictures are to come out sharp. What's more, even though point-and-shoot cameras don't *make* you use more than one button, most *have* more than one button, and sometimes pushing one of those other buttons will help you make a better picture.

Hot Tip _____

Choice is one of the greatest features of point-and-shoot cameras. They offer you lots of choices, but the options are just that—*options*.

Point-and-shoot 35mm cameras have been the best-selling film-camera type for years because they're simple to operate, easy to carry almost anywhere, relatively inexpensive, and they'll give you amazingly well-exposed and sharp pictures in a wide range of picture-taking situations with little effort on your part. But now they're being outsold by digital cameras, for reasons that will be covered in Chapter 22.

Why don't "serious" photographers use point-and-shoot cameras? Actually, they do. Many serious shooters take a point-and-shoot along as a snapshot camera when they're traveling—they like to play tourist just like you do. But for their serious photography, they use serious cameras. Why?

One word: *control*. Serious photographers are control freaks. While point-and-shooters love the simplicity and convenience of letting the camera do everything, serious photographers want to know lots of details, such as …

◆ Where the camera is focusing.

◆ What shutter speed is being used.

◆ What lens aperture is being used.

◆ How the camera meters the scene to determine the exposure (see Chapter 7 for a discussion of metering systems and methods).

These factors all have a bearing on what the picture is going to look like. Serious photographers want to be able to change any or all of these factors when they feel that doing so will produce a better picture.

The good news is that you can have the best of both worlds. The very popular auto-focus 35mm single-lens reflex camera (AF 35mm SLR–see Chapter 2) has a fully automatic shooting mode that makes it as simple to use as any point-and-shoot camera. But it also offers all the control over everything that a serious photographer could want. As bonuses, AF 35mm SLRs have better focusing systems and exposure systems than those of point-and-shoot cameras, and offer lots of versatile features that aren't available on point-and-shoots. The AF 35mm SLR lets you change lenses, which, as you will see in Chapter 9, can greatly expand your pictorial possibilities. And the AF 35mm SLR gives you through-the-lens viewing, so you see when the image is in focus and exactly what the picture will look like, no matter what lens is on the camera and no matter how close you are to the subject. Prices for digital SLRs are coming down, too—there are now four excellent ones available for under $1,000, the Canon EOS Digital Rebel, Nikon D70, Olympus EVOLT, and Pentax *ist DS.

Cameras Don't Shoot Pictures—People Do

A funny thing happened the other day. I was sitting on a park bench watching some children play, when a camera walked up to a couple of the kids, asked them to pose with their puppy, and then took their picture. Next, the camera strolled over to the flowerbed, stooped down, and shot a close-up of a rose. Finally, it stood up, zoomed out to "telephoto," and clicked off a shot of a robin feeding her chicks.

What's wrong with this picture? Cameras don't shoot pictures by themselves. Of course, you need a camera to take pictures, and you have to know how to use it, but the camera is just a tool. *You* make the picture.

Does the camera make a difference? Yes and no. Buying a fancier camera won't automatically make your pictures better. Of course, a knowledgeable photographer can make better photos with a better camera. Simpler cameras have their limitations, and when you get excited about making good photos, you won't want to be limited. The development of a good photographic eye is the most important thing. If you have this, you can make good photos with any camera.

A snapshooter with a snapshot camera will produce snapshots. A snapshooter with a serious camera will still produce snapshots. A good photographer with a snapshot camera will produce good photographs. A good photographer with a serious camera will produce even better photographs. The secret is in the seeing, and we'll go into that in detail in Part 3. But, like a craftsman in any field, you must learn how to use your tools before you can create a masterpiece.

Hot Tip

If you don't have a camera and think you might get serious about photography some day, an AF SLR is just what you need. It gives you simplicity and the option to branch out into more serious photographic pursuits.

Any camera, even a simple single-use or point-and-shoot one, will record what you point it at, but it won't necessarily record it *the way* you see it. To do this, you'll need a lot of neat photographic techniques that you just can't use with such a simple camera. So, by the time you've finished this book, you might want a "good" camera if you don't already have one. We'll show you how to choose and acquire one.

Photograph or Snapshot?

So what's the difference between a photograph and a snapshot, anyway? Well, basically a photograph shows some artistic thought and technical competence on the part of the photographer, while a snapshot is merely a visual record of what was in front of the lens. Today's automatic cameras help with the technical end, but only the photographer can add artistic merit.

Billions of pictures are taken each year, and the vast majority of them are snapshots. Snapshots do have value. They mean a lot to a relatively small group—to those who took them, to those who are in them, and to their families and friends. Collectively, snapshots provide the world with a wonderful historical record of people, places, and events of life on this planet as seen by those living it. A photograph, on the other hand, connects with a wider audience, simply because it is pleasant to look at, or because it hits home with a message, a "universal truth." There's plenty of room for both in the world of photography, and if you're happy taking snapshots, there's nothing wrong with that.

A snapshot is a record of what was in front of the camera lens.

Regardless of whether you're taking snapshots or photographs, there are a number of elements common to both you'll need to learn if you want the results of your camera-work to be better. In the following chapters, we'll discuss your choice of subject, how to use lighting effectively, and how to "compose" your shot. Learning about these elements is like practicing the scales on a piano—this alone won't make you a pro, but you'll never be a pro if you don't learn them.

A photograph shows some thought on the part of the photographer.

The Least You Need to Know

- ◆ Photography has evolved from a cumbersome and imprecise practice to something much simpler and more compact.

- ◆ Photography is both a craft and an art.

- ◆ These days, using a camera for snapshots is really quite simple.

- ◆ The camera is just a tool—it's the person using it who makes the difference between a poor shot and a great one.

- ◆ With reading and practice, you can learn to make better photos, whatever your reasons for shooting are.

35mm Point-and-Shoot Cameras

In This Chapter

- ◆ What's the best camera?
- ◆ Single-use cameras
- ◆ Fixed-focus and autofocus point-and-shoot cameras
- ◆ Zoom point-and-shoot cameras
- ◆ AF 35mm SLR cameras

Point-and-shoot cameras are really easy to use. That's their whole "point." The *35mm* point-and-shoot models were the best-selling cameras for a couple of decades for that very reason, although digital point-and-shoot cameras have recently surpassed them. Also called "compact 35s" (because they're smaller than 35mm SLRs) and "lens-shutter" cameras (because their shutters are located in their lenses, instead of next to the film as in 35mm SLRs), these are amazing all-in-one devices.

The question has probably crossed your mind, "If point-and-shoot cameras are so simple, why read a 400-page book about them?" Because there's

more to photography than pointing and shooting. Simple cameras make it easy to shoot pictures, but they don't make those pictures good. If all you want to do is get a snapshot, any snapshot, you don't have to learn any more about photography than how to put film or a memory card in your camera and how to turn the camera on. But you're missing out on a lot if that's all you do.

Let's start by meeting some cameras. There are 35mm point-and-shoot cameras for every budget, from under $10 to over $500. All use 35mm film and provide simple point-and-shoot operation. Some provide much more.

What's the Best Camera?

At *PHOTOgraphic Magazine*, the question we're asked more than any other is, "What's the best camera?" A simple question—just four short words. Unfortunately, it has no simple answer. The "best" camera for a point-and-shooter would be of no use to an architectural or sports-action photographer. The architectural photographer's large-format view camera would be of no use to the sports-action photographer and be far too complicated for the point-and-shooter. The sports photographer's high-end pro SLR with supertelephoto lens and five-frame-per-second motor drive would be overkill for a point-and-shooter and of little use to the architectural pho-tographer. The best camera depends on the type(s) of photography you do, your photographic experience and skill level, your personal idiosyncrasies, and your budget. What you want is a camera that will make you happy—one that will serve your photographic needs, be comfortable to use, and hopefully leave you with enough money to buy some film! For most readers of this book, that would be a 35mm or Advanced Photo System (APS) camera (see Chapter 5)—either a point-and-shoot model or an autofocus single-lens reflex (SLR) camera—or a digital camera (see Chapter 22).

Whazzat Mean?

The **35mm** in "35mm point-and-shoot camera" refers to the width of the film the camera uses: 35mm film is 35 millimeters wide and conveniently comes in cartridges holding 12, 24, 27, or 36 exposures.

That said, the information in Parts 3 and 4 applies to just about any camera. If you already have a camera, it will do, whatever kind it is, but if you're looking to buy a camera, here are some things you should consider.

There are four basic types of 35mm point-and-shoot cameras: single-use, fixed-focus reloadable, autofocus, and zoom autofocus. And there's the autofocus 35mm single-lens reflex (AF 35mm SLR, for short), which, while bigger and offering a lot more

control than a point-and-shoot "compact" camera, has a fully automatic mode that makes it as easy to use as any point-and-shoot model. One of these camera types is very likely just right for you.

Let's look at the advantages and disadvantages of each type of 35mm point-and-shoot camera.

No Loading Required!

Loading film into a 35mm camera intimidates some people. If you're one of them, I'll show you how to get over that in Chapter 4. One camera type eliminates the problem automatically: Single-use cameras (also known as one-time–use cameras), the simplest and least expensive of all camera types, come loaded with a roll of color-print or black-and-white film. You don't even have to worry about batteries because outdoor single-use cameras don't need batteries, and flash models come with the battery built-in.

Single-use cameras come in a variety of "flavors," including flash, outdoor (no flash), and (shown here) waterproof.

(Kodak)

There's not much to using a single-use camera. All you have to do is advance the film, aim the camera, and press the button. In fact, that's all you *can* do. There's nothing to

set. Focus is fixed at a distance that provides reasonably sharp pictures from around 5 feet to infinity. You don't have to worry about metering because there's no meter. You don't have to worry about setting the shutter speed because there's only one shutter speed. And no problem setting the lens aperture because there's only one aperture.

Single-use cameras are great for kids. If they break the camera or lose it, you're out less than $20. And these cameras are not at all intimidating. There's a shutter button, a winding knob, and (on flash models) a flash button. That's it. If your interest in photography goes no further than occasionally pointing and shooting pictures of family and friends, single-use cameras could be just what you need.

Single-use cameras offer several advantages:

- **They're easy.** You don't have to deal with loading and unloading the film. The cameras come loaded, and you simply drop the whole camera off at the photofinisher when you've exposed the last shot. This simplicity makes them very popular. Kodak estimates that one out of every eight consumer pictures is taken with a single-use camera.

- **They're cheap.** They cost less than $20, and that includes the preloaded roll of film!

- **They're expendable.** If you don't want to risk your "good" camera in hazardous shooting conditions, take a single-use model. If it gets damaged or lost, you're out only $10 to $20. There are even waterproof single-use models.

- **They're readily available.** If you didn't bring a camera, you can buy a single-use camera almost anywhere and take the pictures you would have otherwise missed.

- **They're fun.** They make great gifts for kids and friends, especially at weddings and parties when people want to take pictures but don't want to lug along their "real" cameras.

Of course, there are some disadvantages:

- Picture quality is not as good as with reloadable cameras. The inexpensive fixed-focus lens won't produce pictures as sharp as those you can get with a better camera. And because all pictures get the same amount of exposure, many will be over- or underexposed. Luckily, color-print film has lots of leeway for exposure errors, so your photofinisher can make good prints from most of the shots, but some of your pictures will still be too dark or too light.

◆ Although flash models let you shoot indoors and at night, you have to decide when to use flash, and you have to push a button to activate it. It doesn't fire automatically when needed as it does with reloadable point-and-shoot cameras.

◆ The plastic viewfinders are not very precise, so your carefully composed shots might not come out quite the way you envisioned them.

◆ You have to buy a new camera each time you finish a roll of film.

Photo Fact

Single-use cameras were originally known as "disposable" cameras. That term had an environmentally unfriendly ring to it, so the name was changed to "recyclable," which these cameras are. When you drop the camera off at your photofinisher after taking the last picture on the roll, the folks there remove and process your film and send the camera parts back to the manufacturer. There they are made into new single-use cameras and other things. In fact, according to a Kodak press release, they've recycled 250 million one-time-use cameras—enough to stretch two thirds of the way around the equator!

Fixed-Focus Reloadable Cameras

Next up the point-and-shoot camera ladder are the fixed-focus (or "focus-free") reloadable cameras. These are often called pocket cameras, although some are too big to fit into an average pocket. (They'll fit into a purse, though.) Like the single-use cameras, they have moderately wide-angle lenses prefocused at a distance that will provide reasonably sharp images of subjects at least 5 feet from the camera. But instead of a single shutter speed, these cameras have programmed shutters and built-in exposure meters to give you good pictures in a wider range of shooting situations. They also have built-in flash units that fire automatically when needed, so you can take good pictures of nearby subjects indoors and outdoors at night without worrying about whether you need to use flash. Many of these models have additional features, which you'll learn about in Chapter 3.

If you shoot pictures of family and friends fairly often but have no interest in photography beyond pushing the shutter button, a fixed-focus reloadable camera is probably just what you need. Even pro photographers have been known to carry one of these handy little cameras with them for quick shots on their "off" time.

Here are some advantages of fixed-focus reloadable cameras over single-use cameras:

◆ They give you better pictures.

◆ You don't have to buy a new camera each time you finish a roll.

◆ Flash is automatic.

◆ Many have additional features.

◆ Like single-use cameras, they're relatively compact and easy to take just about anywhere.

Disadvantages of fixed-focus reloadable cameras are …

◆ They cost more than single-use cameras.

◆ You have to buy, load, and unload film.

◆ The additional features make them more complicated.

Autofocus Cameras

Single-focal-length autofocus point-and-shoot cameras are just like focus-free models, except they incorporate automatic focusing for sharper pictures. They often have more features and are a little more difficult to use because you have to let them know what to focus on (you do that by aiming the autofocusing target in the viewfinder at your subject).

If you want your subject to appear somewhere in the picture besides dead center, you have to aim the AF target at it, lock focus by holding the shutter button halfway down, then recompose and shoot. With focus-free cameras, you frame the subject and press the button—the subject will be reasonably sharp as long as it is at least 5 feet away (and you don't jiggle the camera when you press the button).

An autofocus compact zoom camera, like this 35mm Nikon Lite-Touch Zoom 150, is easy to carry and use, provides a variety of lens focal lengths, and produces good image quality.

(Nikon Inc.)

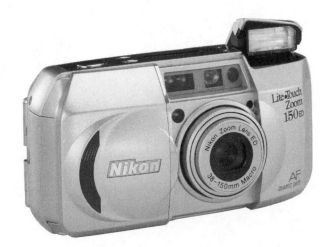

If you are concerned with the quality of your photos, want to make 8 × 10 enlargements of some of your pictures, and want to take the camera with you wherever you go, an autofocus point-and-shoot camera is likely your best choice. As with the fixed-focus cameras, some serious photographers take one of these with them when they're off duty and don't want to lug their serious camera system around.

Advantages of single-focal-length autofocus cameras are ...

- They give you even sharper pictures than fixed-focus cameras.
- You don't have to buy a new camera each time you finish a roll.
- Flash is automatic.
- They're relatively compact and easy to take just about anywhere.

Disadvantages of single-focal-length autofocus cameras are ...

- They cost more.
- You have to aim the autofocus target in the viewfinder at the subject to focus.
- You have to buy, load, and unload film.

Autofocus Zoom Cameras

Autofocus zoom cameras feature a built-in zoom lens, which allows you to change the framing of your picture without moving the camera. You can zoom in for a close-up shot or zoom back for a wide view.

If you like to shoot portraits of family and friends, a zoom camera lets you get those nicely framed head shots without the distortion common in tight shots made with wide-angle point-and-shoot cameras. Zoom cameras are also great for traveling because you can shoot both wide-angle and tighter shots without carrying extra equipment.

The Pentax IQZoom 200 currently provides the longest focal length available in a point-and-shoot camera, 200mm, at the long end of its built-in 48–200mm zoom lens.

Hot Tip

There is a difference between zooming in on a subject and physically moving the camera closer. Zooming the lens magnifies or shrinks everything in the picture equally. But moving the camera closer or farther away changes the relative sizes of nearby and more distant subjects. (See the section on perspective in Chapter 9.)

Olympus's IS-series of ZLR (zoom-lens reflex) cameras provides the added advantage of through-the-lens viewing: What you see is what you get, no matter what the zoom setting and no matter how close the subject. And you can see when the subject is sharply focused instead of just having to trust the camera.

Advantages of autofocus zoom cameras include …

◆ You can change the framing of the picture from wide to tight without moving the camera, simply by zooming the lens.

◆ You don't have to buy a new camera each time you finish a roll.

◆ Flash is automatic.

Disadvantages of autofocus zoom cameras are …

◆ They cost even more than regular autofocus cameras.

◆ They definitely are not "compact."

◆ The telephoto settings of the zoom lenses increase the chances of blurred pictures (because the longer focal lengths magnify camera shake along with the subject, and the camera uses slower shutter speeds because these lenses let in less light at longer focal lengths), and reduce flash range (again, because these lenses let in less light at longer focal lengths).

◆ To focus, you have to aim the autofocus target in the viewfinder at the subject.

◆ You have to buy, load, and unload film.

The Best of Both Worlds

Point-and-shoot cameras are wonderful and very popular devices, but they have their limitations. They don't allow you to set specific shutter speeds, lens apertures, or focus points, and they don't let you know what shutter speed, aperture, and focus point the camera has set. You might not care about such features, and that's fine. But they have definite effects on your pictures, and more-serious shooters want to be able to set and monitor them to produce the effects they want. You'll learn more about this in Parts 2 through 4 of this book. The metering systems in many point-and-shoot cameras aren't accurate enough to provide good exposures consistently on color-slide films, and their autofocusing systems can't handle many action subjects.

There is a camera type that solves all of these problems and more, yet is as simple to use as any point-and-shoot camera. It's the autofocus 35mm single-lens reflex (AF 35mm SLR). All AF 35mm SLRs have a fully automatic mode that makes them point-and-shoot–simple to use. They also offer full manual control of everything, for those who want it. AF 35mm SLRs have metering systems that can handle slide films and advanced autofocusing systems that can handle action. All AF 35mm SLRs have top shutter speeds of at least $\frac{1}{2000}$ second, with the pro model Minolta Maxxum 9 achieving an amazing $\frac{1}{12000}$. All will accept a wide range of interchangeable lenses, from superwide-angle to supertelephoto, including true macro lenses, lots of zooms, and more (you'll learn all about lenses in Chapter 9). Through-the-lens viewing lets you see the image produced by the lens just as it will be recorded on your film. And the AF 35mm SLRs have other features that add versatility.

Bottom line: If you are at all serious about photography or think you might be someday, think about getting an AF 35mm SLR. (Digital SLRs offer all the advantages of 35mm SLRs and then some—learn more about them in Chapter 23—but cost much more. The lowest-cost digital SLR as of this writing has a street price of $899 for just the body.)

Photo Fact

Not only do lenses for AF 35mm SLR cameras provide a far greater range of focal lengths than lenses built into point-and-shoot 35mm cameras, they're a lot faster as well. By having a larger aperture, lenses for 35mm cameras let in a lot more light than lenses for point-and-shoot cameras. More light means you get sharper pictures because you can shoot at faster shutter speeds and use slower, finer-grained films.

The AF 35mm SLR offers lots of benefits for everyone from the point-and-shooter to the serious photographer. Point-and-shoots couldn't have made these two pictures, but AF 35mm SLRs could (and did). They are especially useful for animal shots and still-life close-ups where the framing of the picture matters.

The most versatile cameras for serious photography are the autofocus 35mm SLRs, like this Canon EOS Rebel Ti. The AF SLRs accept a whole range of interchangeable lenses, and provide lots of useful shooting features. Digital SLRs provide the same benefits, but cost a lot more.

(Canon USA, Inc.)

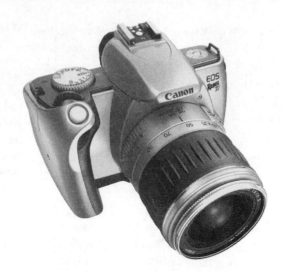

What Does "AF 35mm SLR" Mean?

As we've noted, AF means the camera provides automatic focusing. 35mm means it uses 35mm film. SLR is short for "single-lens reflex," which means the camera uses a single lens for both viewing and exposing the film. A reflex mirror inside the camera reflects the image formed by the lens up to a focusing screen so you can compose the picture and see when it's sharply focused. When you push the shutter button to take the picture, the mirror momentarily flips up out of the light path so the light can get to the film. (There are also twin-lens reflex cameras, which have two lenses, a top lens for viewing and a bottom lens for exposing the film.)

SLR cameras use a reflex mirror to reflect the image up to a focusing screen so you can see when it is sharply focused. SLRs thus let you see the actual image produced by the lens, while point-and-shoot cameras have separate viewfinders that just indicate the approximate area of the scene that will be in the picture.

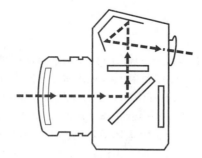

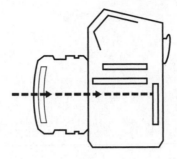

When you push the shutter button all the way down to take the picture, the SLR mirror flips up out of the light path so light can get to the film. This causes the viewfinder image to black out as you take the picture—you can't see the image while the mirror is in the up position. But this blackout is brief—the mirror returns to the viewing position as soon as the exposure has been made.

Mirrors produce laterally reversed "mirror" images. As you'll recall from Chapter 1, the image formed by the lens is upside down. So why does the image look right in the SLR camera's viewfinder? Because 35mm SLR cameras have pentaprism (or pentamirror) finders, where the upside-down, laterally reversed image is reversed again.

Flash

Most AF 35mm SLRs have built-in electronic flash units, like point-and-shoot cameras, but the flash units built into AF 35mm SLRs have greater "reach" because they're more powerful and lenses for 35mm SLRs let in more light. AF SLRs also have more accurate TTL (through-the-lens) flash metering. And when you need more flash power and features, you can attach a dedicated accessory flash unit to the camera's hot-shoe. Chapter 10 tells you all about flash.

Film Transport

While point-and-shoot cameras have built-in motor drives that automatically advance the film after each shot and rewind it at the end of the roll, AF 35mm SLRs add another feature that few point-and-shoots have: a continuous-advance mode. The camera will shoot a series of shots as long as you hold the shutter button down. Continuous advance rates range from 1 to 8 frames per second (fps).

Advantages of AF 35mm SLR cameras include …

- Through-the-lens viewing.
- Better metering and autofocusing systems than found in point-and-shoot cameras.

- Interchangeable lenses.

- A wider range of shutter speeds.

- Manual control when you want it.

- In full-auto mode, they're as simple to use as any point-and-shoot camera.

Disadvantages of AF 35mm SLR cameras include ...

- They cost more than most point-and-shoot cameras.

- They're bulkier than point-and-shoot cameras.

- You have to buy lenses separately.

Watch Out!

You can use up your film in a hurry in continuous-advance mode. Even at the slowest rate of one frame per second, a 24-exposure roll is gone in less than half a minute.

Among the many types of cameras available, several offer true point-and-shoot simplicity. The point-and-shoot-only models are the simplest, but the least versatile. If your interest in photography doesn't go beyond point-and-shooting, you'll be happiest with a point-and-shoot model. But if you are interested in photography (or think you might be someday), then you should consider one of the entry-level AF 35mm SLR cameras.

The Least You Need to Know

- There are lots of camera types, but only a few you need to consider when you're getting started.

- Single-use cameras are great when you forget to bring a camera or don't want to risk losing or harming your "good" camera.

- Point-and-shoot cameras are easy to carry anywhere, and simple to use.

- While AF 35mm SLRs are more expensive, they are easy to use and highly versatile.

Camera Features

In This Chapter

- ◆ The LCD panel and icons
- ◆ Focusing and zoom
- ◆ Exposure, flash, and metering
- ◆ Film transport

Most reloadable point-and-shoot cameras have features that let you go beyond pure pointing and shooting. An informal survey of my point-and-shooter friends indicates that the average point-and-shooter doesn't use these features often, if at all. Why? "It's too much work." "I don't know how." "I don't know what they're for." "I just want to point and shoot." And you know what? These folks are quite happy with their cameras and their photos. Just because your camera has a bunch of features doesn't mean you have to use them all. Use the ones that will help you make better pictures and don't worry about the others.

Which features will help you take better pictures? Let's take a look at them and see what they can do for you. (The next chapter takes you through the nuts 'n' bolts of using the camera.)

Not all point-and-shoot cameras have all of these features, so if some particularly intrigue you, you might want to make sure a potential camera purchase has them before you buy it.

A Gray Area That Makes Things Clear

Most reloadable 35mm point-and-shoot cameras have a liquid crystal display (LCD) panel on the top (it's on the back on a few cameras). This gray rectangle tells you useful stuff like the frame number, the film status (properly loaded, improperly loaded, roll rewound and ready to remove), and information about the various camera modes when you are using them.

With many cameras, you set the various operating modes by pressing a button while referring to the LCD panel. For example, repeatedly pressing the flash-mode button might toggle through the flash modes, the icon for each appearing on the LCD panel as it is selected.

Icon-O-Class

An icon is a little picture that represents a camera feature. For example, a battery symbol is used to indicate the battery status, a lightning bolt to indicate flash status, and an eye to indicate that red-eye–reduction flash mode is in use. Icons appear on the LCD panel to let you know which camera features are currently in use. With some cameras, icons also appear on control dials, to show you which settings are which. Your camera's instruction manual will show you all the icons your camera uses and what they mean.

The LCD panel tells you useful things, such as how many frames you've exposed or have left (36), the battery condition (good), and whether the film is properly loaded (it is).

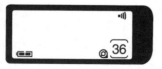

Focusing Modes

You don't have to worry about focusing with focus-free cameras because they don't focus, but the most popular point-and-shoot cameras are the autofocus (AF) models.

And the AF 35mm SLRs provide the best autofocusing systems of all. Here are some features you might find on them.

Single-Shot AF

Most autofocus point-and-shoot cameras offer one AF mode: single-shot. When you aim the AF rectangle in the middle of the viewfinder at a subject and press the shutter button halfway down, the camera will focus on the subject and lock focus there until you either take the picture or let go of the shutter button. With most of these cameras, you can't press the shutter button all the way down to take the picture until the camera has focused on something. This keeps you from shooting out-of-focus pictures of nonmoving subjects.

> **Photo Fact**
>
> How do you know when the camera has focused? The green focus light in the viewfinder will glow steadily. If the camera is unable to focus, the green focus indicator blinks, and the shutter button locks.

Continuous AF

What happens if the subject is moving? With single-shot AF, a moving subject may move out of focus between the moment the camera locks focus and the moment you push the button all the way down to take the picture. Or the camera might not be able to focus on it at all.

To handle moving subjects, most AF 35mm SLRs (and a few point-and-shoot cameras) provide a second autofocusing mode: continuous AF. In continuous AF, the camera keeps focusing on the subject you aim the AF target at, as long as you keep the shutter button pressed halfway down, so you'll get sharply focused pictures of moving subjects. (In theory, anyway. If the subject is moving too fast or you don't keep it in the AF target frame, the camera won't be able to focus on it.)

Trap Focus

Several AF 35mm SLRs have an interesting focusing mode called trap focus, snap-in focus, or catch-in focus. With this mode, you prefocus manually at a distance at which you wish to photograph a subject, then press the shutter button. When the subject

arrives at the prefocused distance, the camera will fire. This mode is handy for photographing birds returning to their nests and for close-ups of skittish subjects. For the latter, set the focus for the desired magnification or distance, then slowly move in on the subject. The camera will fire as soon as the subject comes into focus.

With most AF 35mm SLRs, continuous AF is "predictive." The camera's built-in computer uses data from successive AF readings to calculate the subject's speed and the direction it is moving, then uses this information to predict where the subject will be at the exact instant of exposure and sets the focus accordingly. This compensates for the distance the subject travels during the brief lag between the moment you push the shutter button to take the picture and the moment the exposure is actually made on the film. Today's AF SLRs with continuous predictive AF can track action subjects remarkably well, and if you intend to do serious action shooting, you'll want a camera with predictive continuous AF. You'll learn all about shooting action in Chapter 18.

Two Types of AF

AF 35mm SLRs use a different type of autofocusing system than most point-and-shoot cameras. AF SLRs use passive phase-detection AF systems. That techy term means that the AF system measures contrast—the idea being that contrast of the image is highest when the image is sharply focused. Most point-and-shoot cameras use active infrared AF systems, which send an infrared beam out to the subject and determine focus based on where the reflected return beam hits the camera's AF sensor. (A few point-and-shoot cameras use a less-sophisticated version of phase-detection AF, or both systems, automatically activating the one that will best suit the shooting conditions.)

Infrared AF systems work in total darkness and on subjects with no contrast, but they don't work through window glass (because the beam bounces off the glass and doesn't reach the subject) or beyond about 25 feet (because the reflected beam doesn't make it back to the camera's AF sensor). Phase-detection systems work through window glass and at any distance, but, like our eyes, they have to be able to "see": they don't work in dim light or with subjects lacking in contrast, such as solid-toned walls. Many AF 35mm SLRs provide a focus-assist illuminator, which automatically activates in dim light and low-contrast situations, giving the AF system a target to focus on. Some cameras have the AF-assist built into the camera body; with others, it's built into dedicated flash units.

Landscape (Infinity) Mode

How do you shoot distant landscapes or subjects through window glass with a point-and-shoot camera that has an infrared AF system? You use landscape mode (also called infinity-lock mode). This mode locks focus at infinity (actually, at around 30–50 feet, but that works), allowing you to get sharp pictures of distant subjects and when shooting through window glass.

Wide-Area and Spot AF

Some autofocus point-and-shoot cameras use several AF sensors to provide a wide focusing area. This is great for general shooting because you don't have to put the subject in the center of the frame to focus on it. With wide-area AF, the camera will focus on the closest subject that falls within the wide AF target in the viewfinder.

These cameras usually offer a spot AF mode, which lets you focus on a specific subject. Spot AF is also handy when your subject is surrounded by things that are closer to the camera than it is. With spot AF, you can zero in on the subject so the camera won't focus on the closer surrounding objects.

Simpler cameras offer only spot AF; they have only one AF sensor, but you can shoot any subject with these by aiming the viewfinder's AF target at the subject, pressing the shutter button halfway and holding it to lock focus, then recomposing the picture as desired.

Photo Fact
Point-and-shoot cameras (and AF 35mm SLRs in single-shot AF mode) automatically lock the shutter button when the camera is unable to focus on the subject to prevent you from shooting an out-of-focus picture. Of course, if the subject moves after the camera has focused on it, you can still get an out-of-focus picture, but this "focus-priority" feature is still a helpful device. Continuous AF mode is generally "release-priority": You can trip the shutter at any time, whether or not the camera has focused on the subject.

Focus Lock

All autofocus point-and-shoot cameras lock focus once it has been achieved, as long as you keep the shutter button pressed halfway down. This is handy when you want to compose a picture with the subject outside the AF target area. Just point the AF

target at the subject, press the shutter button halfway until the green in-focus light comes on, and reframe the picture. Single-shot AF mode works this way with AF 35mm SLR cameras. Some AF 35mm SLRs also have a separate focus-lock button.

Macro Mode

Some point-and-shoot cameras let you focus on closer subjects than is normally possible by using the macro mode. Macro mode sets the focus for sharp images within a narrow range of close distances: 1.6 to 2.6 feet, for example (your camera manual will tell you the range for your camera, and the camera's in-focus lamp will blink if you get too close to the subject for the camera to focus on it). Newer cameras focus down to their minimum focusing distance without your having to activate a special macro mode. If you're interested in shooting close-ups, you'll want a camera that offers close-focusing capability. If you're interested in shooting close-ups, you'll want an AF 35mm SLR and a macro lens. Chapter 19 tells you all about close-up photography.

Snap-Shooting Mode

Snap mode zooms the lens to its widest setting and locks focus at a distance that provides sharp pictures at 5 to 15 feet or so. This is great for photographing active subjects, such as kids and pets, because it lets you shoot quickly, without worrying whether the AF target is on the subject(s). With some cameras, snap mode activates continuous-shooting mode when you hold the shutter button down, so you can shoot an action sequence.

Manual-Focus Mode

Of course, all AF 35mm SLRs let you focus manually when you want to. Just move the AF/MF switch on the lens or camera body to MF (manual focus) and rotate the lens's focusing ring until the image appears sharp in the viewfinder. With most cameras, the in-focus indicator glows when focus has been achieved, whether by auto or manual means. Manual focusing is great for situations where the point of focus is critical (such as close-up work) and when the camera is unable to autofocus.

A few point-and-shoot cameras offer manual focusing. Since these cameras don't have through-the-lens

CAUTION

Watch Out!

Don't try to focus the lens manually when the camera is in autofocus mode—you could damage the autofocusing mechanism.

viewing, you focus manually by setting the focusing dial to the estimated distance to the subject. With these cameras, it's best to use autofocusing unless the AF system is unable to focus on the subject.

Zoom Modes

All zoom point-and-shoot cameras let you zoom in on the subject by pressing the T (telephoto) button and zooming back to show more of the scene by pressing the W (wide-angle) button. Some zoom cameras offer special zoom modes, too.

Step-Zoom Mode

In step-zoom mode, the camera automatically shoots several pictures in rapid succession, each at a different zoom setting. This is handy for people who aren't sure how to crop their subject, but as you'll see in Chapter 13, you'll get the best pictures when you decide how to crop them yourself.

Fuzzy-Logic Zoom Mode

This mode utilizes the camera's built-in microprocessor and "fuzzy logic"—a human-like method of computer-thinking—to set the lens focal length, flash, and shutter speed to keep underexposure and camera shake from ruining your pictures. Basically, it activates the flash and zooms to a wider view in dimmer light. Again, I think you'll get better pictures if *you* decide on the zoom setting and whether to use flash (Chapter 10 tells you all about flash).

Portrait-Zoom Mode

In portrait-zoom mode, the camera zooms the lens to maintain a waist-up cropping as the subject moves closer to you or farther away. This is fine if you want waist-up portraits, but portraits generally are more effective with tighter cropping than that. Chapter 16 shows you how to shoot attractive portraits.

Exposure Modes

Point-and-shoot cameras have one exposure mode: programmed automatic. In programmed automatic exposure (AE), the camera automatically sets both the shutter

Hot Tip _____

Entry-level AF 35mm SLRs have a "full-auto" mode in which everything is set automatically—exposure, focus, flash if necessary— just as it is with a point-and-shoot camera. If you're only interested in point-and-shooting, full-auto is the mode to use with these cameras.

speed and the lens aperture to provide proper exposure, based on the camera's meter and its exposure programming. Program AE is ideal for point-and-shooting because you don't have to set anything, but the shutter speed and the lens aperture do have an effect on the picture. Serious photographers like to know which shutter speed and aperture are being used, and they want to be able to set a specific shutter speed or aperture when doing so will give them the precise results they want.

Shiftable Program AE

All AF 35mm SLRs offer programmed AE, too. But some go it one better, by letting you shift the program—by rotating a dial, you can set a different shutter speed or aperture, and the camera will automatically adjust the other control to maintain proper exposure.

Subject Modes

Many point-and-shoot cameras and entry-level AF 35mm SLRs offer several programmed subject modes, which automatically set the camera for shooting specific types of subjects. The most common are portrait, close-up, action, landscape, and night-scene modes.

Portrait mode sets a wide lens aperture to throw the background completely out of focus so the subject stands out. With some cameras, portrait mode also zooms the lens to a waist-up cropping. As mentioned previously, I think you'll generally want tighter cropping on your portraits.

Close-up mode also sets a wide lens aperture to throw the background out of focus so that the subject stands out. Since depth of field is extremely limited at close shooting distances, this isn't always a good idea. With some cameras, close-up mode also sets single-shot AF, single-shot film advance, and central-area metering.

Action mode sets a fast shutter speed to keep moving subjects from blurring. This requires the camera to set a wide lens aperture to produce proper exposure. Sounds like portrait and close-up modes, doesn't it? But there are a few

differences. Action mode switches the flash off and activates continuous AF and advance modes, if the camera has them.

Landscape mode does the opposite. It sets a small aperture for great sharpness from foreground to background. It generally switches the flash off and locks focus at infinity.

Night-scene mode sets a slow shutter speed to capture detail in the dark scene. So you should mount the camera on a tripod or your pictures will be blurred because you won't be able to hand-hold the camera steadily enough to use such long exposure times. If you use flash with night-scene mode, you can get a picture with a detailed flash-lit nearby subject against a beautiful night-scene background.

TV mode sets the camera for shooting pictures on your TV screen or computer monitor. It turns the flash off and sets a sufficiently slow shutter speed (if you shoot at too fast a shutter speed, you'll get horizontal or diagonal bands across your picture). Because of the slow shutter speed ($\frac{1}{30}$ second or longer), you should put the camera on a tripod or other support when using TV mode. Turn out the other lights in the room so they don't reflect in the TV screen.

Thank-you mode sets focus at around 6 feet, handy when you ask a stranger to take a picture of you and your family while on a vacation. With this feature, you don't have to explain to the stranger how to operate your camera, and the camera won't accidentally focus on the background instead of on you.

Of course, with an AF 35mm SLR, you can set any or all of these things yourself. However, you can't set shutter speeds, apertures, or focus points with a point-and-shoot camera, so these modes give you a little control over your pictures with the simple twist of a dial.

Shutter-Priority AE

Besides fully automatic program AE, AF 35mm SLRs offer automatic exposure modes that give you control over the shutter speed and the aperture. In shutter-priority AE mode, you set the shutter speed you want to use (a fast one to freeze action, for example, or a slow one to blur the action), and the camera automatically sets the corresponding aperture for correct exposure.

Aperture-Priority AE

In aperture-priority AE mode, you set the lens aperture you want to use (a small one to get everything sharp from foreground to background or a large one to throw the foreground and background completely out of focus), and the camera automatically sets the corresponding shutter speed for correct exposure. I do just about all of my shooting in aperture-priority AE mode. When I'm hand-holding a long lens or doing aerial photography where I want the fastest possible shutter speed, I set the lens to its widest aperture. When I want lots of depth of field, I stop the lens down to a small aperture.

Photo Fact

While point-and-shooters like automatic exposure control for its simplicity and conven-
ience, serious photographers like it for its speed. It takes time to determine the exposure
manually, then set the shutter speed and aperture. In shutter- or aperture-priority AE, you
can set the control that's important for the shot, and the camera instantly sets the other
one, so you're ready to shoot much more quickly. Especially for action and news pho-
tographers, exposure automation is a terrific boon.

Depth-of-Field AE

Canon EOS AF 35mm SLR cameras have an interesting mode called depth-of-field AE, or DEP. With this mode, you point the camera's AF target at a nearby subject you want to appear sharp in your picture and press the shutter button to enter that distance in the camera's memory. Then you do the same thing for a distant subject you want to appear sharp in the picture. The camera then calculates the aperture and focus setting needed to get both subjects sharp (if possible, given the light level, film speed, and lens in use), and sets them automatically. Chapter 9 tells all about depth of field.

Metered-Manual Mode

AF 35mm SLRs provide full manual control of exposure. In metered-manual mode, you set both the shutter speed and the lens aperture. An indicator in the viewfinder lets you know when you've set what the camera considers to be the correct exposure, but you can disregard that if you wish and base the exposure on a reading from a hand-held meter or your own experience and intuition. Chapter 7 tells you all about exposure.

Metering Modes

The automatic metering systems in most reloadable point-and-shoot cameras either take the entire image area into consideration when calculating the proper exposure, or divide it into two segments and use readings of them to determine the exposure. This works with many subjects, and the exposure latitude of color-print film takes care of many more.

Spot-Metering Mode

Just as spot AF lets you base focus on a specific point in the scene, spot-metering mode lets you base exposure on a specific part of the subject or scene. This is handy when shooting backlit or spotlit subjects. You can meter the subject, and the reading won't be thrown off by the especially bright or dark background. A few point-and-shoot cameras and many AF 35mm SLRs offer a spot-metering mode.

Spot-metering mode measures the light in a tiny central portion of the image. Besides photographing spotlit subjects, spot metering is useful when photographing a bird flying in a partly cloudy sky—the exposure will be based on the bird, whether it's in front of white clouds or dark sky.

Multi-Zone Metering

Most of today's AF SLRs and a few point-and-shoot cameras offer two or three built-in metering systems. The primary one is a multisegment system that divides the scene into six or more segments (one entry-level model uses 35 segments) and then calculates the exposure based on readings from each of the segments. Some cameras also incorporate subject-position data from the AF system for even more accurate exposures. These multisegment metering systems are amazingly accurate and can handle just about anything. I generally set my AF 35mm SLR for multisegment metering and forget about exposure problems.

Another common metering system is center-weighted, or center-weighted average. This system reads the whole image area, but places most of its emphasis on the central portion. When I got into photography, this was the only metering system available, and it was easily fooled by backlighting and spotlit subjects. But it was all we had, so we learned when and how to compensate. Today's multisegment meters are way better.

Exposure Compensation

Sometimes, experienced photographers want to override the automatic exposure setting. Cameras with exposure compensation make this possible. Just "dial-in" the desired amount—it's usually settable in ½-stop increments (some cameras let you set it in ⅓-stop increments), from two or more f-stops less exposure than the automatic setting provides, to two or more f-stops more exposure. Chapter 7 tells you all about exposure.

BLC

Some point-and-shoot cameras provide automatic backlight control (BLC). When the metering system detects a big difference in brightness between the background and central subject, it automatically increases exposure so the backlit subject doesn't come out too dark in the picture. It's automatic and nice to have in a point-and-shoot camera.

Flash Modes

Built-in electronic flash is wonderful. It's always there when you need it and lets you shoot nearby subjects in dim lighting. Most point-and-shoot cameras offer several flash modes. Chapter 10 tells you all about shooting with flash.

Auto Flash

The standard flash mode for point-and-shoot cameras is auto. When the camera thinks flash is needed (in dim light or backlighting), it will automatically fire it. You don't have to do anything. Some AF 35mm SLRs do this, too. Others light the flash icon in the viewfinder when they think you ought to use flash, but you have to push the flash button to activate flash if you choose to use it.

Fill-Flash

When you set fill-flash (also known as force-flash, daylight-sync, and flash-on) mode, the flash will fire for every shot, whether the camera thinks it's needed or not. Fill-flash is especially handy for adding light to dark shadows in outdoor portraits.

Flash-Off

When you select flash-off mode, the flash won't fire, even if the camera thinks it's needed. Flash-off mode is handy when flash isn't permitted (such as at plays and concerts and in some museums), and when you want to capture the mood of the existing lighting (mount the camera on a tripod so the slow shutter speeds don't cause blurred pictures).

Red-Eye–Reduction Mode

Red-eye–reduction mode helps to minimize *red-eye*, those awful red spots in subjects' eyes in flash portraits. It does this by briefly activating a light to "stop-down" subjects' eyes just before taking the picture. With most cameras, this light is a few low-powered bursts from the flash unit. With others, it's the self-timer lamp or the focus-assist lamp with an AF 35mm SLR. It's generally a good idea to use red-eye–reduction mode when you're using flash to photograph people or animals.

CAUTION

Watch Out!

Red-eye reduction delays shooting a little. When you push the shutter button to take the picture, the red-eye reduction light activates, then the picture is taken. This can cause you to miss a spontaneous expression or "magic moment."

Slow-Sync Mode

With a point-and-shoot camera in normal auto flash mode, the camera properly exposes the nearby flash-lit subject and underexposes the background unless it happens to be very well lit. In slow-sync mode, the camera uses a long exposure time to record detail in a dark night background, while the flash properly exposes the nearby subject. The AF 35mm SLRs do a better job of balancing the flash and ambient-light exposures, but even point-and-shoot cameras give you better detail in dark backgrounds in slow-sync mode than in normal flash mode.

Strobe Mode

In strobe mode (available on a few cameras and with higher-end accessory flash units for AF 35mm SLRs), the flash fires repeatedly at a rapid rate. This allows you to record several points in an action in one picture. But the flash has to be close to the subject—in order to fire so quickly, the flash has to operate at low power.

Some AF 35mm SLRs also offer flash exposure compensation, which works like ambient-light exposure compensation, but adjusts only the flash exposure, not the exposure for the ambient light. You'll learn all about electronic flash in Chapter 10.

Advance Modes

All the AF 35mm SLRs and just about all of today's reloadable point-and-shoot cameras have built-in motor drives. These automatically cock the shutter and advance the film after each shot so you don't have to. This single-shot advance feature is a wonderful convenience because the camera is always ready to shoot. (All of us who did photography in the pre–motor-drive days have missed shots because we forgot to wind the camera after making our last shot.)

Continuous Advance

In continuous mode, the camera keeps taking pictures as long as you keep the shutter button depressed. This mode is great for shooting action sequences, but beware— as mentioned earlier, you can run through a lot of film in a short time. And unless you're photographing a fast-moving subject, you'll get a lot of very similar pictures.

Multiple-Exposure Mode

Accidental double exposures were the bane of amateur photographers in the old days when cocking the camera and advancing the film were separate actions. With today's point-and-shoot cameras and AF 35mm SLRs and their built-in motor drives, accidental double exposures are a thing of the past. But you might *want* to make more than one exposure on a single frame on purpose to produce a special effect. Multiple-exposure mode lets you do it. Some cameras limit you to two exposures on the frame; others let you make more. Two is usually plenty; more than that and the image can get very confusing. You'll learn all about multiple exposures in Chapter 14.

Multiple-exposure mode lets you make more than one exposure on a single frame of film.

Self-Timer

The classic self-timer delays the exposure for 10 seconds after you push the shutter button, giving you time to dash into the picture. Most reloadable point-and-shoot cameras and AF 35mm SLRs have a self-timer.

But some cameras offer more than one self-timer mode. Two-second delay mode delays the exposure only two seconds—useful when you're doing high-magnification photography with an AF 35mm SLR and want to give the camera a couple of moments to settle down after you press the shutter button. Double self-timer mode shoots two pictures, one after a 10-second delay and another two seconds later. People will sometimes tense up until the picture is taken, then relax, and that second shot will catch a better expression.

CAUTION

Watch Out!

If you are shooting with flash, the second shot in double self-timer mode will be delayed longer than two seconds because the flash has to recharge after the first shot.

Interval Timer

A few cameras have built-in interval timers. These automatically fire the camera at preset intervals, allowing you to produce time-lapse studies of flowers opening and the like. You can set the number of shots you want the camera to make, and the time interval between them, then activate the timer and go about your business as the camera automatically shoots the sequence of pictures.

Other Features

Some cameras offer additional useful features that can make it easier to shoot, or that let you shoot pictures you couldn't get otherwise. These include a depth-of-field preview, a B or T mode for really long exposures, and switchable picture formats.

Depth-of-Field Preview

Depth of field refers to the area behind and in front of the subject you focused on that will appear sharp in the picture. Small lens apertures provide more depth of field, large apertures less. With a point-and-shoot camera, you can't set apertures, so you really can't do much about depth of field (you can use a fast film to make the camera use smaller apertures and slow film to make it use larger apertures, but that's about it). But with an AF 35mm SLR, you can set the aperture.

So how do you know how much depth of field you have? Some lenses have depth-of-field scales that tell you. Some AF 35mm SLRs also have a depth-of-field preview. Push the depth-of-field preview button, and you can see in the viewfinder how much depth of field you have at the set aperture.

> **Watch Out!**
>
> When you push the depth-of-field button, it stops the lens down to the set aperture. This makes the viewfinder image darker. At really small apertures or in dim light, it's hard to see anything in the viewfinder, including how much depth of field there is.

B or T Mode

The slowest settable shutter speed on most AF 35mm SLR cameras is 30 seconds. And most point-and-shoot cameras stop at one or two seconds. So how do you make a longer exposure? By using B or T mode. In B, the shutter opens when you press the shutter button and stays open as long as you hold the button down. When you're

making a four-hour exposure of star trails, that can get tedious! You can use a locking cable release to hold the shutter open for you. Or, if the camera has a T mode, you can use that. In T, the shutter opens when you press the shutter button and stays open until you press the button again. Naturally, you'll want to mount the camera on a tripod when using B or T mode.

Format

Some 35mm cameras offer a panoramic-format mode. And all reloadable Advanced Photo System cameras offer three formats: full-frame "H," which produces 4 × 7-inch prints; classic "C," which produces the familiar 4 × 6-inch prints; and panoramic "P," which produces panoramic 3.5 × 10- or 4 × 11.5-inch prints. You select the desired print format by moving a lever or switch to H, C, or P before taking the picture.

> ### Photo Fact
>
> Panoramic format isn't bigger than standard format. With 35mm, panoramic-format images are cropped out of the full-frame 24 × 36mm image by masking off the top and bottom so that you get a long, thin 13 × 36mm image, from which the panoramic prints are made. With APS, panoramic-format images are cropped out of the full-frame 16.7 × 30.2mm image by magnetically or optically coding the frame so the photofinishing equipment prints just a 9.5 × 30.2mm portion of the full-frame image. C-format images are coded so the photofinisher prints a 16.7 × 25.2mm portion of the full-frame image. See Chapter 8 for more information about prints.

The Least You Need to Know

- Point-and-shoot cameras are point-and-shoot simple.
- Many offer additional features.
- Some of these features can help you take the types of pictures you want to take.
- You don't have to use all the features packed into a camera.

Master the Mechanics

In This Chapter

- Meet the camera manual
- How to hold the camera
- Focusing
- Loading film into the camera
- Camera care basics

One great thing about point-and-shoot cameras is that they're as easy to use as you want them to be. If all you want to do is point and shoot, that's all you have to do. You can shoot pictures merely by aiming and pressing the button. But most cameras let you do more, and doing more will often get you better pictures. So let's see what that point-and-shoot can really do for you.

Every camera is a magical device. It can record people, places, and events—memories of moments frozen in time. But it's not something to be in awe of. It's just a tool, like a hammer. Okay, it's a *little* more complex than a hammer, but then again, I've never bruised my thumb using a camera.

This chapter shows you the nuts 'n' bolts of using your camera. If you already know how to use yours, you can skip it—though it just might tell you something you didn't already know. If you feel a little intimidated by your camera, you won't after reading this chapter.

I'm in the Booklet

The first thing you should do with any new camera is get out the instruction manual and, camera in hand, go through each feature. There's a lot of useful information in the manual, along with pictures that show you how to use the camera. This chapter will take you through the basic things that cause new camera users trouble, but you have to go through the instruction manual to learn how to use a specific camera because each model has its own idiosyncrasies.

Power Trip: What You Need to Know About Batteries

Once upon a time, cameras were mechanical. The only thing that required a battery was the built-in exposure meter, which was so inaccurate in my camera that I never used it—I used a hand-held meter instead. So I didn't even put a battery in my camera.

Then, one day, the electronic shutter came along. It was much more accurate than the old mechanical shutters, but it required a battery. (Actually, it didn't require one—one mechanical shutter speed was available if the battery died. But what's the point of having 15 precisely timed shutter speeds from 8 seconds to $\frac{1}{2000}$ if you have to shoot at $\frac{1}{60}$ all the time?) Fortunately, a shutter doesn't draw a lot of "juice," so the battery lasted a long time.

Today's cameras not only have electronic metering systems and shutters, they have automatic exposure systems that set the shutter speed and aperture, motor drives that cock the shutter and advance the film after each shot, autofocusing systems, and electronic flash units. Digital cameras also have electronic viewfinders and external LCDs. These electronic features (especially the LCD monitors, motor drives, AF systems, and flash) use lots of power. Bottom line: Today's cameras require batteries and wear them out rather quickly.

Hot Tip

Always carry spare batteries for your camera (and for your flash unit, if you have a separate flash unit).

Rule number one about cameras and batteries: Always carry spares. If the battery in the camera dies and you don't have a spare, you're done shooting. And the lithium batteries used by most point-and-shoot cameras are generally hard to find anywhere but at a camera store.

The next thing you need to know about cameras and batteries is what kind of battery your camera uses. Most modern 35mm point-and-shoot cameras use a three-volt CR-123A or DL-123A lithium battery. Really compact models use the smaller three-volt CR2 lithium battery. Most AF SLRs use a six-volt 2CR5 lithium battery. Many digital cameras use special lithium-ion batteries unique to a specific camera model. Some cameras use the easier-to-find but shorter-lasting AA batteries.

How do you know what kind of battery your camera uses? The instruction manual will tell you. Many cameras list the battery type right on the battery compartment. The dead battery you're taking out of the camera provides a great clue, too. But if you don't have an instruction manual, the battery compartment doesn't say what kind to use, and there's no battery in the camera, you can ask at your local camera store or ask the camera manufacturer—you'll find a list of manufacturers' addresses, phone numbers, and websites in Appendix A.

Photo Fact

Lithium batteries have several advantages over AA alkaline batteries, besides size. (Of course, there are AA lithium batteries, too, but few of today's point-and-shoot cameras use AA alkaline batteries—they're too big.) Lithiums last longer—you get more pictures per battery. Lithiums don't lose power sitting on the store shelf, and they perform better in cold weather. On the downside, lithiums cost more than AA alkalines and are harder to find. You usually can find them at camera stores, however, so buy a few extras and keep them in your refrigerator until you're ready to use them. Lithium-ion batteries can be recharged, while regular lithium batteries cannot. But always use the battery type recommended by the camera manufacturer.

A quick survey of instruction manuals indicates that a typical point-and-shoot camera will let you shoot 10 to 25 24-exposure rolls of film with a fresh battery, using flash for about half the pictures. Consumer digital cameras will provide 50 to several hundred exposures on a set of batteries, or on a single charge with rechargeable batteries. Unlike alkaline batteries, lithium batteries don't fade away; they die suddenly. That's why you'd better have a spare on hand. If the battery dies with a partially exposed roll in the camera, don't panic. Just remove the dead battery and put in a fresh one. With

today's cameras, you can continue shooting where you left off. (With some older cameras, you'd lose the next few unexposed frames on the roll because those cameras went through a start-up routine each time a new battery was installed, thinking you had just put in a new roll of film.)

CAUTION

Watch Out!

Keep an eye on the battery-condition icon on the LCD panel. When it indicates that the battery is getting weak, replace the battery as soon as you finish the roll of film that's in the camera. Unlike alkaline batteries, lithium batteries don't fade away, they die suddenly. Some battery types provide good shooting life, but lose their charge over several days of sitting, and so should be charged the evening before you're going out shooting. Other types develop a "memory," and won't accept a full charge if you charge them before they're fully run down. Read the battery section of your camera's instruction manual to learn the best way to use your camera's batteries.

It's easy to install the battery. All you need to be concerned with is that you match up the + (positive) and - (negative) marks on the battery with those in the battery compartment. There's often a diagram in the battery compartment (and there's always one in the instruction manual) showing the proper orientation for the battery. Hint: Most camera batteries have a flat end and an end with a raised bump in the middle. The end with the bump is the + end.

Hot Tip

While lithium batteries perform better than alkalines in cold weather, it's still a good idea to keep the camera (or at least the batteries) in a warm pocket until you're ready to shoot. Even lithium batteries perform better at normal temperatures.

Most cameras have a power-saving feature that shuts the camera off after a few seconds to a few minutes of nonuse to conserve the batteries. If yours doesn't have this feature, switch the camera off before carrying it for a long period in a camera bag—if you don't, you'll have a dead battery when you pull it out at your destination. With digital cameras, it's best to switch them off if more than a few moments will occur between shots—batteries will last longer that way than if you rely on the camera's "sleep" feature.

To make sure you've installed the battery correctly, switch the camera on (see the instruction manual for the proper method for your camera). If the camera turns on, you've installed the battery correctly. The battery icon on the LCD panel will indicate a new battery, too.

Becoming Attached to Your Camera

Connecting the camera strap to the camera can be a pain, but the effort is well worth it. Besides providing the convenience of letting you carry the camera around your neck so both hands are free, the strap can prevent you from dropping your camera. And if you don't think you'll drop your camera, think again! I've dropped my heavy-duty pro SLR (thank goodness it's a hardy pro model—it looks a bit raunchy, but still works) one of the few times I tried carrying it and several other items as I climbed out of my car. Ironically, the camera strap was attached to the camera—I just hadn't bothered to put it around my neck. Have you ever dropped a bar of soap in the shower? Many point-and-shoot cameras are about the same size and shape. Use the strap! The instruction manual shows a common way to attach a camera strap.

Steady as She Goes

Holding the camera properly is very important for two reasons. First, if you move the camera when you push the shutter button, you'll get blurred pictures. Second, if you accidentally cover the lens, flash unit, or focusing or metering windows while shooting, your pictures won't come out. With an AF 35mm SLR, this is not a big problem because metering, focusing, and image recording are all done through a single "window"—the lens—and that sticks out so far from the camera body that it's pretty hard to get a finger in front of it. Even if you do manage to, you'll see it in the TTL (through-the-lens) viewfinder. But it's easy to accidentally cover one of those windows with a point-and-shoot camera because there are separate ones for focusing, metering, and image recording; they're right on the camera body, and you won't see it in the viewfinder if you cover one of them. From this standpoint, it's actually easier to hold an AF 35mm SLR than a point-and-shoot camera.

CAUTION **Watch Out!** _____

Experienced SLR users are the ones most likely to shoot a point-and-shoot camera with a finger covering something since they're used to through-the-lens viewing. They assume if they see the image clearly in the finder, they're not blocking anything with their fingers. Despite all my years of experience and cameras used, I've still managed to shoot with a point-and-shoot camera with my finger in front of the flash unit and metering window.

The camera manual will tell and show you the best way to hold your particular camera. The precise grip for the left hand varies from camera model to camera model, depending on where the windows and flash unit are located, but here are some general tips.

One safe and steady position for your right hand is with your "trigger finger" resting gently on the shutter button and your thumb on the bottom of the camera, gently opposing the trigger finger's pressure. This keeps your other fingers from covering anything they shouldn't and helps keep you from jiggling the camera as you trip the shutter. Some cameras have a control on the back you work with your thumb, and with these, you have to hold the camera with your right thumb on the back.

Here's a good way to hold an AF 35mm SLR (also a manual-focus SLR, which this one is) cradled in the left hand, with the right forefinger on the trigger and the right thumb on the bottom of the camera, opposing the downward force of the trigger finger.

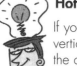

Hot Tip

If you're using flash for a vertical-format shot, hold the camera so that the flash is above the lens, not below it—light coming from above looks more natural than light coming from below.

You want to grip the camera securely but comfortably. With most point-and-shoot cameras, how you have to position your fingers to keep from covering up anything important will not feel comfortable or secure at first. But it will as you practice the grip.

Practice holding the camera properly, both for horizontal shots and vertical shots. Practice in front of a mirror, and see how you look compared to the illustrations in the camera manual.

Pushing the Button

When you push the shutter button, the camera takes a picture. But it does more than just trip the shutter. The button is a two-step device. When you push it half-way down, it activates the camera's autofocusing and metering systems—the camera focuses on whatever appears in the viewfinder's AF target, and the metering system measures the light and sets the shutter speed and lens aperture for proper exposure. When you push the button all the way down, it activates the camera's shutter. The shutter opens to let light reach the film and, after a precisely timed exposure, automatically closes to stop light from reaching the film. The shutter thus serves two functions: It keeps light from hitting the film until you want it to, and it controls how long the light hits the film.

Practice operating the shutter button until you get the feel of it. (Practice operating the shutter button without film in the camera. That way, you won't waste film as you perfect your technique.)

Press the button gently; don't poke it. Don't push it hard. You want to hold the camera as steadily as possible during exposure because if the camera moves during exposure, your picture will be blurred. You'll soon learn to feel the halfway point and won't accidentally make an exposure when you just meant to focus. How do you know when the camera has focused? The green in-focus light in the viewfinder will glow. And with an AF SLR, you can see in the viewfinder that the image is sharp. (The image always looks sharp in a point-and-shoot camera's optical viewfinder, so you have to trust the green in-focus light—one reason why serious photographers prefer SLRs.)

Once established, the focus and exposure settings remain locked in until you either let go of the shutter button or press it all the way down to take the picture.

Photo Fact

The amount of exposure the film receives is controlled by two things: the lens aperture and the shutter speed. The lens aperture controls how much light reaches the film, and the shutter speed controls how long that light reaches the film. How does the camera know how much exposure the film needs? See Chapter 7 for an explanation.

Watch Out!

Some AF 35mm SLRs are a bit hair-triggered—despite all my years of operating hundreds of different cameras, I still occasionally push the button too far with a new camera and accidentally trip the shutter when I just meant to focus. That's why it's important to practice to get the feel of the shutter button on your camera.

Through the Looking Glass

What you see when you look through the viewfinder depends on the camera and your surroundings. You'll see the scene before you, as well as a central focusing target. With a point-and-shoot camera, you'll see some framing lines. You'll also see a glowing green light when the camera has focused on something (the green light will blink if the camera is unable to focus). In dim light, a red lightning bolt will appear, indicating that flash is needed.

The central focusing target shows the area the camera's autofocus system will focus on. Aim the focusing target at your subject, and press the shutter button halfway to activate the AF system. The camera will focus on whatever the AF target is aimed at.

With an AF SLR, you are viewing the image through the lens—the same image that will be recorded on the film. With a point-and-shoot camera, you're looking through a separate window, not through the lens. Because the viewfinder in these cameras generally is above and to one side of the lens, it sees a slightly different view than the lens does. So viewfinders in point-and-shoot cameras include framing lines that show you the area that will be recorded on the film. Parallax isn't a big factor at great shooting distances, but at close distances—and with telephoto zoom settings—it can cause problems. To avoid chopping off the tops of subjects' heads and other mis-framing mistakes, make sure your subject appears within the framing lines in the viewfinder before you shoot.

Parallax is the difference between what the viewfinder on a point-and-shoot camera sees and what the lens sees (and thus records on film). At close shooting distances, this difference can cause you to crop off the top of a subject's head.

Parallax-Compensation Framing Lines

AF Target

Image area recorded on film at close focusing distance

Hot Tip

When shooting at close distances with a point-and-shoot camera, compose the picture in the viewfinder, then re-aim the camera so that the subject falls within the area marked by the framing lines. Anything outside the framing lines will be cropped out of the picture.

One advantage of the AF 35mm SLR camera is through-the-lens (TTL) viewing. There's no problem with parallax because you are viewing the scene through the lens. But with most nonpro 35mm SLRs, a little more of the scene is recorded on the film than what you see in the viewfinder. This compensates for the area a slide mount covers when slides are mounted.

Photo Fact

Some cameras have built-in viewfinder eyepiece correction. This allows eyeglass-wearers to adjust the finder so they can see clearly without their glasses. Many cameras that don't have built-in eyepiece correction offer accessory eyepiece lenses that provide correction.

Cameras are designed for right-eyed people. I became aware of this as age changed my good eye from the right one to the left one. But it's possible to use the camera comfortably no matter which eye you prefer to use. Use the eye that lets you see the best, and get used to holding the camera that way.

Focusing

The simplest cameras have the focus permanently set at a distance that will produce reasonably sharp photos from around 5 feet to infinity. With these "focus-free" models, you don't have to focus—in fact, you can't. Just make sure your subject is at least 5 feet from the camera (the exact distance varies from camera model to camera model; check the instruction manual for your camera), and shoot.

As mentioned earlier, autofocus cameras aren't completely automatic. You still have to tell the camera what you want it to focus on by aiming the focusing target in the viewfinder at the subject. When you partially depress the shutter button, the camera will focus on whatever the AF target is aimed at, the green in-focus indicator in the viewfinder will glow, and you can then press the button all the way down to make the picture. As a safety feature, most autofocus point-and-shoot cameras won't let you

take a picture until the camera has focused on something—the shutter button locks until focus has been achieved.

What if you want to focus on a subject that isn't in the middle of the frame? Aim the AF target at the subject and press the shutter button halfway to focus on it. When the green in-focus light comes on, keep the shutter button partially depressed to lock focus, and recompose the scene with the subject where you want it. Press the button the rest of the way to take the picture. Once focus is established, it locks until you take the picture (or let go of the shutter button).

With normal-spot AF, you have to center the subject in the viewfinder to focus on it, lock focus by holding the shutter button partway down, then recompose as desired and take the picture. With wide-area AF, you can focus on off-center subjects such as the people in this picture without going through all that.

(Ron Leach)

With non-SLR cameras, you have to trust the in-focus light—the image in the viewfinder is always in focus, whether or not the camera has focused on a subject. With an SLR, you can see in the viewfinder whether the subject is in focus, which is one reason why serious photographers prefer SLRs to point-and-shoots.

Focusing by aiming the AF target at the subject is nice, but some cameras offer an easier method: wide-area AF. These cameras use several AF sensors across the frame, covering a wider area. You don't have to dead-center the subject to focus on it; the camera will focus on the closest subject that appears in the wide AF target area.

Most point-and-shoot cameras don't allow you to focus manually, but the AF 35mm SLRs all do. Just set the AF/MF switch to MF for manual focus and turn the lens's focusing ring until the subject appears sharp in the viewfinder.

CAUTION

Watch Out!

If an object that's closer to the camera than your subject appears in the AF frame, the camera will focus on that closer object instead of on the subject.

Why would you need such a feature? One common problem in point-and-shoot photos is the two-shot. You have two friends standing next to each other in front of a wall. You frame them attractively and shoot. When you get your pictures back, the friends are out of focus, and the wall is sharp.

What happened? The AF target was aimed at the wall between the two friends, so the camera focused on the wall.

Autofocus cameras focus on whatever you aim the AF target at. If you aim the target at a wall behind your subjects, that's what the camera will focus on (top). If your subject isn't in the center of the picture, aim the AF target at the subject, press the shutter button halfway to focus on it, then, holding the button halfway down to lock the focus, recompose the picture as you want it and push the button all the way down to take the picture (bottom).

Point-and-shoot cameras generally have just one autofocus mode: single shot. When you aim the AF target at a subject and push the shutter button halfway down, the camera focuses on the subject and locks focus there until you either take the picture or let go of the shutter button.

Hot Tip _____

Autofocus 35mm SLR cameras have better auto-focusing systems than point-and-shoot cameras. They'll focus more quickly and more accurately.

Photo Fact

Each camera (and lens for an AF 35mm SLR) has a minimum focusing distance. If you move closer to the subject than the minimum focusing distance, the camera won't be able to focus. The camera will let you know it can't focus by blinking the in-focus light at you. If you're close to your subject and see the light blink, move back.

Most AF SLRs and some higher-end point-and-shoot cameras offer a continuous autofocus mode in addition to the normal single-shot AF mode. In continuous AF, the camera keeps focusing on the subject as long as you keep the shutter button pressed halfway down—handy when shooting moving subjects. In continuous AF mode, you can't lock focus.

Continuous AF mode in AF SLRs is "smart"—the official term is "predictive." With predictive AF, the camera takes successive focus readings and, from them, determines the subject's direction and rate of motion. The camera's built-in computer uses this data to predict the subject's position at the actual instant of exposure and adjusts the focus accordingly. This compensates for the distance the subject travels between the time you push the shutter button all the way down to take the picture and the moment the film is actually exposed. (There's always a short lag between button pushing and exposure making, because it takes time for the camera to react.)

Setting Shooting Modes

There are two basic methods of setting shooting modes. Some cameras let you do it directly via a dial. With others, you push buttons while watching the LCD panel. Both methods get the job done, and you'll quickly get the hang of whichever mode your camera uses. While some instruction manuals are a little thick, all the ones I've encountered do a good job of explaining how to set the various modes.

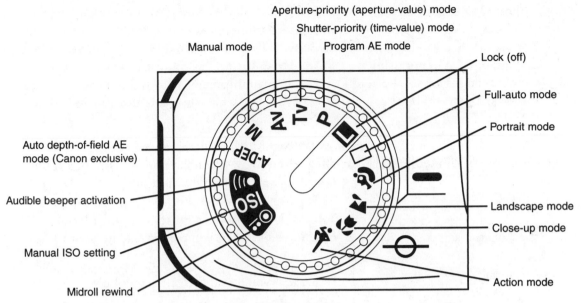

Manual mode

Aperture-priority (aperture-value) mode

Shutter-priority (time-value) mode

Program AE mode

Lock (off)

Full-auto mode

Portrait mode

Auto depth-of-field AE mode (Canon exclusive)

Audible beeper activation

Manual ISO setting

Midroll rewind

Landscape mode

Close-up mode

Action mode

Here's a typical control dial from an AF 35mm SLR. The black line halfway up the dial to the right is the index. To set a mode, rotate the dial so the desired icon aligns with it. The icons on this dial represent (counterclockwise, from the bottom): subject modes, lock (turns the camera off), program AE, shutter-priority (time-value) AE, aperture-priority AE, metered manual, and depth-of-field AE.

Loading Film (Aaarrrggghhh!)

Nearly all of today's 35mm point-and-shoot cameras have built-in motor drives that automatically cock the shutter and advance the film after each exposure and rewind the film after you make the last shot on the roll. The trick is loading film into the camera in the first place. I know people who can program their VCRs to record seven shows over a two-week stretch, yet cringe at the thought of having to load film into their simple cameras.

Anyone who's tried to load film into a 35mm point-and-shoot camera knows that its "automatic" loading feature isn't. What's automatic is the threading of the film leader onto the take-up spool and the advancing to frame one when you close the camera back. You have to put the film cartridge into the camera and pull the right amount of

film leader over to the index mark. But it's not all that hard. I have trouble getting my VCR to play rental tapes, but even I can load film into a 35mm camera. In fact, I can do it with one hand tied behind my back. Literally. And blindfolded, too! I've done it. Many times. I'm not telling you this to boast. I'm telling you because if a klutz like me can do it, you can learn to load film into your camera. What's the secret? Practice! You don't have to be a "natural" to load film into a camera—you just have to practice. And you can do that!

Let's end your fear of film loading once and for all. For this rite of passage, you'll need your 35mm camera and a roll of 35mm film. If you have an old outdated roll of film lying around, that's perfect. Otherwise, buy a 12-exposure roll of the cheapest film you can find. You aren't going to take great pictures with this roll of film; you're going to practice loading your camera.

> **Hot Tip** _____
>
> You don't have to load the camera in the dark. While it's best to avoid direct sunlight, loading film indoors or in the shadow (even the shade of your body) is sufficient. The one exception is Kodak black-and-white infrared film, which must be loaded and unloaded in absolute darkness.

Open the film box. Inside will be a plastic container. Inside that you'll find the cartridge of film.

Pick up the film cartridge and examine it. No, it's not sticking its tongue out at you. The official name for that protruding portion of film is film leader, and it's sticking out of the cartridge so you can feed it to the camera's take-up spool.

Into the Breech

Now, open the camera back. If you just got the camera and don't know how, the instruction manual will show you—generally, there's a button on the left side of the back of the camera that you press or slide to open the back.

Look inside the opened camera. In the center, you'll see the back of the lens. To one side, you'll see a compartment that looks just about the right size to hold a film cartridge. This is aptly called the film compartment (or film chamber, in some instruction manuals). On the other side of the lens, you'll see the film take-up spool. Near the spool is an index mark, usually in red. (The take-up spool is on the right in AF 35mm SLR cameras, but it could be on either side in a 35mm point-and-shoot camera. Which side it's on is of no importance to you or me as photographers.)

Now find a little shaft with a slot in it. (It's at the bottom of the film compartment, if the compartment is to the left of the lens; at the top if the film compartment is to the

right of the lens.) If you look at the flat end of the film cartridge, you'll notice in the center there's a little ridge that looks like it will fit onto that slot. It does. That shaft rewinds the roll of film after you've made the last exposure.

Slip the film cartridge into the film compartment, flat side first, so the ridge fits into the slot on the shaft, then slip the top of the film cartridge into place. The cartridge should fit into place with a little pressure, but you shouldn't have to force it. Practice slipping the cartridge into place: Slip it in, pull it out, slip it in, pull it out, until you get the hang of it.

Now, here's where our practice procedure differs from the one described in the camera manual. The manual says to pull the film leader all the way over to the reference mark. If you do this, the camera will automatically thread the film onto the take-up spool and advance the film to frame one when you close the camera back—and you won't be able to use your practice roll again. So for now, you're just going to pull the leader to within an inch of the reference mark. That way, the camera won't thread the film, and you can keep using the roll for practice.

Close the camera back. The camera will whir briefly, and the letter E will flash on the LCD panel. The E means "error" or "empty," and indicates that the film is not loaded properly.

> **Watch Out!**
>
> It's important to pull the film so that it lies flat across the camera. If you pull out too much film, it will curl, and that can cause it to jam when you close the camera back. If you don't pull the film leader far enough, the take-up spool can't grab it, and it won't thread properly.

Open the camera back, remove the roll of film, and go through the process again. Keep doing it until you feel comfortable with it. When you finally feel comfortable inserting and removing the film cartridge, handling the film leader, and closing the camera back, you can pull the leader all the way to the reference mark. This time, when you close the camera back, the camera will whir briefly, and the number "1" will appear in the LCD panel, indicating that the camera is ready to expose the first frame on the roll.

Pull the film leader over to the index mark, making sure the film lies flat in the camera. Then close the camera back.

Prewind Systems

Some cameras feature a "prewind" system. When you close the camera back, these cameras wind the film completely out of the cartridge, onto the take-up spool. Why? Because with this system, each time you take a picture, the camera winds it back into the cartridge. That way, if you accidentally open the camera back in midroll, you won't ruin your pictures—only the unexposed portion of the film will be exposed and ruined.

> **Photo Fact**
>
> Advanced Photo System cameras are really easy to load. There's no film leader, and the film cartridge just drops into the film compartment—it can go only one way. Chapter 5 introduces you to the Advanced Photo System.

With prewind cameras, the exposure counter generally indicates the number of exposures left, instead of the number taken. So when you first load the camera, the frame counter will indicate the number of shots on the roll (12, 24, or 36), rather than 1.

Meanwhile, Back at the Ranch ...

Go ahead and shoot the roll of film you just put in the camera. It doesn't matter what you take pictures of; you just want to finish that roll.

When you make the last shot on the roll, the camera will automatically rewind the film. Well, most point-and-shoot cameras will. Some cameras just flash the LCD panel at you, and you have to press the rewind button to rewind the film. Either way, the camera rewinds the film for you—you don't have to rewind it manually with a tiny crank as we had to in the "good old days."

When you feel comfortable with the film-loading procedure, you're ready to get out a "real" roll of film and load the camera. Be sure to pull the leader all the way to the reference mark. When you close the camera back, the camera will whir again, the number 1 will appear on the LCD panel, and you're ready to shoot.

It sounds a bit complicated, and it takes a little getting-used-to, but with a session of practice, you'll soon feel comfortable loading film and will never again dread this task.

Of course, if you get a digital camera, you won't have to deal with loading film. And memory cards are very easy to load—just slide the card into the camera's memory-card slot.

Taking Care

Today's camera is low maintenance. Of course, there are some don'ts: Don't drop the camera, get it wet (unless it's weather- or waterproof), touch the glass surface of the lens, touch the insides (or expose them to sand, water, and the like), expose it to magnetic fields, or leave it in a hot or cold place. Follow these rules of thumb, and it should work well for a long time. SLRs tend to last longer than the lower-priced point-and-shoot cameras, but I've seen point-and-shoots last for years.

To clean the camera, use a blower brush (an inexpensive device available at any camera store) to remove surface dust, then wipe the body gently with a soft, dry cloth. Don't use alcohol or solvents to clean the camera body—it's plastic (high-tech plastic, but plastic nonetheless), and could be damaged. (I do know pros who use a soft cloth dipped in a little alcohol to clean their camera bodies when necessary, but all the camera manufacturers say not to do that.) You can also use the blower brush to remove dust from the film chamber, but don't touch or blow on the shutter curtains. To clean the front lens element, again start with the blower brush, then use photographic lens-cleaning tissue moistened with lens-cleaning fluid and gently wipe the lens surface with a spiral motion from the center outward. Be very gentle—the multicoatings used on photographic lenses

CAUTION **Watch Out!** _____

Some point-and-shoot cameras are advertised as *weatherproof* or *waterproof*. There is a difference. Weatherproof cameras may be used in the rain and snow and can handle an occasional splash. They can't be submerged. Waterproof cameras can be used underwater to the depth specified by the manual. Do not let your camera get wet at all unless it is specifically designated as weather- or waterproof!

scratch very easily. If the coating gets badly scratched, your pictures will suffer a loss of sharpness, contrast, and color richness.

If you aren't going to use your camera for a while, remove the battery and store the camera in a cool, dry place away from moth balls. If the storage environment is humid, store the camera in a vinyl bag with a desiccant.

The Least You Need to Know

- ◆ You don't need special talents to learn to use your camera—all it takes is practice.

- ◆ It's important to put in that practice.

- ◆ The camera manual and the information in this chapter show you what to practice and how.

- ◆ Take care of your camera.

APS: Amazingly, Positively Simple!

In This Chapter

◆ What APS is all about

◆ Fabulous features

◆ Why you're probably better off going digital

Developed by Kodak, Fuji, Nikon, Canon, and Minolta to answer the needs of the snapshooting general public, the Advanced Photo System (APS) was introduced early in 1996 as the next big thing for the point-and-shooter. However, digital imaging came along shortly thereafter, and today a digital camera is a far better choice for the point-and-shooter. There are still APS cameras on the market (although even some of the companies that developed APS have quit making them), and they do offer some advantages over 35mm for point-and-shooters, so here's what APS is all about.

What Is APS?

The APS is an alternative to 35mm that offers several advantages. APS film is smaller than 35mm film—it's actually 24mm wide—and comes in a smaller, "intelligent" film cartridge. Both the film and the cartridge "talk" to the camera and to the photofinisher, and the result is better pictures for you.

The smaller film and cartridge mean smaller cameras, and some APS cameras are truly teeny. This makes them even more convenient to carry—which means you're more likely to take your camera along, which means you're more likely to take pictures. Of course, today there are some very tiny digital cameras, too.

Dreading Threading?

With 35mm, you have to thread the film leader onto a take-up spool (even with "autoloading" cameras, you have to pull the leader over until it aligns with an index mark inside the camera). APS offers true drop-in loading. There's no film leader. Just drop the film cartridge into the camera's film compartment (it only fits one way, so you can't load it wrong) and close the compartment door. The camera automatically pulls the film out of the cartridge and winds it to frame number one. The data disk built into the bottom of each APS cartridge tells the camera the film speed, film type, and length, and prevents accidental double exposures.

Loading film into an APS camera is truly drop-in simple. Just open the film-compartment door, slip the cartridge in, and close the door. The camera whirs for a bit, and you're ready to shoot. What's more, the door has a safety lock, so you can't open it until the film is completely rewound into the cartridge.

(Kodak)

It's fast and foolproof. The cartridge indicates whether it contains unexposed film, a partially exposed roll, a fully exposed roll, or a processed roll. And even if you choose

to ignore this information, APS cameras won't let you reload a fully exposed or processed cartridge. (Some higher-end APS cameras offer "MRC" midroll change capability, which lets you remove one film cartridge in midroll, insert another, then remove the second cartridge and reload the original cartridge to finish it without missing a frame.)

Three Formats

All reloadable APS cameras let you select among three image formats for each shot you make: C, H, and P. C is the classic 35mm aspect ratio of 2:3. This means the print or slide you get will have width to length dimensions in the ratio of 2:3. For prints, this typically is 3.5 × 5-inch, or more commonly 4 × 6-inch. H is the 9:16 aspect ratio used by High-Definition Television (HDTV), yielding 4 × 7-inch prints. P is the panoramic aspect ratio of approximately 1:3, and yields 3.5 × 10- or 4 × 11.5-inch prints.

Hot Tip

It's simple to select any APS image format: Just move the camera's format selector to the H, C, or P position. Masks in the viewfinder show you the picture shape, making it easy to compose the pictures in the chosen format.

C format is ideal for folks who are used to prints from their 35mm cameras. P format is great for scenic vistas and any wide or tall subjects. H is a good all-around format; I generally shoot all my APS photos in H format, then decide later which ones I want to crop into P or C format.

All reloadable APS cameras let you select among three print formats for every shot. Because all images are actually recorded full-frame, you can later change your mind and have any picture printed in any format.

(Jackie Augustine)

No matter which format you choose, all images are actually recorded full-frame (H format) on the film and coded as to the chosen format. The photofinisher's printing equipment reads this code and thus knows how to print each frame.

One nice benefit of this system is that you can change your mind later about the format—the folks at the developing lab can override the printing machine and print any image in any format you want. With 35mm, you can't decide later to have a panoramic-format image printed full-frame because only the panoramic portion of the image has been recorded; the rest of the film frame has been physically masked off. (Most single-use APS cameras provide only the H format.)

Here are the relative sizes of images recorded on the film by APS cameras and by 35mm cameras.

Format	Dimensions in Millimeters
APS Full-frame (H)	16.7 × 30.2
APS C	16.7 × 23.4
APS P	9.5 × 30.2
35mm Full-frame	24 × 36
35mm "Panorama"	13 × 36

When your APS film is processed, you get your negatives back (conveniently stored in the original film cartridge, so you can't damage them through handling—and the tiny APS cartridge is a lot easier to store than an envelope of negative strips), a handy index print (which shows every shot on the roll, with crop marks indicating the chosen format for each image), and prints of each shot in its selected format.

The index prints (which were introduced a few years back as an optional service with Kodak's Royal Gold family of 35mm films) make it very easy to order reprints—no more trying to match orange negatives with original prints to make sure you get the right one. Just tell the photofinisher the numbers of the images on the index print that you want reprinted.

Each APS print is imprinted on the back with the date, roll number (which matches the code number on the film cartridge containing the negatives), time, and frame number—things even die-hard 35mm users will love. Higher-end APS cameras allow you to have additional information printed on the backs (or fronts) of the prints, such as shooting data, title, location, or a greeting.

APS Advantages

APS has several advantages over 35mm:

- It offers easier, foolproof film loading.
- It lets you choose among three print formats—before or after shooting the picture.
- It provides easier and safer negative storage.
- Index prints come with every roll.
- Roll and frame numbers and other data are backprinted on prints.

35mm Advantages

However, 35mm has a few advantages of its own:

- Bigger image area
- More widely available films and processing
- Much wider choice of film speeds and types
- Much wider choice of cameras

Print Quantity

Many APS cameras allow you to code each frame at the time of exposure for how many prints you want. This is handy for group shots where everyone will want their own copy of a print.

Midroll Change Capability (MRC)

Some higher-end APS cameras offer "MRC," midroll change capability, which lets you remove one film cartridge in midroll, insert another, then reload the original cartridge and finish it at any time without missing a frame. But you have to reload the cartridge into the same camera it came out of. MRC doesn't work between cameras.

Image Quality

Image quality depends in part on the film size. All other things being equal, the larger the negative or slide, the better the image quality—that is, the finer the grain, the greater the detail, and the richer the colors. The full-frame H-format APS image is only about 60 percent the size of a full-frame 35mm image. But despite its smaller image area, the APS provides image quality that stacks up well against 35mm for a couple of reasons. First, the new-technology films that were introduced with the APS were better than the existing 35mm films. (Of course, this new technology eventually found its way into 35mm films.) Second, the smaller, superthin-based APS film lies flatter in the camera and printer than 35mm film, which makes for sharper images. For print sizes of 5 × 7 inches and smaller, you would be hard-pressed to see a difference between a print from an APS negative and one from a 35mm negative.

Film Choice

Today, the 35mm shooter has a far wider choice of films—well over 100—while the APS film offerings consist of ISO 200, 400, and 800 color-print films from several manufacturers, plus ISO 400 black-and-white film. But ISO 200, 400, and 800 color-print films are what point-and-shooters use, and that's who the APS was developed for. And the APS films are excellent, with image quality that will even satisfy more serious photographers. (For an explanation of which film to use when, see Chapter 6.)

APS films come in 15-, 25-, and 40-exposure cartridges, while 35mm films come in 12-, 24-, and 36-exposure cassettes. This gives the APS user a slight edge in shots per roll, but APS films cost a little more than 35mm films, so the cost per shot is about the same. More labs are set up to process 35mm film than APS.

APS and 35mm Focal-Length Equivalents

APS Format	35mm Format
22mm	28mm
25mm	30mm
28mm	35mm
30mm	38mm
50mm	60mm

APS Format	35mm Format
56mm	70mm
60mm	75mm
75mm	94mm
80mm	100mm
120mm	150mm
170mm	210mm
240mm	300mm

Single-Use APS Cameras

There are several Advanced Photo System single-use models on the market. All feature fixed-focus, fixed-aperture, wide-angle lenses and a single fixed shutter speed, and rely on the wide exposure latitude of their preloaded color-print films to provide good pictures in a wide range of outdoor shooting situations. Flash models produce good pictures both indoors and at night.

If you'd like to use your APS photos in your computer, you can have your photofinisher scan the photos onto a disk (see Chapters 8 and 22). But you might also be interested in the home scanners that let you put high-resolution versions of your APS images into your PC or Macintosh, where you can improve them, add special effects, put them in newsletters, put them on the Internet, and so forth. These scanners range in price from $150 and up—way up. (For more information about scanners, see Chapter 23.)

The Least You Need to Know

- The Advanced Photo System is very simple to use.

- If you have a computer, a digital camera would be a better choice today.

- APS offers many features unavailable in 35mm.

- The only films available for APS are ISO 200, 400, and 800 color-print films and ISO 400 black-and-white film.

- Not as many places process APS film as process 35mm film.

- APS films and processing cost a little more than 35mm.

Part 2

Other Vital Stuff

Although the camera is your main tool for taking pictures, it's not the only one. This part introduces you to the other necessary stuff. You also need film (unless you've gone digital—see Part 5), and you have to expose it properly (your automatic camera will take care of that most of the time, and Chapter 7 helps you when it won't and tells you what to do about it). When you finish shooting the roll of film, you have to get it processed to turn it into pictures you can look at and share. And there are lots of photo accessories on the market, some of which you'll find quite useful. You'll meet them in this part, too.

Chapter 6

All About Films

In This Chapter

- How film works
- Black-and-white vs. color
- Print vs. slide
- Instant films
- Film speed
- Which film is best for you?

Film is very important stuff. Besides recording our pictures, the film we use determines whether those pictures will be in color or in black-and-white, whether they'll be negatives to be printed or transparencies for projection, and how grainy, sharp, and contrasty our pictures will be. The speed of our film (along with the light level at the scene) partially dictates the shutter speeds and lens apertures used to take those pictures (which, in turn, determine the degree of sharpness or blur in pictures of moving subjects, and how sharp subjects in front of and behind the subject will be).

If you're the impatient sort, I'll save you some time and reading: For most nonprofessional photographers (and for many professional photographers and photojournalists), the best film is color-print film. As its name implies, color-print film gives you color prints, which are the easiest and most popular way to view pictures. Your photofinisher can make good prints for you even if your camera exposes the film incorrectly. So for outdoor shooting, I'd recommend one of the "100" color-print films, and for indoor or night shooting, one of the "400" color print films—Agfacolor Vista or Ultra, Fujicolor Superia, Kodak High Definition, and Konica Color Centuria Super, for example. If you don't want to wade through a whole chapter on films, use any of the "100" or "400" color-print films, and you'll be fine.

However, there are lots of films on the market (more than 100 in the 35mm format alone!), and you might be wondering why. You also might be wondering what that "100" and "400" mean. This chapter will tell you.

How Film Works

Photographic film consists of a flexible, transparent base that is coated with a thin layer of light-sensitive emulsion. The emulsion consists of silver-halide particles suspended in gelatin. Silver halides are light-sensitive compounds—they darken when exposed to light. That is what makes photography as we have known it for over a century possible and is why unprocessed film must be kept in light-tight containers. (Of course, we can now make photos without film by using digital cameras. You'll learn all you need to know about digital photography in Part 5 of this book.)

A film manufacturer cuts film into appropriate sizes for use with different cameras; for 35mm cameras, it is cut into strips 35mm wide and packaged in 12-, 24-, 27-, and 36-exposure cassettes. The film tongue sticking out of the cassette always looks dark because its light-sensitive emulsion has been completely exposed to light.

When the film is exposed to the right amount of light through a focused camera lens, a latent ("hidden") image is formed on the light-sensitive emulsion. We can't see this

recorded, but undeveloped, hidden image because it is far too weak. And if we take the film out to look at it, it will be fogged by the viewing light and turn dark right before our eyes.

When the film is developed, the developer chemically amplifies the latent image into a much stronger, visible one. If we were to look at the film right after development, we could see the pictures we shot—for a moment. Then the film would all turn dark because it's still sensitive to light. So processing includes a "stop-bath" step to quickly and evenly stop the action of the developer, and a "fixer step" to remove the unexposed (and thus undeveloped and still–light-sensitive) silver halides from the film. Once the film has been fixed, we can look at it without fear of fogging because it is no longer sensitive to light. After fixing, the film must be washed to remove residual chemicals from the emulsion and then dried.

Seeing Things in Black-and-White

What we see when we look at a fully processed roll of black-and-white film is a series of negative images. What was light in the original scene appears dark, and what was dark in the original appears light. The tones are reversed because of the light-sensitive nature of the film: Bright parts of the scene send a lot of light to the film, exposing their portions of the film a lot, and thus producing corresponding dark areas of developed metallic silver in the negative image. Dark areas of the scene send less light to the film, exposing it only a little; so the corresponding areas of the film contain little developed silver and are mostly clear.

Photo Fact

Black-and-white is the chosen medium of many fine-art photographers because of its beauty and the control it provides the photographer. We don't see in black-and-white; we see in color, so black-and-white is automatically an abstract, "arty" medium. To shoot effectively in black-and-white, you have to ignore colors and think in terms of tones: black, white, and shades of gray. It's best to think in terms of contrasting tones when looking for subjects to shoot in black-and-white: light against dark and vice versa.

Such a negative image can be projected onto a sheet of photographic paper (much as a slide is projected onto a screen—more on slides in a bit), which contains a light-sensitive emulsion similar to the one on the unexposed film. The dark areas of the negative let little light through to the paper, so these areas of the image appear light

in the resulting print, as they did in the original scene. The light areas of the negative let more light through to the emulsion on the paper, so these areas of the image appear dark, as they did in the original scene. The result is a photograph that looks like the original scene, only in black-and-white, not color.

When light from a scene is transmitted by the camera lens and exposed on film, it produces a change in the film's light-sensitive emulsion. This change is known as the latent (hidden) image. When the film is developed, the latent image becomes visible as a negative image; what was dark in the original scene appears light, and what was light in the original scene appears dark.

Color-Print Films

Color-print films (also known as color-negative films, because they produce color-negative images when processed) are more complex than black-and-white films. Color-print films consist of not one, but three light-sensitive emulsion layers—one sensitive to blue light, one to green, and one, to red. These layers also contain color "couplers," which form colored dyes during processing. The result, after processing, is color-negative images. In addition to light parts of the original scene appearing dark and vice versa, the colors are reversed to their complements. The blue-sensitive layer produces a yellow dye image, the green-sensitive layer a magenta dye image, and the red-sensitive layer a cyan dye image. Additionally, the entire film has an overall orange cast.

When the color-negative image is printed on color-negative photographic paper (which is coated with an emulsion similar to that of color-negative film), the results are similar to what happens in black-and-white: Light areas of the negative produce dark areas in the print, and dark areas in the negative produce light areas in the print. In addition, colors in the negative produce their complementary colors in the print: Yellow in the negative produces blue in the print, magenta in the negative produces

green in the print, and cyan in the negative produces red in the print. Hence, you get a color print that looks like the original scene. (The overall orange cast of the color negative compensates for imbalances among the color layers, making the negatives easier to print.)

Color-print films produce color negatives, which can be printed on color photographic paper to produce color prints.

Chromogenic Black-and-White Films

During processing of color films, the silver is bleached out of the emulsion, leaving a dye image rather than an image of metallic silver as in black-and-white films. Back in 1980, Ilford introduced a new "black-and-white color film" called XP1 400, based on color-print film technology: It produced black-and-white negatives, but was processed in the standard C-41 color-print-film chemicals, and the negative images were composed of dye clouds instead of silver grains. Aside from the obvious advantage of being able to get your black-and-white films quickly processed at the nearest one-hour lab, XP1 400 shares the great exposure latitude of the color-print films. Good prints could be made from negatives overexposed up to one stop or overexposed up to three stops. And the *grain* is much finer than with the ISO 400 black-and-white films of the day.

Whazzat Mean?

The images on the film (and those on the prints) are made up of tiny particles called **grains**. In black-and-white, these are grains of metallic silver; in color images, they are tiny clouds of dye left behind after the silver is removed from the emulsion during processing. The faster the film and the larger the print, the more evident these grain particles are. Therefore, if your final image is to be a large print, you'll want to use the slowest (finest-grain) film possible.

Hot Tip

Today, there are several chromogenic black-and-white films available, including Ilford's third-generation XP2 Super 400; Kodak's Black & White BWC, Professional T400 CN, and Portra 400BW; and Konica's Monochrome VX400. If you want to shoot black-and-white pictures with your point-and-shoot camera, use one of these films. And if you use an AF 35mm SLR, you'll find these films to your liking, too.

Color-Slide Films

Color-slide films are similar to color-negative films, but the negative images are reversed to positive during processing, resulting in transparent color images that look like the original scenes photographed. These transparencies are cut into individual frames and mounted to produce color slides for projection. Color slides can also be printed on color-reversal papers, which have similar emulsions and processes, to produce positive color prints. (And color negatives can be printed onto special color-positive films to produce positive color slides for projection—but it's best to shoot slide films if you want slides, and print films if you want prints.)

Color-slide films produce transparent color images, which can be inserted in 2 × 2-inch mounts to produce color slides for projection.

While many serious photographers prefer slide films because the slides show a greater range of tones than prints do and because slide films give you what you shot (your photos can't be misinterpreted by the photofinisher's printing equipment and made too light or too dark or given a color cast), slide films do have their disadvantages. First, they have virtually no exposure latitude. If you over- or underexpose them, your

slides will be too light or too dark, and nothing can be done about it. Second, if you shoot under odd lighting, you're stuck with the results—there's no printing step in which colors can be corrected.

How do you know which color films produce negatives and which produce slides? Color-slide films usually have names ending in "-chrome": Fujichrome, and so on. Also, it tells you on the box.

Hot Tip

Your photofinisher can make color prints from your color slides, and slides from your color negatives, if necessary, but they won't be as good. If you want color prints, use a color-print film. If you want color slides, use a color-slide film.

Instant Films

Polaroid's "instant" films should be called "self-processing" rather than "instant" because they take up to five minutes to develop. But they are truly amazing. Press the button, and a minute or so later, you have your photograph! With some of the films, you can watch the image develop right before your eyes! The big benefits of Polaroid instant films are that you get to see your pictures right away, and you don't have to pay for processing. The drawbacks are that the film itself costs more per shot, you have to have a special camera to use it, the image quality is not as good as with conventional color-print films, and if you want reprints, they'll cost more and won't be as good as reprints from conventional color negatives.

35mm vs. APS

Film comes in a variety of sizes to fit a variety of cameras, from tiny 9mm film for Minox "spy" cameras to individual sheets of film 16 × 20 inches and larger for special-purpose pro cameras. The most popular sizes by far are 35mm and Advanced Photo System.

As you'd expect from the name, 35mm film is 35mm (about an inch and a half) wide. The dimensions of each individual image in full-frame format are 24mm × 36mm. It comes in those familiar cassettes with the film tongue hanging out. APS film is smaller—24mm (about one inch) wide—and comes in smaller cartridges, with no leader sticking out.

Because 35mm films are larger, the images don't have to be blown up as much to produce a given size print, so 35mm films produce sharper, finer-grained pictures,

assuming all other things are equal (lens quality, exposure accuracy, camera not jiggled during exposure). In a 4 × 6-inch print, you wouldn't see a difference, but at print sizes of 8 × 10 and larger, 35mm produces better image quality.

There are more than 100 different 35mm films available, including color-print films from ISO 50 to 1600 (you'll learn what ISO means in the next section of this chapter), color-slide films from ISO 50 to 1600, black-and-white films from ISO 25 to 3200, and special-purpose films, such as infrared (you'll learn about these in Chapter 23). But there are just a handful of APS films, the vast majority being ISO 200, 400, and 800 color-print films (since these are far and away the most popular with point-and-shooters). Kodak and Fuji both announced APS slide films—and we tested them at *PHOTOgraphic Magazine* (they were very good)—but they were not released in the United States. Kodak also offers a chromogenic black-and-white APS film, Advantix Black&White 400.

The images on 35mm films measure 24 × 36mm, while images on APS films measure 16.7 × 30.2mm. "Panoramic"- format images are cropped out of the full-frame image. APS also provides a third format.

Film Speed

How does your automatic camera know how much light the film needs for correct exposure? The film speed tells it. Film speed is a measure of a film's sensitivity to light. The more sensitive the film, the higher its speed-rating number. Point-and-shoot cameras (and many pro 35mm cameras) read the film speed from the film cassette automatically, so you don't have to set it yourself as we did in the old days.

ISO is short for the International Standards Organization, which is a group of standards-setting bodies from many countries. ASA is short for the American Standards Association, the United States's standards-setting body, which became the ANSI (American National Standards Institute) in 1970. ANSI is the United States's member of the ISO. DIN is short for Deutsches Institute Für Normung, a European member of the ISO. Aren't you sorry you asked? (Oh, that's right—you didn't. OK, then, I'm sorry.)

Film speeds are given as ISO numbers: ISO 400/27°, for example. The first figure is the old American ASA speed, an arithmetical measure of film sensitivity. The second figure is the European DIN speed, a logarithmic measure. With ASA numbers, each doubling of the number indicates a doubling of film sensitivity: An ASA 100 film requires twice as much light as an ASA 200 film. In the DIN system, every three steps up the number scale indicates a doubling of film sensitivity: A DIN 24° film requires half as much light as a DIN 21° film.

25/15°	160/23°	1000/31°
32/16°	200/24°	1250/32°
40/17°	250/25°	1600/33°
50/18°	320/26°	2000/34°
64/19°	400/27°	2500/35°
80/20°	500/28°	3200/36°
100/21°	640/29°	
125/22°	800/30°	

Here's a listing of ISO speeds from the slowest to the fastest films in general use today. Each succeeding number represents a ⅓-step increase in speed over the next lower figure. Each doubling of the ISO number represents a one-step increase in film speed— a doubling of the film's sensitivity to light.

DX Marks the Spot

All of today's general-purpose 35mm films have "DX" coding on their cartridges, a Kodak innovation that automatically tells DX-compatible cameras (virtually all current models) the speed of the film, so you don't have to and can't forget to. For photographers who want to rate their films at other than factory-rated ISO speeds, higher-end cameras permit the DX coding to be overridden by setting the meter's ISO index to the desired speed. Most DX-compatible cameras have a small window in the back that shows the film-identification strip on the cassette, so that you'll always know whether there's film in the camera and what kind. The DX coding also helps the processing lab track and process the film.

With nonautomatic cameras, you have to tell the meter the film's speed by setting the meter's ISO index (ASA index on older cameras) to the first number in the film's ISO speed: If you're using ISO 100/21° film, for example, set the index to 100. As you can imagine, many pictures were ruined in the pre-DX days when photographers forgot to set the proper film speed (an especially common occurrence when switching from a film of one speed to a faster or slower one).

What It All Means

Film speed is important for several reasons. It provides a means of properly exposing the film, for one thing. It affects what shutter speeds and lens apertures you can use with a given light level (faster films permit shorter shutter speeds or smaller lens apertures). These in turn determine the degree of sharpness or blur in photos of moving subjects and the amount of depth of field. Film speed generally is also an indicator of potential image quality: Faster films generally are grainier, less sharp, less contrasty, and (with color films) lower in color saturation than slower films.

Photo Fact

The ISO speed is assigned to the film by its manufacturer, based on standards issued by the International Standards Organization (ISO). Any other speed at which we rate a film is called an exposure index, or EI. If you shoot Kodak Tri-X (ISO 400) at a speed of 250, you're rating it at EI 250, not ISO 250—Tri-X's ISO speed is 400, and you can't change that. ISOs and EIs are a matter of terminology. ISO speeds and EI ratings are used the same way: Set your meter's ISO index to the desired rating. (Note: With some DX-compatible cameras, you can't set film speeds other than the ISO rating.)

Fast films: Films with ISO ratings of 400 and higher are considered fast. They require less light for proper exposure, thus letting you (or your automatic camera) set a faster shutter speed. This is an advantage when shooting action subjects because the faster shutter speed will more precisely "freeze" your moving subject. It's an advantage when shooting in dim lighting because the faster shutter speed reduces the blur caused by camera shake. It's an advantage when using the tele end of your point-and-shoot camera's built-in zoom lens because such lenses don't let much light in to the film at tele settings, and so require slower shutter speeds. But faster films are grainier and don't produce as rich of colors as slower films. The fastest films available today are

Kodak Tmax P3200 and Ilford Delta 3200, both black-and-white emulsions. These can be push-processed to even higher speeds when such speeds are needed and maximum image quality is not important. See Chapter 8 for a discussion of push-processing.

Slow films: Slower films (ISO 100 and lower) produce very fine grain, great sharpness, and generally brighter colors than faster films. They're great for shooting in good light, and when you want to make big blow-ups. But because they require more light for proper exposure, you (or your camera) will set a slower shutter speed, which increases the chances of blurred pictures due to camera shake.

You'll notice that I left out the ISO 200 films. While touted as great, all-purpose films, most produce image quality about equal to that of the ISO 400 films. So when ISO 100 isn't fast enough, go right to ISO 400—you'll get twice the film speed as ISO 200 and lose little in terms of image quality.

Fast films let you shoot in dim light. Here's an extreme example: Kodak's superfast T-Max P3200 black-and-white film (ISO 3200) was exposed at EI 50,000 and "push-processed" in Kodak T-Max developer. (The photo was made of a friend of the photographer with a really long lens from across the street to simulate a surveillance-photography situation.)

One thing to consider when choosing a film speed is that faster films cost more than slower ones—ISO 400 color-print films cost about 60 cents more per 24-exposure roll than ISO 100 films. That's only 2½ cents per picture, but if you're on a tight budget and shooting mainly outdoors, you can save money by using ISO 100 film and get more colorful, finer-grained prints, too.

Indoor and Outdoor Films

Daylight (a combination of blue light from the sky and yellow light from the sun) is bluer than incandescent light (such as that from common household lights), which contains more red and orange wavelengths than green and blue ones.

Our eyes can adapt to different colors of "white" light. If we look at a sheet of white typing paper outdoors, it looks white to us. If we take that sheet of white paper indoors and look at it by the light of a tungsten reading lamp, it still looks white to us. Film, however, lacks our ability to adapt to different types of "white" light. If the film is designed to "see" the white paper as white in relatively bluish daylight, it can only see the paper as more-orange under more-orange tungsten lighting. If the film sees the white paper as white under tungsten lighting, it can only see it as bluish under bluer daylight.

Color film that sees things correctly in daylight is known as "daylight-balanced" or "outdoor" film. Film that sees things correctly in tungsten light is known as "tungsten-balanced" or "indoor" film. Because color-negative films can be color-corrected when they are printed, most come in only one variety (basically daylight-balanced). Color-slide films generally are not printed; they are projected just as they come from the processor, so there is no opportunity to correct color balance. Therefore, color-slide films come in two basic varieties—daylight-balanced and tungsten-balanced—to handle the two basic types of lighting generally used for photography.

For best results when shooting color slides outdoors, use daylight-balanced color-slide films. For best results when shooting color slides indoors in artificial lighting, use tungsten-balanced color-slide films. (See Chapter 12 for details on shooting in fluorescent lighting.)

You can shoot daylight-balanced slide films indoors by using a blue No. 80A filter over the camera lens, and you can shoot tungsten-balanced film outdoors (professional motion pictures are made this way) by using an orange No. 85B filter. But it's better to use film balanced for the lighting than it is to filter film that isn't.

So Which Film Should You Use?

If you use a point-and-shoot camera, you'll be best off using color-print films. As mentioned at the start of this chapter, you can't go wrong using ISO 100 color-print film outdoors and ISO 400 color-print film indoors. If you aren't going to have your

pictures printed larger than 5 × 7 inches, you can even go to ISO 800 color-print film for indoor shooting, but it costs more than the slower films.

Which Films Do I Use?

I use lots of different films because testing them is part of my job. But I have my favorites—and those keep changing as better films come out. I do most of my film shooting with AF 35mm SLRs and slide films—at the moment, Kodak's Ektachrome E100VS, Fujichrome Velvia, and Fujichrome Provia 100F because I like their rich, accurate colors. I often use Kodachrome 200 for aerial photography—although very grainy, it produces beautiful, natural colors in clouds lit by late-afternoon sunlight and doesn't take on a bluish cast as many films do in aerial work. And it's very sharp. When hand holding my 200–400mm f/5.6 lens, I use Fujichrome Provia 400F, the finest-grained ISO 400 slide film, and Fujicolor Superia X-TRA, an ISO 800 color-print film that provides near-ISO 400 image quality with twice the speed.

Are these films the best ones for you? Only if you shoot the kinds of things I shoot and have my taste in color. Most point-and-shoot cameras don't have accurate enough metering systems to consistently produce good exposures on slide films. And most people want prints, so print films are a better choice. (One reason why I prefer slide films is many of my pictures are shot for use in *PHOTOgraphic Magazine*, and slide images reproduce better than print images.) If you do want to use slide films, you can try the consumer versions of the films I use (Kodak Elite Chrome Extra Color 100 in place of Ektachrome E100VS, and Fujichrome Sensia 100 and 400 in place of Provia 100F and 400F) and save around a dollar a roll over the cost of the pro films.

Films for Specific Situations

The chapters on shooting specific types of subjects in Part 4 provide my film recommendations for those specific subjects. But here are some things to consider:

Point-and-shoot cameras with built-in zoom lenses give you the double-whammy: The longer focal lengths magnify camera shake along with the subject, and they let in less light, requiring slower shutter speeds. The solution? Use a faster film—ISO 400 or 800. In fact, Kodak once changed the name of its Gold Max 800 film to Gold Max Zoom film for this reason.

For normal 4 × 6-inch prints, you won't see much difference at all between ISO 100 film and ISO 400 film, or even ISO 800 film. So if that's the biggest print size you'll need, use the 400 film and benefit from the faster shutter speeds and smaller lens

apertures. At sizes of 8 × 10 inches and larger, you will notice grain in prints from the faster films. So if you need big prints and shooting conditions permit, use a slower film.

Most brand-name films of a given speed are pretty much equal in terms of grain and sharpness. The big difference is in their reproduction of colors and skin tones. (Where you get your film processed can also make a difference, as you'll learn in the next chapter.) All the major brands produce bright, beautiful colors, but you might like one brand's skin tones better than the others, or one brand's rendition of green glass better, and so on. Try a 12-exposure roll of each brand and see which you like best. User reports in photo magazines will give you an idea of what sorts of things the films being tested do best, but the only way you'll know which film(s) will produce the results you like best with the things you shoot is to try them yourself. If you don't want to go to the trouble and expense of trying the various films yourself, you can take comfort in knowing you can't go wrong with any of the major-brand color-print films.

The Least You Need to Know

- If in doubt, use color-print film—ISO 100 outdoors and ISO 400 or ISO 800 indoors.

- Color-print films are more forgiving of exposure errors than color-slide films.

- Slower films are finer-grained and sharper than faster films, with more saturated colors.

- Slower films are better when you want big enlargements.

- Faster films are better for action and dim-light shooting, and extend the range of your flash.

Exposure Exposed

In This Chapter

- The importance of proper exposure
- How shutter speeds and f-stops control exposure
- How the camera sets proper exposure
- How the camera can be fooled
- Bracketing as an exposure insurance policy

Now that you know what kind of film to use, it's time to use it. The automatic exposure systems in point-and-shoot cameras and the wide exposure latitude of color-print films combine to give you pretty good pictures in a wide range of shooting situations, without you even thinking about exposure. And the multisegment metering systems in the better AF 35mm SLRs are amazingly effective—so much so that I use a high-end AF 35mm SLR in aperture-priority AE mode for just about everything I shoot, even though I usually shoot with unforgiving color-slide films.

If you're happy with the exposures your automatic camera is giving you, you don't *need* to go through this chapter. But there are situations that can fool any camera—even my favorite pro SLR. Some cameras handle some

difficult-exposure situations better than other cameras, but no camera is perfect. And you want to have confidence that your pictures are going to come out, instead of just hoping. The best way to find out how your camera handles things is to check your pictures and see which situations seem to give your camera trouble. This chapter provides some good hints.

Why Proper Exposure Is Important

In order to give you a good picture, the film must receive the proper amount of exposure. Too little exposure and the picture will be too dark; too much exposure and the picture will be too light. Today's color-print films have lots of leeway for exposure errors—you can underexpose them by up to two stops or overexpose them up to four stops, and the photofinisher can still make a pretty good print from the resulting negative. And today's point-and-shoot cameras generally can expose the film within much tighter tolerances than that.

So why do you need to know about exposure?

Photo Fact
AF SLR cameras give you more control over exposure than point-and-shoot cameras do, but there are things you can do with most point-and-shoot cameras to get better pictures, including activating fill-flash or backlight-control mode when shooting against a bright background.

Because films produce the best pictures when exposed properly. While you might get an acceptable print from an under- or overexposed negative, you'll get a much better print from a properly exposed negative. There are situations that will fool your camera's metering system. If you know what those situations are and what to do about them, you'll get better pictures. (This applies to digital photography, too—although you can correct over- and underexposed images in your computer with your image-editing program, you'll get the best image quality if the images were correctly exposed in the first place.)

What Is Proper Exposure, Anyway?

Proper exposure is a bit subjective: It's the exposure that produces the results you want in your photograph. Generally, a proper exposure is one that results in a picture that looks like the scene you photographed, with detail in both dark areas and light areas.

Underexposure results in a print or slide that is too dark, with no detail in the darker areas and murky highlights. Overexposure results in a photograph that is too light, with murky shadows and washed-out highlights.

All that said, realize that good photographs are highly personal. You might not always want a photograph that looks just like the scene you photographed. Fine-art photographers often use creative exposure (and development) control to produce images that show what they saw and felt when they made the shot, rather than faithfully reproducing the natural appearance of the scene. But fine-art photography is beyond the scope of this book. If you're interested in the techniques of fine-art photography, Ansel Adams's books *The Negative* and *The Print* will tell you how one master photographer produced his exquisite images.

Hot Tip

Your photofinisher can probably make good prints for you from under- or over-exposed color-print film negatives, but if you over- or underexpose color-slide film, you're stuck with slides that are too light or too dark.

Underexposure results in a print or slide that is too dark, with no detail in the darker areas and murky highlights.

Overexposure results in a print or slide that is too light, with no detail in the brighter areas and murky shadows.

Shutter Speeds and F-Stops

We're going to do a little math now, but just a little. The basic exposure formula is $E = It$: Exposure (E) is the product of the intensity (I) of the light striking the film and the length of time (t) that light strikes the film. The camera (or the photographer) controls the intensity of the light by adjusting the lens aperture, and the length of the exposure by adjusting the shutter speed.

There is a definite relationship between shutter speeds and lens apertures (which are expressed as f-stops: f/2.8, f/8, f/16, and so on). Each time you (or the camera) changes the shutter speed from one setting to the next higher number (from 125 to 250, for example), you are *halving* the amount of exposure the film will receive, by cutting the exposure time in half (125 and 250 actually represent fractions, so you're really going from $1/125$ to $1/250$ second in this case). Each time you (or the camera) changes the lens aperture from one setting to the next higher number (from f/8 to f/11, for example), you are *halving* the exposure, cutting the amount of light transmitted through the lens in half.

Therefore, if settings of $1/125$ at f/8 produce correct exposure, so will settings of $1/250$ at f/5.6 (halve the exposure time and double the amount of light transmitted by the lens), and $1/60$ at f/11 (double the exposure time and halve the amount of light transmitted by the lens). Proper exposure isn't a single shutter-speed/f-stop combination, but rather a whole series of them. So, if you change one step in shutter speed, such as from $1/125$ to $1/60$, you can maintain the same exposure by adjusting the aperture a full step, such as from f/8 to f/11.

To help you get used to this idea, here's a handy assemble-it-yourself equivalent-exposure calculator. Just cut out the two dials (photocopy them if you don't want to cut up your book), then attach dial A to dial B with a small nail or pin through their centers so they'll rotate. If you set one shutter-speed/aperture combination on the dials, all other combinations that will result in the same exposure on the film will appear opposite one another on the dials.

Why would you shoot at say $1/250$ at f/5.6 instead of $1/60$ at f/11? Because the faster shutter speed will give you sharper pictures of moving subjects. Why would you shoot at $1/60$ at f/11 instead of $1/250$ at f/5.6? Because the smaller lens aperture will increase the depth of field to make the people behind the one you focused on sharper. You'll learn more about depth of field in Chapter 9 and about shutter speeds in Chapters 14 and 18.

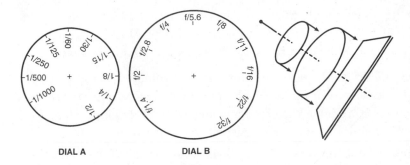

This do-it-yourself dial will help you get used to the relationship between shutter speed and f-stops. Rotate the dials to one shutter-speed/f-stop combination, and all the other shutter-speed/f-stop combinations that will produce the same exposure on the film will appear opposite one another.

Photo Fact
The reciprocal relationship among exposure combinations holds true for "normal" exposure times—those in the $^1/_2$–$^1/_{4000}$ range. At longer and shorter times than these, however, the film doesn't respond equally. This is called "reciprocity failure," and the result is that you must give more exposure than a meter reading (or this dial) indicates when using very short or very long exposure times. With color-print films, this isn't a big deal, but with slide films, you'll have to compensate when using really long or really short exposure times. Film manufacturers can provide you with reciprocity-compensation data for their films if you intend to shoot at such long or short exposure times.

How the Camera Determines Proper Exposure

The camera's automatic exposure system consists of a built-in exposure meter, a tiny computer, and a mechanism that sets the shutter speed and lens aperture according to the computer's instructions. The exposure meter measures the amount of light that strikes its photosensitive cell. The computer uses this data and its knowledge of how much light the film needs (which the film cartridge tells the camera via DX coding) to calculate the shutter-speed/f-stop combination needed to properly expose the picture.

The Exposure Meter

There are two basic types of exposure meters: reflected-light and incident-light. Reflected-light meters measure the light reflected from the scene. Incident-light meters (to be discussed shortly) measure the light incident (falling) upon the scene. Built-in camera meters are reflected-light meters. Through-the-lens meters (found in AF 35mm SLR cameras, but not in point-and-shoot cameras) measure the light

coming through the lens—the very light that produces the image on the film, regardless of the lens's focal length and its corresponding field of view. Non-TTL meters measure the light through a window on the front of the camera and are less accurate.

Exposure meters can't think. All they can do is measure the amount of light that strikes them. Unfortunately, measuring the brightness of the light striking the meter's photosensitive cell can produce incorrect exposures under certain circumstances. If the subject fills the frame and is of average brightness (a medium tone, not too light and not too dark), the meter's exposure recommendation will be accurate. If the subject is particularly dark, less light will reach the meter, so it will call for more exposure. The resulting overexposed picture will be too light—the black subject will be gray in the picture instead of black. Conversely, if the subject is particularly light, more light will reach the meter, so it will call for less exposure. The resulting underexposed picture will be too dark—the white subject will appear gray in the print, instead of white.

Exposure meters are calibrated for medium tones because "average" scenes contain light, dark, and medium tones that average out to a medium tone, and so most of your exposures will be correct. The key thing to remember is that no matter what you take a reflected-light meter reading from, if you expose according to that reading, the metered subject will be reproduced as a medium tone in the resulting photograph. That's the basic rule of reflected-light metering.

If your subject is particularly dark, such as this dog, and you want it to appear that way in your picture, you must give it less exposure than the reflected-light meter suggests. One easy way to do this is by using the camera's exposure-compensation feature.

(Ron Leach)

If your subject is particularly light, like this snowfield, and you want it to appear that way in your photo, you must give it more exposure than the reflected-light meter suggests.

(Ron Leach)

Many newer cameras offer multisegment metering patterns, which divide the scene into several areas and calculate exposure based on the relative brightnesses of these areas. These systems produce accurate exposures in an amazing number of shooting situations but still can be fooled by particularly light or dark subjects.

Light and dark subjects aren't the only things that can fool in-camera reflected-light meters. Particularly bright or dark backgrounds can fool the meter, too. If the background is much brighter than the subject, the meter will "see" all that bright background and call for too little exposure, resulting in a photograph that shows a medium-toned background and a too-dark subject—even a silhouette. Likewise, if the background is a lot darker than the subject, the meter will see all that dark area and call for too much exposure, resulting in a photograph that shows a medium-toned background and a too-light, overexposed subject.

Here we have a white card and a gray card on a black background, in direct sunlight. Because the exposure was based on a meter reading of the gray card, the gray card reproduced as gray, the lighter white card reproduced as white, and the darker black background reproduced as black— just like the original subjects. Any of these subjects can be reproduced as gray by exposing according to a meter reading of it, or reproduced as white by giving more exposure, or as black by giving less exposure.

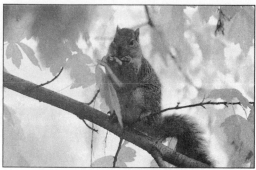

Backlit subjects can fool in-camera meters, which "see" all that brightness behind the subject and call for too little exposure, resulting in a silhouetted subject (left). Silhouettes can be dramatic, but if you want detail in the subject, you must give more exposure than the meter calls for by using the camera's exposure-compensation feature (dial-in + 1.5, as done for the photo on the right) or activating the camera's fill-flash mode.

Multisegment metering does a good job with backlit and spotlit subjects. But if you find that your camera is fooled by such subjects, you can compensate for these situations by giving the film more exposure than the meter indicates when metering a backlit scene or a white subject, and less exposure than the meter calls for when reading a spotlit scene or a particularly dark subject.

Like backlit subjects, spotlit subjects can fool a reflected-light meter, which "sees" all that dark area around the subject and calls for too much exposure, resulting in a washed-out subject. If you want detail in the spotlit subject, you must give less exposure than the meter calls for.

How do you do that? If the camera offers exposure compensation, use that. How much more (or less) exposure should you use? That depends on how you want a light or dark subject to appear in your photograph. As a general rule, increase or decrease exposure ½–2 stops from the meter's indication for slide film, 1–2 stops for print film. Remember Rule No. 1: If you expose according to the reflected-light reading, whatever you took the reading from will appear as a medium tone in the resulting photograph. If the subject is much brighter than a medium tone in real life, give it two stops more exposure than the meter calls for to render it a lot brighter in the photograph. If the subject is much darker than a medium tone in real life and you want it to appear that way in your photograph of it, give it two stops less exposure than the meter reading of it calls for.

Photo Fact
If exposure compensation doesn't sound like a very precise way to determine exposure, well, it's not. Many photographers want more control over their exposures. As you gain experience with your built-in camera meter, you'll develop a feel for its quirks and will become good at properly exposing a wide range of scenes and subject matter. For maximum control over exposure, however, many serious photographers use a spot meter.

Spot Meters

Spot meters are reflected-light meters that read a tiny (1–3°) portion of the scene. You can meter specific subjects or even portions of subjects. There are hand-held spot meters available, and some cameras have spot-metering capability built-in. When using a spot meter, you must think about how you want whatever you're reading to reproduce in your photograph, then apply your newfound knowledge of how reflected-light meters work to make it so. The Zone System, made famous by Ansel Adams, is an excellent, albeit a bit work-intensive, way to do this.

The Zone System breaks the tones in a black-and-white photograph down into 10 Zones, or tones of gray, from Zone 0 (the maximum black the print can reproduce) to Zone IX (paper-base white). Zone V is the medium gray tone that will result from exposing according to the meter reading. Two other key Zones are Zone III, which is a dark area with detail, and Zone VII, which is a light area with detail. Each Zone is one step different in value from the next.

With the Zone System, you must previsualize your final image (that's the tricky part)—see it in your "mind's eye"—before exposing the film, so you can expose to produce the image as you envision it. One simple example is to meter an important shadow area in which you want detail and give two stops less exposure than the meter indicates to "place" it on Zone III. Then read an important highlight area to see where it will fall on the zone scale. If the highlight reads five stops brighter than the shadow area, it will fall on Zone VIII (five stops brighter than Zone III), which will render it near-white with a trace of detail. If that's what you want, shoot. If you want more detail in the highlight, you'll have to reduce film development time to reduce the contrast, thus lowering the Zone VIII highlight to Zone VII (a well-detailed highlight). Conversely, if your scene's brightest important highlight is only three stops brighter than the darkest important shadow area (Zone III), you can increase development to increase contrast and raise the highlight area a zone or more (that is, render it lighter in the photograph).

Of course, you'll have to do some exposure and development-time testing before you can put the Zone System to practical use. And that's a lot of hassle. (I used the Zone System for a lot of my black-and-white work, but now I shoot mainly color slides and rely on the multisegment meter in the AF 35mm SLRs I use.)

An easier (albeit less effective) way you can use a spot meter is as sort of an "educated averaging" meter: Read the darkest and brightest important areas of the scene and expose halfway between the two readings. For example, if the darkest area reads $^1/_{125}$ at f/4 and the brightest area reads $^1/_{125}$ at f/16, expose the scene for $^1/_{125}$ at f/8. If the readings are less than seven stops apart (for black-and-white film) or less than five stops apart (for color film), you'll get detail throughout the photograph. If there's more difference than that, you'll have to decide which area of the scene is most important and expose for that: If the bright area is most important, meter it, then increase exposure about two stops from the meter reading (remember the basic rule that whatever you take a reflected reading from will reproduce as a medium tone if you expose accordingly).

Hot Tip

If you're interested in the Zone System (which is mainly for black-and-white photography), Ansel Adams's books *The Negative* and *The Print* (published by New York Graphic Society) explain it quite well.

Spot meters are also handy for reading subjects that are too far away to meter otherwise. You can turn an SLR camera's TTL meter into a spot meter of sorts by attaching a long lens (or zooming a zoom lens to a long focal length) to narrow the meter's reading angle. Some SLRs have a spot-metering mode, which reads a small central

area of the picture area, indicated by a circle in the center of the viewfinder. The actual area of the scene read changes when you change the lens focal length, when the reading is taken through the lens (TTL) with these cameras.

Incident-Light Meters

The second main type of exposure meter is the incident-light type, which measures the light incident (falling) upon the subject, rather than the light reflected from it. Since incident-light meters don't measure the light reflected from the subject, they can't be fooled by unusually bright or dark subjects or backgrounds. Just hold the incident-light meter right in front of the subject, point its translucent hemisphere (which covers the metering cell) at the camera, expose accordingly, and the subject will be exposed accurately. You don't have to previsualize or even think.

Of course, incident meters have their drawbacks, too. For one thing, you can't always get to the subject to take a reading of the light falling on it. For another, sometimes, you'll have more than one important subject in a scene, as when shooting a landscape in sunlight and shadow. And, of course, incident readings don't tell you anything about the relative brightnesses of the various subjects in your scene and how bright they should be—something you'll want to know if you want control over your photograph.

An incident meter measures the light falling on the subject rather than the light reflected from it. To take a reading, hold the meter in front of the subject and point its translucent hemisphere at the camera.

What If Your Meter Fails?

What if your exposure meter doesn't work at all? Usually, that's because the battery died, so put a new one in. Always carry a spare and change batteries regularly.

If you don't have a new battery, the film instructions generally give you good hints on how to expose the film under a variety of lighting conditions.

You can always fall back on the old daylight rule of thumb. For a front-lit subject in clear daylight, set the lens aperture to f/16 and then use the film's speed as your shutter speed (for example, with ISO 125 film, set the shutter speed to 1/125 second). For a sidelit subject, open the lens one stop (to f/11). For a backlit subject or in open shade (no sun hitting the subject), open another couple of stops. If in doubt, bracket.

Bracketing Exposures

Bracketing exposures is like an insurance policy—you're covering yourself against losing the shot by investing more film to make sure you get it. Bracketing simply means making one photo at the exposure you think is correct, then making additional shots, giving more and less exposure, just to make sure one of the shots will come out the way you want it. (By the way, bracketing is not a beginner's technique. Professionals frequently bracket, especially with slide film. Film sees the world differently than our eyes do, and bracketing helps compensate for that.)

If you determine that the best exposure for a scene is $^1/_{125}$ at f/8 but you're not sure about it, you might make a bracketed series of exposures around that one. Shoot the first frame at the exposure you think is right, then shoot a frame giving one stop more exposure ($^1/_{125}$ at f/5.6), and a frame giving one stop less exposure ($^1/_{125}$ at f/11). If you're really in doubt, you might want to shoot additional frames, giving two stops more and two stops less exposure.

Bracketing in one-stop intervals is fine for black-and-white and color-negative films, but if you're using the less-forgiving color-slide films, you should bracket in $^1/_2$-stop intervals. When you get your film back, select the exposure you like best. With some scenes, you might like several of the bracketed exposures (night scenes, for example). If you keep notes about which settings you use when you shoot your bracketed sequences, you'll learn how to expose to get the results you want in a wide variety of shooting situations and won't have to bracket as often.

Watch Out!

If the battery dies with point-and-shoot cameras, so does the whole camera, not just the meter.

Hot Tip

Some cameras (mainly AF 35mm SLRs) have built-in automatic exposure bracketing, and if you're in doubt about the camera's ability to properly expose a tricky scene, activate this handy feature.

Bracketing exposures means shooting one picture at the exposure you think is right, then shooting additional pictures, giving more and less exposure, to make sure you get one picture that comes out the way you want it.

Going Digital

Consumer digital cameras make getting correctly exposed images simple: You can check the exposure on the camera's LCD monitor before you shoot. If the image looks too light, use minus exposure compensation until it looks right. If the image looks too dark, use plus exposure compensation until it looks right. Digital SLRs don't display the image on the LCD monitor until after you shoot, but you can then check it, and correct the exposure and reshoot the image if necessary. (For more on digital cameras, see Chapter 22.)

The Least You Need to Know

- Proper exposure gives you better pictures.

- The camera sets proper exposure by adjusting the shutter speed and f-stop.

- The camera's meter can be fooled by bright and dark subjects, and by spot- and backlighting.

- When in doubt, bracket exposures.

- Digital cameras make getting correct exposure easy, because you can check the image before or right after shooting it.

Processing: Turning Your Film into Pictures

In This Chapter

- ◆ Where to get your film processed
- ◆ Working with your lab
- ◆ Photofinishing services
- ◆ Doing it yourself

When you finish exposing a roll of film, you have to get it processed. (Okay, you don't *have* to, but you won't get to see your pictures unless you do!) Processing is that magic thing the photofinisher does to convert your roll of exposed film into prints or slides.

One of the most common questions we get asked by point-and-shooters (and by more-experienced photographers, too) is, "Where should I get my film developed?" There are a number of places you can take it: one-hour minilabs, drug stores, supermarkets, discount chain stores, camera stores, mail-order labs, and custom labs. Each has its pluses and minuses.

The short answer is "Anywhere that gives you prints you like." The staff here at *PHOTOgraphic Magazine* uses both a pro lab and the one-hour lab across the street from our offices for our color-print film processing. We send all of our slide film to a pro lab. The one-hour lab does good work, quickly, and is convenient. It does 35mm, APS, and even medium-format film. But you probably don't have this particular one-hour lab right across the street, and some one-hour labs don't do pro-level work. This chapter tells you how to choose and work with a photofinisher.

Photo Fact

There's more to "developing" film than just developing. After the developer chemical is applied, the exposed film is run through several other chemicals to turn it into negatives to be printed or slides to be projected. After its trip through these chemicals, the film is washed (to remove all those chemicals) and dried. Then slide films are cut and mounted, and print-film negatives are printed on color paper. All considered, it's pretty amazing that labs can take your roll of film and give you back prints an hour later!

Types of Processing Labs

You can use many types of labs to get your film processed, and they use several types of processing machines to do it. Most labs in the United States use Kodak's (or Fuji's or Agfa's equivalents) C-41 process for color-print films and E-6 process for color-slide films. Once a color-print film has been developed, most labs use the RA-4 process to create color prints. All common color-print films, regardless of brand, can be processed in C-41 or equivalent chemicals. All common color-slide films except Kodachrome can be processed in E-6 chemicals (Kodachrome requires special chemicals and processing machines; that's why few labs can do it). And all common color photo papers can be processed in RA-4 or equivalent chemicals. Color processing is quite standardized, so from that standpoint, it doesn't make a difference where you get your film processed.

So what *does* make a difference? Let's check 'em out.

Hot Tip

In each category of lab, there are good labs and not-so-good ones. If you don't like the pictures you get from one lab, try another—there are lots of labs to choose from.

One-Hour Labs

Keyword: *quick*. A more accurate name for one-hour labs is minilabs, because some take more than an hour to turn your film into prints or slides. Some minilabs don't even process slide film but send it to another lab. As mentioned in the introduction to this chapter, we use a one-hour lab for much of our color-print film processing, for the speed and convenience. But one-hour labs are more expensive than discount processors. And, as is the case with all processors, some do better work than others.

Some photofinishers process both 35mm and Advanced Photo System film; others just do 35mm, or do 35mm in-house and send APS film to another lab for processing—which takes more time. In either case, APS film processing generally costs a bit more than 35mm processing because the lab has to buy special processing machines to handle APS films. If you're in a hurry to see your pictures and don't mind paying a premium for the privilege, a one-hour lab is for you.

Discount Labs

Keyword: *cheap*. Drug stores, supermarkets, and discount chain stores offer photo-finishing services at low cost. In my area, one local drug store charges less than $5 to develop and print a 36-exposure roll of color-print film at $3^1/_2 \times 5$ size—about one third of what our favorite one-hour lab charges. But these high-volume labs vary widely in quality, and they take one to several days to get you your pictures.

Many nonprofessional shooters buy their film where they get it processed, for the convenience. The discount labs generally have lower prices on film and albums and the like, as well as on processing. Make sure the film's expiration date hasn't passed, wherever you buy your film. (We buy ours from a local photo store that keeps it refrigerated.)

I have some budget-minded friends who frequently use the discount processing at a chain store, and they're willing to wait a few days to get their pictures back in order to save a goodly sum of money. But they don't take their "important" rolls of film there, and they've had problems getting good enlargements. The discount service also returns their 35mm negatives stuffed into one envelope, where they can rub against one another and get scratched. (The store offers a "deluxe " service that includes individual sleeves for the film strips and index prints, but it costs more.) Of course, this isn't a problem with APS film, which is always returned safely stored in the original film cartridge.

If you're on a tight budget and are willing to wait to see your pictures—and if you find the quality satisfactory—a discount lab is a good way to go.

Camera Stores

Keyword: *good*. You'd think camera stores would be great places to take your film to have it processed—the folks there certainly know photography. And generally, you'd be correct. Some camera stores send your film to a photofinisher (usually a good one) for processing, so you have to wait for your pictures and pay a middleman. What you get from a camera store is knowledge and service; the people there should be able to tell you what's wrong if your prints aren't up to your expectations, and what you (and they) can do about it. And, of course, if you need any photo equipment or film, there's a selection right there whenever you drop off or pick up your film.

Mail-Order Labs

Keyword: *convenient*. By their nature, mail-order labs take a while—even if they develop and print your pictures instantaneously, it takes time for the film and prints to get there and back. There's always the chance your film or pictures will get lost en route. And you don't get to talk to someone face-to-face about any problems you have with your prints.

Hot Tip

When you find a good lab, keep using it. Get to know the folks there. When you're a regular customer and they know you, they'll be more likely to help you with any problems you encounter with your prints.

On the plus side, if there's no photofinisher near you, mail-order lets you get your film processed. If you're on a trip and won't be at that location tomorrow to pick up your pictures, you can send the film to a mail-order lab, and your pictures will be waiting for you when you get home. And if you don't feel like taking the film to the lab and going back to pick it up, mail-order solves the problem.

Prints and Slides—and Free Film, Too?

My dad was a movie cameraman. Every now and then, he'd bring me short ends of 35mm movie film to load into 35mm cassettes and shoot in my still cameras. Short ends are leftovers on movie-film rolls that aren't long enough to shoot another "take." So rather than chance running out of film in the middle of a take, the movie people toss them (or give them to relatives of the camera crew).

Motion-picture films are very good—every 35mm movie you see in theaters was shot on them. There are labs that load movie film (not necessarily short ends—some buy fresh rolls) into 35mm cassettes and sell it inexpensively, or even give it away. What's the catch? For one thing, movie films require special processing—they can't be processed in standard C-41 color-print film chemicals, so you have to have them processed by the lab you get them from. And these films were designed to be printed on print-film stock to produce movies for projection—not printed on paper. If you're on a budget, you can try one of these films and see how you like it, but they're not ideal for serious still photography.

Custom "Pro" Labs

Keyword: *quality*. You don't have to be a pro to use a custom pro lab. Custom labs will process film for point-and-shooters, too. And they do excellent work. They have to, or the pros would stop using them.

Custom labs offer custom developing and printing services—they'll push- and pull-process film, do snip tests (cut off a short length of the film and process it to see if it requires special processing), dodge and burn prints to give better detail in shadows and high-lights, do special cropping and really big prints, make color corrections, and lots more.

On the down side, custom labs charge more than other labs. And since they cater primarily to busy pros, they might not be as patient as a camera store or good minilab would be with the problems of a point-and-shooter who brings in one roll at a time.

> **Photo Fact**
>
> Some labs process only color-print film, or only color-slide film, or only black-and-white film. Some labs will do two or all three. Many pro photographers use a different lab for each type of film. We do at *PHOTOgraphic Magazine*, for example, because our slide lab doesn't do prints, and our black-and-white specialist doesn't do color.

Push- and Pull-Processing

Push-processing means overdeveloping the film to compensate for deliberate under-exposure. Why deliberately underexpose the film? One reason might be to enable you to shoot in dim lighting, when the film's ISO speed doesn't permit using the right shutter speed and aperture combination to get the picture you want. Rating the film

at a higher speed—say ISO 400 film at EI 3200—might permit you to use the desired shutter speed/lens-aperture combination and thus get the picture.

Of course, you can't just set the meter's ISO index at any number, expose the film accordingly, and expect to get good pictures. If you expose the film at a speed other than its ISO rating, you have to compensate when processing the film. When you rate the film at a higher speed than its ISO rating, you are underexposing it. If you have the film developed normally, your prints will be too dark, lacking detail in the dark and middle-toned areas, and having weak, grayed bright areas.

Rating ISO 400 film at EI 2400 and having it push-processed allowed me to use a fast enough shutter speed to get a sharp image of this sumo match with a hand-held telephoto lens in the dim arena lighting.

The processing lab can partially compensate for underexposure by overdeveloping the film, which is called push-processing. But you have to tell them what speed you exposed the film at and ask them to push it to that speed. They can then extend the developing time or use a special developer to give you the best possible pictures. Pushed film will result in prints that are grainier and more contrasty than normally exposed and developed film, with less detail in the dark areas, but will be better than if you had underexposed the film and had it developed normally. Most films can be pushed one stop with good results and two stops with okay results. Pushing film more than two stops (that is, rating it at more than four times its ISO speed) should be reserved for emergencies and special grain-effect pictures.

Pull-processing, as you might expect, is the opposite of push-processing: underdeveloping the film to compensate for deliberate overexposure. Why deliberately overexpose the film? To assure good detail in the dark

Hot Tip

If you accidentally expose a roll of film at the wrong ISO speed (not likely with today's DX-compatible cameras, but a common occurrence with older cameras that require the film speed to be set manually), a custom lab may be able to save the pictures via push- or pull-processing.

areas of the picture. The reduced development prevents overly bright areas from becoming too dense on the negative to produce detail in prints. Color-slide films can tolerate a one-stop pull; color-negative and black-and-white films can tolerate more.

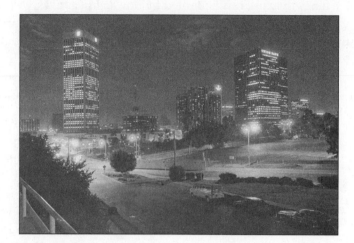

Pull-processing recorded good detail throughout this contrasty night scene.

Pro labs offer push- and pull-processing services, while most labs that service amateurs don't. Labs charge extra for push- and pull-processing—another reason to do it only when necessary. Regardless of where you go, it's a good idea to ask the folks at the processing lab about push- and pull-processing of the films you use before actually doing it. If they offer these services, they'll be able to tell you the best speed ratings for each film, and what you can expect to see.

My Choice

Being the impatient type, I'd recommend doing what we did at *PHOTOgraphic*—find a one-hour lab that does good work. It costs more than the discount chains, but to us it's worth it. And we use a custom lab for slide films because we like the three-hour turnaround and knowing that the processing will be done right, with no scratched film.

If I were on a tight budget, I'd try several of the local low-cost photofinishers and use the one that does the best work. As I said earlier, I have some budget-minded friends who regularly use a large discount chain's processing service, and they get pretty good results at a good price. You can buy individual protective sleeves for your film strips and put each strip in its own sleeve yourself.

Working With the Lab

What if you don't like the prints the lab gives you? Talk with the folks about it. The automatic printing machines they use can be fooled by unusual negatives, just as cameras can be fooled by unusual lighting. So the lab probably can make better prints for you from your negatives. If they can't, ask them why. If you don't buy their explanation (sometimes they'll be right, sometimes not), take your negatives to another lab and see if they can make better prints. If they can, you've found yourself a new lab. If they can't, ask them why. With the exposure latitude and quality of today's color-print films, the lab should be able to make good prints from most negatives.

Watch Out!

One thing no lab can fix is unfocused pictures. If the picture isn't sharp on the negative, the lab can't make a sharp print. It's important to focus properly and hold the camera still when shooting. A tripod (see Chapter 11) will improve focus tremendously.

Photofinishers should be able to fix prints that are too light or too dark, at least to some degree. If there is detail in the negative, the lab should be able to print it, though you might have to go to a custom lab and have a custom print dodged and burned-in (using special techniques to give added or reduced exposure to specific parts of the negative). If the prints are off-color, that should be easy for the lab to fix by adjusting the filtration in the printing machine. Dust spots and water marks on the prints are usually the result of sloppy film handling during processing. The lab should be able to clean the negatives and make spot-free prints.

Some negatives are too underexposed (or more rarely, too overexposed) to print well. You can tell by looking at them (in 35mm, anyway—APS negatives are stored out of sight in the original film canister). If you can barely see an image, the negative is too underexposed, and the lab can't print what isn't there. Such negatives usually occur when you are shooting flash pictures from too far away or when you are shooting backlit subjects without fill-flash. Solutions? Use fill-flash and shoot from within 10 feet of the subject. If the image is very dense and everything looks black, it's overexposed, and the lab won't be able to make a good print from it, either.

Scratching Post

Scratches on negatives appear as white or black lines on prints. Scratches can be caused in-camera or by the photofinishing equipment, and while most are caused by the photofinisher, most photofinishers will blame the camera—one reason why it's important to develop a good, regular relationship with your photofinisher. If the

scratches are on the base side of the negative (the white ones on the print), the lab should be able to make a scratch-free print by applying a scratch-hiding oil to the negative. If the scratches are on the emulsion side of the negative (the black ones on the print), you'll have to have the print retouched (or do it yourself digitally—see Part 5).

Photo Fact

When I got started in darkroom work, my dad grossed me out by rubbing his thumb and forefinger across the sides of his nose and applying the skin oil to a negative to hide the scratches—he said that's how the veteran printers did it. I preferred to use Edwal No-Scratch, a commercial alternative. Either way, he stressed the importance of removing the scratch-hiding substance with film cleaner before returning the negatives to their protective sleeves.

Decisions, Decisions

Many photofinishers offer you a number of choices. You can order "regular" $3^1/_2 \times 5$-inch prints, jumbo 4×6-inch prints, or enlargements of 5×7 inches and bigger. (I've always wondered why only 5×7 and larger prints are considered enlargements—even a $3^1/_2 \times 5$-inch print is considerably enlarged over the size of the original $1 \times 1^1/_2$-inch 35mm negative.) You can save some money by ordering $3^1/_2 \times 5$-inch prints instead of 4×6s, and by ordering two sets of prints at the time the film is processed instead of ordering another set later (assuming you want two of everything on the roll).

Some labs offer index prints from 35mm as well as APS (actually, Kodak introduced index prints in conjunction with Royal Gold 35mm films). The index prints, which show every shot on the roll in thumbnail size, make it a lot easier to keep track of your pictures. Some labs can print the frame number on the back of each print, even with 35mm film (it's automatic with APS). I like this feature because it makes it simple to figure out which negative produced that one print with a perfect expression out of a whole roll of near-identical portrait shots.

Advanced Photo System cameras offering the Print Quantity feature allow you to code each picture as to how many prints you'll want at the time you shoot it. The photofinisher will then automatically make the selected number of prints of each shot when the film is processed.

Many digital cameras offer DPOF: Digital Print Order Format. When activated, this feature records on the memory card the images you wish to have printed, and the

number of prints of each. Then, you can take the memory card to a camera store that offers digital printing services, or insert the card in a home printer that takes memory cards, or even connect the camera directly to a home printer, and the desired images will be printed in the desired quantities.

As pointed out in Chapter 5, with the Advanced Photo System, you can shoot any picture in any of three formats—classic, HDTV, or panoramic—and they will automatically be printed in the chosen format. The index print shows the format you selected for each picture. But you can later have any picture on the roll reprinted in any of these formats because every APS picture is recorded full-frame on the film. With 35mm cameras, if you select the panoramic format, you're stuck with it; the rest of the image has been physically masked off and isn't there on the film. You can have any full-frame 35mm image printed in any format you like by asking the folks at a custom lab to crop it when they make the print.

Photo Fact
How long will your prints last? That depends in part on how you store them. The images on color prints consist of colored dyes, and all dyes fade in time. You can postpone the coming of that time by storing the prints in a dark, cool, dry place, in an archival album made for storing prints. Hanging a print on a wall that gets a lot of sun will make the print fade quickly.

Many labs offer a choice of print surfaces. Glossy shows the greatest range of detail from highlights through shadows, but fingerprints easily. Nonglossy matte surfaces don't fingerprint as easily, but also don't look quite as snappy. Some labs offer textured surfaces, which resist fingerprints and have an elegant look, but the texture hides fine details. If your prints are going to be handled a lot, go for the matte surface; if not, go for the glossy. We always have glossy prints made because they reproduce better in *PHOTOgraphic* (textured prints reproduce poorly).

Some labs offer special print packages—one 5 × 7 and four wallet-size prints, for example—at a discounted price. These can be good deals if you want those sizes.

Digital Services

Chapter 22 covers digital photography, but I'll include some photofinishing aspects here. Some camera stores and photofinishers have kiosks such as Kodak G-3 and Picture Maker, Fuji Aladdin Digital Photo Center, and Sony PictureStation where you can crop, improve, and otherwise manipulate your own pictures, add text, and create items like picture cards and calendars, then have them output on the spot. These computer machines are fun to play with and simple to use. If you have trouble, don't hesitate to ask a clerk to help you.

Photofinishing kiosks, such as Kodak Picture Maker, allow you to enlarge and crop your pictures, remove red-eye, add borders, and create photo collages, calendars, T-shirts, and mugs in just minutes.

Disk-Jockeying

One great photofinishing service for photographers who have computers is the photo disk. For an extra fee, many photofinishers can put your pictures on a CD—just request this when you drop off (or mail in) your film. You can then put the disk into your computer and download your photos to manipulate, include in e-mail, or print out on your home printer. Several versions of this service are available, and some are Windows-only—Macintosh computer users should ask if the service is Mac-compatible.

Kodak Photo CD is the granddaddy of these services and still provides the highest quality. Your pictures are put on the CD at five different resolutions, including one high enough to produce 8 × 10 prints and to reproduce in magazines. You can have a whole roll of pictures put on a Photo CD when you have the film processed (for around $15–20), or you can have individual pictures added later (for $1–4 per picture).

The Kodak Picture CD is a newer service that's not quite as high-resolution (1534 × 1024 pixels versus a maximum of 3072 × 2048 for Photo CD), but better for point-and-shooters— it costs less than Photo CD, and comes with

Hot Tip

Kodak Picture CD is probably the best way for readers of this book to get their pictures into their computers. Photo CD is better for serious and pro shooters.

great software (but in Windows versions only). Just check the box for Picture CD when you drop off your film for processing, and you get back prints, negatives, and the CD, all in a regular processing envelope. Take the CD home, pop it into your computer's CD-ROM drive, and your pictures automatically appear on the monitor. You can use the software right from the CD; you don't have to load it on your hard drive. (Mac users can open their pictures; they just can't use the provided software.) A Picture CD holds one roll of film and costs $8.95–10.95.

Kodak Photo CD is an easy way to get high-quality scans of your pictures into your computer.

Kodak Picture CD puts your pictures on CD for use in your computer and provides a fun magazine-format interface on your computer monitor.

Your Photos Online

Some photofinishers can put your photos on the Internet for you; just ask for this service, then go online and get your digitized images. You can then manipulate your photos with your image-editing program, e-mail them, and order reprints, enlargements, and gifts online. Ofoto.com, EZPrints.com, and PhotoThru.com are examples of these services.

If you're interested in any of these digital services, ask your photofinisher about them or do a search on the Internet to find a photofinisher that provides them.

Doing It Yourself

Making black-and-white prints can be an enjoyable experience. It's genuinely exciting to watch a silver image magically appear on the paper in the developer tray. Also, the skilled black-and-white darkroom worker can exercise a lot of control over his or her pictures by altering developing times, using different developers, and using many other creative techniques. On the other hand, color film and prints are most often processed inside a processing tank or tube where the image can't be seen as it emerges. Color processing is pretty much by-the-book if you want accurate colors.

So, although photo purists might consider this sacrilegious, the fact is, unless you're a fine-art photographer, there's no reason to do your own darkroom work. True, doing it all yourself gives you maximum control over your images, but in color this control is limited anyway, and most folks want color. If you plan on being the next Ansel Adams (a commendable ambition, and if you are sincerely interested in photography you owe it to yourself to check out the exquisite beauty of original prints by Ansel and other black-and-white masters), read his aforementioned books, *The Negative* and *The Print*, and by all means, do your own black-and-white darkroom work. However, for most readers of this book, particularly those of you who shoot nothing but color, it's best to let the lab do it. Many working pro photographers let a lab (or an assistant) do it, too—they're too busy shooting to do lab work.

> **Photo Fact**
>
> For most people—including most professional photographers—doing their own film processing is way more trouble than it's worth. Making black-and-white prints from negatives can be fun, but most people find it a lot more fun to be out shooting pictures.

Darkroom work requires dark—for the amateur photographer, this generally means finding a way to darken a bathroom or kitchen since access to running water is helpful. It requires several chemicals, which are not environmentally (or skin, or lung) friendly. And it requires special darkroom gear—film-developing tanks and reels, timers, safelights, an enlarger, easels, trays and graduates, and more. These days, some (including your author) feel the money would be better spent on going digital. Many of today's digital image-editing programs let you do anything to your photos you would in the darkroom—and much more—right at your desktop, without chemicals or darkness. But lots of hobby photographers (as well as professional, fine-art photographers) enjoy doing their own darkroom work.

The Least You Need to Know

◆ There are lots of places to get your film processed.

◆ You generally get what you pay for.

◆ Discount photofinishers cost less; one-hour minilabs get you your pictures sooner; custom labs offer top quality and more services.

◆ If you don't like your prints, talk to the lab about it.

◆ If you're interested in processing, consider learning how to do your own darkroom work.

Lenses: Interchangeable Eyes

In This Chapter

- ◆ Getting focused
- ◆ Apertures and depth of field
- ◆ Magnification and perspective
- ◆ Interchangeable lenses
- ◆ What the terms in those lens ads mean
- ◆ Caring for lenses

One lens can't do it all. A single–focal-length lens, or even a built-in short-range zoom, is fine for a lot of shooting, but it isn't ideal for all shooting situations. What if you can't get close enough to your subject? Put a long lens on your AF 35mm SLR, and "bring" the subject to you. Can't get far enough back in that little room to get everyone in that family reunion shot? Put a wide-angle lens on your AF SLR and get everyone into the picture.

Besides offering a far greater range of focal lengths than even the widest-range zoom built into a point-and-shoot camera, lenses for the AF 35mm SLRs are much faster (you'll learn what that means soon, but for now, just

realize that faster is better), and generally sharper. Of course, the downside is that you have to buy each of these lenses separately. (Some camera stores will rent a lens for a day, and you might have a photographer friend who can lend you the lens you want to try.)

In order to get the most out of these versatile 35mm systems, you should know some things about lenses and their use. By the time you've finished this chapter, you'll know all you need to know about focusing, apertures, depth of field, flare, focal lengths, magnification, field of view, perspective, and more. This knowledge will help you make better photographs, and it will help you select the lenses that are best suited for the type(s) of photography you want to do. But if you use a point-and-shoot camera, you don't need to know this stuff. You can just read the chapters in Part 4 that pertain to the subjects you want to photograph and learn what you need to know to get good pictures of those subjects.

What Is a Lens?

At its most elemental level, a lens is a disk of transparent material that refracts ("bends") light. Usually made of glass or high-tech plastic, a lens either has opposite surfaces that are curved or one surface that is curved and one that is flat.

Lenses that are thicker in the middle than at the edges (A, B, and E) cause light rays passing through them to converge (focus); lenses that are thicker at the edges (C and D) cause light rays to disperse (spread).

A B C D E

A photographic lens is a metal or plastic tube that holds one or more of these lens elements in place, with a mount at one end to attach it to your camera. Lens makers use various combinations of elements, individually and in groups of two or more elements cemented together, to correct lens aberrations and produce sharp camera lenses.

The primary purpose of a photographic lens is to gather light rays from a scene and focus them sharply onto the film in the camera. The lens also controls the amount of light that reaches the film (via its adjustable opening), the magnification of the image, and the area of the scene that is recorded (via its focal length).

Getting Focused

There are three types of photographic lenses, focus-wise: fixed-focus (sometimes called "focus-free"), manual-focus, and autofocus. The less expensive point-and-shoot cameras have fixed-focus lenses, in which focus is permanently set at one distance (usually the hyperfocal distance—more on that later), relying on depth of field to render subjects from just a few feet away to infinity in reasonably sharp focus.

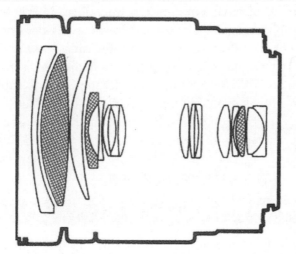

Here's a cutaway view of a zoom lens showing its elements—this one is Tamron's AF28–200mm f/3.8–5.6 LD Aspherical (IF) Super. Why do zoom lenses have all those elements? Mainly to correct a bunch of bad things that happen to image sharpness when you start bending light rays— things with names like aberrations, distortion, and curvature of field.

(Tamron)

Focusable lenses come in two varieties: manual-focus and autofocus (AF). Most auto-focus point-and-shoot cameras provide only autofocusing, while most AF lenses for 35mm SLR cameras can also be focused manually. With SLR cameras, you focus the lens manually by turning the focusing ring until the subject appears sharp in the viewfinder. With simpler cameras, you set the focusing dial to a zone-focus symbol for near, medium, or distant subjects.

Autofocus lenses focus automatically. The trick is to get them to focus on what you want them to focus on. You do this by aiming the viewfinder's AF target at the subject and pressing the shutter button halfway down. A focusing motor in the lens or camera body then automatically focuses the lens on the subject.

The autofocus systems in most compact point-and-shoot 35mm and APS cameras are called "active" because they determine focus by sending an infrared beam out to the subject and noting the point where the reflected return beam strikes the camera's AF-sensor—a sort of electronic triangulation. Infrared AF systems are relatively inexpensive and work in total darkness, but they don't work through windows or on

images in mirrors because the beam bounces off the glass instead of the subject. And they don't work beyond 25 or 30 feet because the beam doesn't make it back to the camera, but that's okay because beyond that, these cameras' wide-angle lenses render everything quite sharply.

The autofocus systems in AF 35mm SLRs are called "passive" because they don't send anything out to the subject. They just measure contrast, the idea being that contrast is greatest when focus is sharpest. Some point-and-shoot zoom cameras use this or both systems because infrared autofocusing doesn't work with longer focal lengths. Passive systems work with lenses of any focal length, at any distance, and on subjects behind glass. But they have to be able to "see"—they can have problems with dimly lit and low-contrast subjects. Autofocus isn't perfect, but today's AF cameras, especially the AF SLRs, work amazingly well under a wide variety of conditions.

Watch Out!

Before focusing a lens on an AF SLR manually, be sure to set the camera for manual focusing. With many AF SLRs, rotating the manual-focusing ring while the camera is in AF mode can damage the autofocusing mechanism. With some AF SLRs, the focusing mode is set via a switch on the camera body; with others, the auto/manual switch is on the lens.

Photo Fact

With most lenses, the front element moves farther away from the film as you focus on closer subjects. Some lenses feature internal focusing (IF), in which lighter central elements move instead of the heavier front elements. This makes for faster autofocusing and more-compact lenses. There's another benefit: Internal-focusing lenses don't rotate the front element as they focus, which is nice when you are using orientation-sensitive lens attachments such as polarizing and graduated filters—their effect won't change as the lens focuses. Chapter 12 tells all about filters.

Letting the Light Shine In

Besides focusing the light on the film, the lens also controls the amount of light that reaches the film. It does this by means of an adjustable mechanism called a diaphragm. The opening in the diaphragm is called an aperture (that's a fancy word for opening).

With some 35mm SLR cameras, you control the size of the aperture by turning the lens's aperture ring to the desired setting. With other cameras, you set apertures by

turning a dial on the camera body while watching the aperture readout on the LCD panel. (Of course, in program and shutter-priority AE modes, the camera sets the aperture automatically for you.) The numbers marked on the aperture ring (or that appear on the LCD panel) are called "f-numbers." The openings the f-numbers represent are called "f-stops."

The large f-number represents a small opening and the small f-number represents a large opening. That's because f-numbers represent ratios: the ratio between the diameter of the aperture and the focal length of the lens. When the aperture ring is set at 4 (known as f/4), the diameter of the opening is ¹/₄ the focal length of the lens. With a 100mm lens, the aperture is thus 25mm in diameter when the aperture ring is set to f/4 (25mm equals about one inch). When the 100mm lens's aperture ring is set to f/16, the aperture diameter is ¹/₁₆ of the 100mm focal length, or 6.25mm (about ¹/₄ inch). The following figure shows the relative diameters of apertures from f/1.4 to f/16.

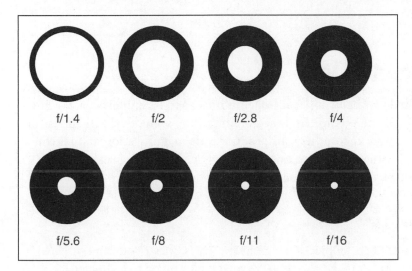

An f-number is the ratio between the diameter of the diaphragm opening it represents and the focal length of the lens. For example, f/4 means the diameter of the opening is ¹/₄ the focal length of the lens (f/4 on a 100mm lens would have a diameter of 25mm).

The f-number system is set up so that the aperture represented by each successive numerically larger f-number transmits half as much light as the previous number. For example, f/8 transmits half as much light as f/5.6. For another example, an aperture of f/2 transmits four times as much light as f/4 because its diameter is twice as wide as f/4 and the opening thus has four times the area of f/4.

Lenses that transmit a lot of light (those with large maximum apertures) are termed "fast": an 85mm f/1.4 or Canon's 50mm f/1.0, for example. Lenses with

small maximum apertures are considered "slow": A 50mm f/3.5 macro lens, for example. Faster lenses provide brighter viewfinder images (with SLR cameras) for easier composing and manual focusing, and they permit shooting at faster shutter speeds in a given light level. But they are also more expensive, heavier, and generally not as sharp at maximum aperture.

Photo Fact

Since the f-number system is based on the ratio between the aperture diameter and the focal length of the lens, in theory, a given f-stop transmits the same amount of light on any focal-length lens. For example, f/8 on a 100mm lens theoretically transmits the same amount of light as f/8 on a 1000mm lens. (Of course, f/8 on the 1000mm lens means an aperture diameter of 125mm, while f/8 on the 100mm lens means a diameter of 12.5mm. That's one reason why you don't see long lenses with large maximum apertures: a 500mm f/1.4 lens would need an effective aperture diameter of 357mm, or about 14 inches!)

The Long and Short of It

The focal length of the lens determines its magnification and its angle of view—how big the subject will be in the picture, and the amount of the scene that will appear in the picture. Lenses with short focal lengths produce little magnification and take in a wide angle of view (that's why they're called wide-angle lenses). Lenses with long focal lengths produce great magnification and take in a narrower angle of view.

Image Size and Perspective

You can change the size of the subject's image in two ways. First, you can switch to a longer lens focal length (to make the subject's image bigger) or to a shorter focal length (to make it smaller). Second, you can move the camera closer to the subject (to make the subject's image bigger) or farther away (to make it smaller). Each of these methods produces a different effect.

Actually moving the camera closer to the subject increases the size of the subject's image on the film, but it also changes the subject's size relative to other objects in the scene (that is, it changes the perspective of the image). Changing to a longer focal-

length lens increases the size of everything in the scene equally; it does not change the perspective. The next time you're watching a movie or television show and wonder whether a particular "move-in" was done by zooming a zoom lens or by actually moving the camera closer, check the perspective. If the other objects in the scene maintain their sizes relative to the main subject, it's a zoom; if the size relationship among elements of the scene changes, it's a camera move.

"Perspective" refers to the apparent relationships among elements of a photograph. You can change it by changing the camera position. Moving closer expands the apparent distance between scenic elements and emphasizes the size difference between nearby and more-distant ones. Moving farther away compresses the apparent distance between elements and de-emphasizes the size differences. Here is the same scene shot from a distance with a 100mm lens (left), and from a closer one with a 24mm lens (right), to maintain the same main subject size. Note how the background seems farther away and smaller in the wide-angle shot, even though neither the subject nor the background has changed in actual size, nor has the distance between them changed.

Perspective changes when the camera moves. Changing focal lengths from a given camera position won't change perspective, as these three photos demonstrate. The top photo was made with a 200mm telephoto lens. Note the size and distance relationships among the various elements of the scene. The middle photo was shot from the same spot, but the 200mm lens was removed from the camera and replaced by a 24mm wide-angle lens. Although all the elements in the scene are smaller and a lot more of the scene is included due to the 24mm lens's much wider angle of view, their relative sizes and distance relationships have not changed. This is easier to see in the bottom photo, which is a blow-up of the center section of the wide-angle shot that covers only the area shown in the 200mm shot. Apart from the fuzziness caused by the extreme degree of enlargement (and the positions of the cars, which were moving), the images are the same—the relationships among the various stationary elements are identical in the two photos; the perspective has not changed.

Why do photographers get the idea that long lenses compress perspective and short lenses expand it? Because we generally move closer to the subject when using a short lens, which does expand perspective (top). And we generally shoot from far away when using long lenses, which does compress perspective (bottom). But it is the camera-to-subject distance, not the lens focal length, that produces the perspective.

How Deep Is My Field?

Besides controlling the amount of light, the aperture controls the depth of field—the area in front of and behind the focused subject in which objects appear acceptably sharp in the photograph. Small-diameter apertures (those with large numerical values, like f/22) provide greater depth of field; large-diameter apertures (those with small numerical values, like f/1.4) provide little depth of field.

The aperture isn't the only thing that affects depth of field. Magnification plays a part: The shorter the lens and the greater the focused distance, the greater the depth

of field. The longer the lens and the closer the focused distance, the smaller the depth of field. So you'll get the most depth of field with a wide-angle lens stopped down to its smallest aperture and focused at infinity. You'll get the least depth of field shooting with a supertelephoto lens at its largest aperture and closest focusing distance.

Some AF 35mm SLR cameras offer a depth-of-field preview, which stops the lens down to the set aperture so you can see in the viewfinder how much depth of field there is at any aperture. (Today's SLR camera lenses have automatic diaphragms, which stay wide open until you press the shutter button to make the exposure, no matter what aperture you set. This provides the brightest possible image for composing and focusing. When you press the shutter button, the lens stops down to the set aperture so the film is correctly exposed.) The depth-of-field preview is a wonderful thing because you don't have to guess if you have enough depth of field to cover important subjects in the picture. But there is one drawback: When you stop the lens down with the depth-of-field preview, the image you see in the viewfinder gets darker.

At small apertures in dim light, the viewfinder image might be too dark to allow you to analyze the depth of field. Many lenses have depth-of-field scales on the lens barrel that tell you approximately how much depth of field you'll have at a given f-stop and focusing distance, and these are handy in dim lighting.

Depth of field affects what appears to be in focus in front of and beyond the focused subject and should not be confused with depth of focus, which is the minute amount the film plane can move toward or away from the lens before the image looks blurred.

Photo Fact

Lenses are sharpest when stopped down about two stops from their maximum aperture. At wider apertures, sharpness is decreased by various lens aberrations; at small apertures, sharpness is decreased by diffraction (the bending of light around obstacles in its path—the obstacle here being the lens diaphragm). When the lens is stopped down to small apertures, the light rays tend to bend away from the lens axis, reducing image sharpness. This is one reason why a pinhole camera, with all its depth of field, still produces fuzzy images—the tiny pinhole aperture diffracts light something fierce. So, unless you need the depth of field provided by a small aperture or need the speed of a wide-open aperture for low-light shooting, you'll generally get the sharpest results when using an intermediate f-stop.

Interchangeable Eyes

You can attach all sorts of lenses to a typical AF 35mm SLR camera. Some are really useful, and some are highly specialized. One advantage the AF 35mm SLR has over the point-and-shoot camera with its built-in lens is a much wider range of focal lengths. Of course, you have to buy (or rent) each lens for the AF SLR, while the point-and-shoot comes with a lens.

Is This Normal?

The "normal" lens for a camera is one with a focal length approximately equal to the diagonal measurement of the film frame. "Whazzat?" you say? For a 35mm camera, which produces 24 × 36mm images on the film, the normal lens is 50mm (the diagonal measurement of the 24 × 36mm frame is 43mm, and 50mm is the closest focal length to that figure). The normal lens produces "normal"-looking images, about what we think our eyes see when we view a scene.

Back when I got into photography, camera dealers tried to sell camera buyers a normal lens with the camera body. But nowadays, dealers generally try to sell buyers a zoom lens. And that's a better deal because a zoom lens provides a whole range of focal lengths in a single lens. I'll tell you about zoom lenses in a bit.

> **Hot Tip**
>
> Be sure to read the camera manual for the proper way to remove and attach lenses. To remove a lens from an interchangeable-lens camera, press the lens-release button and rotate the lens so that the red dots on the lens and on the camera body line up. Then gently pull the lens away from the camera body.

The Broad View

Lenses that take in a wider angle of view than a normal lens are called wide-angle lenses. Wide-angle lenses have shorter focal lengths than normal lenses; some popular ones include 35mm, 28mm, and 24mm. Even wider-angle lenses (21mm on down) are called "superwide-angles."

Wide-angle lenses are handy when you can't move far enough away from a subject to get it all in the picture (when you're photographing a group of people in a small room, for example), as well as for grand scenic vistas (such as a beautiful sunset). They're great for special effects: Move in very close to a subject with a wide-angle

lens, and the subject will appear huge compared to background elements in the scene, due to the expanded perspective.

Move in really close with a wide-angle lens, and you exaggerate the size of the subject. We know that the wing isn't as wide as the air-plane is long—we can see that at the point where the wing joins the fuselage. But the extremely close shooting distance (from right under the tip of the wing, with a 28mm lens) "distorts" the appearance of the airplane.

Fisheye Lenses

I'm not sure exactly what the world looks like to a fish, but fisheye lenses are called that because they have bulging front elements, like fish eyes.

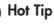

Hot Tip _____

Circular fisheye lenses are very expensive. Sigma's manual-focus 8mm circular fisheye (which is available in mounts to fit most popular 35mm SLRs) is by far the least costly—and it has a street price of around $700! Porter's Camera Store offers a lower-cost (around $80, including adapter) fisheye attachment that threads onto the front of a standard wide-angle lens and produces a circular fisheye effect.

Fisheye lenses come in the shortest focal lengths of all (6–16mm) and have angles of view so wide (180 degrees or greater) that they produce round images on the film instead of the usual rectangular ones. Fisheyes see the world very differently than we do and so distort the image from our perspective—any straight lines not going through the center of the image will be curved (including the horizon if it appears above or below the center of the picture).

Full-frame fisheye lenses "crop" a rectangle out of the circular fisheye image to fill the film frame, thus providing a 180-degree angle of view measured diagonally. As with circular fisheyes, straight lines that don't go through the center of the image are curved.

Zeroing In

Have you ever looked through a pair of binoculars? Then you know what a telephoto lens does. It makes things look bigger and closer.

Most photographers call all lenses that magnify the image more than normal lenses "telephotos." Actually, "telephoto" refers to a specific design in which the physical length of the lens is shorter than the focal length. But if you want to call all long lenses telephotos, go right ahead—you've got lots of company.

Telephoto lenses are great for bringing wildlife subjects to you when you can't get close enough to them, and for zeroing-in on sports action. They're used to produce the "telephoto compression" effect—focus in on distant freeway traffic with a long lens, and the cars will appear stacked up. Short telephotos of about double the normal focal length (85mm to 135mm for a 35mm camera) are ideal for portraits because they produce a good head size at a shooting distance that provides a pleasing perspective. (Perspective is covered in the section "Image Size and Perspective" earlier in this chapter.)

For AF 35mm SLR cameras, telephoto lenses start at around 85mm and go up to more than 1000mm. The longer supertelephotos are very expensive, especially the fast f/2.8 supertelephotos preferred by pro sports and wildlife shooters. I'd love to use them, but I make do with the 400mm end of a 200–400mm f/5.6 zoom that costs around $550. You can buy a 75–300mm zoom lens for under $200 for most AF 35mm SLRs (you'll learn about zoom lenses soon).

Short telephoto lenses are great for portraits because they produce a good head size at a distance that produces a pleasant perspective. See Chapter 16 for more on portraits.

Mirror, Mirror, in My Lens

Mirror lenses, also called reflex lenses, provide long focal lengths in short, lightweight packages by reflecting the light back and forth inside the lens barrel, in effect folding the focal length. Mirror lenses are much shorter than conventional refracting tele-photo lenses of equal focal length, have much closer minimum focusing distances, and are generally not quite as sharp as their refracting counterparts. Most mirror lenses lack a diaphragm (f-stops), so exposure is controlled by adjusting the shutter speed (or by using neutral-density filters, which are built into many mirror lenses). Many mirror lenses focus past infinity (as odd as that may seem) to compensate for the physical expansion and contraction of the lens that can occur when using it in hot or cold situations.

Early mirror lenses were extremely fragile, and this type still requires gentle treat-ment, like any lens. Most of today's mirror lenses are "catadioptric," meaning they contain refracting lens elements as well as mirrors, to produce even more compact lenses.

Mirror lenses generally cost a lot less than their refracting counterparts and so are a good choice for photographers who need a long lens, but are on a tight budget.

CAUTION **Watch Out!** _____

Telephoto lenses magnify the subject, but they magnify blur caused by camera movement, too. The basic rule of thumb for hand-held shooting is to use a shutter speed at least equal to the reciprocal of the focal length of the lens being used: at least $1/50$ for a 50mm lens, and at least $1/500$ with a 500mm lens. I like to put any lens longer than 300mm on a tripod, regardless of shutter speed, for sharpest results.

Zoom Lenses

The most popular type of lens today among amateur photographers is the zoom, which incorporates a whole range of focal lengths in a single lens. Zooming the lens alters the relationships among the elements inside, thus altering the focal length. Popular zoom lenses for AF 35mm SLR cameras include the 28–80mm, 28–105mm, 70–210mm, and 28–200mm, with many other focal-length ranges available. With point-and-shoot zoom cameras, you zoom the lens by pressing the T (tele) button to zoom in on a subject or the W (wide) button to zoom back and show more of the

scene. With a zoom lens for an AF 35mm SLR camera, you zoom the lens by rotating the zoom ring or by pushing and pulling on the focusing ring.

By nature, zooms are heavier than single–focal-length lenses, and slower (there are a few expensive f/2.8 zooms, but most have maximum apertures in the f/3.5–5.6 range). Many zoom lenses have variable maximum apertures: A 70–210mm f/3.5–4.5 has a maximum aperture of f/3.5 at the 70mm setting and a maximum aperture of f/4.5 at the 210mm setting. TTL (through the lens) metering automatically compensates for this, but when using a hand-held meter, you have to use the appropriate index mark (wide or tele) when setting the aperture.

In addition to the benefits of providing a range of focal lengths in one lens, a zoom lens enables you to produce special effects by zooming during all or part of a long exposure, thus creating an "explosion" effect in the image.

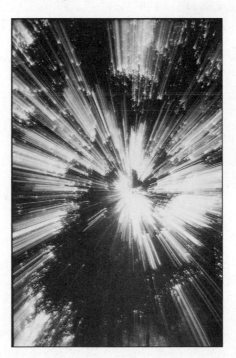

If you zoom a zoom lens during the exposure, you can produce an "explosion" effect like this. Mount the camera on a tripod so it doesn't move, set the camera for a one- or two-second exposure, and zoom the lens from its longest to shortest focal length (or vice versa) during the exposure.

Photo Fact

Many "zoom" lenses are not true zooms. True zooms maintain focus as you zoom them. Vari-focal lenses zoom, but change focus each time the focal length is changed. With AF cameras, this is not a problem, but when focusing manually, be sure to focus at the focal length you're going to use for the shot. (It's generally easier to focus at the longest focal length, then zoom to the desired setting for the shot, but this doesn't work with "zooms" that change focus when they are zoomed.)

Getting Close

As their name suggests, macro lenses are ideal for macrophotography (serious close-up shooting). They have extended focusing mounts so that they can focus close enough to produce life-size images on the film (naturally, these images can be blown up even more when printed or projected). Macro lenses are also optically optimized for close-up work (standard lenses are optimized for moderately distant shooting) and produce better image quality than other lenses in this type of photography.

Photo Fact

Many zoom lenses are touted as having "macro" capability. Usually, this just means they'll focus closely enough to provide ¼– or ⅕–life-size images on the film—useful, but not really macro. And they're not specially corrected for close-up work.

Macro lenses generally come in normal focal lengths (50mm or 60mm), short telephoto (90mm, 100mm, and 105mm), and telephoto (180mm or 200mm). Longer macro lenses produce a given magnification from farther away than shorter ones—handy when you're dealing with subjects you can't (or don't want to) approach too closely.

Because of the high magnification involved, it's best to use macro lenses on a tripod, or with electronic flash. You'll learn all about close-up photography in Chapter 18.

PC Lenses

No, these gizmos aren't Politically Correct, but *perspective-control* lenses that let you correct converging parallel lines when the camera is pointed at an angle to the subject, like when tilting the camera up to get a whole building in a single shot. When you tilt the camera up, the film plane is no longer parallel to the subject plane, so the building's vertical lines converge near the top of the photo. Perspective-control lenses (also called shift lenses) have front elements that can be shifted up, down, left, or

right. So instead of tilting the camera up to get a whole building in the photo, you can just shift the front element up to do it, while keeping the camera pointed straight ahead. Since the film plane remains parallel to the subject plane, there's no convergence. PC lenses are generally 24–35mm wide-angles, because longer lenses would still require tilting the camera up to get a whole building in the frame, even at maximum shift of the front lens element.

Canon offers three manual-focus tilt/shift lenses for its EOS AF SLR cameras, in 24mm, 45mm, and 90mm focal lengths. Besides shifting up and down and left and right, these lenses can be tilted up to 8 degrees to provide increased depth of field (depth of field is greatest when lines drawn through the film, lens, and subject planes meet at the same point, and a tilting lens makes it possible to achieve this situation).

A Soft Touch

Soft-focus lenses for 35mm SLRs come in two types. The simplest, represented by the discontinued Sima SF (which can still occasionally be found at swap meets and used–photo-equipment stores), consists of a single glass element that is not corrected for spherical aberration, thus producing the soft-focus effect. The second type, typified by the Canon EF 135mm SF, Minolta 85mm Varisoft, and Pentax SMCP-F Soft 85mm, has multiple elements and a control ring that allows you to adjust the degree of image softening.

The result of using any of these lenses is a soft, glowing image of the subject—a pleasant effect considerably different from the unpleasant effect of out-of-focus images made with a regular lens, or blurred images caused by camera or subject movement. The soft effect is greatest at maximum aperture. When the lens is stopped down (or, in the case of the diaphragmless Sima, when a smaller aperture disk is used), the effect lessens—the image is sharper.

Double Your Pleasure

A tele-converter (also known as a tele-extender) is a tube that fits between the lens and the camera body. Like the lens, it contains one or more elements. It increases the effective focal length of the lens—with the most common converters, by a factor of 1.4× or 2×. As an added benefit, a tele-converter doesn't change the lens's minimum focusing distance, so a 2× converter converts a 100mm lens that focuses down to 3 feet into a 200mm lens that focuses down to 3 feet—great for close-ups.

Of course, you rarely get anything for nothing, and so it goes with tele-converters. Tele-converters make the lens effectively slower: that 100mm f/4 lens becomes a 140mm f/5.6 lens with a 1.4× converter, and a 200mm f/8 lens with a 2× converter. TTL metering automatically compensates for this, but if you use a hand-held meter, you must give one stop more exposure than it recommends when using a 1.4× converter, and two stops more exposure when using a 2× converter.

Photo Fact

Why does the tele-converter make the lens slower? Remember from the discussion of apertures what an f-number is? It's the ratio between the diameter of the aperture and the focal length of the lens. If you have a 100mm f/4 lens, the aperture diameter is 25mm ($^1/_4$ of 100mm). If you attach a 2× tele-converter to that 100mm f/4 lens, the effective focal length becomes 200mm, but the aperture diameter is still 25mm. 200mm divided by 25mm is f/8. The lens is twice as long and two stops slower with the 2× tele-converter attached. If you use a 1.4× converter with the 100mm f/4 lens, the effective focal length becomes 140mm, and the effective maximum aperture is 140mm divided by 25mm (f/5.6): The lens is 1.4× longer and one stop slower with the 1.4× tele-converter attached.

Another price you pay when using a tele-converter is decreased sharpness. Unless the converter is of good quality and matched to the lens with which it is used, it could decrease image sharpness noticeably compared to using the lens alone. Some companies offer tele-converters specifically designed for use with specific lenses (or lens focal lengths), and these will produce the sharpest results.

The main advantage of the tele-converter is economy. One major manufacturer's 200mm f/2.8 lens sells for around $660. The same company's 400mm f/5.6 lens sells for around $1,100, while a 2× tele-converter sells for about $280. So, you can buy the 400mm f/5.6 lens for $1,100, or buy the 200mm f/2.8 lens plus 2× converter (which turns it into a 400mm f/5.6 lens that focuses closer than the "real" 400mm f/5.6) for $940 and have $160 left for film—plus, you have a 200mm f/2.8 lens, which you wouldn't have if you just bought the 400mm f/5.6!

Lens Talk

If you've read lens advertisements or user reports, you've noticed that photographic lenses contain several elements, often in groups of two or more. Why all these elements? Mainly to reduce the effects of a bunch of bad things that happen to the image when you start bending light rays.

APO

Uncorrected lenses tend to focus short (blue) wavelengths of light in front of medium (green) ones, and long (red) wavelengths behind medium ones. This is called chromatic aberration. APO (short for apochromatic) lenses bring all wavelengths of light into focus at the same place—the film plane. They do this by means of multiple elements made of different-dispersion materials. Apochromatic correction is especially important in long–focal-length lenses. (Chromatic aberration affects the sharpness of black-and-white as well as color photos, because our subjects are in color even if our film isn't.)

Aspherical Elements

With conventional spherical lens elements, light rays entering the edge of the lens are bent more than light rays entering at the center, and thus are focused closer to the lens. This is called "spherical aberration." Aspherical lens elements have nonspherical shapes designed to bring all the light rays to focus at the film plane for sharper images. Aspherical elements are especially important in wide-angle lenses, where they also help to reduce distortion. Aspherical elements also help to produce smaller, lighter, and less-costly zoom lenses.

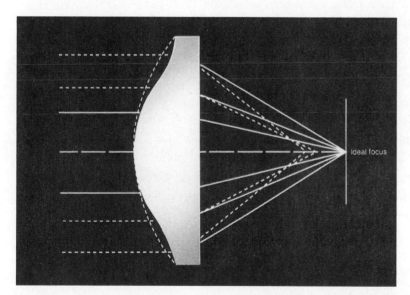

Spherical elements (dashed lines) don't focus light rays coming through their edges at the same plane as light rays coming through the center of the lens, an effect known as spherical aberration. Aspherical elements (solid shape), like this one from a Canon EF lens, correct this problem, and also help reduce distortion.

(Canon)

Distortion

Distortion comes in two basic forms: pincushion and barrel. In pincushion distortion, straight lines near the edges of the frame bow in toward the center of the frame. With barrel distortion, straight lines near the edges of the frame bow out away from the center. Such distortions are often evident in zoom lenses, with barrel distortion appearing at short focal lengths and pincushion distortion at long focal lengths. There's not much you can do about distortion if it is present (just compose so that no straight lines appear near the edges of the frame), so it's wise to check for it before buying any lens.

Pincushion distortion causes straight lines near the edges of the picture to bow inward; barrel distortion causes straight lines to bow outward.

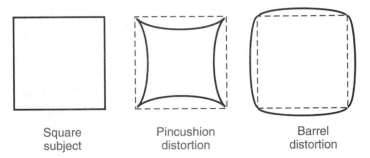

Square
subject

Pincushion
distortion

Barrel
distortion

ED, LD, SD, SLD, and UD Elements

These are various manufacturers' abbreviations for special low-dispersion glass and other material, which minimize a type of chromatic aberration that plagues long–focal-length lens designs. Such elements result in lenses that are sharper, with greater color accuracy and less flare.

Hyperfocal Distance

If your lens has a depth-of-field scale, you can maximize depth of field for a given aperture by setting the lens to its hyperfocal distance. You do this by setting the focusing ring's infinity mark opposite the selected aperture mark on the depth-of-field scale. Depth of field will run from half the hyperfocal distance to infinity. (Fixed-focus lenses on point-and-shoot cameras are preset at their hyperfocal distance—that's how they give you sharp pictures from around 5 feet to infinity.)

Lens Flare

Internal flare is a loss of contrast and sharpness caused by stray nonimage-forming light reflected from inner lens surfaces, a bad side effect of multiple-element lenses. Most of today's lenses incorporate multicoated lens elements whose antireflection coatings greatly reduce the problem. Another form of flare occurs in backlit situations when light from the source directly strikes the front lens element. Using a lens hood, which extends in front of the lens and keeps extraneous light from striking the front element, will generally solve this problem. An added benefit of a lens hood is protection of the front element from fingers and rain.

A lens hood can protect the front element from direct rays from a light source that's just out of the picture area and thus eliminate flare, so it's a good idea to use one whenever possible. This hood has cutouts at the sides so it doesn't appear in the sides of the picture.

Hot Tip _____

Even if your camera does not have interchangeable lenses, it may be possible to add accessory lenses that screw into threads on the front flange of the lens. These may provide extreme wide-angle, or even fisheye effects, as well as telephoto effects. These front-end adapters are quite common for digital cameras. Don't expect them to be the optical equals of interchangeable lenses. The best will probably come from the camera's manufacturer.

Vignetting

A final lens problem is vignetting, the cutting off of the corners and edges of the image. This can be caused by a lens hood that is too long for the lens, or it can be

inherent in the lens itself—it's especially evident in high-ratio zoom lenses, such as 28–200mm models. Stopping the lens down will generally eliminate inherent vignetting; switching to a shorter hood will eliminate lens-hood–caused vignetting.

TLC for Lenses

Caring for lenses is easy, and important if you want yours to have long and accomplished lives.

When removing or attaching a lens, don't force it. Read the camera manual for the proper procedure (it generally involves aligning an index mark on the lens with an index mark on the camera's lens mount) and follow it. If the lens doesn't lock into place or release easily, you're probably not following the procedure in the book. And, of course, don't drop the lens (or camera)!

When the lens is not attached to the camera, keep it capped front and rear (lenses come with front and rear lens caps—don't lose them). Keep the lens in its case or in a padded compartment of your camera bag when not in use.

Some experts recommend keeping a skylight or UV filter on the lens at all times for protection—the filter will absorb the dirt and dings that the front lens element would otherwise suffer. Other experts point out that the filter is an excuse not to be as careful with the lens and that it adds two more glass or plastic surfaces to degrade image quality. They recommend using a filter only when its specific effect is needed—or if the lens is endangered by blowing dirt or sand. (I believe in this second theory.) In any event, keep the filter clean and scratch-free if you use it, otherwise you'll be better off without it.

Keeping It Clean

A dirty lens is an unhappy (and unsharp) lens. Keeping your lenses capped when not in use will help them stay clean, but sooner or later, the front and rear elements will need cleaning. Cleaning them properly will keep the lens ready to shoot sharp photographs.

To clean the lens barrel, wipe it gently with a soft, dry cloth. To clean the glass or plastic front and rear elements, use lens-cleaning tissue and lens-cleaning fluid made specifically for photographic lenses.

Watch Out! _____

Never apply lens-cleaning fluid directly to the lens—it might seep inside the lens at the edges of the front or rear element.

First, use a soft camel's-hair lens brush to gently flick away large dust particles from the lens surface. Next, blow away remaining particles with a blower brush or spray can of compressed air (don't spray the air directly at the lens; spray at an angle to the surface). Apply a small amount of photographic lens-cleaning fluid to a piece of photographic lens-cleaning tissue, and gently clean the lens using a circular motion, starting at the center of the glass and working out to the edges. Work gently—while photographic tissue is not likely to scratch the glass, it's very easy to scratch the fragile multicoatings, and a scratch on either produces the same effect: degraded images. Finally, gently buff the lens with a fresh, dry piece of lens tissue.

The Least You Need to Know

- The lens focuses light on the film.

- You can change what the camera sees by changing its lens or by moving the camera.

- The lens and shooting distance control the size of the subject and the perspective in the picture.

- The lens controls the amount of light that reaches the film.

- Depth of field increases with smaller apertures, greater shooting distances, and shorter lenses.

- It's important to take good care of your lenses.

The Brilliance of Flash

In This Chapter

- ◆ Why use flash?
- ◆ Flash exposure
- ◆ Slow-sync, strobe, and bounce flash
- ◆ Off-camera flash
- ◆ Flash problems (and solutions)

Most point-and-shoot cameras—including the entry-level AF 35mm SLRs—come with built-in electronic flash units. And that's a wonderful thing because it means you always have enough light to take pictures of nearby subjects.

AF SLR cameras also accept dedicated accessory electronic flash units—spare light, conveniently packaged in a "little black box." Dedicated flash units provide the same simple operation as built-in flash units, but they also provide a lot more: more power, more accurate exposures, more features, and more versatility. (But also more expense—top-of-the-line dedicated flash units cost more than a point-and-shoot camera. But you don't need a top-of-the-line unit to get many of the advantages of dedicated flash.)

This chapter tells you all about your built-in flash and accessory flash.

Why Use Flash?

You know why—so you can take pictures when there isn't enough light to do so otherwise. But can't you take pictures in dark places without flash? Of course you can (with most cameras), and you'll retain the "feel" of the existing lighting that way—in fact, Chapter 21 deals with that. But to shoot in dark places without flash, you have to use fast films (or higher ISO settings on a digital camera), which increases grain or "noise"; or you have to use slow shutter speeds, which means you have to mount the camera on a tripod or your pictures will be blurred because no one can hold the camera steadily enough during those long exposures. It's easier to push the flash-activation button than it is to lug a tripod around, so many people use flash.

But there's more to electronic flash than just providing enough light to take pictures in dark places. Flash can make your sunlit pictures better, too, by lightening those harsh shadows on faces. If you have an AF 35mm SLR and an accessory flash unit that you can move off-camera, you can produce some beautiful lighting for all kinds of subjects. And you can create some exciting special effects with flash, too, as you'll see later in this chapter.

Fascinating Flash Facts

Today's flash photographers have it easy, thanks to automatic flash units, TTL flash-exposure control, and dedicated flash. With built-in flash units in point-and-shoot cameras, you don't have to do anything—the flash unit automatically charges and fires when the camera's control system thinks flash is needed, and the exposure for the flash-lit subject is controlled automatically. Some AF 35mm SLRs work that way, too, but most just activate the flash symbol in the viewfinder when they deem flash necessary. You then can activate the flash (by pushing the flash button) or choose to shoot by existing light.

Dedicated accessory flash units that attach to the camera's hot-shoe work the same way. The viewfinder symbol lets you know when the camera's programming thinks flash will be helpful. Just turn on the flash unit, and when it has charged and is ready to fire (which takes a few seconds), the camera automatically sets the proper

Whazzat Mean?

A dedicated accessory flash unit is designed to tap into the camera's circuitry when you slip it into the camera's dedicated hot-shoe atop the viewfinder. Thus connected and switched on, it automatically sets the right flash-sync shutter speed, activates the viewfinder's flash-status indicator (flash charging, flash ready), and automatic exposure control (generally TTL).

flash-sync shutter speed (even if you've set an incorrect one), and the viewfinder's flash symbol glows to tell you you're ready to shoot. Push the shutter button, and the camera's on-board computer automatically controls the flash duration to provide proper exposure within the flash unit's usable range. Many of today's SLR cameras beautifully balance exposure of flash-lit subject and ambient-lit background—automatically.

Besides the automatic flash mode, which automatically fires the flash when it's needed, point-and-shoot and AF 35mm SLR cameras also offer a flash-on or fill-flash mode in which the flash fires for every shot, whether the camera thinks it's needed or not. This mode is especially useful to lighten harsh shadows in outdoor portraits. There are some other handy flash modes, too, but first, let's take a trip back to the days before automatic flash—not just so you can see what you've missed (lucky you!), but so you can see the principles behind electronic flash. (If you don't care about principles, skip to the next page.)

Back in the Good Old Days (Not!)

There was a time when it wasn't so simple. We're going to "flash" back to those days for a moment.

One common cause of ruined flash pictures in the days before dedicated automatic flash was too fast a shutter speed. At slower shutter speeds, the focal-plane shutters found in virtually all 35mm SLR cameras work like this: The first shutter curtain moves across the film frame, uncovering it so it can be exposed to light. After the set exposure time, the second shutter curtain moves across the film, covering it and ending the exposure. At slower shutter speeds, there is a brief time when the entire image frame is uncovered before the second shutter curtain begins to cover it, so the flash can be fired while the entire image frame is exposed. But at faster shutter speeds, the second curtain starts to move across the film before the first curtain has completely uncovered the frame, in effect, moving a slit across the film to expose it. If you shoot a flash picture at too fast a shutter speed, only the portion of the film that is uncovered by the slit when the flash unit fires will be exposed. Many photographers were disappointed to find only part of a picture on each frame because he or she forgot to set the proper flash-sync shutter speed.

How fast is too fast? That varies from camera model to camera model, from $^1/_{60}$ to $^1/_{300}$ second—back then, $^1/_{60}$ was the norm. The camera's instruction manual will tell you the maximum allowable flash-sync shutter speed for your camera. On cameras with a shutter-speed dial, it's marked with an X.

High-Speed Sync

A few cameras offer "high-speed sync" with specific dedicated flash units, in which you can shoot flash pictures at faster shutter speeds than the normal maximum sync speed—up to the camera's fastest shutter speed. In this mode, the flash fires very rapidly for an extended period so that the whole film frame gets exposed as the shutter slit moves across it. This is great for sunlight-fill shooting, when the natural light might be too bright for you to use slower shutter speeds, but the flash must be very close to the subject—in order to flash so rapidly, it has to flash at very low power.

As mentioned earlier, today's SLRs with dedicated flash units automatically set the proper flash-sync shutter speed when you switch the flash unit on, even if you've set one that's too fast. And that's a truly wonderful thing.

With lens-shutter cameras—which include all the non-SLR point-and-shoot 35mm models—the flash syncs at all shutter speeds because the shutter uncovers the entire film frame at all shutter speeds.

> **CAUTION**
>
> **Watch Out!**
>
> When using studio systems or other nondedicated flash units that attach to the camera via a cord instead of the hotshoe, you must set the right shutter speed yourself—the camera won't do it for you.

Some flash units (professional studio systems, for example) do not offer dedicated shoe-mount operation. These must be connected to the camera via a sync cord. Many of today's cameras don't have a sync-cord terminal. You can use studio systems with these cameras if the studio flash heads have slave triggers. Slave triggers fire the flash units to which they are connected when they "see" the burst from a camera-triggered built-in or shoe-mount flash.

What Is X Sync, Anyway?

Earlier cameras had two flash-sync settings: X for electronic flash, and F, M, or FP for flash bulbs. Electronic flash reaches peak intensity almost instantaneously, then is gone, so X sync activates the camera shutter and then fires the flash; thus the shutter is fully open when the flash fires. Flash bulbs take a while to reach peak intensity and have a much longer duration than electronic flash, so F, M, and FP sync fire the flash first, then activate the shutter when the flash has reached peak intensity. If you shoot with electronic flash at F sync with one of these cameras, the electronic flash will come and go before the shutter opens, and you won't get a picture. Today's automatic cameras have only X sync, thus eliminating this problem.

Flash Exposure

Most of today's dedicated electronic flash units feature TTL automatic exposure control, in which the camera meters the flash through the lens and adjusts the flash duration to provide proper flash exposures throughout the flash unit's effective distance range. But before going into that, I'm going to cover manual flash, so you'll understand the principles involved (and also more of what we had to go through back in the days before autoflash).

When you shoot with electronic flash, the very brief duration of the flash burst serves as your shutter speed because it controls the duration of the exposure. All you (or your automatic camera) must do is set the lens to the right f-stop. With a manual flash unit, one way to determine the right f-stop is to use the exposure calculator on the back of the unit. First, tell the calculator how much light the film you're using needs by setting the calculator's film-speed index to the ISO speed of your film. Next, focus on your subject and read the focused-upon distance (which, for on-camera flash, is the flash-to-subject distance) on the lens barrel. Using the exposure calculator on the back of the flash unit, locate the flash-to-subject distance. Opposite the distance, you will find the correct f-stop to use for the picture.

Photo Fact

The flash from an electronic flash unit is very brief—from $1/1000$ second for most manual units at full power and for auto units used at the far end of their range, to $1/20,000$ or shorter for variable power manual units set at very low power and auto units used at very close range. This makes flash ideal for freezing nearby action subjects and for minimizing the effects of camera and subject movement in close-up photography. (See Chapter 18 to learn about close-up photography.)

The exposure calculator on manual flash units tells you what apertures to use when shooting at different flash-to-subject distances, once you've set the ISO speed of the film you're using. For example, this one indicates that at f/2.8, you can shoot from up to 35 feet from a subject; at f/5.6, you must be within 17 feet of the subject; and at f/16, you must be within 6 feet of the subject.

You'll notice that the farther away you get from the subject, the larger the aperture you must use. When the subject is a long way off, you won't be able to open the lens enough to provide proper exposure. That's why you shouldn't shoot flash pictures from the stands at a night baseball game or other event where you're a long way from your subjects—the flash will have little effect, and the picture will be underexposed or blurred due to a slow shutter speed.

Another way to determine the correct f-stop manually is by using the flash unit's guide number. The guide number is a rating of the flash unit's illuminating power, provided by the manufacturer. Just divide the flash-to-subject distance into the guide number, and the result is the f-stop to use. If the guide number is 80 for the film speed you're using, and the flash unit is 10 feet from the subject, 80 divided by 10 equals f/8. If the calculated f-stop comes out in-between settings, set the aperture halfway between the lens's closest apertures: For example, if the calculated aperture setting comes out to 9.4, set the aperture between f/8 and f/11.

The Dreaded Guide Number Test

Since the manufacturer's guide numbers tended to be a bit optimistic to boost sales, serious flash photographers often shoot their own guide-number tests. Here's how to do it.

Have a friend sit on a chair 10 feet from the flash unit, holding a series of cards marked with your lens's f-stops. Shoot a series of flash shots (being sure to give the flash unit plenty of time to recycle between exposures—10 seconds after the ready light comes on should be sufficient), one at each f-stop, with your friend holding the appropriate card for each shot.

Watch Out!

If you find yourself shooting in a larger or darker-walled room than the one in which you shot your guide-number test, or outdoors at night, you'll have to give more exposure than the guide number indicates. Conversely, if you shoot in a smaller room with more-reflective walls, you'll have to give less exposure.

After the film has been processed, examine it and pick the best exposure. Multiply the number on the card in that frame by 10 (the flash-to-subject distance), and you've got your guide number for that flash unit and film.

Guide numbers are just guides, not ironclad laws. In the old days, manufacturers provided "Kodachrome" guide numbers for ASA (ISO) 25 film. Today, they generally give guide numbers for ISO 100 film. A flash unit's guide number for ISO 100 film will be twice its guide number for ISO 25 film (and half its guide number for ISO 400 film). Along the same lines, guide

numbers given in feet will be 3.28 times higher than guide numbers given in meters. So if you're comparing the power of two or more flash units, make sure the guide numbers for all are given for the same film speed and the same units of measure (that is, feet or meters).

The best way to get accurate flash exposures manually is to use a flash meter to measure the light. A flash meter is specially designed to measure the brief burst of light from the flash—normal ambient-light exposure meters can't read such a brief burst. The flash meter is easy to use: Hold the meter right in front of your subject, point its translucent hemisphere at the camera, fire the flash, and set the lens to the f-stop indicated by the meter reading. This works with any number of flash units, even if some or all are bounced from walls or umbrella reflectors. If you intend to do a lot of flash photography, especially with studio flash units, you should consider buying a flash meter. It will pay off in saved film and peace of mind. I use a flash meter for all my studio-flash work, but use the camera's TTL flash-exposure control for shooting in the field.

Here are the results of a guide-number test. These results indicate the guide number for this flash unit and film is 80: The best exposure at the 10-foot shooting distance is f/8, and f/8 multiplied by 10 feet is 80.

Photo Fact

Most flash meters let you fire the flash to take a reading in two ways: cord and cordless. In cord mode, you plug the flash sync cord into the flash meter and press a button on the meter to fire the flash. Cordless mode lets you take a reading without a sync cord by firing (or having an assistant fire) the flash by pressing its test button. Cordless mode saves you the trouble of switching the sync cord back and forth between the camera and the flash meter.

Automatic Flash

Automatic flash is easy: Just push the shutter button, and the camera's electronics give you a properly exposed flash-lit subject. Many AF SLRs even properly balance the flash-lit subject and ambient-lit background exposures automatically.

The subject must be within the flash unit's effective distance range for automatic flash exposure to work properly. This range depends on the flash unit's power, the film speed, and the speed of the lens on the camera. With point-and-shoot cameras, it's generally around 3 to 12 feet with ISO 100 film. With top-of-the-line dedicated flash units for AF 35mm SLRs, it's around 2 to 25 feet with ISO 100 film and a typical zoom lens.

There are two basic types of automatic flash systems. Most point-and-shoot cameras use a "flashmatic" autoexposure system; the flash duration is constant, and the camera provides correct flash exposure by adjusting the f-stop based on the camera-to-subject distance as measured by the camera's autofocus system. This essentially automates the guide-number method of exposure control.

CAUTION

Watch Out!

Beware of foreground objects when using automatic flash. If there is an object in the scene that's closer to the flash than the main subject, the flash will probably expose the near subject properly and underexpose the more distant main subject.

Most AF 35mm SLRs employ TTL (through-the-lens) flash metering, which measures the light reaching the film. This is more accurate than the flashmatic system and allows the camera to automatically balance exposures for the flash-lit nearby subject (by controlling the flash duration) and the ambient-lit background (by adjusting the aperture). And it does all this nearly instantaneously—a wonder in itself, as you'll see when I show you what's involved in doing it all yourself in the next section.

Early automatic flash units were neither TTL nor flashmatic: You set the aperture you wanted to use, and a sensor in the flash unit read the light reflected from the subject and adjusted the flash duration to provide proper exposure. The distance range is different for each aperture—at larger apertures, the flash "reached" farther; at small apertures, the subject had to be closer. Some TTL units operate this way when used off-camera wirelessly.

Bear in mind that, like automatic-exposure cameras, autoexposure flash units compute their exposures for average conditions. If you're shooting particularly light or dark subjects, in a small, highly reflective environment, or in a large, dark one, you'll have to make some adjustments to compensate. Some AF 35mm SLRs or their dedicated flash units have a flash exposure-compensation feature that allows you to do this—and to adjust the flash-to-ambient light ratio, too.

Fill-Flash

Calculating exposure for fill-flash used to be one of the most dreaded problems in photography. But today's automatic cameras do it automatically. Many AF SLRs automatically balance flash and ambient-light exposures for perfect portraits day or night. Some even allow you to adjust the ratio between the flash illumination and the existing light—you can set the flash to overpower the ambient light (which results in a picture with a properly exposed subject against a dark background), or as a fill light to lighten the shadows. But—so that you'll understand the principles involved—here's how to handle fill-flash manually.

First, determine the exposure for the ambient light in the usual manner (using the camera's built-in meter or a hand-held meter, whatever you normally use) and set the camera accordingly—let's say you get an exposure of $1/125$ at f/8.

Next, use the flash unit's exposure calculator or guide number to determine the flash-to-subject distance that calls for one stop more exposure. In this case, the distance calls for an aperture of f/5.6. If you put the flash unit at that distance and shoot at f/8, the flash image will be one stop underexposed—a level that works well for a fill light.

You can set the flash so that it matches the sun's effect by putting the flash unit at a distance that calls for the same aperture as the ambient-light exposure (f/8 in our example).

You can also use the flash unit as your main light by putting it at a distance that calls for less exposure than the ambient light (f/11, for our example) and setting the lens to

the flash-indicated aperture (f/11). This will result in a properly exposed flashlit subject against an underexposed (dark) background—an effective way to play down a distracting background or to make the subject stand out from the background.

As noted earlier, some 35mm SLR cameras require shutter speeds no faster than $^1/_{60}$ when used with electronic flash. If you're using fast film outside, you might not be able to use such a slow shutter speed. ISO 400 film requires a shutter speed of $^1/_{400}$ at f/16 in bright sunlight; how do you shoot at $^1/_{125}$ if your lens stops down only to f/16? Solutions: Use slower film or a neutral-density filter to permit use of the required slow shutter speed (for more on filters, see Chapter 12).

The required flash-to-subject distance might be different than the desired camera-to-subject distance when using fill-flash. Solutions: Using an extension sync cord, move the flash unit off-camera to the required distance; move the camera and flash to the required distance, and use a zoom lens to recompose the image as desired (this will change the perspective, however); or use the flash unit's variable power settings (if it has them) to adjust the flash output to an appropriate level for the camera-to-subject distance.

Aren't you glad your camera does all this automatically?

Slow-Sync Flash

Slow-sync flash is a useful feature of some cameras, both point-and-shoot and SLR. With slow-sync flash, the camera uses a slow shutter speed to properly expose a dark background (such as a night skyline), while also properly exposing a nearby subject lit by flash.

Slow-sync flash mode uses a slow shutter speed to bring out detail in a dark background behind a flash-lit main subject. This photo was made with a Nikon Nuvis 160i Advanced Photo System camera in slow-sync mode.

(Lynne Eodice)

Slow-sync flash mode allows you to combine the brief flash duration's action-freezing power with a long ambient-light exposure to blur the motion. Normal front-curtain sync fires the flash at the beginning of the exposure, then records ambient-light speed streaks; thus the streaks appear in front of a forward-moving subject.

Normal Sync

With most cameras, the flash fires at the start of a long exposure (this is known as "front-curtain" or "first-curtain" sync). If you make a long exposure of a subject moving across the frame, the flash will fire at the start of the exposure, then the ambient light will record a ghost image of the subject as it moves across the frame. In the resulting photograph, the ghost-image "speed streak" will appear in front of the subject—not a natural effect.

Rear Sync

Some cameras also offer "rear-curtain" or "second-curtain" sync, in which the flash fires at the end of the exposure, just before the shutter closes. With rear-curtain sync, the ghost-image speed streak will be recorded by ambient light as the subject moves across the frame, then the flash will fire to sharply record the subject at the end of the exposure. In the resulting photo, the speed streaks will appear behind the subject—a more natural effect.

Rear-curtain sync fires the flash at the end of the exposure, after the ambient-light streaks have been recorded; thus the ghost-image speed streaks follow rather than precede the moving subject.

Strobe Flash

Many photographers refer to portable electronic-flash units as "strobes," but true strobes are electronic flashes that fire repeatedly at a rapid rate. Many high-end, shoe-mount flash units offer a "strobe" mode, and you can use it to produce motion-study special effects. You must position the flash unit close to the subject because the strobe function works only at low power settings (the unit can't recycle fast enough at higher power settings). Subjects moving across the frame work best, because with subjects that stay in one position, the overlapped areas will be overexposed. Remember that the background isn't moving, so it receives exposure each time the flash fires. To avoid overexposing the background, shoot in a large room with the subject well away from the background or outdoors at night. Lighting the subject from the side rather than from camera position will also help keep light off the background.

In strobe mode, the flash fires repeatedly at a rapid rate. This allows you to capture several points in an action in a single shot.

Bounce Flash

Direct flash is pretty harsh lighting. You can soften the light from the flash by bouncing it from a large white surface, such as a wall, ceiling, Fome-Cor, or poster board. This is known as *bouncing light*. Soft bounce lighting is attractive and forgiving—there are no harsh shadows to shout "bad lighting" at the viewer. If you have just one flash unit, bounce it and you'll be pleased with what you can do with that single unit. Chapter 15 tells you all about soft and hard light and lighting in general.

Many shoe-mount flash units have heads that swivel and tilt, so you can aim them at the ceiling or a nearby wall for bounce lighting while the flash unit remains attached to the camera's hot-shoe, so you still get TTL automatic flash exposure control. If your flash unit loses its TTL capability when you remove it from the camera, the easiest way to determine exposure is by using a flash meter. If you have to determine exposure for bounce flash manually, measure the distance from the flash unit to the reflecting surface and add this to the distance from the reflecting surface to the subject. Divide this combined distance into the flash unit's guide number, then open the lens one stop from the resulting figure. Bracket exposures to compensate for variations in bounce surfaces.

A white wall is a good choice for a bounce reflector because it reflects white front, side, or side-front lighting, depending on whether you position your subject with the wall directly to one side, directly in front, or in-between. Ceiling bounce light generally comes from too high an angle to produce flattering people pictures but is useful for providing overall illumination while eliminating the flat look of on-camera flash. (If you bounce the light off a colored surface, your subject will take on the surface's colorcast in a color photo.)

Whazzat Mean?

Bouncing light is a photographer's term for reflecting the light off a ceiling, wall, umbrella reflector, or any other surface, to soften the light.

Watch Out!

When you use a non-automatic flash unit off-camera, remember to use the flash-to-subject distance, not the camera-to-subject distance read off the lens's focusing ring, for exposure calculations. Of course, flash units that retain their TTL operation when used off-camera provide proper exposure automatically.

The larger the light source, the softer the light. Bouncing light from the small flash tube off a large surface increases the size of the light source many times and thus makes the light a lot softer.

Off-Camera Flash

Moving the flash unit off the camera offers several advantages. First, it eliminates that dimensionless "paparazzi" look of direct on-camera flash, red-eye, and annoying shadows on walls behind your subjects. Second, it allows you to use umbrella reflectors, which soften the light while still providing directional lighting.

Direct on-camera flash is not the best lighting for portraits because it makes the face look two-dimensional, is harsh, can cause red-eye, and casts an unattractive shadow on the wall behind the subject.

Move the flash unit above and to one side of the camera, and you eliminate the wall shadow and red-eye and give the face some depth.

Umbrella fabric comes in white (soft), silver (harder, but still much softer than direct flash), and gold (adds a warm cast to color portraits). Because the light must travel from the flash unit to the reflector and then back to the subject, and some light is lost en route, you need a fairly powerful flash unit for umbrella work. Thus, the silver umbrella is probably your best bet because it reflects more light than white or gold.

The direct light of the flash might be too harsh, even when the flash unit is moved off-camera (left). Bounce the flash off a photographic umbrella reflector, and you get beautiful soft lighting (right).

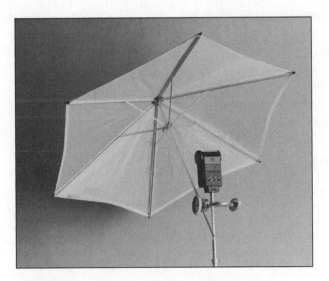

Photographic umbrella reflectors (and the means to connect your flash unit to one) are available at your local camera store. They soften the light quite beautifully.

Problems, and What to Do About Them

Here are some of the more common flash-photo problems and their solutions.

Red-Eye

If you've shot flash pictures of people or animals, you've no doubt encountered red-eye—the big red spots in eyeballs that ruin so many portrait shots.

Red-eye occurs because the flash unit is too close to the camera lens; the light goes straight into the eyes and is reflected off the retinas right back into the lens. There's only one way to eliminate red-eye when you shoot: Move the flash unit away from the lens. Obviously, you can't do this with built-in flash units. So the camera manufacturers provide a red-eye–reduction flash mode, which does reduce (but doesn't eliminate) red-eye. How does it do that? It emits a pre-exposure light burst to "stop-down" the subject's eyes, so less light can be reflected back from the retinas. Usually, this pre-exposure burst is several low-power bursts from the flash unit itself, but some cameras make the self-timer lamp glow for a second or two instead.

If you do have red-eye in some of your prints, all is not lost—you can remove it with a red-eye pen, which should be available at your local camera store. This is a black pen that adheres to photo prints, and you just "dot the eyes" with it to cover the red spots and turn them black. If your images are digital (either shot with a digital camera, or film images scanned into digital form), you can remove the red-eye with your image-editing software (some consumer editing software even removes red-eye with one click of the computer mouse).

Long Recycling Times

After you take a flash picture, it takes the flash a few seconds to recycle, to recharge itself so it's ready to fire again. When the batteries get weak, recycling times get longer (that's one way you know it's time to put in new batteries). Recycling times are also longer after you shoot at the flash unit's maximum distance, when it uses more power. When you shoot with a TTL flash unit at close range, the flash recycles almost instantaneously because it doesn't have to use a lot of power to illuminate a nearby subject.

If the flash unit doesn't work or takes an unusually long time to recycle, the battery has probably died. Built-in flash units get their power from the camera's battery; dedicated flash units use their own batteries. Be sure to carry spare batteries for both your camera and your flash unit.

Incidentally, today's flash units have energy-saving circuitry, but it's a good idea to switch the flash unit off when you aren't going to use it for more than a few minutes.

Subjects at Different Distances

As you'll recall from the illustration of the flash-unit exposure calculator, the farther away a subject is, the larger the lens aperture needed to provide correct exposure. That's because light from the flash decreases in intensity as the distance from the flash unit increases. Thus, if you use on-camera flash to photograph a group of people, with some closer to the camera than others, the closest subjects receive more exposure than more-distant ones. This problem has several solutions.

First, you can move the subjects so that they're all the same distance from the flash unit. Second, you can move the flash unit off-camera so that it is the same distance from all the subjects. Third, you can bounce the flash off the ceiling, a nearby wall, or a large umbrella reflector, all of which even out the lighting.

If you photograph a group of people with direct flash, the closest subjects receive more exposure than farther ones (top). One solution: Move the flash unit off-camera so it is the same distance from all the subjects (bottom).

(Carol Kramer)

Reflections

If you shoot a flash picture with a shiny surface, like a mirror or window (or even a glossy-painted wall) behind the subject, the flash will be reflected right back into the camera lens. If such a background is unavoidable, move your camera or flash unit and shoot at an angle to the shiny surface so the flash won't be reflected right back into the lens.

No Modeling Lights

One drawback to using electronic flash is that you won't see what the lighting looks like until you get your pictures back. The brief flash doesn't last long enough for you to examine the lighting. Studio flash systems solve this problem with modeling lamps, which are continuous-output bulbs that let you see what the lighting looks like so you can do something about it if you don't like it.

With built-in and on-camera flash, you do have a pretty good idea of what the lighting will look like—we've all seen lots of on-camera flash pictures, and they all look about the same: flat, two-dimensional, and a bit harsh. If you move the flash unit off-camera, you can hold a powerful flashlight next to the flash unit to get a vague idea of what the lighting will look like. A better bet is to bounce the flash from an umbrella reflector. That will soften the light so it will look pretty good from almost any angle—there won't be any harsh, unattractive shadows.

Angle of Coverage

When you use flash with a wide-angle lens, subjects at the edges of the picture will probably be too dark because the flash unit's angle of coverage isn't wide enough to cover the whole picture area. Even if the manual says the flash can cover a 24mm lens, subjects at the edges will be darker than those in the center of the picture. If you encounter this problem, use a longer lens focal length when shooting with the flash in the future.

The Least You Need to Know

- Built-in and accessory flash units let you shoot pictures when it's otherwise too dark.

- Flash can make your sunlight portraits better.

- Today's automatic flash units make it easy to shoot good flash pictures.

- You'll generally get better flash pictures if you can move the flash unit off-camera.

- Soft, bounced flash produces beautiful lighting for people pictures.

Useful Shooting Accessories

In This Chapter

- ◆ Lens attachments
- ◆ Triggering devices
- ◆ Camera supports
- ◆ Storage and transport
- ◆ Date backs
- ◆ Optional power sources

A number of nonessential items can make your photographic life easier—and make it possible for you to do things you couldn't do without them. What are these amazing things? They're shooting accessories, and you'll learn all about them in this chapter.

Because there are chapters devoted to filters, close-up gear, flash, and lighting, I won't cover those accessories here. These pages introduce you to a host of great devices that can help you in your photographic endeavors.

Lens Hoods

As I mentioned in Chapter 9, lens hoods keep extraneous light from striking the front element of your lens and causing flare. Flare spots can produce interesting special effects, but you'll generally want to avoid them. The overall loss of contrast and color saturation caused by flare is rarely desirable. Attaching a lens hood to your lens will eliminate flare unless the flare-producing light source actually appears in the picture.

You'll want to use the longest lens hood that won't produce vignetting (cutting off the corners of the image). With zoom lenses, a hood that's fine at the telephoto end of the focal-length range could vignette at the wide end. Collapsible rubber lens hoods take up minimal space and allow you to adjust them for different focal lengths. Lens hoods also provide some impact protection for the front lens element. For the flare and impact protection, you should use a lens hood whenever possible.

Lens hoods for wide-to-tele zoom lenses (like the one on this Tamron 28–105mm zoom) have a cutout design so that they don't vignette at wide-angle focal lengths.

Lens Shades and Matte Boxes

Lens shades and matte boxes are accordion-like devices that attach to the front of the lens and, besides serving as adjustable lens hoods, allow you to position vignetters, masks, and diffusers in front of the lens to produce a variety of interesting special effects.

Right-Angle Adapters

Right-angle adapters let you shoot photos of things that are off to one side—great for shooting covert portraits if the ethical considerations of doing so don't bother you. These devices work best with telephoto lenses (100mm or longer for 35mm cameras). Porter's version is called the Angle Scope and sells for less than $60 (plus adapter ring).

Stereo Adapters

Stereo adapters produce two images on a frame of slide film through openings about the same distance apart as the human eye. When these slides are viewed with the companion stereo viewer, they appear to be in 3D. Pentax and Porter's offer stereo adapters that work with a normal lens on any brand camera.

This Pentax stereo adapter and viewer let you shoot and view images in 3D—and it can be used with any SLR camera.

Slide Duplicators

Slide duplicators attach to the front of the camera lens and let you make copies of your slides. Slip the slide into the slot in the duplicator and point the duplicator at a light source. A white piece of poster board in direct sunlight, an electronic flash unit, or a projector lamp (using tungsten film) are common light sources for slide duplicating.

Triggering Devices

There are a number of ways to fire your camera besides pushing the shutter button with your finger. Why? Because pushing the button can jiggle the camera, even when it's mounted on a tripod, and other times, you'll want to fire the camera from afar.

To avoid jiggling the camera, you can use the self-timer to trip the shutter. If the camera has a mirror prelock, activate it, then use the

 Hot Tip

Some slide copiers attach to a bellows unit and allow you to crop in on your images. These are more costly than simple slide duplicators and, of course, require a bellows unit.

self-timer to fire the camera after a few seconds to let the vibration caused by the mirror flipping out of the light path subside. Of course, this method is not applicable for decisive-moment photography, but it's great for still-life and macro work.

Cable Releases

Cable releases come in different lengths and allow you to fire the camera from a distance. Mechanical cameras use plunger-type mechanical releases. Electronic cameras use electronic releases, which don't jiggle the camera at all. Most camera manufacturers offer cable releases designed for their cameras. There are also a variety of generic releases available from other manufacturers. Make sure you get the proper one for your camera model.

Mechanical plunger-type cable releases, which are used by most older cameras, are simple, inexpensive devices, but they can help you get sharper pictures. Many of today's electronic cameras require electronic cable releases rather than the mechanical plunger types.

Remote Controls

Wireless remote controls let you fire the camera from a greater distance and come in two varieties: infrared and radio. Infrared remotes operate out to about 100 meters (325 feet), while radio remotes can have much greater range—out to 700 meters (2,300 feet). Infrared remotes also require line-of-sight to the camera, while radio remotes don't. Most camera manufacturers offer wireless remotes for their cameras, and independent manufacturers also offer remotes that work with many cameras.

Remote controls consist of a transmitter trigger that you keep with you and a receiver that attaches to the camera or flash unit you want to fire from afar. This is an infrared unit. There are also radio remote controls, which don't require line-of-sight between the transmitter and receiver.

Sound Triggers

Sound triggers fire the camera when they detect the sound of an action, which is great for capturing popping balloons and other actions too quick to react to manually. The Woods Shutter Beam is a sound trigger that can also be set to fire the camera when a subject breaks an infrared beam, such as a bird arriving at its nest. The unit is so precise that it can capture bullets leaving the muzzle of a gun, bursting balloons, and jumping insects.

Intervalometers

Intervalometers automatically fire the camera at preset intervals, allowing you to produce time-lapse studies of flowers opening and the like. A few cameras have built-in intervalometers; others gain this feature via a multifunction back (such as Nikon's MF-28 for the F5 pro AF SLR), and you can buy separate intervalometers to use with other cameras. Most let you set the number of shots you wish to make, as well as the time interval between them. The device then activates the unit, recording the sequence automatically as you go about your business.

Tripods

When shooting at slow shutter speeds or at great magnifications (as with telephoto lenses or in macro work), camera shake causes unsharp images. A good camera

support can solve this problem. And truthfully, it's a good idea to use a camera support whenever possible, even when shooting at high shutter speeds, because you'll get sharper images.

Tripods are the most popular and useful camera supports for general photography. These three-legged camera stands serve two useful functions: Besides virtually eliminating camera-shake–induced image blur, a tripod locks in your composition so you can carefully examine it and won't have to worry about accidentally changing it as you make the exposure.

If you've ever tried still-life, scenic, or architectural photography, you know that trying to maintain a precise composition with the hand-held camera, especially if you have to physically move scenic elements or use a perspective-control lens, is just about impossible. But put the camera on a tripod, and you can arrange scenic elements to your heart's content, knowing the camera will be pointed right where you left it when you go back to check the scene. You'll also know that you won't accidentally move the camera as you squeeze off the shot.

> **Photo Fact**
>
> Tripods come in various materials. A common one is aluminum alloy. It's light and strong but can be uncomfortable to hold in cold weather. Carbon fiber is lighter but more expensive. Wood is beautiful and sturdy, making it great while shooting but heavier to carry. Excellent tripods are available in all three materials.

Aluminum tripods are light, strong, and relatively inexpensive, making them ideal for most readers of this book. Major brands like Benbo, Manfrotto (shown here), Cullmann, and Gitzo are all good.

What to Look For in a Tripod

The primary requirement for a tripod is sturdiness. If the tripod is too flimsy to support your camera, it's not going to serve its purpose (but if it's so heavy that you don't bother taking it along, it also does no good). When evaluating a tripod, partially extend its legs and center column, lock them in place, mark their positions with pencil lines on the legs and column, then press down on the camera mount with the palm of your hand. The legs or center column should not slip or bow when you do this (the pencil lines will indicate this). Extend the legs and center column to maximum height and check the tripod for stability by pushing on the camera mount.

The tripod's legs should extend far enough to mount the camera at eye level without using the rising center column (the center column is best used for fine-tuning camera height; extend it only if necessary because extending it provides less stability than the tripod legs). The leg and center column locks should be easy to operate and lock the legs and column securely. A geared center column is easier to set at a precise height than a simple push-pull column. The tripod should allow you to mount the camera as low as you're likely to want it, although if an otherwise excellent tripod won't, you can always pick up an inexpensive mini-tripod for low-angle work.

Tripod Heads

The tripod head should permit using the camera in both horizontal and vertical positions. It should allow the camera to be panned 360° and tilted up and down as much as you're likely to want to tilt it. All locks and handles should operate easily and smoothly. Levels on the tripod and the head are very handy for architectural and landscape work.

A ball head lets you position the camera as you wish with the twist of a knob. The second knob on this Slik unit lets you adjust the friction.

Three-way pan-tilt heads and ball heads are both great. Ball heads let you adjust the camera to any position with the twist of a single knob, and then lock it there with an opposite twist. Pan-tilt heads provide precise adjustments along three axes. Try both types and see which best suits you. (With either head type, you should get one with a quick-release mechanism, which allows you to quickly remove the camera from the tripod for hand-held shooting.) There are even special panorama heads that properly position a camera so that you can make a 360° sequence of photos that can be seamlessly mated together to produce a superwide 360° panoramic print. Video photographers will want a fluid head, which dampens movement for smooth pans and tilts.

Tripod Tips

You'd think that using a tripod would be pretty straightforward: Attach the camera, point the camera, and shoot. Well, it is, and it isn't. Here are some tips that can make life with a tripod easier and more effective.

First, as mentioned earlier, don't use the extending center column as your primary camera-height control. Use the extending tripod legs to set the height; use the center column to fine-position the camera if need be.

Second, extend the thicker portions of the tripod legs before the thinner ones; the tripod will provide sturdier support that way.

Third, for additional stability and especially handy in a windy environment, suspend a weight from the center of the tripod. This will help stabilize it and keep it from being knocked over.

Watch Out! _____

Before carrying a tripod from location to location, make sure that all the locks are securely locked (or better still, remove the camera from the tripod).

Fourth, when possible, have one of the tripod legs pointed in the same direction as the camera and lens. This will keep you from tripping over a tripod leg while behind the camera.

If you need to extend the tripod legs only partway, extend them to the desired height before spreading them; that way, it's easier to see when they're all extended the same amount.

Other Camera Supports

A monopod is essentially a tripod leg to which the camera or a head can be attached. It's lighter and easier to carry than a tripod and steadier than hand-holding the camera. Some monopods double as handy hiking canes. Clamp-pods have a camera-

mounting screw at one end and a clamping device at the other, allowing you to mount the camera on a variety of handy objects, such as beams and tree branches. Suction-pods use suction cups to attach the camera to smooth surfaces.

Gunstock supports attach the camera to a rifle-stock device, great for steadying long telephoto lenses. Beanbags allow you to support the camera on uneven surfaces, such as the crotch of a tree. Check out your local camera store to see what's available. If you're handy around the shop, you might also be able to make your own camera-supporting device.

You can mount your camera on the window of your car, with Celestron's car window mount.

Storing and Carrying Your Photo Gear

You have to keep your camera gear somewhere and carry it to your shooting locations, whether that means an exotic foreign land or your own backyard. Accessory manufacturers offer you many ways to do it.

Ever-Ready Cases

Ever-ready cases tightly fit the camera. They consist of a bottom half that always stays on the camera and a top half that opens to allow you to shoot. Camera manufacturers offer leather ever-ready cases for their cameras, and Zing offers neoprene ever-ready cases that fit most cameras (neoprene is the material used to protect scuba divers, and 5mm of it—with an extra 3mm on the bottom—protects the camera from shock and dirt, while leaving it easily accessible).

Hard Cases

Hard camera cases provide maximum impact protection for your camera gear. Most offer moisture and dust protection as well. Some will hold a lot of gear; be careful not to load so much that the case is too heavy to carry (some cases come with built-in or

accessory wheels to make moving them easier). If you have a lot of gear, it's a good idea to use two cases, one for stuff you really need, and the other for stuff you might need for the shoot. Silver aluminum cases will reflect sunlight and keep your equipment cooler than black cases will—something to consider if you work outdoors a lot. Built-in locks are a nice feature that will keep people from taking things out of the case, but they won't prevent someone from walking off with the whole case.

Hard camera cases provide maximum protection. This huge Pelican case, for example, is made of lightweight, unbreakable, corrosion-proof resin and is watertight. Roll-A-Way wheels make for easy movement over smooth surfaces.

Camera Bags

Camera bags come in just about every shape and size imaginable. Besides adequate capacity, look for the following characteristics:

◆ **Sturdy materials and construction**

◆ **Padding** (especially on the bottom so you don't damage your gear if you set the bag down too hard)

◆ **Comfort** when you're carrying it. (Does the strap keep slipping off your shoulder? Is the weight well distributed? Does pointy-edged equipment stab you as you walk with the bag?)

◆ **Convenience** (Can you get at needed gear without setting the bag down? Do you need both hands to unlatch the top to get at equipment? Is everything easily accessible or do you have to burrow through stuff to get at a needed item?)

Photo Backpacks

Photo backpacks provide the same functions as camera bags, but leave your arms free. Things to look for in a backpack are comfort (padding, straps, balance), versatility, and sturdy construction.

Photo Vests

Photo vests are a great convenience. They allow you to carry a lot of gear, balanced around your body, with both hands free. Again, construction, comfort, and convenience should be considered (for example, can you get at items without removing the vest?).

A photographer's vest is a transport solution that keeps your hands free for shooting. This Domke PhoTOGS jacket from Tiffen provides 16 pockets and removable sleeves.

Camera Straps

Camera straps are an important accessory. Whenever you're using your camera hand-held, you should use a strap, so you can't accidentally drop the camera and damage it (don't think it can't happen!). Wide straps spread the camera's weight over a larger area of your neck, and so are more comfortable than narrow straps. Springy straps like those from Op/Tech are even more comfortable, making the camera seem lighter than it actually is. Zing's SLR Action Strap wraps around your hand and secures the camera while providing freedom of movement. There are straps that hold the camera against the body so it doesn't bounce around while you move, straps that hold two cameras one above the other, even colorful "designer" straps—whatever your strap needs, someone makes it.

Hot Tip

For the best in camera supplies, check at your local camera store. Also be sure to check out the Porter's Catalog (Porter's Camera Store, www.buyporters.com), which carries a number of high-quality and hard-to-find products.

X-Ray Bags

X-ray bags are lead-lined pouches designed to protect your film from airport x-ray devices. Larger bags will also hold a camera. While the degree to which airport x-ray machines can harm films is the subject of much debate, many feel it's better safe than sorry. We use 'em.

X-ray bags protect your film from airport x-ray machines. Lead-lined bags from Sima and Op/Tech (shown here) are available at local camera stores.

Date-Backs

Most point-and-shoot cameras, including AF SLRs, come in date-back versions, and a few come only in date-back form. Date-backs let you print the time and date on the film when you shoot a picture. With most 35mm cameras, this data appears in the image area, so be sure to switch the date function off unless you want to see that information in your pictures. Advanced Photo System cameras magnetically encode the date on the film (and other information, depending on camera model—refer to Chapter 5 to learn all about APS), so it doesn't automatically appear on the print—and when printed, it appears on the back, not on the picture.

CAUTION

Watch Out!

If your camera is a date model, be sure to switch the date function off unless you want the date to appear in your pictures.

Many pro SLRs accept other camera backs. Multifunction backs provide data imprinting (not just time and date, but also shooting data, and the back for Nikon's F5 top-of-the-line pro model even imprints the photographer's name and copyright) plus other functions: intervalometer, expanded automatic exposure bracketing, very long-timed exposures, and more. Bulk-film backs accept long rolls of film, allowing you to shoot up to 250 exposures between reloadings. Digital backs let you record pictures in digital form for use in computers (you'll learn more about that in Part 5).

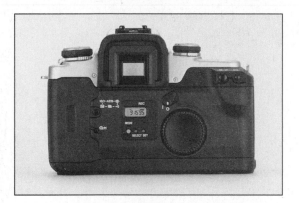

A date-back lets you imprint the date or time on the film.

Optional Power Sources

The standard power sources for cameras and flash units (generally lithium, alkaline, or nickel-cadmium batteries) are fine for normal shooting. But optional power sources can provide faster advance rates, more shots between battery changes, the economy of rechargeable batteries, and even AC operation. Some optional power sources come with an extension cord, so you can keep the battery pack in a warm pocket for better cold-weather performance. Camera and flash manufacturers make optional power sources for their equipment, and independent manufacturers also offer power sources for many cameras and flash units.

Quantum's Battery 1+ is a good example of an optional power source. It can be used with a wide variety of dedicated flash units and digital cameras, and provides many more shots than the gear's standard batteries.

The Least You Need to Know

- ◆ Lens hoods can keep flare from ruining your pictures.

- ◆ There are more ways to trip the shutter than pushing it with your fingertip.

- ◆ You'll get sharper pictures if you use a tripod or other camera support.

- ◆ A camera bag makes it easy to keep your photo gear together and cart it around.

- ◆ Optional power sources give you better performance, plus more shots before you have to change batteries.

Photo Filters

In This Chapter

◆ Colored filters for color and black-and-white

◆ Filter factors and color balance

◆ How to handle mixed lighting

◆ Polarizing, neutral-density, and graduated filters

◆ Types of filters and how to attach them

◆ Caring for filters

Filters are to the photographer what seasonings are to the chef. Used properly, these magic disks can turn an otherwise dull photo into a feast for the eyes. But if you use the wrong ones or overdo it, they'll spoil the entree. The entree is the photographic image. Just as you wouldn't want your main impression of an expensive steak to be "pepper," you wouldn't want your main impression of a photograph to be "polarizing filter."

Choosing the right filter requires that you understand a few basic things about light and color, and you'll learn them in this chapter. As with the chef's seasonings, each filter has a specific purpose (or several purposes) but can be used for other things as well. For example, in black-and-white

photography, colored filters are generally used to provide contrast between objects of different color but equal brightness in a scene. They can also be used to exaggerate tonal relationships and for special effects in color photography. (You'll learn about special-effects filters in Chapter 21.)

Once you've learned about filters and what they do, try them out in your own photography. Don't be afraid to overdo it at first—that's how you learn what works and what doesn't. But remember, you should use a filter because doing so will give you a better photo. If it won't, don't use it.

> **Hot Tip**
>
> You can use many filters with a point-and-shoot camera. Make sure that colored and polarizing filters cover both the lens and the metering window (see the camera manual to see which one it is on your camera) and that the special-effects filters described in Chapter 21 cover only the lens. Be sure to tell your photofinisher that you used a filter so he or she won't try to correct the color or effect when making your prints.

Colored Filters

As you'd expect, colored filters add their color cast to color photographs. Attach a red filter to the front of your lens, and your color photos will come out looking quite red. You can use an orange filter to enhance a sunset shot (or to add color when it is lacking). Or use a green filter on that sunset for a really strange effect. A CC30 red filter (more on CC filters later) will nicely cancel the cast of cyan-tinted aircraft and train windows, so you can get good color shots through them.

But colored filters can also be used very effectively in black-and-white photography, to change the light/dark relationships among colored objects in a scene and thus provide contrast between objects that would reproduce as about the same shade of gray if no filter were used. For example, red flowers reflect about the same amount of light as green leaves, so both colors will reproduce as about the same shade of gray in a black-and-white photograph of the flowering plant taken without using a filter.

If you photograph the plant with a red filter over the camera lens, the red flowers will become lighter and thus stand out from the darker green leaves. Colored filters lighten objects of their own color in black-and-white photographs, while darkening objects of the complementary color.

You can also provide separation between the flowers and leaves by using a green filter, which will lighten the green leaves and darken the red flowers. The decision is yours; it's just a matter of deciding what you want your photograph to look like, then applying your knowledge of how colored filters work to make it look that way. Because the eye is drawn to bright areas in a photo, you'll generally want to use a filter that will make the main subject light and its surroundings darker.

A red filter lightens these red flowers (which appear here as white) and darkens the green leaves, providing good separation in the photograph.

A green filter darkens the red flowers and lightens the green leaves, also providing separation between them. Which of these two renditions you prefer is up to you. Colored filters allow you to produce the one you want.

Which colors are complementary? And what will a colored filter do to all the other colors in the scene? The following "color asterisk" shows you. It plots out complementary colors opposite one another. If you draw a line through the center of the color asterisk perpendicular to the line representing the color of the filter being used,

all colors on the same side of the line you drew as the filter color will be lightened in a photo made with the filter, and all colors on the opposite side of that line will be darkened. The farther from the line a color lies, the greater the effect the filter will have on that color.

Note: If your filter's color is in between the primary colors shown on the asterisk, just put in a line representing that color between the appropriate primary color lines and draw a line perpendicular to it.

The color asterisk allows you to predict the effects of a colored filter on various colored objects in a scene—see text for details.

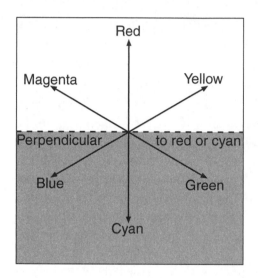

Another good use for colored filters in black-and-white photography is to compensate for the fact that film is more sensitive to ultraviolet and blue light than our eyes are. Due to this greater sensitivity, objects in a scene that reflect a lot of blue and ultraviolet, such as the sky, appear lighter in a photograph than they appear to our eyes in real life. A partly cloudy blue sky, exposed without a filter, does not produce a very dramatic photograph because the blue photographs too light.

Photo Fact

Colored filters have no effect on the white clouds because they contain no color. Colored filters have no effect on neutral (white, gray, or black) objects because there is no color there for the filter to selectively absorb. That's why a colored filter can't darken an overcast gray or hazy white sky (although it can darken the bluish shadow portions of the clouds). Further note: Atmospheric haze is caused by the scattering of ultraviolet and blue radiation, and colored filters can reduce this. But fog and smog actually consist of particles in the atmosphere, and no filter can "cut through" opaque particles.

A yellow filter will absorb some of the ultraviolet and blue radiation and thus darken the sky so that the white clouds will stand out. An orange filter, which absorbs more blue light, will darken the sky even more. A red filter, which absorbs cyan and green as well as blue and ultraviolet, will really darken the blue sky in a black-and-white photograph.

Filter Factors

I kind of lied to you earlier, for simplicity's sake. Colored filters don't really add their color to a scene. What they actually do is subtract all the other colors. Colored filters transmit light of their own color and absorb light of their complementary color. Since they do absorb some of the light from the scene, you must increase exposure when using colored filters or your photos will be underexposed (too dark).

How much should you increase exposure when using a given filter? To a degree, a camera's built-in through-the-lens (TTL) meter will take care of it for you. But often a meter's light-sensitive cells and the film being used will have different color sensitivities. For more precise results, meter without the filter, then increase the exposure per the filter factor. The filter factor is just a number indicating how much you should increase exposure to properly reproduce neutral (colorless) subjects—those whose tones should be unaffected by the filter. The following table is a list of filter factors for commonly used colored filters, for both daylight and tungsten illumination. Note that red filters have higher factors in daylight, which is comparatively low in red wavelengths, while blue filters have higher factors for tungsten light, which is comparatively low in blue wavelengths.

Filter Factors of Common Filters

Filter	Daylight Factor	Tungsten Factor	Color
No. 8	2	1.5	Yellow
No. 11	4	4	Yellow
No. 12	2	1.5	Yellow
No. 15	2.5	1.5	Yellow
No. 25	8	5	Red
No. 29	16	8	Red
No. 47	6	12	Blue

continues

Filter Factors of Common Filters (continued)

Filter	Daylight Factor	Tungsten Factor	Color
No. 47B	8	16	Blue
No. 50	20	40	Blue
No. 58	6	6	Green
No. 61	12	12	Green

It's generally easier to open the lens a certain number of stops (or fractions thereof) than to give "2.5×" more exposure, so the following table shows the value of each filter factor in terms of f-stops.

Filter Factor/f-Stop Increase

Filter Factor	Open Lens This Many Stops	Filter Factor	Open Lens This Many Stops
1	0	12	$3^2/_3$
1.25	$^1/_3$	16	4
1.5	$^2/_3$	20	$4^1/_3$
2	1	24	$4^2/_3$
2.5	$1^1/_3$	32	5
3	$1^2/_3$	40	$5^1/_3$
4	2	50	$5^2/_3$
5	$2^1/_3$	64	6
6	$2^2/_3$	80	$6^1/_3$
8	3	100	$6^2/_3$
10	$3^1/_3$		

If you're using more than one filter over the lens at a time, determine the exposure correction for the combination by multiplying the filter factors of the filters or by adding the f-stop increases. For example, if you're using a No. 25 red filter (filter factor 8, f-stop increase 3) plus a polarizer (filter factor 2.5, f-stop increase $1^1/_3$), multiply the filter factors ($8 \times 2.5 = 20$) or add the f-stop increases ($3 + 1^1/_3 = 4^1/_3$ stops). To maintain sharpness (and to avoid vignetting), don't use more than two filters at a time.

	Filter Factor	f-Stop Increase
Filter #1	8	3
Filter #2	×2.5	+ 1$\frac{1}{3}$
	20	4$\frac{1}{3}$

If you have a filter that's not listed in the table and you want to learn its filter factor, here's a good way to determine it. Get a packet of Kodak gray cards from your local camera shop. With no filter over the lens, meter one of the gray cards and expose a frame of it accordingly. Put the filter over the lens and expose additional frames of the gray card in $\frac{1}{2}$-stop increments, starting with the original metered exposure and ending with three or four additional stops of exposure.

Once the film has been processed, take the unfiltered frame and find the filtered frame that matches it in density. The number of stops of increased exposure given to the matching frame is the amount of correction to use for future shooting with that filter.

Color Balance

One reason colored filters are used in color photography is to correct for color differences between light sources and the film's color balance. There are two basic types of color film: color-slide film and color-print film. Color-print film can be color-corrected when prints are made from the negatives, so it comes in only one variety for amateur still-camera use. With color-slide films, the slide is the end result; there is no printing process in which to correct incorrect color rendition. So, there are two varieties of color-slide film: daylight-balanced ("outdoor") and tungsten-balanced ("indoor").

Color Filters for Color Photography

If Your Film Is Balanced for	And You Want to Expose It By	Use This Filter or Equivalent	Or Your Photos Will Be Too
Daylight	3200 K light	No. 80A	Orange
Daylight	3400 K light	No. 80B	Orange
3200 K light	Daylight	No. 85B	Blue

continues

Color Filters for Color Photography (continued)

If Your Film Is Balanced for	And You Want to Expose It By	Use This Filter or Equivalent	Or Your Photos Will Be Too
3200 K light	3400 K light	No. 81A	Blue
3400 K light	Daylight	No. 85	Blue
3400 K light	3200 K light	No. 82A	Orange

Daylight (a mixture of yellow light from the sun and blue light from the sky) is bluer than tungsten or photoflood light. Thus, if you use a film balanced for indoor light outdoors, your pictures will be too blue unless you use the appropriate filter to compensate for the difference in lighting color. Likewise, if you shoot daylight-balanced film indoors, your photos will look too orange unless you use the appropriate filter. The preceding table shows you which corrective filters to use when shooting with various film and lighting combinations.

No film is balanced for fluorescent lighting, which emits a strange light spectrum. By using a special fluorescent-light filter (offered by several manufacturers in both daylight-film and tungsten-film versions, generally designated FLD and FLB, respectively) over the camera lens, you can greatly improve color photographs made by fluorescent light, but don't expect perfect color rendition. Fujicolor Reala and most higher-speed color-print films produce better results under fluorescent lighting than other color films.

Hot Tip

It's best to work with a film balanced for the light source being used for three reasons. First, the color will be better if you do, even if you use corrective filtration with the mismatched film. Second, the filters block some of the light, making focusing more difficult and requiring increased exposure. This is a disadvantage particularly when using daylight film in dim indoor lighting. Third, for maximum image quality, it's always better to shoot without anything between the subject and the camera lens.

For those who are interested, the reason a filter can't fully correct for fluorescent light is that various portions of the spectrum are virtually absent from the fluorescent

lamp's output, and a colored filter can't add color; it can only take it away. A red filter doesn't add red to a scene; it subtracts (absorbs) all the other colors. If a fluorescent-light tube emits virtually no red light, a red filter can't add it; it can only reduce the amount of green and blue.

Fine-Tuning Color With CC Filters

Color-compensating (CC) filters are handy for fine-tuning color balance when precise color rendition is critical. CC filters come in the three additive primary colors (red, green, and blue) and their complementary colors (cyan, magenta, and yellow), and in several densities.

If you must make very long or very short exposures (as in tungsten-lit studio work at small apertures or when using automatic electronic-flash units at close flash-to-subject distances), reciprocity failure can cause a color shift with color film. If you shoot a test roll of the same film-emulsion batch as the rolls you'll be using for the actual shoot, you can determine what color corrections are needed to produce perfect color balance under those particular shooting conditions and use appropriate CC filters to make the corrections. Another good use for CC filters is to remove the cyan cast caused by shooting through cyan-tinted windows often found in trains or airplanes (use a CC30R red filter).

Mixed Light Sources

Shooting under mixed lighting conditions—for example, a room interior lit by tungsten lamps, fluorescent overhead lights, and daylight coming through the windows—and getting proper color in your pictures is quite a challenge because each light source adds its own color cast to the scene. But there are a few things you can do. You can turn off the fluorescent lights, put amber filter material over the windows, and shoot tungsten-balanced film (that's what professional cinematographers do). You can hide electronic flash units (which are daylight-balanced) in the room-lamp shades, let the daylight come in through the windows, and shoot daylight-balanced film. Or, as is the case with fluorescent lighting, you can shoot Fujicolor Reala or one of the high-speed, color-print films, which seem to handle mixed lighting better than other film types. (Of course, if precise color rendition is not essential, you can just shoot the scene as you find it—you can get some interesting images that way.)

Polarizing Filters

While a red filter works great in black-and-white photography when you want to darken a blue sky, you can't use it for that purpose in color work, or your photograph will have a red cast. But there is a filter that will do the trick: the polarizer.

"Normal," nonpolarized light waves vibrate in all directions perpendicular to their line of travel. If a light ray hits a nonmetallic surface, the vibrations in only one plane are reflected completely—the reflected light is "polarized."

A polarizing filter polarizes light—it permits the vibrations in only one plane to pass, blocking the vibrations in all other directions. If a polarized light ray strikes a polarizing filter, three things can happen. If the polarized light is vibrating in the plane that the filter lets pass, it will pass through the filter. If the polarized light is vibrating perpendicular to the plane the filter lets pass, the polarized light ray will be blocked by the filter. If the polarized light ray is vibrating at an angle to the plane the filter lets pass, a portion of the ray will pass through the filter.

CAUTION

Watch Out! _____

With some 35mm SLR cameras, the built-in through-the-lens metering system will automatically compensate for the polarizer, but most of today's SLRs use metering (and autofocusing) systems that polarize light, and thus won't work properly with standard linear polarizing filters. With these cameras, you must use a special circular polarizer. Refer to your camera's instruction manual; if still in doubt, meter without the polarizing filter and then use the filter-factor method to calculate the exposure.

A lot of light from the sky is polarized when it is reflected by dust and water particles in the air, so you can use a polarizing filter on the camera lens to block some of the polarized light, thus darkening the sky in the resulting photograph. You'll get the maximum darkening effect when shooting with the sun to one side; you won't get any darkening when shooting directly toward or away from the sun. Just rotate the polarizer in its mount until you see the desired effect, then shoot.

Polarized light from the sky and reflections from water reduce contrast and give a scene an overall hazy appearance. By blocking some of this polarized light, a polarizer cuts through some of this haze and improves scenic contrast.

The polarizer is also handy for eliminating unwanted reflections from nonmetallic surfaces (a polarizer can't eliminate reflections from metallic surfaces, because these

reflections are not polarized). If you see a reflection and want to get rid of it, just put the polarizer on the lens and rotate it until the reflection is gone. (If you aren't using a single-lens reflex camera, which permits you to view through the lens, examine the scene through the polarizer from camera position, rotate the filter until you see the effect you want, and then attach the filter to the camera lens in the same relative orientation.)

The polarizer has a filter factor of 2.5 (increase exposure by $1^1/_3$ stops when using it), and this applies no matter how the filter is oriented (that is, whether or not it is eliminating reflections).

Neutral-Density Filters

Neutral-density (ND) filters reduce the amount of light entering the lens without otherwise affecting it. They are useful when longer exposure times or wider lens apertures are needed, as well as for reducing light in precise increments for film-speed testing.

Kodak Wratten gelatin neutral-density filters come in the widest range of densities—from 0.10 to 4.00, in 0.10 increments at the lower densities, each .10 reducing the light by $1/_3$ stop (so an ND 0.60 filter reduces the light by two stops, for example). Some manufacturers designate their neutral-density filters by filter factor: 2×, 4×, and so on. The following table correlates the two designation systems for you.

Neutral-Density Filters

Filter	Density	f-Stop Decrease
1.25×	0.10	$^1/_3$
1.5×	0.20	$^2/_3$
2×	0.30	1
2.5×	0.40	$1^1/_3$
3×	0.50	$1^2/_3$
4×	0.60	2
5×	0.70	$2^1/_3$
6×	0.80	$2^2/_3$
8×	0.90	3

continues

Neutral-Density Filters (continued)

Filter	Density	f-Stop Decrease
10×	1.00	3$\frac{1}{3}$
100×	2.00	6$\frac{2}{3}$
1,000×	3.00	10
10,000×	4.00	13$\frac{1}{3}$

Graduated Filters

One of the most useful filters for scenic photographers is the graduated ND, which is half neutral density (one, two, or three stops' worth) that gradually fades to clear near the middle of the filter. Such filters are ideal for scenes in which the sky is much brighter than the foreground landscape—just position the filter over the lens so that the ND portion covers the sky and the clear portion lets all the light from the foreground through. You will cut the excess contrast down to something the film latitude can handle, so you'll get detail in both the dark foreground and the bright sky.

Many filter manufacturers make color-graduated filters. Like their neutral-density counterparts, they come in several densities (usually one- and two-stop densities). Colors vary from realistic tones (sunset, blues, and pinks) to gaudy special-effect colors.

Most photographers use graduated filters to darken the bright sky in relation to a dark landscape, making it possible for the film to handle the contrast between the two. However, two filters, one upside-down, can be used successfully in some cases. The classic example of this is a sunset over the ocean, when a graduated tobacco filter (color on top) adds color to the sky, and a graduated blue (color on bottom) adds vibrancy to the blue water.

Types of Filters

Filters come in several forms: gelatin film, gelatin laminated in glass, glass laminated with dyed adhesive, glass, and high-tech plastic. Gelatin filters offer precise coloration and (when new and clean) excellent optical properties, and they can be cut to any size or shape desired. On the minus side, gels damage easily and are difficult to clean once soiled. If you handle them carefully, though, they'll do their job well. Kodak Wratten

gels are used extensively by advertising photographers and in the professional motion picture industry.

Laminated filters are more resistant to damage than gels and can be cleaned repeatedly. Their drawbacks are that they're more expensive and cheap ones can, in time, delaminate. Tiffen laminated filters, like Kodak gels, are long-lasting and widely used by professional cinematographers, and you can't get a better recommendation than that.

Solid glass filters are relatively immune to the problems that shorten the lives of the filter types just mentioned—everyday handling, age, temperature, and humidity extremes—but are more difficult to color precisely. Some manufacturers, such as B + W, do it very well. Glass filters can be thinner and lighter than laminated filters. Antireflection coatings similar to those used on lenses help maintain image quality with the better filters.

Space-age acrylic (plastic) filters are more susceptible to damage than glass filters but are more durable than gels and generally less costly, and their optical and color properties are quite good. Cokin offers a wide variety of good acrylic filters.

Each type of filter attaches to the lens in its own way. Gelatin filters can be held in front of the lens in a pinch, but a better method is to use a gel-filter frame and a filter-frame holder. The filter gel slips into the filter-frame insert, and the frame drops into the frame holder. The filter holder is attached to the lens with an adapter ring.

Screw-in glass filters simply screw into threads on the front of the lens. This is very convenient but limits flexibility with graduated filters; the graduated area always goes across the middle of the image.

If you have several lenses and they take different filter sizes, get filters that fit the largest lens, then use step-down rings to attach them to the smaller-diameter lenses. The step-down ring screws into the camera lens; the large filter screws into the ring.

If you have to use a filter that's too small to screw into the lens, use a step-up ring to attach it. The step-up ring screws into the lens, and the smaller filter screws into it. Note: Using a smaller filter can cause vignetting (darkening of the corners of the image). You can see this in the viewfinder of an SLR camera (use the depth-of-field preview to check for vignetting).

Modular filter systems like the Cokin filters consist of a filter holder, a series of different-sized adapter rings to attach the holder to various-diameter lenses, and a wide variety of filters. The appropriate adapter ring screws into the camera lens, and

the filter holder attaches to the ring. Then you just insert the desired filter into the holder. Some holders can hold two or three filters simultaneously (but it's not a good idea to use more than one at a time, or image quality can suffer).

Taking Care of Your Filters

Photo filters will last a lifetime—theirs, not yours. All colored filters will fade in time because the dyes that are used to color them are somewhat unstable. The best way to prolong the coming of that time is to be sure that you store them in a cool, dark, dry place in their original packaging when you aren't using them.

Most modular filter systems consist of a filter holder, a series of different-size adapter rings to attach the holder to various-diameter lenses, and a wide variety of rectangular plastic filters that slip into the holder.

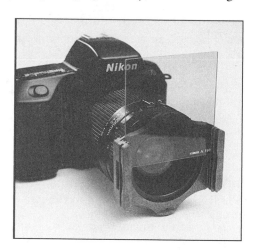

Hot Tip

Filter systems are quite popular because they are economical. By using one filter holder on all your lenses, you can save a bundle by just having to buy one modular filter for each type you use—in comparison to buying separate filters for each different lens diameter in your optic arsenal.

Handle filters only by their edges. Gels can be handled by their corners, preferably using the tissue paper that comes in their packaging.

Treat your filters just as carefully as you do your lenses—after all, they're all important parts of your camera's optical system. To clean glass and plastic filters, first blow off dust particles with a can of compressed air or a soft camel's-hair brush, then apply lens cleaner with lens-cleaning tissue. It's best not to try to clean gel filters with tissue and fluid—if the smudges and dust won't brush or blow off, replace the filter.

The Least You Need to Know

◆ Filters can make your pictures better.

◆ Filters can also make your pictures worse.

◆ Colored filters can do wonders for black-and-white pictures, too.

◆ Colorless filters do lots of amazing things.

◆ There are several types of filters.

◆ Treat your filters as you do your lenses.

Part 3

How to Make Better Photos With Any Camera, Right Now

People shoot billions of photographs every year. Most of them are not so terrific.

Why do bad photos happen to good people? Because people take "point-and-shoot" too literally. Today's point-and-shoot cameras and color-print films give you an amazingly high percentage of sharp, well-exposed pictures. But even with all their amazing technology, they can't decide where to point, and they don't decide when to press the shutter button. That's where you come in.

You don't need a fancy camera to take good pictures. Those wonderful pictures in the ads for point-and-shoot cameras were indeed shot with those point-and-shoot cameras. But they were almost always shot by professional photographers. You can bet those pros didn't just mindlessly point-and-shoot those pictures. They thought about a lot of things before pushing the button. If you think about those same things before you push the button, you'll get better pictures, too. In this part of the book, I'll let you in on some secrets: what pro photographers think about when they're shooting and how they see.

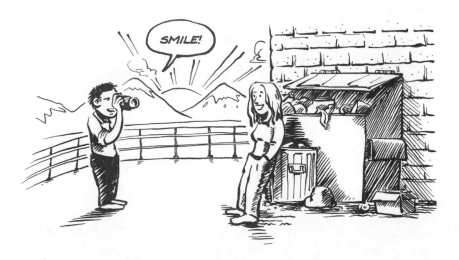

Chapter 13

The Secret Is in the Seeing

In This Chapter

- The use of off-center framing
- A sense of direction
- About that horizon line
- Panorama mode isn't just for scenics
- It's okay to move the camera
- Putting it all together

This chapter will help you make your photos more interesting. Knowing how to work your camera is important because if you don't know how, you can't take pictures. But knowing how to work your camera won't make your pictures good. What you're about to learn in this chapter can.

In this chapter, I'll show you some things that serious photographers think about when they shoot. Thinking about them when you shoot can improve your photos. It's that simple. You don't have to be a natural-born artist. There's a lot you can do to make your photographs more interesting, and the tips in this chapter should help you do just that.

But don't think of these tips as commandments or a series of steps you must always follow. They're just ideas to help you make better pictures.

As you shoot and study more pictures, thinking about what you see in the viewfinder and what you see in the final photograph, you'll develop a feel for composition, and your own photographic style will begin to emerge.

The Magic of Seeing

My first photographic hero, Ansel Adams, told us in the August 1980 issue of *PHOTOgraphic Magazine* that he considered three things when asked to judge photographs:

♦ What the photographer saw

♦ How he or she saw it

♦ How he or she recorded it

You do need some equipment (any camera will do), and you have to know how to use it; otherwise, you won't be able to effectively record what you see. But the art of photography is in the seeing.

Hot Tip _____

There's always something neat to shoot. You just have to learn to see it. This chapter will help!

To create photographs that are more than just snapshots, you should think about three things: your subject, how you frame it with the camera, and the lighting. Chapter 15 covers lighting, and what you choose to shoot is up to you. This chapter shows you some things to think about when you point your camera.

Have you ever wondered why the great photographers could make magnificent photographs of stair railings, barn doors, and bell peppers, while you sometimes can't seem to find anything worth shooting? Here's a hint: Look for lighting instead of things to shoot. Look for the interplay of light and shadow. Look for shapes and forms. Look for color, for contrast, for texture, for lines, for patterns. Look. There's always something neat to shoot; you just have to learn to see it. This chapter and the next will help.

One more thought: As mentioned in the introduction, don't forget that you do photography because it's fun. Going out and looking and discovering and figuring out how to record your vision are the point. Sure, it's great to come back with great images, but photography is not just a means to an end; it's also an end in itself. Enjoy it!

Now let's see what we can do to help you see like a photographer!

Missing the Bull's-Eye Can Be a Good Thing

Because the focusing target in the camera's viewfinder is located right in the middle, people tend to compose their pictures with the subject right in the middle. This isn't always a bad thing. With some subjects (symmetrical ones, for example), centered can be effective. But putting every subject dead-center is a sign of a lack of imagination, and you'll wind up with a collection of boring pictures.

For variety, try putting the subject anywhere but dead-center after you've focused on it.

Some subjects "work" dead-centered in the frame—symmetrical ones, for example. But always putting every subject dead-center makes for a boring photo album.

(Renee Chodor)

After you focus on your subject, try framing it off-center and see how it looks. If you're not sure which looks better, shoot it both ways, and then look at your prints.

The Rule of Thirds

The most commonly doled-out compositional advice is the rule of thirds. This rule (which is just something to think about, not a commandment) tells you to divide the picture into thirds vertically with two horizontal lines and horizontally with two vertical lines. Position your subject at one of the intersections created by the four lines. (No, you don't physically pick up your subject and move it—you aim the camera so that the subject appears at the desired position in the viewfinder.)

Here, the racing car is positioned at the lower-left rule-of-thirds intersection. This position works well with the rest of the things in the picture, providing a pleasant balance. Had the car been positioned at the lower-right intersection, it would have been facing into the picture instead of out of it, but there was nothing visually interesting going on in the scene to the left of the car.

Viewfinder Awareness

Have you ever gotten your pictures back from the photofinisher only to be unpleasantly surprised by things that weren't there when you shot them, such as a telephone pole "growing out of the subject's head," spotty lighting, or a crooked collar? Obviously, those things were there when you shot the pictures. You just didn't see them. Most of us become so absorbed in our subjects that we don't notice what's going on elsewhere in the viewfinder. We take these "accidental" pictures because we don't see what is in our viewfinders.

Watch Out!

A single subject positioned on one side of the photo can be effective, but it can also result in a picture with a lopsided feel. It's often better to include a secondary subject to balance the main one.

We generally see what we want to see, what we are looking for. Our attention is thus limited to certain

things, causing us to miss other things. The camera, of course, records everything it sees, whether we see it or not. One important part of learning to make better pictures is learning to see what the camera sees.

We concentrate. The camera sees everything. We can make the camera concentrate, through the choice of lens focal length, aperture, selective focus, exposure, and lighting, but first we have to be able to see what the camera sees.

You can learn to see what the camera sees. Once you've positioned your subject, carefully examine the rest of the image area—the foreground, the background, the edges, and secondary subjects. If you see a telephone pole growing out of your subject's head (or a distracting element anywhere in the scene), move the subject or the camera. If the lighting looks bad, move the light source or the subject. If the subject has a crooked collar, straighten it.

Practice studying everything that appears in your viewfinder because what's there will be in your photograph—whether you noticed it or not. Soon, seeing what is in the viewfinder will become second nature to you, and unpleasant surprises in your pictures will be a thing of the past. (You won't have much time to examine everything when shooting candid people pictures and action shots, but you'll be surprised at how much you can notice quickly with practice. Any problems you can correct before shooting will result in better pictures.)

Hot Tip _____

Practice makes perfect—or at least better. One of the best ways to improve your photographic eye is to look through the viewfinder and practice studying everything you see there. Don't just pay attention to your main subject—notice all the things in the periphery and the background. They'll end up in the picture, too, so you should start learning to be aware of their presence and how they will affect the overall look of your picture.

Simplicity

One effective way to draw the viewer's attention to your subject is to shoot it against a simple background. If the subject is the only thing in the picture to look at, the viewer will look at it.

Form vs. Function

One of our biggest problems creatively, especially with familiar subjects, is that we see what we expect to see, instead of what is there. If all we note when we look at a clock is the hour, we aren't likely to produce a creative photograph of the clock.

We see function, not form. When we look at a cookie, for example, we see something to eat, not a design. The camera doesn't know about function; it only sees form.

Look at each subject not for its function, but for shapes and forms: the way light hits it and creates highlights and shadows, the fine details, contrast, color, and the subject's relationship with other things in the field of view.

One way to get away from our literal-mindedness is to look at a familiar subject from a different angle. Seen from directly below, this power-line tower becomes a geometric study in lines.

A Sense of Direction

Pictures of moving subjects are generally more effective if you leave a little space in the picture in front of the subject for it to move into.

Since action often happens too fast for you to be able to study composition while shooting, check out your background beforehand. If there are distractions, find another camera position that will provide a better background.

Tripods: The Serious Shooter's Best Friend

Ansel Adams once described the 35mm camera as "an extension of the eye as used freely in the hand." And its hand-holdability is high on the 35mm camera's list of advantages over larger-format cameras. But even the 35mm camera (and the APS camera, too, for that matter) can sometimes benefit from being attached to a tripod.

The tripod can be your best friend because it locks in your composition so you can study all the elements and maintains your composition so you won't accidentally move the camera before you shoot. The tripod also holds the camera firmly in place during exposure to eliminate blurred images due to camera shake.

Where Should I Put That Horizon?

A common problem in landscape photos is where to put the horizon. Generally, the subject will tell you. If the most interesting area of the picture is the sky, place the horizon low in the frame to show a large area of sky. If the sky is dull and the foreground is interesting, place the horizon high in the picture. Most composition gurus will tell you that putting the horizon in the middle of the frame is bad, but if the sky and the ground are of equal importance, the middle might be the best place for the horizon line. It doesn't take a lot of effort to tilt the camera up and down a bit and see where the horizon line works best.

Hot Tip

Many 35mm point-and-shoot cameras and all APS cameras provide a panoramic-format mode that crops a long, thin image out of the normal full-frame area. This mode is a natural for wide scenic vistas, but you needn't limit yourself only to horizontal landscapes.

The Classic S-Curve

That old stand-by, the S-curve, is a useful compositional tool when it seems natural. An S-curve lends a feeling of elegance and grace to a picture, according to our tradition (begun by the English painter William Hogarth back in the 1700s, who termed the S-curve the "line of beauty"). You can find S-curves in rivers, roadracing courses, sand dunes and their shadows, and cloud formations—think about that when photographing these subjects. Any compositional concept is bad when it appears forced. That's why they are tools—you can use them when they help and ignore them when they don't.

That old compositional device, the S-curve, can be a useful compositional tool, as in this aerial photo of an aqueduct cutting through snowy terrain.

It's Okay to Move the Camera

One thing that identifies a picture as a snapshot right away is its point of view: shot from eye-level and from too far away.

Watch Out!

Don't be afraid to move the camera. While you don't have to be experimental in every shot you take, try varying the level from which you take the shot and the position of the camera (vertical vs. horizontal vs. diagonal).

It's all right to move the camera! You can rotate it to take vertical-format images when that suits the subject. Portraits generally work best in the vertical format, as do pictures of tall buildings and giraffes.

Diagonal compositions create a dynamic, somewhat unsettling effect. Sometimes, this can be a good thing. Other times, not. How can you tell? You guessed it: Tilt the camera to a diagonal and see.

A corner of a brick building becomes an interesting pattern when photographed at a diagonal and lit from the side by afternoon sunlight.

Higher and Lower, or Unusual Angles

Snapshooters shoot everything from their own eye level. In many cases, you can make much more interesting pictures if you shoot them from higher or lower than that.

What determines whether you should shoot from higher or lower? Your call. Shooting down on a person or animal tends to diminish its importance, while shooting up at a subject from a low angle tends to make it seem more impressive. Shooting familiar scenes and subjects from above or below provides a new slant. Photograph children and pets from their eye level for more intimate images. Any camera height but human eye level adds interest to your images because it shows them differently than how we normally see them.

The photographer brings the viewer into this cute kitty picture by dropping down to their eye level and moving in close.

(Leslie Soultanian)

Framed!

Many people have their prints framed for display. But you can also "frame" your subject when you shoot the picture. Using foreground objects to frame a subject can add interest and depth to your picture. You can use the framing objects to hide distracting elements in a scene. And next time you're shooting one more sunset or ocean view, you can use framing—like a flowering tree branch—to make these familiar settings more appealing.

When framing a subject, be sure to stop the lens down to increase depth of field—out-of-focus foreground objects generally look like mistakes. With a point-and-shoot camera, you can't adjust the aperture, but if you use a fast film, that will make the camera stop the lens down and increase the depth of field.

Timing Is Everything

The great photojournalist Henri Cartier-Bresson was known for his remarkably poignant photos and for coining the phrase *decisive moment*. His photos often captured just the right instant, the moment that best encapsulated the scene or action being photographed.

You're not likely to be doing serious photojournalism, but you will be recording family events—parties, weddings, junior's football game, daughter's dance recital,

and the like. The right timing helps in these photos, too. Timing is also critical in action shots.

How do you develop a good sense of timing? Practice, practice, practice! Learn all you can about what you'll be photographing beforehand. If you're going to photograph junior's baseball game, learn about the game and where action is likely to occur. If you're going to photograph a wedding, think about the kinds of pictures you're going to want (or that your friends who are involved are going to want). For example, when the bride and bridegroom feed each other the first slices of the wedding cake, you want to catch that. Be in an appropriate position, film in the camera and flash ready. You'll get more details on how to photograph specific subjects in Part 4, but the point is, learn all you can about what you'll be shooting and think about where you'll want to be to catch the action. Then you'll be ready when those decisive moments happen.

Whazzat Mean?

The **decisive moment** is the moment that reveals the essence of what is happening.

Putting It All Together

As you start to become aware of what actually appears in the viewfinder and think about the things you've learned in this chapter, you'll start to see pictures before you bring the camera up to your eye. That's when photography becomes exciting.

Making It Happen

Most of this chapter has been concerned with learning to see picture possibilities in "found" scenes. It's okay to set up a shot, too. If you find a scene that's interesting but lacks something, it's okay to add that something for artistic purposes. (An exception to this is when shooting a "natural" photo—it's all right to set up a shot to create art, but not if you try to pass it off as having occurred naturally. One famous scientific journal received a lot of flak a few years ago when it digitally moved one of the Great Pyramids to make a shot fit on the cover. Artistically, that's fine, but it shouldn't have been passed off as a straight photo.)

The best photographs aren't just correctly focused, properly exposed, and well-composed. They also evoke an emotional response in the viewer. If you have to add something to the scene to do this—a model (a friend will do), or the ethereal effect of infrared or very grainy film—do it. Creative photographers do.

I saw this man impatiently awaiting a New York City subway train and liked the perspective of the lines.

When photographing action, shoot lots of pictures, but watch for opportune moments, such as this one, when the three skydivers were all separated.

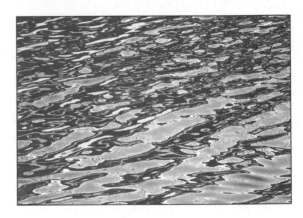

Abstract patterns make great photo themes. Wonderful patterns occur in puddles, wet streets at night, and many watery surfaces. This one was spotted in an ocean inlet near a pier.

Divide the image area into quarters and place your subject in one of the segments, rather than dead-center, and you'll often get a better picture. Here, the colorful leaf nicely balances the dark bird.

(Mike Stensvold)

One great way to get some unique landscape photos is to shoot from a light airplane (or a helicopter, if you have a large budget!). I photographed this pattern in farm fields by banking the plane so I could shoot straight down.

(Mike Stensvold)

Look for new ways to treat everyday subjects. Here, I shot up at the cable from a ski-lift chair, just as the mechanism blocked the sun.

(Mike Stensvold)

Simplify, simplify! This simple, pleasant composition is just a slice of sky between two buildings. Keep an eye out for such simple, graphic arrangements—they're all around us.

(Mike Stensvold)

A slow shutter speed will blur a moving subject, while a shorter shutter speed will "freeze" its motion.

(Mike Stensvold)

Try to catch your live subjects doing something, rather than just standing around. It's difficult to check the background while tracking a moving subject, but you can check for distractions before the subject arrives, and adjust your camera angle to eliminate them.

(Mike Stensvold)

You don't have to shoot all your portraits in the vertical format. For variety, try some horizontal-format portraits, too. And you don't have to dead-center your portrait subject, either.

(Mike Stensvold)

A zoom lens provides a whole range of focal lengths in a single package. These two images were shot from the same spot, just by zooming the lens from its shortest focal length to its longest.

(Mike Stensvold)

Soft light from a thin overcast works well for flower shots.

(Mike Stensvold)

You'll get the prettiest, most dramatic landscapes by shooting early or late in the day when the low-angle sunlight creates long shadows that bring out the scene's texture. For maximum texture, shoot with the sun to one side so that its light shines across the subject. This image was shot with an APS camera in H (full-frame) format.

(Mike Stensvold)

When shooting landscapes, include a person for interest and scale. Shoot the scene with and without the person, and you'll have two good shots.

(Lynne Eodice)

I rarely carry my "serious" AF 35mm SLR when hiking for exercise, but I usually take a small "pocket" camera just in case I come across a nice shot. An inexpensive digital camera recorded this trailside foliage—one of many photos I have that wouldn't exist if I didn't have a "take-anywhere" pocket camera. Look for interesting patterns in nature whenever you're outdoors.

(Mike Stensvold)

Try to photograph flowers and animals from their level, rather than looking down at them from human eye level. The results will let the viewer see these subjects from a new perspective.

(Mike Stensvold)

Sunrises and sunsets make beautiful subject matter.

(Mike Stensvold)

Two ways to deal with big buildings: Tilting the camera up at a sharp angle from the base of a high-rise produces a study in converging verticals (left). Zeroing in on a small portion of two skyscrapers from afar with a long lens produces a different pattern effect (right). The lit building against the shaded building adds contrast and interest to the picture.

Light and shadow can be the subject of your picture or can be used to "shape" a subject into something more interesting.

The Least You Need to Know

◆ Your picture will be better if you think about what you see in the viewfinder before you shoot.

◆ If the background is distracting, move the camera or subject so you have a better background.

◆ Look for lighting, and the interplay of light and shadow.

◆ Don't shoot every picture with the subject dead-center.

◆ Examine the subject from a variety of angles—low, high, to the side.

Does the Camera See What I See?

In This Chapter

- ◆ Shutter-speed effects
- ◆ Depth of field
- ◆ A different point of view
- ◆ Odd eyes
- ◆ Exposure effects
- ◆ Multiple exposures

The camera can see things in ways we can't. Some people find this annoying because it means their pictures don't always come out the way they expect. But to the photographer who understands why the camera sees differently, it opens up a whole world of photographic possibilities. The camera can show us things we can't see. And that's pretty neat!

Chapter 21 is all about fun tricks you can use to produce unusual pictures. But many special effects are based on the fact that the camera can see differently than we do. So this chapter is really about special effects, too.

The camera can see differently than we do because we can change the shutter speed, the lens aperture, the exposure, and the lens. We can do these things directly with an AF 35mm SLR camera. With a point-and-shoot camera, we have to be a little devious and trick the camera into doing what we want. Let's see how we can take advantage of the camera's ability to see things in ways we can't.

As Time Goes By, in the Blink of an Eye

Scientists tell us that the human eye sees at a "shutter speed" of about $1/50$ second. Because the camera's shutter can be set to a wide range of speeds, from much shorter than $1/50$ to much longer, the camera can record things in ways we don't see them. It can freeze motion that's too fast for us to see clearly, and it can blur slower motions that we do see fairly clearly. Fast shutter speeds freeze action in a way the eye cannot. Long exposure times blur motion in a way the eye does not. The farther the shutter speed is from $1/50$, the less the resulting photo will be like what our eyes see.

> **Hot Tip**
>
> While you can't set a specific shutter speed with point-and-shoot cameras, you can make such cameras employ their fastest shutter speeds by shooting with fast (ISO 400 or 800) film in bright light.

All of the AF 35mm SLR cameras currently in production provide top shutter speeds of at least $1/2000$. Most go to at least $1/4000$, quite a few to $1/8000$, and the Minolta Maxxum 9 tops out at an amazing $1/12000$. A shutter speed of $1/2000$ has 40 times the action-stopping power of the human eye; a shutter speed of $1/8000$ has 160 times the eye's action-freezing ability. Even $1/500$—available on some point-and-shoot compact cameras—has 10 times the eye's ability to freeze motion.

This is about how our eyes see this ocean scene—and it's a pretty boring picture.

If we use a fast shutter speed, we can freeze the moving water—a more interesting image because we don't see this subject in this way.

Going the other way, we can use a slow shutter speed to blur the moving water (with the camera mounted on a tripod to hold it steady so the stationary portions of the scene aren't blurred by camera movement)—another more interesting rendition of the scene.

Freezing Motion with Flash

You can really freeze motion with an automatic electronic flash unit used at close range. Dedicated shoe-mount flash units, used at close range, produce exposure times of $1/20000$ second or shorter—short enough to freeze actions our eyes can't see, such as a balloon bursting, a light bulb breaking, or a drop of milk splashing into a saucer of milk. Just position the flash unit a couple of feet from the subject, and you'll get an action-freezing flash duration. The AF 35mm SLR's TTL flash-exposure system will automatically provide the correct exposure.

The tricky part is to get the flash (and camera) to fire at the right instant. This is all but impossible to do manually, relying on your own reflexes. One solution is a sound trigger, a device that fires the flash when it detects a sound. This is ideal for subjects like shattering light bulbs. There are also electric-eye triggers that fire the camera and flash when a subject breaks an infrared beam. These devices are great for subjects that do not make a distinct sound and remote wildlife photography—the subject takes its own picture when it breaks the infrared beam. The Shutter-Beam from Woods Electronics (phone 760-788-9906; www.woodselec.com) is a sound/infrared trigger that can be set to fire the camera and flash when it detects the sound or movement of a subject.

Long Time, Go See!

At the other end of the shutter-speed spectrum, all of the current AF 35mm SLRs make timed exposures as long as 30 seconds, providing 1,500 times the motion-blurring ability of the eye. Many point-and-shoot cameras make exposures of one second or longer, providing at least 50 times the motion-blurring ability of the eye. You can use a neutral-density filter to reduce the amount of light entering the lens if you wish to use a long exposure time in bright lighting. To make a point-and-shoot camera employ a long shutter speed, use slow film, turn off the built-in flash, and shoot in dim light.

The effects of different shutter speeds depend on the speed and direction of the subject and the subject's distance from the camera. It's a good idea to shoot several frames, each at a different shutter speed, to learn which shutter speeds work best with each type of subject (use shutter-priority AE if your camera has this mode). Keep in mind that the farther the exposure time is from the eye's $1/50$, the more pronounced the motion-freezing or -blurring effect. Also keep in mind that the idea is to produce a good photo—the most extreme effect isn't necessarily the best. You can even combine a very short exposure and a long one in the same picture to create an effect the eye can't see. By combining a long existing-light exposure with a brief electronic flash exposure, you can get a sharp image of a nearby moving subject plus motion blur in a single shot.

Set up your subject in a dimly lit room and set the camera for slow-sync mode. Start the subject in motion and press the shutter button. The flash will fire, freezing the subject in mid-motion, and the long exposure for the existing light will record a ghostly blur as the subject moves. If your camera doesn't have a slow-sync mode, use shutter-priority AE mode and set a two-second exposure time.

Really Long Exposures

As pointed out in Chapter 1, the word "photography" literally translates as "writing or drawing with light." You can put this literal translation into (special) effect by mounting your camera on a tripod and opening the shutter in a darkened room (or outdoors at night away from any lights), and then using a light source to "draw" images on the film.

One excellent and inexpensive light source for light-drawings is a simple *penlight*. Mount the camera on a tripod, position the person with the penlight in the frame, darken the room, open the camera shutter on B or T (or a set shutter speed that's long enough to allow the drawing to be completed), and have the person point the penlight at the camera and trace out a pattern. The person doing the drawing should wear dark clothes and avoid pointing the penlight at herself, so she doesn't appear in the picture.

Whazzat Mean?

A **penlight** is a pen-sized, pen-shaped flashlight with a tiny bulb at the front.

You can suspend a penlight from the ceiling using a 2 to 3-foot length of string, position the camera below, swing the penlight, and open the shutter (try 30 seconds at f/5.6 with ISO 100 film).

Many cameras have a B (bulb) setting or mode, in which the shutter remains open as long as you keep the shutter button depressed (for really long exposures, it's convenient to do this using a locking cable release, rather than by holding the button down

with your finger). A few cameras provide a T (time) mode, in which the shutter opens the first time you push the shutter button, and remains open until you press the shutter button a second time, thus doing away with the need for the locking cable release.

These long-exposure modes let you produce a variety of neat drawing-with-light effects. Many AF 35mm SLR cameras make timed exposures of up to 30 seconds, which is long enough to produce many of these effects.

Another way to capture motion and sharpness in a single shot is to make a long exposure of a scene that contains moving and still subjects, such as freeway traffic at night, using a tripod-mounted camera. The resulting picture will show headlight and taillight streaks, while the stationary portions of the scene remain sharp.

You can make vehicular or pedestrian traffic magically disappear from a daylight picture by mounting the camera on a tripod and making a long exposure. Time how long it takes the people or vehicles to move across the image area and use that as your exposure time. The moving cars and people will not appear in the picture because their images won't be in any one place on the film long enough to record there.

A long exposure with a tripod-mounted camera blurred the moving subjects and sharply recorded the rest of the scene. The subject here was freeway traffic at night.

(Lynne Eodice)

Architectural photographers use this technique to get traffic-free shots of buildings. To use such long exposure times in daylight conditions (you can't use this technique at night because the cars' head- and taillights will appear in the picture as streaks), you'll have to use a slow film and perhaps a neutral-density filter. (See Chapter 12 to learn about neutral-density and other useful filters.) Set the required shutter speed in shutter-priority AE mode and if the camera indicates that overexposure will occur, place a two- or three-stop neutral-density filter over the lens.

Watch Out!

If the cars or people stop moving during your long exposure, they will appear in the picture. If they stop for part of the exposure time, they will appear as ghostly images, which can be an interesting effect.

Depth of Field: A Little or a Lot

As was explained in Chapter 9, the lens aperture controls the depth of field for a picture. Wide apertures (f/1.4 or f/2.8, for example) produce shallow depth of field. Small apertures (f/22 or f/32, for example) produce great depth of field. By varying the point of focus and the depth of field (by way of the lens aperture), you can produce a variety of effects the eye doesn't see.

When we look at a scene, we see everything sharply because our eyes instantly focus wherever we look. By shooting with the lens at its widest aperture, we can make the camera see only the focused subject, while the rest of the image goes completely out of focus. If there's a distracting background or foreground in your scene, you can throw it out of focus by focusing on the nearby subject and shooting with the lens aperture wide open. The longer the lens and the closer the focus point, the more out-of-focus the background and foreground will be.

A wide lens aperture and a long lens isolated this green heron from the distracting background. If you want a huge rising or setting sun in your photo, use a long lens and compose the scene with a nearby foreground subject. Focus on the nearby subject, and the out-of-focus sun in the background will appear much larger than it would with the lens focused at infinity.

When you want everything in the picture sharp, from foreground to background, you can maximize the depth of field by using a wide-angle lens and stopping it down to its smallest aperture. With a point-and-shoot camera, use a fast (ISO 400 or 800) film to make the camera use a small aperture.

Watch Out!

Viewing the sun through a telephoto lens can result in severe eye damage. Point the camera to one side of the sun to focus on the nearby subject, then move the camera to include the sun (hold a white card a few inches behind the viewfinder, and you can see when the sun is in the frame—its image will be projected on the white card).

Do You See What I See?

Sometimes, the camera does see what we see, but we think the pictures look odd because we aren't aware of what we see. Wide-angle distortion and telephoto compression are examples of this. If we move very close to a subject, the perspective will be expanded, and if we move farther away, it will be compressed. But our mind tends to correct these perspective effects so we don't notice them unless we think about them. But when we look at a picture shot from very close to the subject, especially one shot with a wide-angle lens, we notice the expanded perspective right away. Ditto when we look at a picture shot from far away, especially one made with a telephoto lens.

Wide-angle "expansion" exaggerates the size of nearby subjects and expands the apparent distance between near subjects and far ones. To produce the effect, move in close to the subject with a wide-angle lens.

(Ron Leach)

Parallel lines seem to converge as they fade into the distance. To some degree, our brain compensates for this effect because we know lines such as the sides of buildings are indeed parallel. But the camera doesn't have a brain (that's why it needs ours), so we can produce some interesting "special-effect" images by moving close to a subject containing parallel lines and shooting with a wide-angle lens to get the whole subject or scene in the frame. For example, if we stand near the base of a tall building and photograph it with a lens wide enough to get it all in, the sides of the building will seem to converge toward the top. If we shoot a cityscape with the camera pointed up, the buildings at the sides of the image will tilt into the image.

Odd Eyes

While wide-angle expansion and telephoto compression effects are due to the camera-to-subject distance, not to the lens itself, some lenses do produce effects our eyes can't see on their own. Fisheye lenses take in a 180 degree (or greater) angle of view and curve straight lines that don't go through the center of the image. Our eyes don't see like that, so fisheyes can produce some unusual pictures.

Fisheyes come in two varieties—circular and full-frame. Circular fisheyes produce round images, and full-frame fisheyes produce frame-filling rectangular images. Because they fill the frame and curve straight lines, full-frame fisheyes produce especially weird pictures—the circular fisheye tells the viewer right off that a gimmick lens was used, but the full-frame fisheye leaves the viewer wondering a bit uneasily, "What's wrong with this picture?"

Our eyes can't zoom (although our attention can), but you can zoom a zoom lens from its shortest focal length to its longest (or vice versa) during a one- or two-second exposure to create an explosion effect that our eyes can't see. If you wait a beat before zooming, you'll get an identifiable image of the subject plus the zoom streaks; if you zoom immediately, you'll just get streaks. This technique works best with a tripod-mounted camera and a contrasty subject.

Overexposed?

One way you can put the camera's ability to see differently to good use is through exposure variations. Overexpose slide film a bit, and you render a scene in pastels. Underexpose a bit, and you render the scene in rich color. You can even change the overall mood of a picture by changing the exposure. (You can do these things with

print films, too, but you have to tell your photofinisher not to correct the "incorrect" exposures when making prints from the negatives.)

Double Your Pleasure

Accidental double exposures were once the bane of amateur photographers: Many photos were ruined because the photographer forgot to advance the film after a shot and made the next shot on the same frame. So, manufacturers started designing cameras to make this impossible by having the shutter-cocking mechanism also advance the film. But multiple exposures are an effective special-effect technique, and today, many SLR cameras (and some point-and-shoot compacts) have a special multiple-exposure mode that allows you to make more than one exposure on a single frame of film. The multiple-exposure technique can be used to produce a variety of effects that the eye can't see, including montages, see-through images, ghost images, putting the same person in several places in a scene, and "earthquakes." (To produce an "earthquake" effect, make 9 to 32 exposures on the same frame while hand-holding the camera. This is most easily done with a motor-driven camera, and some cameras won't let you make that many exposures on a frame.)

The simplest multiple exposure is the montage—shoot the first image, recock the shutter without advancing the film (use the camera's multiple-exposure mode), and make the second exposure. The trick to this technique is finding two images that work well together. Here, a shot of brush was exposed over a cityscape to add texture.

If your multiple images overlap, the film frame will be overexposed unless you reduce exposure to compensate for the extra exposures. The simplest way to do this is to multiply the ISO speed of the film you're using by the number of overlapping images you intend to make on the film frame, and set your meter's ISO index to this figure

(if your camera allows you to set film speeds manually). For example, if you are going to make 3 exposures on the frame and are using ISO 100 film, 3 times 100 equals 300—set your meter's ISO index to 320 (its closest number to 300). If you're making an "earthquake" image using 32 exposures on the same frame, 32 times 100 equals 3200—set your meter's ISO index to ISO 3200. Remember to reset the film speed back to normal when you're through making the multiple exposures, or you'll under-expose all of your subsequent "normal" single-exposure shots. If the multiple-exposure images don't overlap on the frame, give each image normal exposure (that is, keep your meter set at the normal ISO speed).

Photo Fact

Some cameras offer "double-exposure" capability, while others offer "multiple-exposure" capability. Double-exposure means you can make no more than two exposures on a single frame of film. Multiple-exposure means you can make more than two exposures on a single frame. Some cameras limit you to three to nine exposures in multi-exposure mode, while others let you make as many exposures as you want. From a practical standpoint, two is usually enough—more than that, and the picture gets confusing.

Few digital cameras provide a multiple-exposure mode, but that's okay. If you use a digital camera, it's better to create your multiple-exposure images in the computer, using your image-editing software.

With a point-and-shoot camera or an AF SLR that doesn't let you set film speeds, use the exposure-compensation feature or shoot on color-print film and let the photo-finisher figure out how to print the multiple-exposure negative.

The step-zoom is produced by making three or four exposures on a single frame, each at a different focal-length setting.

Our eyes can't see through objects, but our cameras can, via double exposures. Here, an exposure was made with the plastic body removed from the telephone, then the body was carefully replaced and a second exposure made.

The Least You Need to Know

♦ The camera can see things in ways we can't. We can use this to our photographic advantage.

♦ Long exposures blur motion; short exposures freeze it.

♦ Moving closer expands perspective; moving back compresses it.

♦ Increasing exposure makes the picture lighter; decreasing exposure makes it darker.

♦ Multiple exposures can let us see through subjects.

♦ Fisheye and zoom lenses can show us things we couldn't see otherwise.

Shedding Light on the Subject

In This Chapter

◆ Light and shadow

◆ Hard light and soft light

◆ How much is enough?

◆ What color is white?

◆ Putting it all together

◆ Common photographic light sources

If there's one "secret ingredient" that makes the difference between an interesting photo and a dull one, it's the lighting. Ideally, a photo has an interesting subject and is well-composed and well-lit. But an interesting subject badly composed and poorly lit results in a bad photo, and a well-composed picture of a dull subject poorly lit makes for a bad photo. In other words, good composition or an interesting subject alone won't guarantee good results. On the other hand, interesting lighting can make for an interesting photo even if the subject is dull and the composition is poor.

Lighting is one of my favorite parts of photography. I love going out looking for lighting that makes a subject come alive—even if the subject is just a big rock. Exciting lighting is the secret to consistently interesting pictures. Next time you're out looking for things to photograph, look for lighting instead of things, and your quest will be a lot more successful.

I'll cover the specifics of lighting various types of subjects in the chapters on shooting those subjects in Part 4. This chapter introduces you to light and shows you how it affects your pictures.

Light and Shadow

Several things about light affect every photograph: where the light is coming from, whether it's harsh or soft, how much of it there is, and (in color photography) its color. This is the case whether you're taking advantage of the light that exists at the scene or providing the light yourself. You should think about these things each time you shoot a picture. At first, you'll have to make an effort to do that, but before long, you'll consider the lighting automatically, and your pictures will be better for it.

The most important thing about light in terms of its visible effect on the picture is where it's coming from—where the highlights and shadows fall—because that determines the overall look of the photograph. A subject or scene will look quite different when lit from the front, the side, or behind.

Whazzat Mean?

Lighting directions are specified relative to the subject, rather than to the camera. For example, **front lighting** means the light is falling on the front of the subject (and therefore generally coming from behind the camera). **Backlighting** comes from behind the subject (and therefore in front of the camera).

Front Lighting

New photographers are generally advised to "shoot with the sun behind you" because the frontal lighting (on the subject) thus produced is "safe"—it's bright and shadow-free. Light that comes from in front of the subject produces a flat, shadowless effect—the shadows are cast behind the subject, out of sight. This makes *front lighting* easy to work with, but generally not very exciting. Front lighting is great for passport photos and overall views because nothing is hidden in shadow. But photographers seldom use it for artistic effect because it doesn't show the subject's texture and depth and provides little drama. In other words, direct frontal lighting is pretty dull!

Built-in flash units (and shoe-mount flash units with SLR cameras) produce flat frontal lighting that screams "snapshot" at the viewer. It's that "paparazzi" look you see in all the tabloids. And how many of those photos are attractive? If there's a wall right behind the subject, on-camera flash will cast an unattractive shadow on it. And on-camera flash frequently produces red-eye. The way to resolve all of these problems is to move the flash unit off-camera. Of course, you can't do that with a built-in flash, but many SLRs offer off-camera flash extension cords and even cordless off-camera flash operation (as detailed in Chapter 10). With built-in flash, you can eliminate the wall shadow by moving the subject away from the wall and minimize red-eye by using the camera's red-eye reduction mode, but you're still stuck with the flat, "tabloid" look.

These two pictures were taken moments apart in the late afternoon from a light airplane circling the lakeshore. Note how different the same subject looks in front and backlighting.

On-camera direct flash is also harsh lighting, and we'll get to that in the section "Hard Light and Soft Light."

When the light comes from directly in front of the subject, the result is a flat, shadowless effect that shows the subject clearly but isn't very exciting.

Shadows—"the dark side of light"—make great photo subjects.

Sidelighting Brings Out Texture

Light that comes from one side of the subject is great for emphasizing texture and shape because it produces strong shadows. Outdoors, *sidelighting* occurs when the sun is low in the sky—in early morning and late afternoon—and you are shooting in a northerly or southerly direction. Professional scenic photographers do most of their shooting early or late in the day to take advantage of this dramatic lighting.

It's best to avoid direct sidelighting for portraits because it isn't attractive. It emphasizes the texture of the subject's skin. Light from somewhere between front and sidelighting can be very effective, however.

Whazzat Mean?

Sidelighting occurs when light comes from one side of the subject.

Backlighting

Light coming from behind the subject casts shadows toward the camera, produces a bright edge around the subject, and causes translucent subjects, such as leaves, to seem to glow from within. But it can fool your camera's exposure system. Since the background is generally brighter than the subject with backlit scenes, most cameras will "see" all that brightness and provide too little exposure, turning the subject into a near-silhouette. If you want a properly exposed subject, activate the camera's *backlight* control or (for nearby subjects) fill-flash mode. Or you can use a reflector to "bounce" light from the backlight source onto the subject. If you have an AF 35mm SLR, you can move in close so the subject fills the frame, use the AE lock to lock in the exposure, then move back to your shooting position, recompose, and make the shot. The multisegment metering systems in many of today's AF 35mm SLRs can handle backlighting very well automatically.

CAUTION

Watch Out!

Shooting toward the light source can produce beautiful pictures, but it can also cause flare and silhouetted subjects.

When you shoot in backlighting, you are pointing the camera toward the light source. If direct light strikes the front element of the lens, it can result in a loss of contrast and color due to lens flare. You can minimize flare by using a quality multi-coated lens, keeping it clean, and attaching a lens hood to prevent direct rays from striking the lens's front element. Of course, if the light source actually appears in the picture, a lens hood won't help.

You can minimize flare by attaching a lens hood to keep direct rays from striking the lens's front element.

Top Lighting

Because sunlight generally comes from above, lighting from above (or *top lighting*) looks natural. So you should generally position your light source at some angle above the subject. But light from directly above the subject (or almost directly above), such as noon sunlight, is bad for portraits because the subject's eyes get lost in deep shadows. It's bad for scenic pictures, too, because shadows are short and not dramatic. So lighting from directly above should generally be avoided.

Low Lighting Angles

In nature, light seldom comes from below a subject. Campfires illuminating campers or the setting sun illuminating higher clouds are a couple of rare instances where lighting from below appears natural. Therefore, you shouldn't light your subject from below if a natural appearance is desired in a photograph. For eerie Halloween portraits, such ghoulish lighting can be effective.

Of course, light doesn't have to come from directly in front of, behind, to one side of, above, or below the subject. It can come from somewhere in between. For example, the "classical" studio portrait lighting setup starts with a light above and to one side of the subject (45 degrees above and 45 degrees to one side, varied as needed to tailor the lighting to the particular face). Chapter 16 shows you how to light people attractively.

Main Light and Fill Light

In any lighting setup, outdoors or indoors, the dominant light source—the one that provides the lighting direction—is known as the *main* or *key light*. The main light establishes where the highlights and shadows will be. Sometimes a single light is all you need to produce the desired effect.

More often, though, a second light, known as the *fill light*, is used to direct light into the shadow areas and lighten (fill) them to the desired level. The fill light can be a less powerful or more distant light unit or a reflector that directs light from the main source into the shadow areas. The main light establishes the lighting direction; the fill light establishes the lighting ratio. The lighting ratio is the difference in brightness between the highlight area and the shadow area. Generally, the lighting ratio for a portrait should be relatively low—in the 2:1 to 4:1 range (this is the ratio of the amount of light on the highlighted portion to the light on the shadow portion).

Hot Tip

There should be only one main light in a photo—one lighting direction and one set of shadows. If your fill light is too bright, it might cast a second set of shadows. And that looks bad.

A common fill source for outdoor portraits is an on-camera or built-in flash unit. It will reduce the brightness difference between the sunlit highlights and the black shadow areas— but it won't keep subjects from squinting in the bright sunlight.

(Ron Leach)

Hard Light and Soft Light

Next to its direction, the light's quality, its hardness or softness, has the greatest effect on the look of a photograph. Hard light sources produce dark shadows and harsh highlights. Soft light sources produce weak shadows and muted highlights. The larger the light source relative to the size of the subject, the softer the lighting. Direct sunlight and direct flash are hard sources; skylight and flash bounced off a large umbrella reflector are softer. Some subjects are better lit with hard light, others with soft light. Use the type that will produce the effect you deem right for your image. Soft light is much more forgiving than hard light because the shadows are weak and not so obvious. Especially for people pictures, it's always safer to use soft lighting.

Photo Fact

The sun is really big—some 864,000 miles across. But it is also very far away—about 93 million miles. So its size relative to the size of objects here on Earth is small—about the equivalent of a 1-inch–diameter light source 9 feet from the subject. As my high school chemistry teacher was so fond of saying, everything is relative.

Another good source of soft lighting outdoors is open shade—light from the sky, with direct rays of the sun blocked by a large nearby object, such as a building. The resulting lighting can be quite attractive for portrait subjects. In color, shoot on negative (print) film, and the blue cast can be corrected when prints are made. With slide film, you might want to use a warming filter, such as one of the 81-series.

For indoor portraits, face your subject toward a nearby large window, and you get beautiful soft lighting for portraits. Like skylight, window light is generally bluish (because it generally is skylight, unless direct sun is coming in through the window).

How Much Is Enough?

The quantity of light present has little bearing on the look of the lighting, but it can have a great impact on the photograph through its influence on lens aperture and shutter speed (and film speed required). If there's a lot of light, you can use fast shutter speeds (or your point-and-shoot camera will select them automatically) to minimize blurring due to camera shake or subject movement. Or you (or your automatic camera) can use a small lens aperture to increase the depth of field. Or you can use a slower film, with its finer grain and richer colors. Conversely, if little light is present, you must use faster (grainier) film, slower shutter speeds, and wider apertures.

When it's overcast, grand scenic vistas aren't at their best. But it's a great time to concentrate on close-ups of flowers and small animals. Soft lighting works very well with them.

Direct sunlight is a hard light source because the sun's disk is relatively small compared to the size of the subjects here on earth (left). An overcast layer diffuses the sun's light, turning the whole sky into a large soft light source (right). Which rendition you like is up to you.

Dim light means you have to use a fast film (with its inherently larger grain, reduced sharpness, and less-intense colors), a slower shutter speed (possibly requiring use of a tripod), and/or a wider lens aperture (with its limited depth of field). Here, a tripod was used to hold the camera still during the long exposure required by the dim night lighting.

What Color Is White?

The color of the light doesn't have much effect on today's black-and-white films but obviously can have a big effect on color photos. If the light isn't that for which the film is designed, your color photos will have an undesirable color cast. This is less of a factor with color-print films, which can be color-corrected when prints are made, but it's a big factor with color-slide films.

Color-slide films come in two types: daylight-balanced and tungsten-balanced. To films balanced for daylight, tungsten light looks too red; to films balanced for tungsten light, daylight looks too blue.

Early or late in the day, when the sun is low in the sky, the color of daylight is more orange than at midday. This occurs because the atmosphere scatters the shorter (blue and cyan) wavelengths so that mainly the longer yellow, orange, and red ones come through; the sun's rays must travel through more of the atmosphere when the sun is low in the sky. This warm light can be attractive for some subjects but will throw "proper" color balance off.

While subjects lit by low-angle sunlight take on a warm cast, subjects in the shade take on a cool blue cast because they are lit only by blue light from the sky. The contrast between warm and cool light can make for interesting photographs. However, if the entire subject is in the shade, you might want to place an 81-series warming filter over the camera lens to eliminate the blue cast.

Night scenes are lit by a variety of light sources and can be successfully photographed on daylight or tungsten color films. Daylight films provide a warmer rendering, while tungsten films provide a cooler rendition. And, of course, there's always black-and-white …

Putting It All Together

There are other elements involved in lighting, but you can exercise tremendous control over the look of your photographs merely by considering the direction and quality of the light source(s). This applies whether you are shooting in existing light (in which case your job is to learn to see exactly what's happening lighting-wise to your subject and scene, and move the subject or find another time of day or year when the light is right, if necessary), or in the home studio (in which case your task is to choose the position and quality of the light sources to produce the effect you want).

If you're shooting a scenic subject and don't find the lighting to your liking, come back later and it might be better.

Common Photographic Light Sources

You don't need a studio full of professional lighting equipment to make good use of lighting in your pictures. Sunlight, skylight, and window light are available to everyone, and point-and-shoot cameras and entry-level AF 35mm SLRs come with built-in flash units. And existing light—"whatever happens to be there"—can give you some beautiful lighting for your photos.

The most common light sources used by nonprofessional photographers are sunlight, skylight, built-in flash, accessory flash, window light, tungsten lamps, and existing or available light.

Sunlight

The sun offers several advantages as a photographic light source: It's free, it's bright, it's daylight-balanced, and you don't have to transport it. But it's not perfect: It's not always available, it's harsh (but can be softened by positioning a translucent material between the sun and subject), and it's not always where you want it.

The sun is a free source of bright light, but you can't put it where you want it. You either have to turn your subject so the light falls on it as you want it to, or (in the case of scenery, which you can't move) wait for the sun to move into an appropriate position.

Skylight

Skylight is free and soft, and you don't have to transport it, but it's not always available, and it's bluish. A thinly overcast sky is a beautiful light source, with less blue. Soft skylight is great for photographing fast-moving kids and pets because it's the same wherever they go—you don't have to worry about them moving out of the light. In direct sunlight, they'll go from front lighting to sidelighting to backlighting to shade; but with even lighting from a lightly overcast sky, it won't matter where they go—the lighting will be good.

Electronic Flash

Built-in flash is always available, has an action-stopping brief duration, is daylight-balanced, and provides automatic exposure control. However, its flat frontal lighting angle isn't attractive and produces red-eye (most cameras with built-in flash have a red-eye–reduction feature), it's harsh, it's not effective beyond 10 to 15 feet, and there's no way to preview the lighting effect because the light is there for only a fraction of a second.

Hot Tip _____

Whenever you see photographs you like, think about the lighting. Ask yourself where the main light source was relative to the camera and subject. Is the lighting hard or soft? What would the image have been like if the opposite had been the case or if the light had been coming from another direction? You can learn a lot about lighting by analyzing images you like.

Dedicated accessory flash units are easy to carry and more powerful, have an action-freezing brief duration and daylight color balance, and offer adjustable power levels, TTL automatic exposure control, bounce capability, and special effects (such as strobe and rear sync). But the lighting angle is flat unless you can remove the flash unit from the camera via sync extension cord or slave, the light is harsh (if you can move it off-camera, you can soften it with an umbrella reflector), and you can't preview the lighting effect. Chapter 10 tells you all about electronic flash.

Tungsten Lamps

"Hot" tungsten lights offer the advantage of continuous output—you can easily see their effect—but they're hot and bright (making live subjects uncomfortable) and incompatible with daylight-balanced color films. Tungsten lights are less costly than pro studio flash systems and are a good way for new photographers to learn about lighting.

Lighting Accessories

The most popular lighting accessories are bounce umbrellas. These umbrella-shaped reflectors effectively increase the size of the light source, thus softening it—the bigger the umbrella, the softer the light. Aim your light source into the umbrella, and the reflected light output is enlarged and softened as it is reflected (bounced) from the surface. Umbrellas are easily positioned sources of soft light. Of course, you can't use a bounce umbrella with a built-in flash unit because the umbrella would cover the camera lens.

The bounce umbrella's inner surface is generally covered with white, silver, or gold fabric. White produces the softest light, silver produces a harder and brighter but still soft light, and gold produces a warmer light that's great for people pictures.

Professional photographers use umbrellas with their studio flash systems, but you probably can find hardware to attach your dedicated camera-mount flash unit to an umbrella at your local camera store. Of course, to use the flash unit with an umbrella, you'll have to use the flash unit off-camera (firing it via an off-camera sync cord or a slave unit—see Chapter 10), mounted on a light stand. The beautiful soft light you'll get will make the effort worth it. (TTL flash units should provide correct exposures when used with an

Hot Tip

Because the light reflected from a photographic umbrella (or any other surface, for that matter) is never as bright as the original light source, it's best to use a fairly powerful light source when bouncing light.

Watch Out!

Look out for natural reflectors. Any surface near your subject can reflect light onto it, and if the surface is colored, it will reflect its color onto the subject. I learned this the hard way in one of my first color outdoor portrait sessions when the beautiful green setting reflected green onto the subject's face, leaving her with a sickly skin tone and me with a sickly feeling.

umbrella reflector. Pros use flash meters with the camera in manual mode to determine exposure.)

Shoot-through umbrellas are covered with translucent fabric. The light source is again aimed into the umbrella, but the umbrella is aimed at the subject—you're using light transmitted by the umbrella rather than light reflected from it. Shoot-throughs are handy when you want to put the light source very close to the subject or have a low ceiling that prevents you from positioning a standard umbrella high enough.

Another useful lighting accessory is a flat reflector. This can be a large sheet of white poster board or a commercially produced photographic reflector. The reflector is used to direct light from the main light back onto the subject. A white reflector yields soft light, a silver reflector (made by covering your white poster board with tin foil) yields harsher, brighter light; a gold reflector yields warmer light; and a black "reflector" can be used to block light off a portion of the subject.

One of the biggest differences between a photographer and snapshooter is the photographer's ability to see and work with lighting. You can develop this ability by practicing the things you read in this chapter. You don't need a fancy studio to get great photos, but you do need exciting lighting. And you can create or find that almost anywhere.

The Least You Need to Know

- Lighting is a very important element of every photograph. Learning to see and control lighting will make your pictures better.

- The lighting direction creates the overall look of the photo.

- With natural light, you can control the effect by moving your subject and camera or by waiting for the sun to move to a better position for scenic subjects.

- Built-in electronic flash lighting is convenient but not exciting.

- Soft light is more forgiving than hard light.

- When you go out looking for things to photograph, look for lighting instead of things.

Part 4

How to Photograph ...

Now that you've learned about cameras, lenses, accessories, films, exposure, processing, lighting, and seeing, you probably want to know how to get great pictures of your favorite subjects. That's what this part of the book is all about. It shows you how to photograph people, landscapes, action, close-ups, nature subjects, and your travels, and by available light and at night. If you're interested in one or more of these subjects, turn to its chapter.

How to Photograph People

In This Chapter

- ◆ Deciding where to put the camera
- ◆ Looking at your lighting options
- ◆ Choosing the right films
- ◆ Posing your subjects
- ◆ Watching those backgrounds

Why do people buy cameras? More than for any other reason, to take pictures of people—their friends, their children, and their families. People are the most popular photo subjects, and whatever is in second place doesn't even come close.

Professional portrait photographers generally use fancy cameras and lighting equipment and shoot in a studio. But you can create great people pictures with a point-and-shoot camera and natural lighting. This chapter shows you how.

No matter what the situation, the three main things to think about when photographing people are the camera position, the lighting, and the pose. Put the camera in the right place with the right lighting and the right pose, and you'll get a great picture. It's that simple.

Saving Faces

Let's start with where to put the camera. Most point-and-shooters take their people pictures from either too far away or too close. If you shoot from too far away, your subject will be too small in the picture. If you shoot from too close, the subject's features will be distorted. Portraits look most natural when taken from around 4 feet from the subject. If you move in much closer than that, the subject's features will appear elongated in the picture. If you shoot from much farther away, the features will appear flattened. It's all a matter of perspective (as we discussed in Chapter 9).

Portraits of people have the most pleasing perspective when shot from around 4 feet away. Lenses in the 85mm to 135mm range produce a pleasant framing at this distance (left). If you use a shorter lens, you'll have to move closer to get the same head size, and moving closer will expand perspective, elongating the subject's features (middle). If you use a longer lens, you'll have to move farther back to get the same head size, and moving farther away will compress perspective, "squashing" the subject's features (right). Of course, if you have a subject who has pointy features, you might want to shoot from a little farther away with a longer lens to compensate.

Elongated features are a common problem in portraits made with point-and-shoot cameras. The wide-angle lens built into many of these cameras requires you to move quite close to get the subject's head big enough that all the details of the face are clear.

What's the solution? Move back and shoot from around 4 feet away. If you have a zoom camera, zoom the lens to frame the picture the way you want it from that distance. If you have an interchangeable-lens camera, use a lens in the 85 to 135mm range (70–105mm with APS cameras). What if your camera has a built-in wide-angle lens? Use a fine-grain ISO 100 film and shoot from around 4 feet; when you take it to

the photofinisher, tell him or her to crop the photo, keeping the subject at the center. Or take waist-up shots or even full-length portraits. (Now you know one of the reasons why zoom cameras are so popular: They handle people-shooting so easily.)

Hot Tip

Generally, it's best to shoot portraits from around 4 feet away, whether you want a tight headshot or a waist-up view. Use your zoom lens (or different single-focal-length lenses, with an AF 35mm SLR) to crop the portrait as you want it, from the 4-foot shooting distance.

The Height of Deception

Something most people don't think about when photographing people is the height of the camera relative to the subject's face. But the camera height does make a difference. Portraits of people generally work best when the camera is at the subject's eye level. This is especially important when photographing children and pets; shooting down on them diminishes them, making them seem unimportant. Shooting from their eye level brings the viewer face-to-face with them—a much more effective picture.

Shooting down at a small child or pet from adult eye level diminishes the subject. You'll get better pictures of kids and pets if you shoot from their eye level.

(Ron Leach)

But eye level isn't the only way to go. You can do a little "cosmetic surgery" by raising or lowering the camera a bit to suit your subject. If the subject is balding or has a weak chin, shoot from a little below his eye level. This will de-emphasize the bald pate and make the chin look stronger. Conversely, if the subject has a double chin, shooting from higher up will hide it.

Lighting Up Their Lives

Lighting can make a big difference in your people pictures. You can make your subject look terrific, boring, or even evil with lighting. Here are some tips.

Avoid Harsh Light

Harsh light is not attractive for people pictures unless it is used very skillfully. The classic Hollywood glamour photographers, such as George Hurrell, made many great portraits using harsh lighting. But they were experts at positioning their lights and had the help of professional make-up artists. And they had movie-star subjects! For us plain-folk photographers and subjects, soft lighting is better because it's far more forgiving of imperfect light positioning and imperfect complexions. (Chapter 15 explained harsh and soft lighting.)

Photo Fact

You might not have a professional Hollywood make-up person on hand, but it's worthwhile having your subject (or a knowledgeable friend) do a little "prep" work before shooting a formal portrait. Check over your subject before you shoot and make sure the hair is combed, the collar is not crooked, and the lipstick is on straight. (After all my years of photographing people, I recently messed up some otherwise nice shots of a beautiful lady because I didn't notice that she'd smudged some lipstick on her chin at some point during the shoot.) These details are so easy to fix before you shoot the picture and so hard to live with afterward.

The worst possible lighting for people pictures is the direct sunlight of high noon. Not only is this lighting harsh and bright, producing unattractive stark, white highlights and totally black shadows and causing your subject to squint, but the high angle of the light makes eyes disappear in deep pockets of shadow. The harsh, high-angle lighting also emphasizes wrinkles, even in younger subjects.

If you have to shoot portraits at high noon, have your subject turn away from the sun instead of toward it. The sun is never directly overhead at noon, except at the equator—it's always a bit south of overhead in the Northern Hemisphere and a bit north of overhead in the Southern Hemisphere. So it's always possible to turn the subject so the sunlight is slightly behind him or her.

If you must shoot outdoors at high noon, turn your subject away from the sun. The lighting on the face will be much more pleasant. Fill-flash can add life to the eyes.

(Ron Leach)

It's Getting Late, but That's Great

The sun can be a wonderful light source for people pictures late in the afternoon (especially a hazy afternoon) when it is low in the sky, within 30 degrees of the horizon. The sun's light is less intense then, so the subject can look into it without squinting. The low-angle sun produces attractive *catchlights* in the subject's eyes. The lighting angle produces much more pleasant shadows. Early morning sun offers the same benefits, but most people aren't at their photogenic best first thing in the morning.

Whazzat Mean?

A **catchlight** is a reflection of a light source in the subject's eyes. The catchlight can be a reflection of the main light source or of a reflector that's reflecting light from the main light back into the subject's face.

For variety, try some shots with the subject angled toward the sun instead of facing directly into it. For example, if the sun is due west, instead of having the subject face due west, have him or her face west-northwest or west-southwest. This gives the face some modeling, producing a more interesting effect than the flat look of direct frontal lighting.

Modeling is the illusion of a three-dimensional form in a two-dimensional photograph created by light and shadow on the subject's face. Flat frontal lighting produces little if any modeling; sidelighting produces lots of modeling. Hard light produces more modeling than soft light because the shadows are stronger.

Backlighting

Another effective way to use the late-afternoon sun for portraits is to have your subject turn his or her back to the sun, and use backlighting—light from behind the subject. This leaves the face lit by pleasant soft light from the sky and produces a beautiful glowing rimlight around the subject. This works best when the sun is high enough above the horizon that it doesn't appear in the picture. If the sun does appear in the picture, you'll get flare and underexposure.

One problem with backlighting is that it can fool your camera's built-in exposure meter. This isn't a big problem when the sun is high enough that it is out of the picture, but if the sun appears in the picture (or is blocked only by the subject), it will cause underexposure and a too-dark subject. Some cameras have an automatic backlight control; when the meter "sees" that the background is much brighter than the center of the image, it assumes you're shooting a backlit situation and increases exposure to compensate. The simplest solution with point-and-shoot cameras is to activate the fill-flash mode. With other cameras, you can use exposure compensation or spot-meter the subject. Many pros use a hand-held incident-light meter for backlit situations.

> **CAUTION**
>
> **Watch Out!**
>
> Light from the sky is blue, and it will give your subject's skin a bluish cast if you shoot on slide film. Use print film, and the photofinisher can eliminate the bluish cast when making the prints.

Fill-flash not only provides a solution to the backlighting exposure problem, it also adds catchlights to the subject's eyes, giving them "sparkle." Another solution is to use a large sheet of white poster board as a reflector. Position the poster board right next to the camera so it reflects the sun's light onto the subject's face. If you

are shooting a tight headshot, you can have the subject hold the white poster-board reflector in his or her lap—but check the viewfinder carefully to make sure the reflector doesn't sneak into the picture.

The No-Lighting Technique

Studio photographers often use large softlights or bounce-umbrella reflectors to simulate the lovely soft light of open shade or an overcast sky. You don't have a studio, but you have something better—real open shade or the real overcast sky.

You can produce pleasant soft lighting for outdoor portraits simply by moving your subject into an area shaded from direct sunlight, such as the shadow of a building, so the subject is lit only by the soft light from the sky.

Open shade produces pleasant soft lighting for people pictures.

Likewise, on a lightly overcast day, the cloud layer acts as a huge diffuser, turning the whole sky into a soft light for your portraits. A light overcast is great for photographing kids because it's the same everywhere, so it doesn't matter if the subject moves around. Avoid shooting in heavy overcasts if possible because the lighting lacks modeling (there are no shadows at all) and isn't very bright.

The Merry Window

Indoors, a large picture window can provide beautiful light for portraits. The larger the light source relative to the subject, the softer the light. So the closer the subject is to the window, the softer the light. Window light can be quite harsh if the window is small or the subject is a great distance from the window.

As with late-afternoon sunlight, you can give the window-lit portrait direction by having the subject face at an angle to the window instead of straight into it.

Window light isn't very bright, especially if the subject is some distance from the window, so use fast color-print film (ISO 400 or 800). Window light also tends to be bluish since it's mainly light from the sky, but the photofinisher can correct this when making prints from the negatives.

Built-In Flash

Built-in flash is the most frequently used man-made light source for people pictures. It provides a fairly harsh direct frontal lighting that is pleasant if not terribly exciting.

If you're shooting indoors in dim lighting or outdoors at night, use your built-in flash. If you're shooting in harsh sun outdoors, use fill-flash mode to lighten the shadows. But you'll generally get more attractive and interesting portraits using existing light as described in the previous few sections of this chapter.

Built-in flash lets you shoot pleasantly lit portraits in dim light, but use the camera's red-eye–reduction mode.

(Keith Ewing)

In dim lighting, built-in or on-camera flash can produce red-eye, those demonic red spots in subject's eyeballs. Most cameras with built-in flash have a red-eye–reduction

mode, which fires a pre-exposure light to stop-down the subject's eyes and minimize red-eye. When shooting people pictures with built-in flash, activate the camera's red-eye–reduction mode.

Photo Fact

When you use red-eye–reduction mode, there's a slight delay between the time that you press the shutter button fully to take the picture and the time the camera actually makes the exposure. This delay occurs because the camera fires several weak flash bursts (or activates a continuous lamp) to "stop-down" the subject's eyes before taking the picture, thus reducing the red-eye. This delay can prevent you from capturing those fleeting expressions. And the preflashes sort of rule out shooting without the subject's awareness.

Off-Camera Flash

If you can move your flash unit off-camera (you can with many AF 35mm SLRs by using a flash extension cord, or, with some camera systems, wirelessly via built-in slaves), you can create some wonderful lighting for portraits. See Chapter 10 to learn all about electronic flash.

People Films

Today's color films are amazingly good at reproducing colors beautifully, including skin tones. Each color film has its own special palette, and you might prefer the skin tones of one film over those of others. If you like the skin tones in your photos, keep using the film you're using. If you don't like them, try another film.

Some pro color-print films were designed specifically for photographing people. These include Kodak Portra 160NC and 400NC (natural color), Kodak Portra 160VC and 400VC (vivid color), Kodak Portra 800, Fujicolor Portrait NPS 160 and NPC 160, Fujicolor Portrait NPH 400, Fujicolor NPZ 800, and Agfacolor Portrait 160. These are wonderful films, and most pro people photographers use one or more of them. They cost more than general-purpose films, and photofinishers that cater to nonprofessionals might have trouble printing them properly. I'd recommend that you stick with your usual favorite film(s)—all of today's major-brand color-print films produce attractive skin tones. If you don't like the skin tones you get with your usual films, then you might want to try one of the pro people films.

Posing

Pictures of people just standing there say "snapshot" to the viewer. You can make better pictures of people if you take the time to pose them. Poses can be formal or casual. Casual generally works best for photos of family and friends. The trick is to make the people and poses look natural. You can do this by directing the subject into a position that looks good.

For headshots, you can shoot a direct frontal portrait or shoot at an angle to the subject's face. Either the head or the body should be turned at an angle to the camera for the best result; if both head and body face the camera straight-on, the effect is pretty boring.

Hot Tip

Regardless of the framing, always focus on the subject's eyes because the eyes are the first thing the viewer will notice in a portrait. They should always be sharp.

You also can shoot a tight headshot, a loose headshot, a waist-up portrait, a three-quarter–length (knees-up) portrait, or a full-length portrait. You can change the framing of the subject by moving closer or farther away, by changing the lens focal length, or both. Try different framings by moving the camera and by changing the focal length and see what works for your subject.

Try several variations on each pose you come up with. While most portraits are shot in the vertical format, you can pose your subject so that you get a nice horizontal- or square-format composition, for variety.

Candid poses can be set up and still look natural. Just be patient with your young subject.

(Ron Leach)

Formal poses work well for business-related pictures and shots for newsletters. You can use harsher lighting with men than with women. You can eliminate glare from glasses by having your subject turn his or her head left or right a bit or tilt it up or down slightly until there is no glare.

(Lynne Eodice)

Props

You can get better pictures of children if you give them a prop—something to play with, so they're not self-conscious about you and the camera. The prop can be one of their toys, something you bring to the session, or something that's available where you're shooting.

Environmental portraits use the subject's environment as a prop. By showing the subject at work or play, the environmental portrait says something about who the person is and what he or she does, instead of just showing what the person looks like.

Groups

Photographing more than one person is trickier than photographing a single subject because you have to make sure all the subjects in the photo look good. One secret is to shoot lots of pictures—that increases your odds of getting one where everyone looks good and no one is blinking or looking weird.

Make sure no one's face is blocked by someone else, that no one's shadow falls across someone else's face, and that no one is "upstaging" someone else in the shot. Shooting outdoors in soft skylight can solve the shadow problem.

More important than the pose is the attitude. If the subjects are having fun, you'll get a good picture that they and their family will like.

When you have several people in the picture, you have to arrange them in an attractive manner, and watch out that no one's head or shadow blocks someone else's face.

(Lynne Eodice)

When photographing a large group, a good picture is one where everyone looks pleasant and can be seen. When photographing two people, you'll get the best pictures when the people are interacting with each other in some way.

Two-person shots are generally more interesting if the two are interacting instead of just standing there. Some people will naturally interact; others will have to be directed.

(Lynne Eodice)

What's Going On Behind My Back?

A common problem in people pictures is distracting backgrounds. It's natural to get so wrapped up in your subject that you don't notice what's going on elsewhere in the picture. Unfortunately, the camera sees all.

The solution is simply to examine the background before you shoot. Does the subject stand out? If not, move the subject in front of a less distracting background. If the subject is light, position him or her in front of a dark background; if the subject is dark, position him or her in front of a light background.

Is there a tree or telephone pole "growing" out of the subject's head? If so, move the subject or move the camera so you shoot from an angle that doesn't include the distracting element.

CAUTION Watch Out!

Don't let a busy background distract from your main subject. Move in or zoom in tightly on your subject so less of the background shows.

Weddings

Sooner or later, everyone who owns a camera is asked by a friend or relative to photograph a wedding. Having photographed a few myself early in my photo career, I always refuse such requests and refer the querying party to a professional wedding photographer. A pro who specializes in weddings knows what to shoot, how to shoot it, how to avoid unduly disrupting things, and most important, how not to blow the assignment. A wedding is a major event for those involved. The wedding photographer's job is to capture the spirit and facts of the event on film for the eternal joy of all concerned. He or she had better get it right the first time because there's no second chance. But since virtually every photographer somehow eventually finds him- or herself having to shoot at a wedding (in place of the official photographer, or on behalf of friends), here are a few tips:

1. Try to stay out of the pro's way. If you make him or her miss a shot, the wedding couple and their families will not soon forgive you.

2. Use color-print film. The pros use the ISO 160 and 400 professional color-print films mentioned in the section on people films. But you'll do just fine with a fast consumer color-print film such as Fujicolor Superia X-TRA 400, Kodak High Definition 400, Agfa Vista 400, Fujicolor Superia X-TRA 800, or Konica Centuria Super 800. The important thing is to be sure to bring plenty of film—you don't have to use it all, but if you run out, you'll miss something good.

3. Bring at least one spare battery for your camera and at least one spare set for your flash unit if you have a separate flash unit.

4. Don't compete with the pro. He or she will get the standard wedding shots, so you don't have to. While the pro is shooting the bride tossing her garter or bouquet into the crowd, take pictures of the crowd trying to catch it. When the couple is exchanging "I do's," catch the bride's mom or the bridegroom's dad reacting. Be sure to take lots of pictures of the kids in their cute outfits.

5. At the reception, be sure to get shots of different people with the lucky couple—those shots will be treasured forever, and the pro might not get around to everyone in the party. You have the advantage of knowing who is likely to want pictures with whom.

Hot Tip _____

Shoot lots of pictures, especially when photographing children or groups. That way, even if there are a lot of not-so-great photos, you're more likely to capture that great expression on Junior or get a group shot where no one is blinking or looking weird.

Pets

Many pet owners consider their beloved beasties members of the family, so let's talk a bit more about pet photography here. Much of the advice given for photographing people also applies to photographing pets: Shoot from the pet's eye level, shoot from around 4 feet away, use the focal length to frame the subject as you want it, avoid high-noon sunlight, and use red-eye–reduction mode if you have to shoot with built-in or on-camera flash (dogs and cats show red-eye worse than people do, although the spots in the eyes aren't always red).

Children with their pets are a winning combination. The secret: Keep a camera handy, loaded with film. Then you'll be ready when those magical moments occur.

(Ron Leach)

One big difference between photographing pets and photographing people is that pets won't listen to you. You can't direct them. So you either have to try to shoot as best you can or have the pet's owner try to get it to cooperate. Some of the best pet photos are of children with their pets, so be sure to get some of those.

Be ready for those humorous moments that occur.

(Michelle Brady)

With pets, it's okay to shoot from closer than 4 feet with a wide-angle lens, if you want a humorous distortion effect.

(Ron Leach)

The Least You Need to Know

◆ Shoot lots of pictures, especially when photographing kids or groups.

◆ For the most attractive portraits, photograph individuals from around 4 feet away and choose a lens focal length to frame the subject as desired.

◆ Shoot from the subject's eye level.

◆ Avoid direct noon sun for people pictures.

◆ Give the subject some direction—don't have him or her just stand there.

◆ Watch out for distracting backgrounds.

How to Photograph Action

In This Chapter

- ◆ Dealing with action: freezing vs. blurring
- ◆ Focusing on a moving target
- ◆ Understanding action lenses
- ◆ Getting the right point of view
- ◆ Making the most of lighting
- ◆ Buying the right action films

Shooting pictures of moving subjects is a challenging and rewarding way to spend some film. Whether you're photographing your daughter's soccer game, your son's go-kart race, your kids at play in the backyard, or a professional sports event, there are lots of great action pictures just waiting for you to capture with your camera. Sure, the pro action photographers use lots of fancy and costly equipment—superfast supertelephoto lenses, high-end pro SLRs with fast motor drives, and powerful pro flash units—but you can get some great action shots with almost any camera. It just takes some knowledge of the activity you are photographing and a few special skills. In this chapter, you'll learn the basic skills of the action photographer. They will seem difficult when you first try them (I can still remember how awkward I felt the first few times I tried shooting action,

and that was more than 35 years ago), but you can master them with practice. You have to practice them to master them; just reading about them won't do the trick.

When you first start practicing the techniques presented here—panning the camera, shooting at the peak of the action, focusing, and the like—don't put film in the camera. That way, you won't waste a lot of film while you get the hang of doing these things and begin to develop a sense of timing (which is the key to any good action picture). Practice focusing (both in AF mode and manually, if your camera permits it) and following the action with the camera. Practice tracking your child or pet around the yard, trying to snap the shutter at the right moments. Practice panning the camera by tracking cars driving by on a busy street (from the safety of the sidewalk— not from the middle of the street!). When you start to feel comfortable doing these things, put some film in the camera and start taking pictures of these same subjects. When you see your pictures, you'll be able to check on your progress and see which techniques you've got down and which ones still need work.

Go to the local park and photograph kids playing. Go take pictures of the action subjects you want to photograph (I find birds in flight a fun challenge when I don't have a specific assignment to photograph). Practice and practice some more. It will seem difficult at first, but, after a while, the mechanical aspects will become second nature, and you'll be able to concentrate on composition, emotional moments, and all the other things that make for good pictures, action or otherwise. Soon, you'll have some exciting pictures to show for your efforts.

Freeze It or Blur It?

There are two basic ways to deal with action, photographically: Freeze it sharply or blur it. To freeze action, shoot at a fast shutter speed. To blur action, shoot at a slow shutter speed. With an AF 35mm SLR, use shutter-priority AE mode and set the shutter speed you want to use. With a point-and-shoot camera, use a fast film (ISO 400 or faster) when you want sharp action shots and a slow film (ISO 100) when you want blur.

How fast of a shutter speed do you need to freeze a moving subject, and how slow of a shutter speed do you need to appropriately blur a moving subject?

It depends on the subject's speed and direction of travel, its distance from the camera, and the lens focal length you're using. Faster-moving subjects, subjects moving directly across the field of view (from right to left or left to right, as opposed to coming toward the camera), nearby subjects, and subjects photographed with long focal

lengths require faster shutter speeds to freeze their motion. And if you want to blur the motion, how blurred do you want it to be?

To freeze an action subject, use a fast shutter speed. You can make a point-and-shoot camera set a fast shutter speed by shooting in bright light and using ISO 400 or 800 film.

To blur an action subject, use a slow shutter speed. You can make a point-and-shoot camera set a slow shutter speed by shooting in dimmer light and using ISO 100 film.

These are things you have to learn through experience. When you shoot an action subject, try using different shutter speeds and keep notes. Then look at your pictures and your notes and see which shutter speed(s) produced the results you like. As a rule,

shutter speeds of $^1/_{1000}$ or faster freeze most sports action, and shutter speeds of $^1/_{15}$ or slower blur them. Shutter speeds in between (which include the whole range on many point-and-shoot cameras) might or might not freeze action subjects; it depends on the subject and what it's doing.

Panning

What if you want to show motion and also have the subject appear sharp? Use a slow shutter speed and *pan* the camera to follow the subject while you shoot. Start tracking the subject through the viewfinder before it gets to the point where you want to record it, release the shutter when the subject reaches the desired point, and remember to follow through—don't abruptly stop panning after you trip the shutter.

Whazzat Mean?

Panning means smoothly moving the camera to track the moving subject so that the subject remains in one spot in the viewfinder.

Panning sort of reverses reality. In reality, the subject is moving and the background is stationary. When you pan the camera to track the subject, however, you're "stopping" the subject on the film and causing the background to "move." The result is a picture with a sharp subject against a blurred background, which is a great way to emphasize the speed of a race horse or race car. Again, the best shutter speed for a given subject depends on the subject's speed and distance, but $^1/_{30}$ is a good starting point.

It takes some practice to master panning. Especially when using long lenses, it's not easy to keep a speeding race car in the viewfinder at all, much less centered therein. But with practice, you can become expert at it, and you'll get some great action pictures.

Hot Tip

For panned shots, stand facing the spot where you want to photograph the subject. Keeping your feet planted in place, turn your upper body to face the approaching subject. "Capture" the subject in the viewfinder and pan the camera to track it by turning your upper body back toward "centered." You can sense when you are pointed straight ahead, and thus will know when to press the shutter button to make the picture.

Peak Action

Another way to get a sharp picture of an action subject when using a slow shutter speed is to shoot at the peak of the action. What goes up comes back down, and there's a point at which it stops going up before it starts back down. Shoot at the point when the subject appears to hang motionless in midair, and you'll get a sharp action shot. This technique is especially useful when you're shooting in dim lighting, which requires a slow shutter speed.

Getting Focused

Focusing on rapidly moving subjects is not easy, even with an autofocus camera. You have to keep the subject in the AF target area in the viewfinder, or the camera won't focus on it. Practice (neighborhood kids and pets make good practice subjects), and you'll develop a knack for focusing on moving subjects and accurately tracking them with the camera.

One trick the pros use is to prefocus on a point you know (or anticipate) your subject will cross and then shoot as it arrives there. This is much easier than trying to focus on a rapidly moving subject while simultaneously trying to pan the camera smoothly. Prefocusing works well with auto races (focus on a spot on the track) and baseball games (focus on one of the bases) but is less useful with more random-moving sports, like football and soccer.

If you prefocus on a spot on the track where action is likely to occur, you'll be ready to shoot when it does. Prefocusing even speeds things up with an auto-focus camera. If you can't pre-focus on the subject, you'll have to follow-focus on the subject as it moves. Birds in flight make great practice subjects—if you can track and focus on them, you can handle most moving subjects.

Autofocusing on Action Subjects

You'd think that autofocusing would make action shooting easy. With some AF cameras, it does. But there's still more to it than pointing and shooting.

One key to success is making sure you keep the subject in the viewfinder's AF target area at all times. If you let the subject move out of the target area, the camera won't focus on it.

If your AF camera has a continuous predictive AF mode, that's the one to use for action shooting. If the camera just has single-shot AF, you can still shoot action, but you'll get fewer sharp pictures because the moving subject won't be at the same distance when the film is exposed as it was when the camera focused on it. That's because there is a slight delay between the time you press the shutter button all the way down to make the exposure and the time the camera reacts and exposes the film.

Watch Out!

If you try to focus by aiming the viewfinder's AF target at the subject in the usual manner, the subject will move out of focus during the delay between the time you press the shutter button and the time the film is actually exposed. With a point-and-shoot camera that doesn't have a continuous AF mode, prefocusing is the best way to get sharp action shots.

I've found that the best way to use AF for action (with a camera that offers predictive AF) is to track the subject with the camera, press the shutter button halfway down to activate the AF system, then press the shutter button all the way down as the decisive moment arrives. This gives the AF system time to acquire the subject and do its predictive calculations. If you just suddenly stab the shutter button, the AF system might not have enough time to focus on the subject before the exposure is made.

Action Lenses

Action photographers use a wide range of lens focal lengths. As in all photography, use the lens that frames the scene the way you want it from your shooting position. A zoom lens is nice because it lets you vary the composition without moving the camera. But most serious action work is done with long lenses in order to bring the viewer up close to the action.

Pro action shooters use fast supertelephoto lenses—300mm and 400mm f/2.8 and 600mm f/4 lenses are especially popular. They provide fast shutter speeds to help freeze the action, but they are prohibitively expensive—several thousand dollars.

Slower long lenses are more accessibly priced and bring you just as close to the action. But you have to use a faster (and thus grainier) film to get the same shutter speeds. The pros need to produce the highest-quality images to sell in that highly competitive market, but you can get some great shots with slower lenses, faster films, and an entry-level AF 35mm or Advanced Photo System SLR.

Pros use superfast supertele-photo lenses to "get right up close" to the action. You won't be able to do this with a point-and-shoot camera, but there are ways you can get good action shots without super-long lenses.

*(Karel Kramer/*Dirt Rider *magazine)*

Point of View

Selecting the right place for the camera can make a big difference. Walk around the location before the action starts and look for suitable shooting locations, taking into consideration access to subjects, the background, the lighting, and your personal safety. At some events, you can get up front, while at others you can't. Either way, find a site with as clear a view as possible of the subject(s). At races, there is generally more action at the corners, where the cars bunch up as they slow down. At a baseball game, you might focus on first base for an inning or so, then try the batter's box for a while, then the pitcher's mound, and so on. Whatever the activity, go for the location with the clearest view of some likely excitement and focus on the anticipated scene of the action.

This was a good shooting location because the early morning light turned the smooth lake surface into a mirror. All that was required was patience, until a bird flew by.

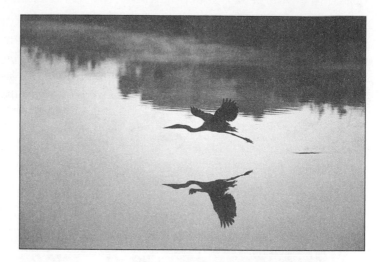

Look for ways to hide distracting background elements. In the top photo, I shot from a low angle, so the subject blocked them. From my location for the bottom photo, there was nowhere I could put the camera that didn't include distracting background elements, so I watched the action and found that, at this point, the motocrosser kicked up a cloud of dust that obscured most of the background distractions. Scout out your shooting location beforehand, and you'll get better pictures. Both pictures were made with an Advanced Photo System camera—the Nikon Pronea S and IX-Nikkor 60–180mm zoom lens.

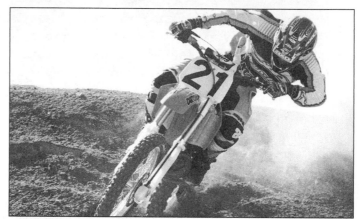

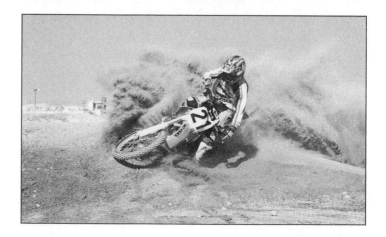

Once you've situated yourself and your camera and picked a lens focal length, examine what you see in the viewfinder. You've taken the time and trouble to select a good camera site and a good action spot; why not invest a little bit more to ensure that nothing in the scene will distract from or hide your subject? There won't be time to examine everything in the viewfinder while you are shooting a fast-moving subject, but you can examine the area beforehand and determine the best point at which to shoot the subject. Don't just look for distracting elements; look for the best possible composition. You don't have to center the subject in the viewfinder; in fact, it's generally better to compose with the subject to one side or high or low in the frame. Imagine your subject in the scene as you inspect what you see in the viewfinder, and mentally note the most effective framing(s).

Lighting

When you check out your shooting area, think about the lighting, too. Outdoors, the sun is generally the main light source. If it's early or late in the day, you don't want to set up shooting into the sun. While backlighting can be dramatic, it's not ideal for most action shots and can cause lens flare. A thin overcast produces more even lighting but reduces the overall light level, requiring slower shutter speeds or faster film.

Pro action photographers use powerful electronic flash units indoors, outdoors at night, and even outdoors in the daytime. The flash units built into point-and-shoot cameras (and even AF 35mm SLRs) aren't powerful enough to do pro-type flash action shots, but can be effective if you can get within 10 to 12 feet of your subject.

If you have an AF 35mm SLR, you can attach a more powerful dedicated flash unit and shoot action subjects from farther away than you can with a built-in unit.

Watch Out!

Never put yourself in danger trying to get too close to the action—no photo is worth it.

You can also combine flash with existing light in a dark location to produce some freeze-blur action special effects (see Chapter 10).

Action Films

You'd think that the faster the film, the better for action shooting, but that's not necessarily the case. Pros tend to use the whole range of film speeds. I know some professional motocross photographers who do most of their action shooting with Fujichrome Velvia, an ISO 50 slide film (which they rate at EI 40).

Obviously, they have to shoot in bright light or with flash very close to their subjects. And they use super-fast pro lenses. For night events, of course, they switch to faster films.

I use ISO 100 and 400 slide films (often pushing the 100 films to EI 200), and ISO 800 print film for my daylight action shooting. At night and indoor events, I'll use the slowest film that will permit me to use a reasonable shutter speed; this ranges from ISO 400 to 1600 color-print films. I do most of my action shooting with lower-cost, slower telephoto and zoom lenses. With point-and-shoot cameras, I'd use ISO 400 and 800 color-print films (or one of the chromogenic black-and-white films, if I wanted black-and-white pictures), unless I wanted pan-blur pictures, in which case I'd use ISO 100 color-print film.

Knowing the Subject

Timing is the secret to great action photos. Timing is a matter of knowing the activity you're shooting, anticipation, practice, and good luck.

Take care of the first three, and luck will come your way. Keep in mind that cameras—especially point-and-shoot autofocus cameras—don't react instantaneously. There's a delay between the moment you press the shutter button all the way down and the moment the film is exposed. So you not only have to know enough about the subject you're photographing to be able to anticipate the decisive moments, you have to press the button a beat before the moment actually occurs. You can learn to do this with practice.

Being familiar with the subject you're photographing will help you anticipate the action, be it a baseball game or a hummingbird. If you know what, where, and when action is likely to occur, you're more likely to be ready to record it when it does.

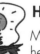

Hot Tip _____

Molly, the golden retriever, taught me a good lesson in concentration. If I threw her one tennis ball, she'd catch it. If I threw her three at the same time, she'd try to catch them all and get none. That's how it is with action shooting. Divide your attention among too many subjects, and you'll end up with nothing. Pick one subject for a shot and stick with it for that shot. You can try another subject for the next shot.

In ball games, follow the ball because that's where most of the action occurs. It's generally best to concentrate on an individual or the direct confrontation between two individuals, even in team sports. Don't try to get everyone in one shot—the picture will be too busy, and the people won't all be doing something interesting at the same time. Pick one subject and track him or her; if you try to track two subjects at the same time, you'll most likely miss them both.

You don't have to photograph professional events to see true competition. You're more likely to get good shots at amateur events like kids' baseball games because you're more likely to be able to find a good shooting position. Access to the "good" spots at most pro events is limited to pro photographers with photo passes. So practice the pro techniques described in this chapter, and put them to work at Junior's pee-wee football game, daughter's dance recital, and all the action that happens in your life.

The Least You Need to Know

- ◆ Practice the techniques described in this chapter until you master them.

- ◆ Learn about the sports and other activities you wish to photograph.

- ◆ Use fast films when you want to freeze action.

- ◆ With bright lighting and fast film, you can make some good action shots with your point-and-shoot camera.

- ◆ Check out the lighting and background when scouting a spot for you and your camera.

- ◆ If you're serious about sports photography, get an AF 35mm SLR and a 300mm telephoto (or 75–300mm or 100–300mm zoom lens).

How to Get Closer to Your Subjects

In This Chapter

- ◆ Getting closer to your subject with close-up and split-field lenses
- ◆ Magnifying your subject using extension tubes, bellows units, and macro lenses
- ◆ Using lens-reversing rings and tele-converters
- ◆ Making the most of your close-up equipment

Moving in close with your camera opens up whole new worlds to photograph. You can zero in on a small portion of a large object to create an interesting abstract image or fill the frame with a tiny subject. Either way, close-up photography enables you to produce images that are out of the ordinary.

Close-up photography has many definitions. For the purposes of this section, close-up photography means shooting closer to your subject than is possible with normal camera lenses. You can do this in a number of ways: close-up lenses, extension tubes, bellows units, macro lenses, and more.

We'll start by showing you how to get close, then give you some ways to make better close-up photos once you do.

How to Get Close

Many point-and-shoot film cameras have a macro or close-up mode. This isn't for serious close-up shooting, but it does let you shoot less than 2 feet from the subject. If you have one of these cameras, be sure to shoot some pictures from that minimum shooting distance—you can get some interesting, tightly framed pictures and abstract images of common subjects.

For truly serious close-up shooting, though, you need an SLR camera—35mm or digital. SLR cameras provide a variety of ways to "get close." They all involve buying additional equipment, but some of the items are quite inexpensive.

Photo Fact

Many consumer digital cameras have a macro mode that permits focusing on subjects just inches from the front of the lens. For example, the Canon PowerShot Pro 1 will focus down to 4 inches in macro mode. However, with most such cameras, macro mode is available only at the widest focal length—you'd get a lot more magnification if they'd focus that close at the longer focal lengths (a few digital cameras, such as Minolta's DiMAGE A2, provide macro mode at both ends of the focal-length range). Some digital cameras even offer a "super macro" mode, which lets you focus even closer (down to 1.2 inches with the Pro 1, at reduced resolution). Digital cameras with macro mode are a terrific choice for casual close-up shooting—far better than point-and-shoot film cameras.

Close-Up Lenses

The simplest and least-expensive way to get your camera lens to focus closer than its normal minimum focusing distance is to attach a close-up lens. Close-up lenses are plus-diopter elements similar to those used in eyeglasses to correct farsightedness, and just as the eyeglasses enable our eyes to focus on closer objects than they normally can, close-up lenses enable the camera lens to focus on closer objects than it normally can.

Close-up lenses look like clear filters, and they screw into the front of the camera lens, just like filters.

The strength of a close-up lens is expressed as a diopter number. The diopter number indicates how close your camera lens can focus with the close-up lens attached, in fractions of a meter. A +2 close-up lens will let you focus $^1/_2$ meter away, a +3 close-up lens $^1/_3$ meter away, a +4 close-up lens $^1/_4$ meter away, and so on. These distances apply regardless of the focal length of the camera lens; a +4 close-up lens will let you focus $^1/_4$ meter away whether attached to a 50mm lens or a 200mm lens. These focused distances are based on the camera lens being set at infinity. When the camera lens is focused more closely than its infinity setting, the combination of camera lens and close-up lens will focus even more closely.

You can buy close-up lenses individually or in handy sets that contain three lenses: +1, +2, and +3 or +4.

To focus even closer, you can combine close-up lenses. A +1 and a +4 equal a +5 (you can focus $^1/_5$ meter away). Always attach the higher-numbered close-up lens to the camera lens and the lower-numbered one to the higher-numbered one for best results.

Hot Tip

For most readers of this book, inexpensive close-up lenses or a tele-converter will get you close enough—few of you will need the more elaborate and costly items, but they're included here for those who think they might want to try them someday.

Watch Out!

If your lens already can focus closer than $^1/_2$ meter (around 19 inches), the +2 close-up lens will actually make it focus farther instead of closer—that minimum focusing distance with the lens set at infinity is $^1/_2$ meter, no matter what the focal length or minimum focusing distance of the lens you use it on.

Here's what close-up lenses can do for you. The top-left photo was made with a normal 50mm lens at its minimum focusing distance. The top-right photo was made with a +1 close-up lens attached, the bottom-left photo with a +2 close-up lens, and the bottom-right photo with a +4 close-up lens.

Naturally, the longer the focal length of the camera lens, the larger the image at a given camera-to-subject distance, with or without a close-up lens. A 50mm lens with a +4 close-up lens will focus $\frac{1}{4}$ meter (about 10 inches) away; a 200mm lens with a +4 close-up lens will also focus $\frac{1}{4}$ meter away. But the 200mm lens will produce four times the magnification of the 50mm lens at that (and any) distance.

While close-up lenses have the advantages of simplicity, relatively low cost, and no required exposure compensation, they have a couple of limitations. First, close-up lenses won't take you much closer than life-size (1:1), and second, close-up lenses produce some loss of image quality, especially around the edges. This loss of sharpness becomes greater as the strength of the close-up lens increases. For really serious close-up work, extension tubes and bellows are better choices. (Note: Stopping the camera lens down improves sharpness when using close-up lenses. And there are two-element close-up lenses that provide better image quality, especially with telephoto lenses.)

Close-up lenses are fine for subjects like flowers, but their poor edge sharpness makes them bad for copying flat subject matter, such as photographs.

Split-Field Lenses

Split-field lenses are close-up lenses cut in half, allowing you to focus on a very near subject (through the close-up lens half) and a distant one (through the empty half) simultaneously. Like close-up lenses, split-field lenses come in several strengths.

In the left photo, with the camera focused on the distant portion of the scene, the nearby portion is completely out of focus. With a split-field lens attached for the right photo, everything is sharp.

Extension Tubes

Extension tubes are just light-tight spacers that fit between the camera body and the lens. They contain no glass elements; they merely increase the distance between the optical center of the lens and the film, thus producing magnification of the image. Since they contain no glass elements, extension tubes don't degrade image quality as close-up lenses do. For greater extension (and thus, greater magnification), you can combine two or more extension tubes.

Photo Fact
The magnifications or reproduction ratios mentioned in this chapter refer to the size of the image as it appears on the film. Life-size means the tiny subject appears life-size on the 1 × 1.5-inch 35mm negative or slide. Of course, the subject will appear much larger than that when a big print is made from the negative or when the slide is projected.

The extension tube attaches to the camera. The lens attaches to the extension tube. The degree of magnification depends on the length of the extension tube relative to the focal length of the lens being used with it. When the extension tube is the

same length as the focal length of the lens attached to it (for example, a 50mm extension tube with a 50mm lens), a life-size, or 1:1 reproduction, ratio is reproduced; the image of the subject appears life-size on the film. If the extension tube is longer than the focal length of the lens, greater-than-life-size magnification is achieved.

It follows that the shorter the focal length of the camera lens, the greater the magnification produced by a given extension tube. A 50mm extension tube with a 50mm lens yields a life-size image on the film; the 50mm tube with a 24mm lens yields a twice-life-size (2:1) image. The instruction manual that comes with the extension tubes contains tables that indicate what the magnification is with a given tube and various camera-lens focal lengths, but it's simple to calculate for yourself: Divide the length of the extension tube by the focal length of the lens, and the result is the magnification produced by the combination (for example, a 50mm tube divided by a 200mm lens focal length equals a $^1/_4$–life-size "magnification").

When you increase the distance between the film and the optical center of the lens (as is the case when you are using extension tubes or the soon-to-be-discussed bellows units), you also reduce the amount of light transmitted to the film because the diameter of the lens opening is smaller relative to the overall focal length of the lens/extension combination. Fortunately, your camera's built-in, through-the-lens exposure meter automatically compensates for this loss of light.

If you use a hand-held meter, you must remember to compensate for the loss of light caused by using the extension tube(s) or bellows. The formula to do this is fairly simple: f = [FL/A], where f is the effective f-number of the lens/extension-tube combination, FL is the effective focal length of the combination, and A is the diameter of the lens aperture. For example, if you're using a 50mm extension tube with a 50mm camera lens set at f/8, FL = 100mm (50mm lens plus 50mm tube), and A = 6.25mm (50mm lens divided by the set f-number of f/8). Therefore, f = 16 (100 divided by 6.25). This means that when the 50mm lens is set at f/8 and attached to a 50mm extension tube, the effective f-stop of the combination is f/16—two stops smaller than f/8. So you must give the shot two stops of additional exposure to compensate for the light lost due to the extension. Aren't you glad that 35mm SLRs come with built-in TTL meters that compensate for this light loss automatically?

Aside from the light loss caused by the extension, the only drawback to extension tubes is that the lens won't focus out to infinity when using a tube—but, then, you aren't using extension tubes to shoot distant subjects; you're using them for close-up work. Note that the camera lens won't focus out to infinity when a close-up lens or bellows (discussed next) is attached, either.

Bellows

A bellows is, in effect, a flexible, variable-length extension tube. It provides magnifications up to about four times life-size on the film with a standard 50mm camera lens, and up to 25 times life size with a special bellows lens.

CAUTION **Watch Out!** _____

Some extension tubes and bellows are not "automatic." This means the linkage between the camera and lens that tells the built-in meter which aperture the lens is set at is disconnected. With nonautomatic extension tubes, you must use stopped-down metering, whereby you manually stop the lens down to the selected aperture so the meter can read the light actually transmitted by the lens/extension-tube combination at that aperture. See your camera or extension-tube manual for specifics.

The camera body attaches to the bellow unit's rear standard. The lens attaches to the bellows's front standard. With some bellows, a cable release connects the camera cable-release socket to the bellows cable-release socket. A second cable release attaches to the bellows's shutter-release button. When the button on this cable release is pressed, it causes the other cable release to fire the camera shutter. Different bellows have slightly different cable-release connections—they're detailed in the bellows instruction manual.

The entire bellows assembly attaches to a focusing rail, which, in turn, attaches the assembly to a tripod. A knob on the focusing rail gradually moves the whole assembly forward and back for minute control of focusing. The focusing rail is marked in millimeters so you can readily figure out how much extension is being used and set a desired amount. Tables in the bellows instruction manual tell you how much extension to use to produce a given magnification with a given lens and how much exposure compensation is necessary.

Some bellows units have a rotating lens standard, so the lens can be reversed easily. Reversing the lens provides slightly greater magnification and sharper results in close-up work. A useful bellows accessory is the macro stand, which holds both bellows and subject in position for sharp, precise close-up images.

The main disadvantage of a bellows is the same as an extension tube's—loss of light due to the increase in the lens-to-film distance. As with extension tubes, a 35mm SLR's through-the-lens exposure meter compensates for this. Also, the bellows instruction manual includes exposure-compensation tables for various magnifications.

The entire bellows assembly attaches to a focusing rail, which in turn attaches the assembly to a tripod. The knob on the focusing rail gradually moves the whole assembly forward or backward for minute control of focusing.

A bellows unit can let you get very close to your subject, as this shot of a portion of a dime illustrates.

Macro Lenses

Macro lenses focus more closely than standard lenses, and they're optically optimized for close shooting distances, so they produce great image quality in close-ups. And unlike lenses attached to an extension tube or a bellows, macro lenses can focus out to infinity, so they're great all-around lenses. Most macro lenses today will focus close enough to produce life-size (1:1) images on the film. Those that don't come with a short extension tube (called a "life-size adapter") that enables them to do so.

The most commonly used macro lenses come in standard focal lengths (50mm, 55mm, and 60mm) and short tele (90mm, 100mm, and 105mm) focal lengths. There are also a few longer macro lenses (180mm and 200mm). A 200mm macro lens produces a life-size image from four times as far away as a 50mm macro lens—handy if

your subject is a deadly snake or a skittish insect—giving you more room to position your light source (if you're using artificial lighting, such as flash).

Macro lenses are designed primarily for close-up work, and they produce excellent image quality at close focusing distances. But the image quality of today's macro lenses is excellent at normal shooting distances, too—and macro lenses are the only close-up devices that let you go from 1:1 to infinity focus. On top of all that, macro lenses work just like standard lenses; there's no exposure compensation needed as with extension tubes and bellows. If you're interested in close-up work and need a telephoto lens as well, you should consider a 100mm or longer macro lens—it could be well worth the additional cost.

Macro lenses produce great results in close-up work and general photography.

Macro lenses do have their drawbacks, including a lack of lens speed compared to nonmacro lenses of equal focal length, added weight, and higher cost.

Lens-Reversing Rings

The lens-reversing ring has a camera-body mount on one side and a threaded ring into which the front of the camera lens screws on the other. The reversing ring attaches to the camera, extension tube, or bellows, just like a lens. The front of the camera lens screws into the reversing ring.

Why use the lens reversed? Because standard (nonmacro) lenses are optically optimized for

Watch Out!

Many zoom lenses are touted as being "macro." Most really aren't—they'll focus only close enough to produce 1/2–life-size images on the film. Only a few macro zooms focus down to 1/2–life-size, and none go to life-size.

normal shooting distances, they produce somewhat below-optimum image quality at close-up distances—particularly edge softness due to curvature of field. Reversing the lens produces better results for close-up work (especially when photographing flat subjects such as photos), and greater magnification with normal and wide-angle lenses.

Tele-Converters

The tele-converter (also known as a tele-extender) is a handy device that mounts between the camera body and lens and increases the effective focal length of the lens. If you attach a 2× tele-converter to a 50mm lens, you'll have a 100mm lens; attach a 200mm lens to the converter, and you'll get a 400mm lens.

There are also 1.4× and 1.7× tele-converters. This AF Adapter for Pentax AF SLRs provides 1.7× magnification (it turns a 100mm lens into a 170mm lens, for example) and provides autofocusing capabilities with nonautofocus Pentax lenses that have maximum apertures of f/2.8 or faster.

Most major-brand tele-converters produce good results. There is a slight loss of image quality, but not a lot. Some manufacturers offer matched tele-converters, made specifically for use with a particular lens (or a specific focal-length range). These can produce even better photographic results than general-purpose converters.

Tele-converters have one major drawback: they cause a loss of lens speed. When you attach a 2× tele-converter, the lens becomes effectively two stops slower. For example, attach a 50mm f/1.4 lens to a 2× converter, and you've got a 100mm f/2.8 lens. Attach a 200mm f/4 lens, and it becomes a 400mm f/8. Automatic converters that connect to the

Photo Fact
Tele-converters look sort of like extension tubes, but extension tubes are hollow tubes—they contain no glass elements. Tele-converters do contain glass elements.

camera's metering system will automatically compensate for this loss of light transmission when the camera's through-the-lens metering is used. With other converters, you must meter in the stopped-down mode. When using a separate hand-held meter and a 2× tele-converter, set the lens to an aperture two stops larger than the meter reading calls for: If the meter calls for f/11, set the lens aperture ring to f/5.6 (or increase exposure two stops by slowing the shutter speed). The following chart shows how much light is lost when using various tele-converters.

Converter	Light Loss
1.4×	1 stop
1.7×	1.5 stops
2×	2 stops
3×	3.3 stops

Another nice thing about tele-converters—and the reason they are included in this chapter—is that the lens's minimum focusing distance remains the same when a converter is used. Because of this, you can get some great close-up images by using a teleconverter.

This San Francisco street scene was shot hand-held with a 200mm lens and 2× tele-converter, the equivalent of hand-holding a 400mm lens.

Close-Up Equipment Tips

Moving in close magnifies everything—the image and the effects of camera and subject movement. To minimize camera movement, it's a good idea to attach the camera to a sturdy tripod for close-up work. Trip the shutter with a cable release (or the camera's self-timer, if precise timing of the moment of exposure isn't essential)—the mere act of pushing the shutter button with your finger can introduce enough camera movement to reduce sharpness in high-magnification photography.

Watch Out!

You won't be able to see through the viewfinder with the mirror lock up, but for most close-up work, you'll have your composition locked in with the tripod before you make the exposure, so that won't matter.

Hot Tip

If there's a breeze, you can use a sheet of poster board to shield your subject from it. White poster board makes a good reflector. Don't use colored poster board; the board's color will reflect onto the subject. Dark poster board can be used to block harsh sunlight from the subject.

If your SLR camera has a mirror prelock, use it to lock the mirror in the up position before shooting. The vibration caused by the mirror flipping up out of the way when the shutter is tripped can shake the camera enough to reduce image quality when working at high magnifications, especially at shutter speeds in the one second to 1/30 range.

To minimize blur due to subject movement, usthe fastest shutter speed the light level will permit. Depth of field is extremely limited at close-up shooting distances, so you'll generally want to shoot at the smallest aperture possible to maximize it. Of course, short shutter speeds require larger apertures, and vice versa. One answer is fast film—today's ISO 400 films are by and large excellent.

You can get around the fast shutter speed/small lens aperture dilemma by using electronic flash. Used at close range, a simple electronic flash unit provides enough light to permit stopping the lens way down to maximize depth of field, while its brief flash duration minimizes the effects of camera and subject movement.

An off-camera sync cord will let you move the flash unit off the camera's hot-shoe for more lighting flexibility—you can use the flash to produce side lighting to bring out the subject's texture and three dimensionality, or use the flash to backlight a translucent subject to make it seem to glow from within.

When using extension tubes or bellows, you'll find the image in the viewfinder quite dark because of the extension. To make focusing easier, don't use the central split-image—it will black out. Instead, use the plain ground glass area of the viewfinder. You might carry a small flashlight to help illuminate your subjects for easier focusing.

Dedicated electronic flash units, used at close-up shooting distances, provide enough light to allow you to stop the lens down for maximum depth of field, while the brief flash duration minimizes the effects of camera and subject movement.

Close-Up Shooting Tips

You don't *have* to enter the life-size realm to get nice close-ups. Just shooting as close as your camera will permit will provide your pictures with a new point of view. If you have a point-and-shoot zoom camera, try different zoom settings from the closest distance it will let you shoot.

These close-ups were made with an APS SLR with 22–55mm zoom lens.

(Ron Leach)

Lighting for Close-Ups

Just as in any type of photography, lighting is a key element in every close-up photo. Chapter 15 tells you all about it, but here are some things to think about as it pertains to close-up shooting.

Lighting the subject from directly in front has a flattening effect because there are no shadows, but it also shows all the detail in the subject because there are no shadows to hide it. Sidelighting emphasizes texture and roundness, which are often very important aspects of close-up subjects. Backlighting makes translucent subjects seem to glow from within, emphasizes edge details, and can provide separation from the background by creating a rim of light around the subject.

Be aware of the background, especially in black-and-white work, where there is no color contrast to separate subject from background. For example, shooting a dark fern against the light sky will provide good subject-background separation; shooting it against the dark ground won't.

Front lighting is good for turning close-up subjects into abstracts, because it minimizes the feel of depth in the picture.

(Lynne Eodice)

Sidelighting emphasizes form and surface texture.

(Lynne Eodice)

Backlighting (rimlighting) emphasizes edge details and can make a subject stand out from the background.

(Lynne Eodice)

Depth of Field

Depth of field is minimal at close-up shooting distances, even at small lens apertures, so focus carefully on the most important part of the subject. When shooting at near–life-size magnifications, it's easier to focus by moving the camera closer to or farther from the subject than by rotating the lens's focusing ring. AF SLRs do a good job of autofocusing with macro lenses, but extension tubes and bellows are move-closer-or-farther devices.

The Least You Need to Know

- You can shoot interesting close-ups with a point-and-shoot camera.
- Many digital cameras provide excellent close-up capabilities.
- You need an SLR for serious close-up work.
- There are lots of ways to make an SLR focus more closely.
- Close-up lenses are the simplest and least expensive way to get close.
- A tripod is very helpful in close-up work. Electronic flash is a great light source for close-ups.
- As in all photography, consider the lighting and background before you shoot.

How to Photograph Great, Outdoors

In This Chapter

- ◆ Making the most of lighting
- ◆ Timing is still everything (even with subjects that don't move)
- ◆ Photographing beasts in the wild and elsewhere
- ◆ Getting artistic with trees and flowers
- ◆ Shooting buildings and skylines

Outdoor photography encompasses a wide range of subject matter: wildlife, landscapes, close-ups, people, architecture, sports action, and more. People, sports action, and close-ups each have their own chapter in this book, so this chapter will show you how to take good pictures of landscapes, beasties, buildings, and plant life.

It's great to get out in the fresh air and enjoy the works of nature … and the works of man. And it's great to bring back great photos of what you see

while you're out there enjoying it all. This chapter will give you some ideas that will help you do just that.

You don't have to visit exotic locations to have a lot of fun and bring back great photos. Your own backyard and your own town will yield a wide variety of outdoor photo opportunities—parks, trees, flowers, buildings, zoos, outdoor outings with the family, and the like. Smart subject selection and creative cropping can give you great shots just about anywhere.

A few words about nature and photographic ethics: It's okay to photograph zoo and other captive or tame animals and to manipulate your images with a computer (or in the darkroom). A great picture is a great picture, no matter how it was produced. But it's not okay to try to pass off photos of captive animals as having been taken in the wild or to claim manipulated images are "straight" photos. Just be honest—it's that simple!

Landscapes

Landscapes are a very popular photographic subject, and quite a few photographers make a good living photographing them professionally. Those pros usually work with large-format view cameras and medium-format cameras that are beyond the scope of this book, but you can shoot wonderful landscapes with an AF 35mm SLR (I can think of at least one famous landscape shooter who worked exclusively in 35mm) and even with a point-and-shoot camera. You don't need exotic lens focal lengths, super-fast lenses, or any special equipment. A tripod can be helpful to lock in your compositions but certainly isn't necessary for 35mm and APS landscape photography.

Hot Tip

If you're planning a trip to a national park or any scenic location, call ahead and ask a ranger when the best time of day and year is to photograph its picturesque features. Save yourself from experiences like mine, when I showed up in Yosemite late one August to photograph the breath-taking waterfalls I remembered from my last trip (in April), only to discover they dry up for the summer.

One thing you have to deal with in landscape photography is that you can't move your subject or the sun. If you're photographing a person outdoors and you don't like

the lighting, you can have the person face into the sun or away from it, or move into the shade. With landscape subjects, you have to be there when the lighting is right. If the subject faces east and you want front lighting, you have to shoot it in the morning when the sun is in the east. If you want sidelighting on that subject, you have to position yourself north or south of it. If you want backlighting, you have to shoot in the afternoon when the sun is in the west. Professional landscape photographers plot all this out beforehand, so they get to each subject they intend to photograph at the right time of day (and in the right season, and in the right weather). Your schedule probably doesn't allow you to do that (mine sure doesn't), but there are some things the pros do that you can do to make beautiful landscape pictures.

Lighting Is the Key

The secret to striking landscape photos is great lighting, which occurs early and late in the day, when the sun is low in the sky and produces long, dramatic shadows. If you shoot with the sun off to one side, the strong sidelighting will emphasize the texture and shape of mountains, hills, rock formations, and even clouds.

If you are traveling and come across something you wish to photograph, go ahead and photograph it, even if it's midday. But if possible, come back later in the day, when the lighting is more dramatic. Professional landscape photographers plan their outings to be at the sites they wish to photograph when the lighting is right. You might not have that flexibility when traveling, but keep in mind that the best lighting for landscapes occurs early in the morning and late in the afternoon.

Artistic Considerations

Exciting lighting can make for an exciting landscape shot, but your pictures will be even better if you compose the image interestingly. Distant scenes with the horizon running through the middle of the picture are pretty dull, even with exciting lighting.

One effective way to get more dynamic landscapes is to move in close to an interesting element in the scene with a wide-angle lens (or the wide setting on your point-and-shoot camera's built-in zoom lens).

Don't be afraid to move the camera to get a better picture. Sometimes, just moving the camera a little to the left or right or a little higher or a little lower will hide a distracting element or bring into view something interesting.

Shoot with the sun off to one side early or late in the day (here, the sun was to camera left), and you get strong sidelighting, which emphasizes the texture and form of your landscape subjects. Shooting with the sun off to one side also makes your polarizing most effective, darkening the sky to make white clouds really stand out.

(Lynne Eodice)

Another advantage of early or late sunlight is that its low angle lets you produce images like this, with a black silhouette offsetting the richly sunlit area. For this effect, you should expose for the sunlit area, and let the dark area go black. You couldn't make this shot at midday.

(Lynne Eodice)

Try shooting an attractive scene at different times of day, from sunrise through twilight. You'll likely get several "keepers."

(Lynne Eodice)

Some famous scenic subjects have been photographed so many times you can see the holes left by all the photographers' tripods. But that doesn't mean you should avoid photographing those subjects. They're oft-photographed because they make for great pictures. If you're going to an area that has some of these subjects, look at some of the famous photos of them before you go to get some ideas about how to photograph them—and when (what time of day, what season, what weather).

Formats

Most people shoot landscapes in the horizontal format, and that often works. But don't forget about the vertical format. It can also be effective. If you're having trouble composing a landscape, especially one with a foreground subject, try the vertical format. Be sure to use your camera's panoramic format (if it offers one) for both horizontal and vertical images.

A foreground subject can add interest and perspective to a scenic shot. Forests are most easily photographed on overcast days as was the case here because the even lighting is less contrasty. On sunny days, the bright sunbeams and deep shadows are dramatic, but they're difficult to handle with color film.

(Lynne Eodice)

Dealing With the Sun

The sun is an important element in every landscape photo, even though it doesn't appear in most of them. It produces the highlights and shadows that make the picture interesting or dull.

Another way to add interest is to include the sun in the shot. If the sun is too bright to look at with the naked eye, use a wide-angle lens, so it'll occupy only a small portion of the picture or flare will wash out the whole image. When the sun is near the

horizon so you can look at it with the naked eye, you can make it appear huge by using a telephoto lens and focusing on a nearby foreground subject. The out-of-focus sun in the background will look much bigger than if it were in focus.

Sunrises and sunsets are very popular landscape subjects, and with good reason—they're beautiful. If there are some clouds the sun can light up from below, so much the better. Some of the most dramatic sunrise and sunset photos are made when the sun is just below the horizon, lighting those clouds. When the sky is spectacular, include a lot of it in the picture by placing the horizon line low in the frame. When the sky isn't so spectacular, place the horizon higher to include more of the surface—sunrises and sunsets over a large body of water can be very colorful.

 Watch Out!

Never look at the sun through a telephoto lens—severe eye damage can result. To avoid this, mount the camera on a tripod, focus on the nearby subject with the sun just out of frame to one side, then remove your eye from the viewfinder and turn the camera slightly to put the sun back into the frame.

This cloud formation just seemed to fit into the space between the two big rocks. The fact that one rock is in shadow and the other is in sunlight adds visual impact.

You can add interest to a sunrise or sunset shot by including a foreground subject. If you want the foreground subject to appear as a silhouette, just let the camera expose the scene automatically. If you want detail in the subject, use fill-flash mode, and the flash will add light to the subject. Some AF 35mm SLRs will automatically balance exposures for a flash-lit foreground subject and an ambient-lit background—see Chapter 10 for details.

Silhouette a foreground subject to add interest to a sunset shot.

(Lynne Eodice)

Waterscapes

Everything that applies to photographing landscapes also applies to photographing waterscapes. Plain water makes for a boring photo, but if you include a foreground subject or interesting reflections, you can add lots of interest. Foggy mornings and evenings can be really dull and gray, but if the sun breaks through, foggy mornings can be sources of wonderful atmospheric waterscape pictures. The fog reduces the scenic brightness range, so automatic exposure will give you good pictures with no compensation.

Hot Tip

A good way to add interest to a shot of moving water is to use a longer exposure time. This blurs the water into a "cotton-candy" effect that can be quite interesting.

Where Do You Find Landscapes?

Classic landscape shots picture wild areas—national parks and monuments, wild lands, and the like. By all means, visit these places and take pictures; they're beautiful places to see in real life, and they make for terrific pictures. But you don't have to go to the ends

of the world to shoot interesting landscapes. There are probably some picturesque places right near you (several of the photos here and in other chapters of the book were shot in a flood basin in the middle of the densely populated San Fernando Valley adjacent to Los Angeles).

Reflections in bodies of water can make for interesting images.

The traditional landscape subjects make for great pictures—that's why they're photographed so often. The slot canyons of Utah and northern Arizona, as shown here, are one example. Metering can be tricky; use spot mode to read a midtoned area or to determine the brightness range (that is, read the brightest and darkest areas, then set the exposure halfway between). If the scenic brightness range is excessive (more than about five stops), it's better to expose for the highlights and let the dark areas go black.

(Lynne Eodice)

Bagging Beasties

Professional wildlife photographers study up on their subjects, then go out in the field for days, weeks, and even months. Most of us don't have the time for that, but there are some shortcuts to great animal photos. One is to shoot from established animal viewing areas. Many national parks and wildlife refuges have viewing platforms for photographers and spectators.

Long lenses (and a tripod to brace them) are a must for photographing animals from these areas—300mm and longer for 35mm cameras. Unfortunately, a point-and-shoot camera isn't going to get you great wildlife shots in the wild.

However, you don't need wild subjects to get good animal photos. You can make some nice shots of domestic animals, too, and such beasties are generally more accessible. Since domestic animals are tamer and less dangerous than wild ones, you can get closer and use shorter lenses, including those built into point-and-shoot cameras.

Don't forget about small, common animals—they make good photo subjects, too. Smaller animals tend to be more skittish, but with patience (and a long lens), you can get some cute pictures.

Hot Tip _____

If you have to shoot through a chain-link fence, move the camera as close to it as you can and shoot at the lens's widest aperture to minimize depth of field. This usually will throw the fence so far out of focus that it doesn't even show in the picture. If the animal is behind glass, move the lens against the glass to avoid reflections.

At the Zoo

As mentioned at the beginning of this chapter, there's nothing wrong with photographing captive animals in a zoo, as long as you don't try to pass the shots off as having been taken in the wild. At a large zoo, you can find almost any type of animal you want to photograph. Petting zoos offer opportunities to make pictures of children interacting with cute beasties.

Try to do your zoo photography at off-times—it's hard to shoot when there are people everywhere. Weekdays during the school year are better than weekends and summer days, and first thing in the morning is better than later in the day if you want to avoid crowds.

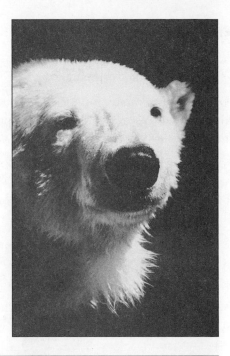

This polar bear close-up was made at the zoo with a 400mm mirror lens on an Advanced Photo System camera, the Minolta Vectis S-1.

(Lynne Eodice)

Domestic animals make great outdoor photo subjects because you can approach them more closely and safely than you can wild animals.

(Ron Leach)

Patience is a virtue, especially when photographing animals. Find a spot that gives you a good view of the animal you wish to photograph, check the lighting and background to make sure both are attractive, and then wait for the animal to strike a pose … or at least look in your direction.

Photographic Considerations

Although animals themselves are fascinating, don't forget about good photographic principles—lighting and composition, for example.

Lighting is a key element of every photograph, and that includes photos of animals. When you are checking out animals to photograph and spots to photograph them, think about the lighting as well as the background.

Depending on which way the animal's enclosure faces, the lighting might be better in the morning or in the afternoon. Midday sun generally isn't attractive for the same reasons it's not good for people pictures; it comes from too high an angle and is too harsh.

Lighting is a key element of every picture, and that includes pictures of wildlife. Here, side-lighting and the right angle of the head adds life to the great blue heron's eye.

Flying and quick-moving nonflying animals require good action techniques (see Chapter 17). Practice tracking and focusing on birds and neighborhood pets, and you'll be ready for your wildlife subjects.

As with people photography, don't simply shoot the whole animal standing there. Once you've got your "record shot," be creative. Crouch down low, move to a high vantage point, shoot from one side of the viewing area and then from the other side. Use a long lens to zoom in on the most interesting part of the animal.

For variety, try using a long lens to tightly crop the subject. About the only way to get this close without exotic equipment and lots of patience is to photograph captive birds.

(Ron Leach)

Beasties and Their Environment

Environmental portraits tell the viewer something about the animal's habitat and lifestyle. When shooting in the wild with a point-and-shoot camera, concentrate on environmental portraits of the animals if you can't get close enough to fill the frame with the animal. Even if you have a camera with a long lens, shoot some environmental portraits of the animals.

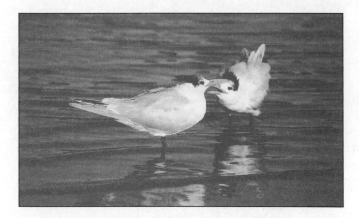

Animals interacting are more interesting than one animal just standing there. As I recall, this conversation was something about one good tern deserving another.

The scenery can add interest to your photo album or slide show. At wild animal parks and some zoos, you can get shots of animals in natural-appearing habitats. Be sure to choose a shooting angle and lens focal length that keep unnatural elements from appearing in the picture.

You might have to shoot close-ups of just the animal's head to crop out distracting elements.

People Outdoors

Outdoors is a great place for people photography, too. Chapter 16 tells you all about photographing people, indoors and out, but here are some tips.

Direct, high-noon sunlight is bad for people pictures because it's too harsh, making people squint; and it comes from too high an angle, hiding eyes in pockets of deep shadow. But the sun makes a great people-lighting source late in the day when it is low in the sky. Then, it's not so harsh and comes from a more pleasant angle. You can have the subject face directly into the afternoon sun for front lighting or at an angle for directional front-sidelighting. Or you can have the subject turn his or her back to the sun for softer light on the face. (If you do this, it's a good idea to use a reflector or fill-flash to add a little light to the face and sparkle to the eyes.)

Take advantage of outdoor props. For example, you can pose your subject in a doorway, adding interest to the picture and giving you a good compositional element.

> **Watch Out!**
>
> Don't give up on overcast days. The clouds act as a huge diffuser, turning the whole sky into a pleasant soft light source that can produce attractive portraits.

Doorway portraits can be an interesting outdoor theme.

(Ron Leach)

Flora

Trees and flowers are fun photo subjects. Trying to capture their beauty on film is a challenging and rewarding form of photography. Here are some tips.

Many flowers and leaves are translucent; they have texture and color but let light come through. If you shoot such subjects backlit, they seem to glow from within—a very beautiful effect.

If you're photographing a large tree, use a wide-angle lens and shoot at a small aperture to increase the depth of field and get everything sharp from nearest branch to farthest. With a point-and-shoot camera, use ISO 400 film to force the camera to use a small aperture.

Hot Tip

When shooting flower close-ups, you can use a wide lens aperture to isolate a single flower from its surroundings or a small aperture to show the surroundings. Try both ways and see which pictures you like best.

Backlighting can make translucent leaves come alive in a photo.

(Lynne Eodice)

Flowers offer color as well as interesting shapes. You can photograph a whole field of flowers for their vivid colors (try both eye-level and very low shooting angles, and use a wide-angle lens) or move in to photograph just a few. You can move in even closer and photograph a single flower if your camera and lens permit it. With a point-and-shoot camera, use macro mode. With an AF 35mm SLR, use a macro lens or attach a close-up lens to the camera lens (see Chapter 18 to learn about close-up photography).

Try unusual angles. Here, shooting straight down produced an interesting pattern. The old "rule of thirds" can be used effectively with natural subjects.

Think about what you enjoy about the location and try to capture that in your pictures. If you can make the viewer feel what you felt when you were there, you've done your job as a photographer.

Buildings

Buildings are good photo subjects because they can give you some great pictures, and they're readily available. Although professional architectural photographers use complex large-format view cameras to photograph buildings, you can make interesting photos of them with any camera. Here are some tips.

Straight shots of buildings can be dull. A couple of ways to improve your shot is to shoot early or late in the day when the light comes from a low angle. Include a foreground object to add interest.

If you have a long lens (200mm or longer, preferably), you can zero in on a small portion of a building or buildings, compressing the scene into an interesting abstract image.

Reflections in modern glass buildings can be interesting. You can focus in on just the distorted reflection or include enough of the building so the viewer can tell at a glance what it's a picture of.

As in all types of photography, it's important to consider the lighting when taking pictures of buildings. Try shooting buildings in the late afternoon (or early morning) when the warm low-angle sunlight and cool blue shadow areas contrast to create a beautiful

effect. Midday sunlight isn't best for shots of entire buildings, but the high-angle harsh lighting is great for bringing out textural detail in photos of vertical surfaces.

As with any subject, cropping in to abstract a portion of a building can produce effective photographs. The diagonal composition adds to the abstract-pattern effect.

Look for reflections in glass building surfaces—they can yield interesting images. Many buildings are lit beautifully at night. Put your camera on a tripod, compose carefully, and you'll get some nice pictures. Oddly enough, built-in camera meters seem to handle night shots of lit buildings quite well.

As you learned in Chapter 9, shooting up at tall buildings causes the sides to converge near the top of the picture. This can be a useful effect. If you wish to avoid it, though, you have to keep the camera pointed straight ahead, which means you have to use a wide-angle lens to get the whole building in. Or you can shoot from halfway up a neighboring tall building.

Try shooting from different vantage points. Stand directly under a power-line tower or other such structure and shoot straight up to abstract it. Move around with your camera. Frame the subject with foreground elements. Try different focal lengths and shooting distances. A single subject can yield a variety of exciting images when shot in different ways.

Night can be a good time for architectural shots—the artificial lighting can be beautiful.

(Lynne Eodice)

City Skylines

Photograph your city's tall buildings from a distance against the rising or setting sun and also away from the rising or setting sun. Shoot just before the sun comes up or just after it goes down, while there's light in the sky but the building lights are on.

Shooting up at tall buildings with a wide-angle lens produces a looming effect.

One way to avoid converging vertical lines in shots of tall buildings is to shoot them from halfway up another tall building. Here, I aligned the window frames of the building I was in with the edges of the building I was photographing by moving the camera back from the window until the frames matched the building's edges.

Try shooting from different vantage points, with different focal lengths, and at different times of day (and, if the structure is lighted, at night). Try framing the subject with foreground elements, and balancing it with another element. A single subject can yield a wide variety of images when shot in different ways.

(Ron Leach)

Outdoor Films

For general outdoor photography in sunlight, you can use slow films. ISO 100 color-print films are ideal, even for point-and-shoot cameras. If you need great depth of field with a point-and-shoot camera, switch to ISO 400 film.

Hot Tip

Digital camera users will find it almost impossible to use their LCD viewfinders in bright sunlight. There is a way though: a sunshade. See Chapter 22 for more information.

I use slide films—Fujichrome Velvia (ISO 50 and ISO 100), Kodak Ektachrome E100VS, Fujichrome Provia 100F (both ISO 100), and Kodachrome 200 (ISO 200)—for most of my outdoor shooting, switching to faster films when I shoot action with long lenses—Fujichrome Provia 400F (ISO 400) and Fujicolor Superia X-TRA color-print film (ISO 800).

The Least You Need to Know

◆ You can photograph lots of interesting things outdoors with any camera and any lens.

◆ The best outdoor lighting usually occurs early and late in the day.

◆ Try different lenses and different shooting distances for different effects.

◆ Don't forget about vertical and panoramic formats.

◆ As in all photography, lighting is a key element in every outdoor picture.

◆ Buildings make great photo subjects.

Chapter 20

Using the Light That Is There

In This Chapter

- ◆ What you need to shoot in dim light
- ◆ Photographing shows and concerts
- ◆ Shooting at night

Did you know that you have a photo studio? A dandy one. It comes complete with all kinds of sets, lots of terrific lighting, and many moods. And you can use it whenever you want.

Where is this wonderful studio? Everywhere! It's the world! Nature has given us magnificent subjects, backgrounds, and light. Great pictures are there for the taking. Of course, nature isn't our only benefactor. Humankind has added lots of great subjects and lighting (indoors and at night) for us to discover and use.

The world of available-light photography covers pretty much everything outside the formal photo studio. Between sunrise and sunset, daylight is available. The noon sun at the beach is available light if you happen to be at the beach at noon on a sunny day. Available light doesn't have to be dim or difficult. However, dim and difficult lighting is what photographers generally think of when they hear the term "available-light photography," so

much of this chapter is about dealing with dim light. Part 3 (the one about seeing and lighting) shows you how to find and create good lighting and how to work with it to get good pictures, and Chapters 16 through 20 show you how to use light to make great pictures of people, landscape, action, close-up, nature, and travel subjects.

What You Need to Shoot in Dim Light

In bright light, you can shoot with a slow film and get sharp, colorful, near-grainless pictures. It's a little harder to get good pictures when the light level drops, but it's not all that hard when you know how.

Serious available-light shooters use a variety of tools to get good pictures in a variety of shooting conditions. These tools include fast lenses, fast films, special processing, tripods and other camera supports, and exposure bracketing. They also use serious cameras, not point-and-shoot models. But you can shoot in a variety of conditions with a point-and-shoot camera, too—you just won't be able to use the camera hand-held in as many situations as AF SLR users can. AF SLR users can "handle" more situations. Now, let's look at the tools of the available-light photographer.

Fast Lenses

Point-and-shoot cameras generally come with slow lenses: The "window" in the lens that lets light in to the film is smaller than it is in lenses of equal focal length for AF 35mm SLR cameras. Single–focal-length point-and-shoot cameras have maximum apertures of f/3.5 to f/5.6. Zoom cameras have even slower maximum apertures, generally f/3.5 or smaller at the widest focal length and f/8 or smaller at the longest. Even the less-expensive lenses for AF SLRs are faster than this—fixed–focal-length lenses in the 35mm to 135mm range commonly have maximum apertures of f/2.8 or faster, and zooms in that range have maximum apertures of f/5.6 or faster, even at their longest focal lengths. More expensive pro lenses are a couple of stops faster.

What all this means is that AF SLR users, with their lenses that let in more light, can shoot at faster shutter speeds in any given light level—and that means they can shoot hand-held in light levels that require a point-and-shoot camera to be mounted on a tripod

> **Hot Tip**
>
> When you want to shoot by available light with a point-and-shoot camera, be sure to select flash-off mode, because in auto mode, the flash fires in dim conditions.

for sharp results. Of course, any camera will produce sharper results when mounted on a sturdy tripod, and I use a tripod whenever I can for dim-light shooting.

Fast Films

Although you can't switch to a faster lens with a point-and-shoot camera, you can switch to a faster film. Faster film makes the camera use a faster shutter speed and thus helps keep camera shake or subject movement from blurring your pictures. Faster films are grainier, but a sharp, somewhat-grainy picture is almost always preferable to a blurry fine-grained picture. If you have to shoot in dim light with a point-and-shoot camera, use a fast film or a tripod.

Besides being grainier than slower films, fast films (ISO 400 and higher) produce less-saturated colors. But today's fast films, especially ISO 400 and 800, are amazingly good. The fast color-print films are better than the fast color-slide films—I prefer slide films, but if I need a film speed faster than ISO 400, I switch to color-print films because they produce better image quality than the faster slide films do. As I mentioned in Chapter 6, I really like ISO 800 color-print film when I need that much speed (when hand-holding my 400mm f/5.6 supertelephoto lens, for example).

For indoor and night available-light shooting with a point-and-shoot camera, use ISO 800 color-print film.

Superfast films (ISO 1000 and higher) are noticeably grainier than ISO 400 and 800 films but still produce surprisingly good picture quality for the speed involved. For best picture quality, don't use a faster film than you actually need, but don't be afraid to use a very fast film when you do need it.

When do you need it? If you have to hand-hold the camera, you should use a shutter speed equal to the reciprocal of the focal length of the lens you're using (or a faster shutter speed). If you're shooting hand-held with a 50mm lens, you should use a shutter speed of $1/50$ or faster; if you're hand holding a 200mm lens, you should use $1/200$ or faster. If the light is too dim to permit that, it's time to switch to a faster film, or you'll get blurry pictures due to camera movement. If you want to

Hot Tip

Point-and-shoot cameras don't tell you what shutter speed the camera has set, so it's safest to put the camera on a tripod for all dim-light shooting. If you don't have a tripod, you can brace the camera against a handy solid object, like a doorway or ledge, to steady it.

shoot at a small aperture so you'll have enough depth of field to get a main foreground subject and an important background subject sharp, and the light level won't let you do that at a hand-holdable shutter speed, it's time for a faster film. Maybe you need both a fast shutter speed and a small lens aperture to get the picture you want. In any of these situations, the solution is to switch to a faster film.

Kodak T-Max P3200 provided enough speed at 3200 to let me make this shot hand-held with an AF 35mm SLR and short telephoto lens.

Image Stabilizers

Several Canon and Nikon lenses incorporate image stabilizers that help greatly when you have to shoot hand-held at slower shutter speeds. You can often get sharp results three shutter speeds slower with the stabilizer than without. For example, with a 400mm image stabilizer lens, an "average" photographer could get sharp hand-held shots at shutter speeds as slow as $^1/_{50}$ second. Canon's image-stabilizer lenses are designated "IS"; Nikon's, "VR" (for "vibration reduction"). Minolta has incorporated an image stabilizer in its DiMAGE A1 and A2 consumer digital cameras.

Accessory gyro stabilizers are also available for cameras. These contain a spinning gyro mechanism that resists movement, helping keep the camera steady for sharper images. Such stabilizers are quite costly, but can be very useful if you do a lot of hand-held low-light shooting.

Special Processing

Sometimes even the fastest film available isn't fast enough. Maybe you only have ISO 100 and 400 film, and you need ISO 1000 to use a fast-enough shutter speed or small-enough lens aperture. You can expose the ISO 400 film at 1000 (by setting the camera's ISO index to 1000 instead of 400 if the camera permits you to override the automatically set film speed) and have the lab push-process the film. Chapter 8 introduced you to push- and pull-processing. Push-processing partially compensates for underexposing the film (which is what you are doing when you expose ISO 400 film at 1000). Push-processed pictures are grainier and contrastier than normally exposed and normally processed pictures with less detail in the dark areas, but they're better than blurred pictures (which you'd get if you exposed the film at its normal speed) or murky dark pictures (which you'd get if you exposed the film at the higher speed and had it processed normally).

Most films push one stop with good results and two stops with okay results—it's generally better to switch to a faster film than to push film two stops. If you need a speed increase of more than two stops, it's definitely better to switch to a faster film than to try to push a slower film that much. I use ISO 100 slide films for most of my shooting. If I need a speed of 200, I'll rate the film at 200 by setting the camera's ISO index to 200 (if your camera doesn't allow you to set film speeds manually, use its exposure-compensation feature and set -1 stop of compensation). If I need a speed of 400, I'll switch to ISO 400 film. And if I need a speed of 800, I'll switch to ISO 800 color-print film. When pushing film speed, remember to mark the film cassette as to the film speed you used, and tell the processing lab the film was exposed at that speed.

Available-light scenes sometimes have an extremely wide brightness range. That means the brightest important areas (sunlit subjects outside a picture window, for example) are a lot brighter than the darkest important areas (people seated at a table in the dark room, for example). With such scenes, film can't hold detail in both the brightest and darkest subjects if exposed and developed normally.

A good way to handle these situations is with pull-processing. Overexpose the film (by setting your exposure meter's ISO index to a lower number than the film's speed), and have the lab underdevelop it to compensate. Black-and-white films respond to pull-processing

> **CAUTION**
>
> **Watch Out!** _____
>
> Push film speed only when necessary because doing so reduces image quality.

better than color films do—as a general rule, you can pull black-and-white films two or three stops, but one stop is about the limit for color films before you start running into color shifts.

Photo Fact

Special extended-range developers—my favorite is Perfection Super Speed—produce better results with pull-processing than simply reducing the development time as a normal developer does. Custom labs generally have their own methods for pushing and pulling film; ask your lab how far they can push and pull the film(s) you use.

Bracketing Exposures

As explained in Chapter 7, bracketing exposures means to take one picture at the exposure you think is right, then take additional pictures, giving more and less exposure than that. This pretty much guarantees that you'll get at least one picture that's exposed properly.

Many AF SLRs have a feature called automatic exposure bracketing, which conveniently takes three consecutive pictures, each at a different exposure setting. When you're shooting in dim or contrasty lighting—which is often the case with available light—you should bracket exposures. (Or learn Ansel Adams's Zone System—but its nuances are beyond the scope of this book. See Adams's books *The Negative* and *The Print* if you're interested in this very accurate way to expose and process black-and-white film.)

Bracketing not only compensates for situations that "fool" your exposure meter, it also helps to compensate for reciprocity failure. As explained in Chapter 7, at very long and very short exposure times, film loses sensitivity, resulting in underexposure even though it's exposed according to the meter reading. To compensate for this, you must give the film more exposure than the meter calls for. Each film's reciprocity characteristics are different, and you can get specific data for a given film from its manufacturer. As a general rule, if you intend to make long exposures (several seconds or longer), bracket by shooting one picture at the metered exposure, another giving one stop more exposure, and another giving another stop more exposure (0, +1, and +2 on the exposure-compensation dial).

Camera Supports

As you've probably gathered by now, I'm a big fan of tripods. Granted, one of the big advantages of the 35mm (and APS) camera over larger-format cameras is that it's "an extension of the eye as used freely in the hand," as larger-format guru Ansel Adams put it. And I do shoot hand-held a lot. But if sharpness is very important, I put the camera on a tripod. Why? Because the tripod can hold it steadier than I can. It's that simple. If your subject isn't moving, you can get sharp pictures at long exposure times by attaching the camera to a sturdy tripod.

If carting a tripod around is too awkward, try a monopod—it will help you produce sharper pictures than you'd get with the hand-held camera. And as mentioned earlier, you can always brace the camera against a handy solid object, like a doorway or a low wall. (See Chapter 11 for more about camera supports.)

Focusing in Dim Lighting

The autofocusing systems built into AF SLRs have a hard time focusing in dim light for the same reason we have trouble focusing in dim light manually—neither the AF system nor our eyes can see well enough to focus. Fast lenses let more light reach the AF sensor and so allow the camera to autofocus and us to focus manually more easily. Most AF SLRs also have a focus-assist feature, in which the camera (or a hot-shoe–mounted dedicated flash unit) emits a patterned beam that provides the AF system with something to focus on. Focus-assist enables the camera to autofocus in dim light, but it slows down the process and doesn't work beyond about 20 feet.

Point-and-shoot cameras with infrared AF systems can focus fine on nearby subjects in dim lighting, but some point-and-shoots have passive AF systems like the AF SLRs, and they have trouble in dim light. A few point-and-shoot cameras have both systems, switching to infrared in dim lighting.

> **Hot Tip**
>
> One nice feature of AF SLRs is the in-focus light in the viewfinder. It works when you are focusing manually, too. So even if you can't tell when the subject looks sharp in the finder, the in-focus light will let you know.

Photographing Shows and Concerts

Stage shows and concerts are best photographed by available light for three reasons. First, using flash generally is not permitted because it would disturb the other audience members and the performers. Second, using flash will destroy the carefully designed lighting effects—and you'll get your best pictures by taking advantage of those. Third, you'll very likely be too far away from the subjects to use flash because the flash units built into point-and-shoot cameras and AF SLRs aren't very effective beyond 10 to 15 feet.

It's tough to get great shots at big-time concerts and plays because only credentialed photographers can get close to the action, and photography by others is often prohibited. You'll have better luck arranging to shoot from a good vantage point at amateur events, such as your child's school or church play or concert. If you have to shoot from your seat, a fast zoom lens and fast film will let you vary the cropping and allow you to shoot at fast-enough shutter speeds to get sharp images with the hand-held camera. At smaller community theaters and school events, you can sometimes arrange to shoot during a dress rehearsal and thus gain access to good vantage points.

This picture was shot during a dress rehearsal, which allowed me to shoot from a good vantage point. You can get some good close-ups during dress rehearsals and breaks.

If the stage lighting is even across the picture area, your camera's built-in exposure meter will provide good exposures. If the lighting is uneven or a performer is spotlit, use your camera's spot-metering mode (if it has one) to meter the main subject. Pro theatrical photographers often use incident light meters and take readings from the stage during rehearsals to determine accurate exposures for each lighting effect.

Night Photography

Night is a beautiful time with many moods. Neon-bright boulevards, colorful amusement parks, eerie seascapes, and lonely moonlit landscapes all are there for the (picture) taking. Many subjects that are dull by day become fascinating when darkness falls and the night lights come on. Shooting at night is a great way to escape the doldrums of "everyday" photography.

All you need to make good night pictures is a camera that can make long exposures and a tripod to hold it during those exposures. If you use a fast film, you can shoot street scenes without a tripod. The tripod, however, greatly expands your realm of potential photographs and allows you to use slower films that produce better image quality. A small flashlight to help you see while making camera settings is another useful item.

Night Exposures

In a surprising number of night situations, your camera's built-in exposure meter will provide good results. If you don't have a meter, the accompanying chart gives you a few exposure suggestions to get you started. Either way, it's a good idea to bracket exposures when shooting in conditions you've never encountered before. The following table gives you some starting points for night exposures, using ISO 400 film.

Night Exposure Starting Points

Subject	Exposure (ISO 400)
Distant cityscapes	5 sec. at f/4
Nearby cityscapes	1/30 at f/2.8
Lit buildings	1/15 at f/2
Street scenes	1/60 at f/2.8
Reflections in wet streets	1/15 at f/2

continues

Night Exposure Starting Points (continued)

Subject	Exposure (ISO 400)
Freeway traffic	10 sec. at f/16
Amusement parks	1/30 at f/2.8
Outdoor sports in stadiums	1/125 at f/2.8
Fireworks	f/16 (for duration of burst)
Neon signs	1/60 at f/5.6
Christmas lights	1/2 at f/4
Store window displays	1/60 at f/4
Star trails	20 min. to all night at max. aperture
Full moon	1/500 at f/11–16
Moonlit scenes (full moon)	3 min. at f/2.8

Bracketing exposures is probably the most important piece of advice I can give the neophyte night photographer. Although purists will cringe at this, there is really no single "correct" exposure for a typical night scene. The less exposure you give, the darker the scene will appear; the more exposure, the lighter. The exposure that produces the most accurate rendering of a given night scene is not necessarily the exposure that will produce your favorite image. So it's a good idea to bracket exposures at night; you'll get several different usable images of the scene. Start with your in-camera meter's recommendation or those in the accompanying night-scene exposure chart, and bracket. Keep notes, and soon you'll know how to expose different types of night scenes to produce what you want in your photograph.

If you have a tripod, you can use longer exposures and slower films for sharper, finer-grained images. If you want to do hand-held night shooting, you'll need a fast film (ISO 400 or faster). Kodak's T-Max P3200 and Ilford's 3200 are the speed kings of films, capable of reaching exposure indexes of 6400 and beyond.

Night scenes generally contain extreme contrasts—from light sources themselves to black unlit areas. It's best to expose for the lit areas and let the unlit ones go black—after all, that's what makes a night scene look like a night scene. So use your camera's spot-metering capability (if it has it) to meter an important lit area of the scene, lock in that exposure, and then compose your picture and shoot. And be sure to bracket exposures.

With a tripod, you can use longer exposures and slower films for better image quality.

Night scenes generally contain extreme contrasts— from light sources themselves to black unlit areas. It's generally best to expose for the lit areas and let the unlit ones go black.

Another way to get better-than-normal detail in a night scene with black-and-white film is to use extended-range development. Generously expose the film to record detail in the dark areas (10 seconds at f/5.6 with Tri-X film is a good starting point) and use a special extended-range developer to keep the bright areas from becoming

unprintably dense on the negative. Perfection Super Speed developer, used per the extended-range instructions packaged with it, is excellent for this effect. (Write Perfection at 10021 La Tuna Canyon, Sun Valley, CA 91352 for information on their current developers.)

Photo Fact

If you want detail throughout your night scene, cheat! Shoot at twilight, when the city lights are on, but there is still some light in the sky. A more complicated way to produce a similar effect is to make a double exposure—one shot just before the city lights come on to record overall detail and one shot after dark to record the lights. This means you have to keep the tripod-mounted camera from moving at all for a couple of hours—the twilight method is quicker and easier.

You can get detail throughout a "night" scene by cheating—shoot at twilight when the lights are on, but there's still light in the sky.

Overexposure and extended-range development can provide more detail in all areas of a night scene than normally is possible.

You can also try the opposite treatment: pushed development. If you develop the film yourself, underexpose the film by a couple of stops and develop it in a "speed-increasing" developer. There are several such developers on the market that produce usable images when the film is rated at higher-than-normal speed (that is, under-exposed).

Note: You can't increase film speed very much, but you can get usable images at two to four times the normal ISO by using such developers. When you push film to a higher EI, you won't get the same image quality you get with normally exposed and developed film—you'll get more grain, more contrast, less shadow detail, and less sharpness—but you can make shots that wouldn't be possible otherwise. Push-processing is a useful technique if you keep its limitations in mind.

As mentioned in Chapter 6, there are two types of color-slide films: daylight and tungsten. Daylight films produce accurate colors in daylight; tungsten films produce accurate colors in tungsten lighting. Night scenes are often illuminated by a variety of light sources, so no film will get everything right. You can use either daylight or tungsten slide film for night scenes. Daylight films yield warm (orange) renditions, and tungsten films yield cool (blue) renditions. Try both types and see which gives you the effect you like. (Consumer color-print films just come in daylight-balanced versions, and these work fine for night photography.)

Things to Shoot at Night

Cityscapes make good night-photography subjects. For distant landscapes, try to pick a night with some clouds in the sky to break up all that black space. During a really long exposure, the clouds might come out blurred because they are moving, but that can give the shot an eerie touch. Your camera's built-in meter will likely be fooled by all the black in such scenes, so it's best to bracket exposures around those listed in the accompanying night-exposure chart.

Medium-distance cityscapes take well to the extended-range treatment and hold a good amount of detail throughout. Use Tri-X film and bracket around a base exposure of 10 seconds at f/5.6.

> **Hot Tip**
>
> A neat long-exposure night trick is to zoom a zoom lens during exposure, thus creating an explosion effect. Another is to set your camera on your car's dashboard and make a long exposure while driving down the road. (Pay attention to driving while doing this! Better still, have someone else drive while you shoot.)

Close-up cityscapes generally call for stopping the lens down for adequate depth of field, which, in turn, requires longer exposure times—no problem when your camera is mounted on a tripod. Wide-angle lenses provide good depth of field at relatively wide apertures—useful for night work when you need sharpness from near to far.

Wide-angle lenses provide good depth of field at relatively wide apertures. Here a 24mm lens at f/8 got everything sharp, from the nearby pole to the background.

Individual buildings are good night subjects for standard or extended-range treatment. When abstracting portions of buildings, you can use your built-in light meter's reading as a starting point.

Zooming a zoom during exposure can be very effective with contrasty night scenes.

Neon signs make for colorful night photos. Actually, "neon" signs aren't all neon—the red ones are; other colors are produced by other glowing gases in the light tubes. But whether they're neon, argon, krypton, or whatever, these colorful lights are great photo subjects. And they're easy to photograph. Just move up close so the sign fills the frame, and your camera's built-in meter will provide a good exposure (you can lock the exposure by holding the shutter button partway down or using the camera's AE lock feature, then move back if you wish to include more of the scene). But as with all night subjects, it's wise to bracket exposures.

You can shoot a single sign against a dark background or against a lit one, where the neon accents the photo. If your camera can make multiple exposures, try shooting several signs on a single frame, each at a different angle—the resulting picture will have a dynamic, 3D effect. (Pick signs with black backgrounds for the most dramatic effect.) Or shoot a neon alphabet—locate and shoot all the letters of the alphabet in neon. Or shoot the letters in your name, each from a different neon sign.

This neon Mona Lisa was captured with a 35mm compact camera in auto mode.

(Jackie Augustine)

Naturally, the moon is fair game for the night photo stalker. The proper exposure? On a clear night, the same exposure you'd use to shoot any sunlit scene on Earth: Use the inverse of the ISO number (such as $^1/_{25}$ with ISO 125) at f/16. Of course, if the night is hazy or foggy or the moon is very low in the sky (so the atmosphere reduces its intensity), more exposure will be required. Again, bracket exposures to be safe. To get a big moon, you need a long lens—500mm or longer. But you can use a smaller moon as a compositional element in a scene. Or you can make a double exposure to put a moon in a moonless scene—shoot the scene, and then, on a full-moon night, expose the moon onto that frame (remember where you wanted to put the moon in the scene and position it accordingly).

> **CAUTION**
>
> ### Watch Out!
>
> Beware of bright lights ruining your star-trail shots. During one of my few star-trail shoots, a police helicopter flew over and hit my camera with its searchlight about three hours into the exposure.

You can photograph star trails by pointing a tripod-mounted camera skyward and making an exposure of 20 minutes to several hours, with the lens aperture wide open. If you point the camera at the North Star, the trails will form circles around it; otherwise, the trails will appear as arcs.

Fireworks displays can be spectacular subjects. You can mount the camera on a tripod and open the shutter for one or more bursts (block the lens, without touching it, during the spans between bursts) or hand hold the camera for one burst.

Try some of these techniques the next time you're out at night, and you will add some great shots to your portfolio.

The Least You Need to Know

- The world is your studio, complete with subjects, sets, and lighting.

- To shoot in dim lighting, use fast lenses, fast films, or a tripod.

- In dim or unusual lighting, bracket exposures.

- Shooting at night is a great way to escape the doldrums of everyday photography.

Part 5

Extras! Extras!

This part introduces you to two kinds of extras you can use to take your picture-taking a step further. First, we'll examine special effects. As you'll see, your choice of lens, film, and filters can allow you a lot of creative freedom with your camera and give you some spectacular results.

Second, we'll look at digital imaging, the fastest-growing segment of photography. If you have a computer, you should read this part of the book, because you can use your computer to make your photos better—and have a lot of fun in the process.

You don't need a digital camera to do digital photography. In fact, many photographers shoot with their regular film cameras and have those images converted for use in the computer. You can do that, too. This part shows you how.

21

In-Camera Special Effects

In This Chapter

- ◆ Using lenses to make odd pictures
- ◆ How reflections and glare can be good things
- ◆ Making special pictures with special films
- ◆ Having some fun with special-effects filters

Special effects can be lots of fun. You can let your imagination go wild and create pictures that are truly special. While computer-manipulated special-effect images are quite popular today, especially in advertisements, you don't need a fancy computer setup to produce a variety of great special effects. In fact, you don't need a lot of fancy photo equipment to create special effects. Many great effects can be done with just a camera and a lens. Some effects require special equipment, but you don't necessarily have to buy this equipment—you might be able to borrow it from a photographer friend or rent it for a day from a photo store.

I've already introduced you to some special effects. In Chapter 9, you met fisheye and soft-focus lenses. In Chapter 14, you learned how the camera can see things in ways the eye can't when using different shutter speeds, lens apertures, and multiple exposures. I'll briefly review the use of lenses

for special effects, but you should read Chapter 14, too, if you're interested in special effects. You'll meet some new effects in this chapter. The camera records slices of reality—moments plucked from time—and this in itself is a special effect. You can also take advantage of camera features, accessories, and special films to produce images that show either reality in a way we don't see or things that aren't real. Experimenting with these effects can be a lot of fun.

In this chapter, you'll find a catalog of simple special-effects techniques. Experiment with them, master them, and then put them in your mental file of techniques for future shooting. You'll find that many of them will help you in straight photography because they make you think. You can't snapshoot special effects.

Special-Effects Lenses

Several types of lenses produce special effects by their very nature: fisheyes, soft-focus lenses, anamorphic lenses, and even zooms.

Hot Tip

Most special-effects images are far more effective in color (in fact, most of the images reproduced here were shot in color). Be sure to try your effects in color.

Fisheye Lenses

Fisheye lenses take in wide angles of view and curve straight lines that don't pass through the center of the picture. There are two basic types: circular and full-frame. Circular fisheye lenses produce round images on the film. Full-frame fisheyes crop a rectangle out of the circular image to fill the film frame. See Chapter 9 for more details.

Circular fisheye lenses produce circular images and curved lines. This picture was made with an inexpensive circular fisheye adapter that fits on the front of a regular lens.

Soft-Focus Lenses

Soft-focus lenses produce a diffused, ethereal effect that's great for glamorous portraits and mystical scenes. The effect of a soft-focus lens is not the same as shooting a picture out of focus with a normal lens. The soft-focus lens produces its effect by overlaying one or more unsharp images over a primary sharp image of the subject. An out-of-focus image lacks the primary sharp image.

Hot Tip

If you have a camera that can make in-register multiple exposures, you can produce a true soft-focus effect by mounting the camera on a tripod and making two exposures on a single frame, one sharply focused and one with the image out of focus. Shoot with the lens wide open to minimize depth of field.

Soft-focus lenses produce pleasant, ethereal images.

Anamorphic Lenses

Anamorphic lenses are used in professional motion picture photography to compress wide scenes onto the narrow movie film in the camera, then to spread the image to fill a wide theater screen when the movie is shown in theaters. These lenses do their thing by producing different magnifications along the vertical and horizontal axes, thus squeezing or expanding scenes. The anamorphic lenses used by the movie

industry are very expensive, but Cambridge Camera Exchange offers an anamorphic adapter that screws onto the front of a regular still-camera lens and produces the anamorphic effect.

Anamorphic lenses let you distort images horizontally, vertically, or diagonally. Unfortunately, some vignetting occurs with anamorphic adapters.

Zoom Lenses

Zoom lenses are wonderful devices. They contain a whole range of focal lengths in a single lens, allowing you to set any of them with the twist of a wrist or the touch of a button. They also can produce a neat special effect. If you zoom the lens from its shortest focal length to its longest (or vice versa) during a one- or two-second exposure, you'll get an explosion effect. If you wait for about half the exposure time before zooming, you'll get an identifiable image of the subject plus the zoom streaks. The effect works best with contrasty scenes.

Photo Fact
Point-and-shoot zoom cameras don't allow you to zoom the lens during exposure, but AF 35mm SLRs do.

Focus Effects

One of the simplest special effects is out-of-focus highlights (OOFs). Just pick a scene that contains bright highlights, set the lens to its widest aperture, and rotate the focusing ring until the highlights are completely out of focus. You can find suitable subjects almost anywhere: highlights in a puddle of water in the midmorning, fireworks bursts at night, or any light sources in the picture. The OOF effect works best with longer-than-normal focal lengths because the highlights will be stronger and depth of field will be more limited. If you use a mirror lens, your OOFs will become rings of light.

Be sure to keep the lens aperture wide open when shooting OOFs. If you stop the lens down, the depth of field might increase enough to partially negate the effect, and you'll just get an out-of-focus photograph. If your camera has a depth-of-field preview, use it to see what effect stopping the lens down will have on the image.

Another focus-related technique you can do with any lens—although it, too, is most effective with longer focal lengths, which limit depth of field—is selective focus. Focus on a nearby subject with the lens aperture wide open, and the limited depth of field will blur any foreground and background elements to abstraction, leaving the main subject sharply focused. This technique is especially effective for close-ups of flowers, blurring the surrounding greenery.

Reflections and Flare

Reflections are a good source of distorted special-effects images. Any object with a reflective surface can be used; the more uneven its surface the better. Reflections in water can produce some great effects, warping and disjointing the reflected subjects in wild ways. You can produce any number of reflection variations with a sheet of flexible Mylar material (available at some art supply stores). Modern glass buildings are another great source of reflections. Just remember to focus on the reflection, not on the reflecting surface, if you want a sharp image. (With Mylar reflections, it's sometimes effective to focus on the surface and let the subject go soft, especially with bright-colored subjects.)

Flare occurs when light strikes the front surface of the lens. Normally, you want to avoid this (generally by utilizing a lens hood). But flare can also produce some striking special effects.

Modern glass buildings are a great source of reflection special effects. If you want both the reflection and the reflecting surface to be sharp, stop the lens down to increase the depth of field.

Curved surfaces distort the reflected image. The reflecting surface here was a mirrored pillar. You can also use a sheet of reflective Mylar and curve, bend, or warp it to produce a wide range of weird reflections.

Diffraction stars can be produced by positioning the sun just behind a subject or subjects, so its rays bend around the objects.

(Lynne Eodice)

Special Films

Several special 35mm films produce special effects by their very nature, just as the special-effects lenses do. The most interesting are Kodak High Speed Infrared 2481, Konica Infrared 750nm, Kodak Ektachrome Infrared 2236, Kodak Technical Pan 2415, and Kodak Recording Film 2475.

Black-and-White Infrared Film

Kodak High Speed Infrared and Konica Infrared 750nm are infrared-sensitive black-and-white films that yield somewhat grainy and contrasty images in which healthy foliage and warm subjects generally appear white, and the sky and water generally appear black. Originally designed for scientific use, these are good special-effects films, producing eerie landscapes and ghoulish portraits. The films are sensitive to visible wavelengths as well as to infrared radiation, so a deep red No. 25 filter is generally used for pictorial work, to block out most of the visible radiation and obtain the maximum effect of the infrared.

Because we can't see infrared radiation, the exact photographic effects of infrared are generally something of a surprise—that's part of the fun of using these films. Unfortunately, because our exposure meters don't measure infrared radiation, there's really no way to accurately gauge exposures, so bracketing is definitely in order. Start by setting your meter's ISO index to 50 and expose accordingly (this takes into consideration the filter factor of the red No. 25 filter—don't meter through the filter), and then shoot additional frames, giving more and less exposure than the meter reading suggests.

Two more practical points about using black-and-white infrared films: First, because of their unusual sensitivity, it's best to load and unload your camera in total darkness—don't even open the plastic container the film comes in unless you're in total darkness, or you'll fog the first few frames on the roll (see the film instruction sheet). Second, camera lenses don't focus infrared radiation at the same plane as visible radiation, so for precise focusing, you must use a lens with an infrared focusing mark. After focusing on your subject in the usual way, rotate the lens's focusing ring so that the focused-upon distance is opposite the lens's infrared focusing index rather than opposite the normal focusing index mark. It's also wise to stop the lens down as much as possible when shooting infrared film to maximize sharpness. (Not all lenses have infrared focusing indexes—or even focusing scales.)

Color Infrared Film

Kodak Ektachrome Infrared EIR is a color-slide film (hence the "chrome" in its name) that's sensitive to visible radiation and to infrared radiation out to 900nm. Where normal color-slide films have three emulsion layers, one sensitive to blue, one to green, and one to red, Ektachrome Infrared's three layers are sensitive to infrared, green, and red (all are also sensitive to blue—thus the need for a blue-blocking filter). Originally designed for scientific purposes, Ektachrome Infrared is a great special-effects film. Try exposing it with a red No. 25 filter or a green No. 58 filter and see what you get. Scientific work is often done with a yellow No. 15 filter, which usually produces yet another effect.

As with black-and-white infrared, exposure is something of a guessing game. When using yellow or red filters, bracket around a meter reading at EI 50; with a green filter, start with EI 20; and with the blue filter, start at EI 10. Each different exposure produces quite different results; you'll probably get several images you like by bracketing exposures.

> **Photo Fact**
>
> Kodak's relatively new Ektachrome Infrared EIR false-color slide film can produce some wild colors when exposed through red or yellow filters. And unlike its predecessor, it uses standard E-6 processing, which is widely available.

Technical Pan Film

Kodak Technical Pan film is the sharpest, finest-grained black-and-white film available in 35mm cassettes. Tech Pan has two primary uses: producing high-contrast images with no mid-tones, and continuous-tone images that can be enlarged greatly with excellent image quality.

For high-contrast effects, have the film developed in Kodak D-19 developer per the film instructions and the resulting negatives printed on high-contrast paper. For continuous-tone pictorial images, rate the film at EI 25 and develop it in Kodak Technidol developer. In order to reap the maximum benefit of this film's remarkable sharpness, attach your camera to a tripod when shooting, use a cable release to trip the shutter, lock the

> **Watch Out!**
>
> Few one-hour labs and mass-market photofinishers will process these special films, so you'll have to use a custom lab, which is generally more expensive. If you like special effects, the cost is worth it.

mirror up if your camera permits it, and shoot at your lens's sharpest aperture (usually a couple of stops down from wide open). Tech Pan is sharper than any lens you're likely to be using.

When processed in Kodak D-19 developer and printed on high-contrast paper, Technical Pan film yields extreme-contrast pictures consisting only of black and white, with no intermediate gray tones at all—an interesting special effect.

Tech Pan has extended red sensitivity, meaning that red objects in a scene will appear lighter in prints than in photos made using a normal panchromatic black-and-white film. Tech Pan is a great film for aerial photography because this extended red sensitivity and inherent high contrast offset haze and add snap to photographs. Some photographers have not been happy with the film's overall tonality for general pictorial work—the images are incredibly sharp and virtually grainless, but they don't quite have the tonality of, say, Tri-X. Note: Kodak has recently discontinued Tech Pan, but some dealers may still have it.

Grainstorm!

To produce grain-effect images, use a high-speed film (Kodak Tmax P3200 for black-and-white, one of the ISO 1600 color-print films for color), shoot with a wide-angle lens, center the subject, and have the processing lab blow up the central area of the image containing the subject.

Shoot with a grainy film using a wide-angle lens, then blow up a small portion of the image, and you have a grainstorm.

"Instant" 35mm Films

Polaroid offers several "instant" 35mm films that self-process in 60 seconds in a Polaroid AutoProcessor. A fun one is PolaPan (ISO 125/22), which provides beautiful, full-range black-and-white positive images that can be projected as slides or printed on color-reversal paper. The slides show a wide range of tones because they are viewed by transmitted light, rather than printed on paper and viewed by reflected light.

One caution: Polaroid 35mm instant films have an unusual surface reflectance that can cause exposure errors when you're using a camera that employs off-the-film metering.

Special-Effects Filters

There are many special-effects filters on the market: diffusers, fog filters, star filters, multi-image filters, graduated filters, bicolor polarizers, and more. Cokin and Tiffen offer a tremendous variety, as do other manufacturers (check what's available at your local camera store).

I don't have room to cover every special-effects filter here, but I'll introduce you to the most popular ones.

Colored Filters

Shoot with a colored filter over the lens, and your picture will take on the filter's color. If you shoot print film, be sure to tell your photofinisher that you used a colored filter, so the technician doesn't correct the color cast when making your prints.

One great filter effect is the *tricolor technique*. Find a scene that includes moving and stationary elements, mount the camera on a tripod, and compose your picture. Then, instead of making one exposure, make three exposures on the same frame—one through a No. 25 red filter, one through a No. 58 green filter, and one through a No. 47 blue filter. Since these filters combined transmit all colors of the spectrum, stationary subjects in the scene will appear normal. But moving subjects will take on rainbow colors. Waterfalls and ocean breakers are natural subjects for this technique. Determine exposure in the usual manner, then open the lens one stop for the red-filter exposure and two stops for the green- and blue-filter exposures. (Actually, it's best to change the exposure using the shutter speed rather than the lens aperture so you don't change the depth of field.)

Whazzat Mean?

The **tricolor technique** is the use of multiple exposures and filters to give a rainbow effect to moving objects.

Colored filters work in black-and-white photography, as well as in color photography. A colored filter transmits light of its own color and absorbs light of its complementary color, and so renders objects of its own or similar color lighter and objects of the complementary color darker in a photograph. For example, red filters are often used to darken blue skies so that white clouds stand out dramatically or to darken blue shadows to punch up contrast for a dramatic effect.

A red filter will darken a blue sky in a black-and-white photo, making white clouds stand out dramatically. Fisheye lenses have a few filters built in because an external filter won't fit over the bulging front lens element.

Fog Filters

Fog filters make a scene look foggy. They contain particles and patterns that scatter the light, just as real fog does, thus softening contrast, muting colors, and producing halos around lights in the scene. Fog filters come in several strengths, from weak to strong. You can also vary the effect of a given fog filter through exposure (more exposure increases the effect) and choice of lens aperture (wider apertures increase the effect).

Some fog filters are graduated from a heavy fog effect in the top portion to a weak effect in the bottom portion. Nearby areas of the scene (exposed through the weak portion of the filter) therefore show little fogging, while distant portions of the scene (exposed through the foggier top portion of the filter) will show more fogging. This creates a picture with a more realistic fog effect.

Fog filters make a scene look foggy. No exposure compensation is required, although you can increase the effect through slight overexposure.

Star Filters

Also called cross-screen filters because of the cross-hatched pattern they contain, star filters turn light sources and bright highlights in a scene into flared stars. These filters come in varieties that produce 4-, 6-, 8-, and 16-point stars, as well as variable

versions. Star filters don't require exposure compensation, but with some, the effect changes at different apertures, so it's a good idea to look through your camera's depth-of-field preview (if the camera has one) to check the effect at the aperture you intend to use. Many star filters also decrease sharpness a little. You can use star filters with point-and-shoot cameras; just hold the filter in front of the lens while you shoot.

Graduated Filters

Graduated neutral-density filters can help keep the bright sky from burning out in a scenic shot. Graduated color filters can add their color to the top or bottom portion of the image. These filters gradually change from clear to either gray or a color, beginning around the middle of the filter. Just position the filter over the lens so that the dense portion covers the bright part of the scene (usually the sky). Scenic photographers use graduated filters a lot to hold detail in a bright sky and a dark foreground in the same scene.

Star filters turn point-light sources into stars.

(Ron Leach)

Diffraction Gratings

Diffraction gratings break up white light sources into their spectral components, producing rainbow slashes through point light sources. Inexpensive diffraction grating films are available from Edmund Scientific Company (609-573-6879; scientificsonline.com; item number as of this writing is 3054509). Laser-produced diffraction filters (available from several manufacturers) break up the light into families of colorful slashes. Diffraction-grating effects are, of course, most effective in color photos. No exposure compensation is needed, and you can use these filters with point-and-shoot cameras—just hold the filter in front of the lens while you shoot.

A laser-produced diffraction filter produces this effect in a shot of freeway traffic at night.

Diffusion Filters

Diffusion filters produce soft, glowing images by letting most of the light through unaltered to produce a sharp main image and diffracting some of the light to produce unsharp secondary images overlying the primary sharp one. Diffusion filters are generally used for portraits, but also work well with scenic subjects, especially with backlighting. Some diffusion filters also reduce contrast, while others soften the image without affecting contrast. Most filter manufacturers offer diffusion filters, generally in several strengths. Some manufacturers also offer several types: standard, warm, more flare, and less flare.

Diffusion filters produce a soft effect that's great for portraits.

(Lynne Eodice)

Polarizing Filters

Besides their practical uses (eliminating reflections from nonmetallic surfaces and darkening a blue sky in color photos without altering the colors in the scene), polarizing filters can do interesting things with clear plastic subjects: They'll bring out colors you can't see. Many crystalline subjects take on beautiful colors when viewed through a polarizing filter. Some of these, such as crystallized Epsom salts, citric acid, or photographic fixer ("hypo"), require two polarizers—one between the light source and the subject, and one over the camera lens. But some, like inexpensive clear plastic items, will produce colors with just a single polarizer used on the camera lens.

For maximum effect, light the plastic subject from above and behind, so glare appears on the top surface. Then rotate the polarizing filter until you see an effect you like. Large, soft light sources, such as a picture window, work best, in fact.

> **Hot Tip**
>
> The best diffusion filters soften the image without reducing contrast; some filters gray the image as well as soften it. You can use a diffusion filter with a point-and-shoot camera by holding it over the lens as you shoot.

> **Watch Out!**
>
> No exposure compensation is required for speed filters, but I don't recommend using one of these with a point-and-shoot camera—it's too hard to get the filter precisely positioned in front of the lens.

Speed Filters

Several speed filters are available from Cokin and others. These blur half the image into speed streaks, creating the illusion that the subject is moving very fast—even if it's not moving at all. You can make stationary subjects appear to move or pan with a moving subject to really get a speed effect.

Cokin's Super Speed filter gives half the image a motion effect. You can make stationary subjects appear to move or pan with a moving subject to really give a speed effect. Cokin also makes a Speed filter, which produces streaks.

Multiple-Image Filters

Multiple-image filters are very popular, but I'm not sure I know why. I've never gotten a shot I liked with one. These filters come in two basic types—radial and linear. Each type comes in several varieties. The radials produce three or more peripheral soft images circling a mostly sharp central image, while the linears produce a number of soft repeated images to one side of the image. The effect of these filters changes with aperture, focal length, and distance. Small apertures produce enough depth of field that the filter facets become visible in the picture. Long lenses crop most of the peripheral images out of the picture, while wide-angle lenses vignette—normal to short-telephoto lenses work best. Moving farther from the subject causes the peripheral images to spread out, while moving closer bunches them together. Experiment with different apertures, focal lengths, and distances to see what you come up with. No exposure compensation is required.

Multiple-image filters produce secondary images surrounding or to one side of the subject.

The Least You Need to Know

♦ Special effects give you pictures that are unusual.

♦ Odd lenses produce odd images, but you can make odd images with ordinary lenses, too.

♦ Reflections and lens flare can be put to creative use.

♦ Several special films let you produce pictures obtainable in no other way.

Chapter 22

Digital Imaging

In This Chapter

- ◆ Understanding what digital imaging can do for you
- ◆ Getting your pictures into and out of the computer
- ◆ Working with your pictures in the computer
- ◆ Using a computer to do other fun things with your photography

When I got started in photography, "digital imaging" meant finger painting, or coloring one of those paint-by-numbers things. The idea of using computers to create and enhance photographs—and the concept of the home computer—hadn't even crossed anyone's mind.

Today, though, digital imaging—the recording, manipulation, and outputting of images using electronic cameras and computers (versus conventional analog imaging, which uses film and film cameras)—is very popular with both point-and-shooters and professional photographers. Some traditional photographers resent digital imaging, claiming that it isn't photography. (It is.) Other photographers are so excited about it that they proclaim, "Film is dead." (It isn't.)

Digital imaging is simply another tool for the photographer, one that makes it easier to do some things photographers have traditionally done

in the darkroom, and one that makes it possible to do things with photos that can't be done any other way. You can use this tool however you want: You can take pictures with digital cameras, and then do whatever you want to them on the computer. You can take pictures with a film camera, same as always, have those images converted into digital form, and do whatever you want to them on the computer. You can do just the things you would normally do in the darkroom—dodge (make parts of the picture lighter), burn (make parts of the picture darker), change the contrast, correct the color balance, and other "standard" photo procedures—but without the mess, the odors, the ecologically unfriendly chemicals, and the hours spent alone in the dark. Adventurous photographers find that they can easily create special effects that are extremely difficult or even impossible in the darkroom—often with just a few clicks of the mouse button.

But the photographic uses for your home computer go beyond just manipulating images. You can archive and keep track of your pictures, using features of special image-management programs such as ACDSee. You can improve your photography by examining great photos and learning new techniques via pictorial or instructional CD-ROMs. You can visit online photo sites, join photo chat groups, check out photo-company websites, and lots more. In this chapter, I'll introduce you to these applications, along with some of the hardware and software that make them possible with your home computer.

 Hot Tip _____

If, after reading this chapter, you're interested in finding out more about digital imaging, check out *The Complete Idiot's Guide to Digital Photography*. But this chapter will give you an overview of digital photography, so you'll know what's involved. Keep in mind that digital imaging is a fast-evolving medium, so you'll also want to consult monthly publications like *Petersen's PHOTOgraphic Magazine* to get the latest info.

What Do You Need?

To do digital imaging, you need four things: a computer, a way to get your photos into it, image-editing software, and a CD or DVD burner to archive your digital images (which would soon fill up your hard drive if you stored them all there). A home photo printer is also useful, but you can take your CD or DVD full of images to a photofinisher or digital photo lab to have the images printed, or even use an online photo service for prints.

If you have a home computer, all you need to try digital imaging is an easy-to-use photo-editing program such as the current version of Adobe Photoshop Elements, Jasc Paint Shop Pro, Microsoft Picture It!, MGIPhotoSuite, Ulead PhotoImpact, ArcSoft PhotoStudio, or Corel Picture Publisher. These programs take you step by step through such activities as enhancing and cropping pictures, eliminating red-eye and scratches, removing distracting background elements, and adding special effects and text. Some even let you create digital photo albums, photo greeting cards, and calendars, and prepare your pictures for e-mailing or to be put on mugs and T-shirts. They all work on a "typical" home computer, but they work better and a lot faster on a powerful one. The faster your processor and the greater the amount of RAM, the happier you will be.

Unfortunately for Macintosh computer users, however, some of these programs are available for Windows only. The more-serious, more-capable (and much more expensive) professional image-editing programs such as Adobe Photoshop are available for both Mac and Windows because many imaging pros use Macs. Check to see what's available at your local computer store or on the web.

Photo Fact

What image-editing software do the pros use? Most (myself included) use Adobe Photoshop, the long-time pro standard for photo editing, but it's overkill for anyone but the truly serious. It costs around $600, requires lots of computer power, and takes a very long while to master—but it can do just about anything. Minimum computer requirements for Photoshop are a Pentium-level PC or a Power Mac, with 192 MB of RAM (a lot more is a lot better—you can't have too much RAM when working with high-resolution photos) and at least 280 MB of free space (320 on a Mac) on your hard drive (again, more is better).

Besides the photo-editing programs, there are fun programs like Kai's Power GOO, which lets you distort pictures in interesting ways, and ArcSoft PhotoMontage, which lets you create mosaic images from a library of your own or supplied pictures; and panoramic programs, such as Spin Panorama, which let you "stitch" photos together to create panoramic images. If you're interested in such effects, check out the programs available at your local computer store or in one of the Mac or PC catalogs.

To keep track of your pictures, many of the low-end photo-editing programs have album capabilities, and there are special image-tracking programs such as ACDSee and Jasc Photo Album. These make it easy to create electronic albums of your digital pictures so you can quickly and easily find one when you need it.

Getting Your Pictures into Your Computer

You can get your prints, negatives, and slides into the computer by having them scanned by a photofinisher or digital lab that provides this service, or by scanning them yourself using a home flatbed or film scanner. The most direct way to get images into your computer is to shoot them with a digital camera and download the images to the computer.

You can download the images by connecting the camera to the computer (generally via a USB port), or simply by removing the memory card ("digital film") from the camera and inserting it into an inexpensive card reader that connects to the computer. Once the images are in the computer, you can open them, adjust and improve them, create special effects, and save them. Then you should copy the images onto a removable storage medium such as a CD-R or DVD-R disk.

You can print your images directly from the computer using a home photo printer that connects to the computer, or bypass the computer using a stand-alone photo printer—just insert the memory card with the images and print from that. Or you can take your CD or DVD full of photos to a photo store or custom lab and have your images printed there.

Digital Cameras

When I wrote the original version of this book (in the spring of 1999), I did all my shooting on film. Digital cameras were costly, had few features, and didn't produce very good image quality. That is no longer the case. Today, point-and-shoot consumer digital cameras ("digicams," for short) cost little more than point-and-shoot film cameras with similar features and turn out very good images. If you're a point-and-shooter and have a computer, your next camera definitely should be digital.

The Pros of Digicams

Shooting with digital cameras offers a number of advantages over shooting with film. For one thing, you don't have to buy film—or pay for processing. This can save you a bunch of bucks if you do lots of shooting. Digital also provides instant gratification—you can see your image right after you shoot it. In fact, with consumer digicams, you can see it before you shoot it, displayed on the camera's LCD monitor. Besides staving off impatience, this gives you the valuable opportunity to check the exposure

and focus while you're still right there, so you can adjust and reshoot on the spot if necessary. You can even erase a bad image on the spot.

Another digital-camera advantage is that your photos are digitized automatically as you shoot, so they're ready to use in your computer. Photo database software makes it easy to keep track of your burgeoning digital photo collection, so you can retrieve photos and data about them very quickly. You can archive a bunch of images on an easy-to-store under-$1 CD. If you shoot for publications, you can send high-resolution digital images on a CD or DVD, while your "originals" remain safely at home—no more worry about slides getting lost or damaged in the mail or by the client.

I've taken the tiny 3-megapixel Minolta DiMAGE Xt on many a hike, and it's given me photos where I'd have had none if I didn't have this little camera. I would have gone without a camera if my only choice had been taking my big pro SLR.

Today many consumer digital cameras have more and better features than point-and-shoot film cameras. These include faster lenses (much faster at telephoto settings), the ability to focus down to mere inches from the front of the lens, and the ability to shoot movie clips and add sound to images, as well as the aforementioned ability to see your images immediately and fix exposure, focus, and composition problems on the spot.

The Cons of Digicams

There is a downside, of course. Affordable digital cameras still can't quite match film in ultimate image quality, but this is a concern only if you want to make huge prints from your photos. Images from a good 4-megapixel consumer digicam can turn out very good 11 × 17-inch prints on a photo-quality inkjet printer, and images from a 6-megapixel entry-level digital SLR can be printed still larger.

Because many require that you scroll through menus on the LCD monitor to make camera settings, digicams are often more difficult to learn and use than film cameras. For serious photographers, digital SLRs that provide the same range of versatility as an entry-level AF 35mm SLR cost several times as much. And although you don't have to buy film, you do have to buy memory cards to hold your images as you shoot (and those aren't cheap, although they are reusable), and some form of storage for your "keepers" after you shoot (CD and DVD burners are the hot answer to this today).

Pixels

Digital images are composed of tiny "square dots" called picture elements, or *pixels*. The more pixels an image has, the better its resolution—the more detail it will have, and the bigger you can "blow it up."

A megapixel is a million pixels. A 1-megapixel digital camera, at its maximum quality setting, produces images composed of approximately 1,000,000 individual "square dots" (actually, most "1-megapixel" cameras provide images measuring 1,152 × 864 pixels, which works out to 995,328 pixels, or .995 megapixel). A 3-megapixel camera produces images composed of around three million pixels (actually, most give you a bonus: 2,048 × 1,536 pixels, or 3.14 megapixels), a 5-megapixel camera, images of around five megapixels (2,560 × 1,920 pixels, or 4.9 megapixels), an 8-megapixel camera images of around eight megapixels (3,264 × 2,448 pixels, or 7.99 megapixels), and so on. Most digital cameras utilize some of the image sensor's pixels for nonimage stuff, so compare the actual horizontal-by-vertical pixel resolutions to get an idea of two cameras' relative resolutions.

Whazzat Mean?

Pixel is short for *picture element*, the basic unit of digital images. A 2,048 × 1,536-pixel digital picture is made up of 3,145,728 pixels—2,048 along one dimension by 1,536 along the other dimension. The more pixels an image contains, the greater the detail, but the more space the picture takes up on the storage disk (and in the computer's memory).

What do these pixel counts mean from a practical standpoint? Well, a common rule of thumb for publishing images is that you need 300 dpi (dots per inch) at the printed size for top image quality. Divide the digicam's pixel image dimensions by 300, and that's how big it can be published in a quality magazine, in inches: a 2,048 × 1,536-pixel (3-megapixel) image can thus be run up to 6.8 × 5.1 inches, a 2,560 × 1,920-pixel (5-megapixel) image up to 8.5 × 6.4 inches, and so on.

In reality, you generally can make a good 8 × 10-inch print from a 2-megapixel image, a good 11 × 14-inch print from a 3-megapixel image, and a good 11 × 17-inch print from a 4-megapixel image on a photo-quality inkjet printer. As with 35mm film images, how big you can blow them up really depends on your personal standards—what one viewer considers fine, another might find unacceptable. It's a very good idea to view some prints made from a specific digicam's images before buying, if you intend to print your images.

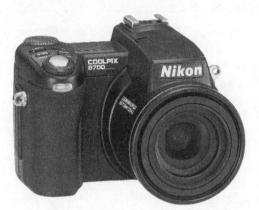

Nikon's Coolpix 8700 was one of the first 8-megapixel consumer digicams, capable of producing excellent image quality and loaded with features.

Just for reference, the general consensus is that it takes at least an 8-megapixel image to approach 35mm film quality. If you have the five-digit budget and don't mind limiting yourself to stationary subjects and a camera that needs to be tethered to a computer, digital scanning backs for medium- and large-format cameras are available with much higher, "better than film" resolutions. But these exotic tools are beyond the scope of this guide.

By the way, 640 × 480 pixels (0.3 megapixel) is fine for e-mailing and website use—in fact, high-resolution files are not good for e-mailing and web use, due to their large file size.

For serious photography, I'd recommend getting a camera with at least 3-megapixel resolution, and 4 or 5 megapixels is even better. As this edition of the book goes to press, five 8-megapixel consumer digicams have come on the market, from Canon, Konica Minolta, Nikon, Olympus, and Sony, each selling for around $1,000.

Other Important Digicam Stuff

Although the "megapixel wars" have drawn most of the attention, there are more factors than just pixel count that contribute to digital image quality. The image-sensor's

dynamic range and color response, and the camera's lens and electronics, also come into play, as does file *compression*—the more an image is compressed, the less space it will take up in memory, but the lower the image quality (some digicams allow you to shoot images uncompressed when desired, and some use more efficient compression schemes than others).

Whazzat Mean?

Compression is a way of shrinking a picture's file size so it takes up less space on its storage medium, be that a CD, a floppy disk, a Zip disk, a computer hard drive, or a digital camera's memory. The more you compress the images, the more images you can fit in a given amount of disk space or camera memory. Essentially, compression works by analyzing the image data and throwing away information the compression program deems unnecessary. Compression systems range from very good to not so good, but all result in an image that contains less information—less detail—than the original, uncompressed image contained.

Unfortunately, the only way to know whether a digital camera's output suits your needs is to check it out for yourself, by visiting a retailer that sells the product(s) in question, or by consulting friends who have the devices. User reports in photo magazines will give you a starting point, but you should see the results with your own eyes before plunking down a lot of money for a digicam (or scanner, for that matter). Consider the following questions when choosing a digicam:

- **Do you want a zoom lens?** The optical zoom range is what's important— "digital zoom" just "crops in" on the existing image, eliminating pixels and thus reducing the resolution. If you care about image quality, don't use the "digital zoom" feature.

- **Does the camera have an optical or electronic viewfinder as well as an LCD monitor?** Running the LCD monitor all the time really eats up batteries, many monitors are hard to see in daylight, and holding the camera at arm's length to view via the monitor while making a shot doesn't make for steady hand-holding of the camera. Some digicams have rotating monitors—handy for odd-angle and low-level shooting.

Most digital cameras have LCD monitors, allowing you to view your image and reshoot it on the spot if you don't like what you see. This is a tremendous advantage.

◆ **What storage medium does the camera use?** Built-in memory fills up quickly, and few cameras even have built-in memory for image-storing nowadays. Most store images on interchangeable memory cards—when you fill a card with images, just remove it from the camera, replace it with a new one, and continue shooting. For a while, CompactFlash and SmartMedia cards were the "standard," with Sony cameras using Sony's own Memory Sticks. Today, tiny SD (Secure Digital) and MMC (MultiMediaCard) media and the newer and even tinier xD (xD-Picture) cards are used in many cameras to keep size down. The type of card you use is dictated by your camera; all do a fine job of storing images. The important thing is to make sure you have some spares when you go out to shoot.

◆ **What image formats does the camera use?** Uncompressed TIFF files produce the best image quality, but some cameras don't allow you to shoot uncompressed images. JPEG compression is efficient, but the greater the compression, the lower the image quality. RAW format potentially can provide the best image quality, as there's little or no compression and all processing is done in your computer. But RAW images must be processed using special software—you can't just open them in most image-editing programs and set to work. For best image quality, shoot in RAW or TIFF mode. But RAW and TIFF images take up a lot more room on memory cards (and in your computer) than JPEG images. We do most of our digital shooting at the camera's highest-quality JPEG setting here at *PHOTOgraphic Magazine*.

◆ **How easy/hard is it to download images to your computer?** Most of today's consumer digicams use a USB interface—if you have an older computer that doesn't have USB, make sure you can connect your digicam to your computer.

To open RAW images, you must install and learn the special software from the camera maker. Of course, a card reader for your computer makes downloading images a snap—just insert the card into the reader and drag the images onto a new folder on your desktop.

◆ **How big is the camera?** Digicams run from easily pocketable to pretty big—the teeny ones are easy to carry but can be awkward to use (it's harder to hold a long focal length steadily with a tiny camera, and the control buttons are often smaller); the big ones generally have more features.

◆ **What power source(s) does the camera come with, and which ones must you pay extra for?** As mentioned, LCD monitors use up batteries very quickly. And that can get expensive with single-use AAs. If the camera accepts rechargeable batteries, you can re-use them. And if it has an AC adapter, you can run it off AC current when downloading images, or when shooting indoors, and thus extend battery life. Whatever batteries you use, make sure you take at least one spare set when you're out shooting. Some rechargeable batteries lose their charge just sitting there, so it's a good idea to charge the batteries the night before you go out to shoot—some can go dead if they've sat for even a few days.

◆ **What software does the camera come with?** Most come with proprietary software, plus an entry-level or intermediate image-editing program, and some bonus demo software.

Photo Fact

I test all sorts of digital cameras for *PHOTOgraphic Magazine*, but for the record, I currently own a Canon EOS 20D 8.2-megapixel digital SLR, a tiny 3-megapixel Minolta Xt point-and-shoot, and the camera that got me started in digital shooting, a now-discontinued 4-megapixel Pentax Optio 430RS compact point-and-shoot digicam.

Of course, a huge consideration is ease of use. In general, digicams are more difficult to operate than film cameras, because many require you to scroll through menus on the LCD monitor to make settings. And even settings that don't require scrolling through monitor menus can be more hassle than with a typical AF 35mm film SLR. It's wise to try before you buy. Some models are easier to use than others, and the only way you'll know whether you like the way a specific camera works is to try it. If you like to focus and set exposure manually on occasion, check to see how difficult this is to do with any camera you're considering purchasing.

Digital SLRs

As this third edition of the book goes to press, there are more than a dozen full-featured interchangeable-lens digital SLR cameras in production, ranging in price from $900 to $8,000 and in resolution from 3.5 to 13.5 megapixels. These are the ultimate digital shooting devices for most working pros and serious amateur photographers, as they combine great image quality with great versatility, and are just as field-worthy as their 35mm counterparts (with one exception: you have to be very careful when changing lenses not to get dust on the image sensor).

Watch Out! _____

When you remove a lens from an SLR camera to switch to a different lens, dust can enter the body. With a film SLR, the worst-case scenario will be dust on the film frame about to be exposed. With a digital SLR, the dust gets on the image sensor, and will appear in every image you take from that point on. So it's very important to follow the directions in the camera manual when changing lenses on a digital SLR.

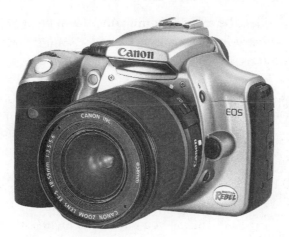

Canon's EOS Digital Rebel was the first digital SLR to sell for under $1,000, yet shares many features with the more costly EOS 10D model, including the 6.3-megapixel image sensor.

Digital SLRs offer the same advantages as film SLRs: The through-the-lens optical viewfinder means that what you see is the image formed by the lens, regardless of focal length or shooting distance. And if you choose to focus manually, just rotate the focusing ring on the lens until the image appears sharp in the viewfinder—much simpler and more precise than manually focusing a consumer digicam.

Interchangeable lenses are another big SLR advantage: You can remove the lens from the camera and attach another better suited to the task at hand. Digital SLR manufacturers offer a wide line of lenses for their cameras, from full-frame fisheyes to supertelephotos, including true 1:1 macro lenses and a host of zooms. The digital SLRs are also generally more rugged than their consumer-digicam brethren, have more serious-photography features, and offer better performance, especially with action subjects.

One thing to keep in mind when selecting a digital SLR is that all except the Canon EOS-1Ds and Kodak DCS Pro SLR/n and Pro SLR/c utilize image sensors that are smaller than a full 35mm film frame. These smaller sensors "see" a smaller portion of the image produced by any given lens than a 35mm film frame "sees," producing a "crop" effect. For example, my EOS 10D camera has a 1.6X crop factor, which means a 100mm lens on the digital camera crops like a 160mm lens on a 35mm film SLR. This is great for wildlife photography (if I put a 300mm lens on the camera it in effect becomes a 480mm lens), but not so great for wide-angle work: If I put a 24mm wide-angle lens on the digital camera, it crops like a 38mm lens on a 35mm film camera.

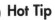

Hot Tip

For readers of this book, the most likely digital SLR candidates are the two least-costly (yet quite excellent) ones: Canon's EOS Digital Rebel and Nikon's D70, both 6-megapixel models.

Scanning Your Photographs

Scanning lets you do digital photography with your film camera. If you prefer to shoot film, or have an extensive collection of existing prints, slides, and negatives, you can get these images into your computer by paying someone to scan them or by scanning them yourself. This is particularly appealing to those who already own film cameras, have become familiar with them, and have strong preferences in film types. Another advantage of scanning is that it lets you use any of your existing negatives, slides, or prints digitally.

Scanning Services

As you learned in Chapter 8, many photofinishers can put the pictures you shoot with your film camera on a CD for use in your computer. All you do is check the appropriate box on the order form when you drop your film off for processing. When you pick up your negatives and prints, you also get a CD containing digitized versions of

your pictures. Take the disk home, put it in the CD drive in your computer, and you can access your pictures just as you can access anything on a CD. The following services are available.

Kodak Picture CD

Kodak Picture CD is a good solution for point-and-shooters. It stores scanned images from 35mm or Advanced Photo System film at 15-megapixel (1,536 × 1,024 pixel) resolution, good enough to produce excellent 4 × 6-inch prints and fair 8 × 10s on a good photo-quality inkjet printer. The Picture CD even comes with its own software—take the CD home, pop it into your computer's CD-ROM drive, and your pictures automatically appear on the monitor. You can use the software right from the CD; you don't have to load it on your hard drive. A Picture CD holds one roll of film and costs from $9 to $11.

Kodak Photo CD

Many serious photographers have their pictures put on a Kodak Photo CD. Photo CD was Kodak's first digitizing service and still provides the highest quality. Your pictures are put on the CD at five different resolutions, ranging from quick-access thumbnail (192 × 128 pixels) to a resolution more than high enough to produce an 8 × 10-inch print (3,072 × 2,048 pixels—6 megapixels). You can have a whole roll of pictures put on a Photo CD when you have the film processed (for around $20), or you can have individual pictures added later (for $1–$4 per picture). A Photo CD holds about 100 pictures. Each image is compressed to ¼ the file's actual size for storage-space efficiency, then it is expanded when you call it up in the computer.

Higher-resolution images take up a lot of space on the CD or in your computer and require a lot of RAM to manipulate—and they aren't really necessary for home-computer uses. Picture CD quality is sufficient for many home-computer uses.

> **Hot Tip**
>
> There's also a Pro Photo CD, which stores images at a sixth, much higher resolution—4,096 × 6,144 pixels, 25 megapixels—but at a much higher cost.

Online Photo Service Bureaus

Online service bureaus are more expensive than Photo CD but can provide even higher-resolution scans. These are great for pros who need their pictures turned into huge posters or to have them reproduced as spreads in magazines. One reason why

people want to get pictures into their computer is to be able to share them with family and friends. Online services, such as www.mpix.com and Kodak's ofoto (www.ofoto.com), make this relatively easy. If you shoot film, just check the box on the order form for online delivery of your images. If you shoot with a digital camera, follow the instructions on the website as to how to upload images. You can e-mail photos, order prints, and even store images online.

Unless you have high-speed Internet access—DSL or cable—uploading or downloading photos online can take a lot of time, so having them already available online and working with their thumbnails can be a timesaver. In just a few minutes, you can instruct the online photo service to send a dozen snapshots to all your friends and relatives. You simply select the ones you want to send from thumbnail images, then provide the e-mail addresses you want to send them to, and the service does the rest. The recipients can even order prints directly. Such online storage was essential when computers had only low-capacity hard drives. It has become less important now that many users have high-speed Internet connections, and most computers are equipped with huge hard drives and offer unlimited storage by means of their built-in CD-R and DVD-R drives.

> **Watch Out!**
>
> Digital services come and go. Do an online search for "online photo services" to see what's currently available.

Scanning Your Photos Yourself

Having your pictures scanned is easy, but if you have lots of pictures to scan, especially at higher resolutions, it can get expensive. That's when you might want to consider buying your own scanner. Home scanners connect to your computer and are operated via an on-screen control window.

> **Whazzat Mean?**
>
> Dots per inch (dpi) are the scanner's "pixels"—the units into which the scanner converts the picture being scanned. As with pixels, the larger the number, the greater the detail in the resulting image and the more room the resulting picture takes on the storage medium (or in the computer's memory).

The least-expensive home scanners are the flatbed print scanners, which look like flattened photocopying machines. You place your print facedown on the glass bed, close the lid, click the appropriate on-screen buttons, and your picture soon appears on your screen, ready for you to do with it as you will. Good 2,400-dpi flatbed scanners (*dpi* means *dots per inch* and is a convenient way of describing a scanner's resolution) are available for under $100, with semipro

models (which have higher resolution and reproduce a greater range of densities) available for under $500. For most readers of this book, a $100 2,400-dpi flatbed scanner will do nicely for prints.

A flatbed scanner, such as this Canon CanoScan 8000F, converts prints to digital form for use in your computer.

Film scanners scan negatives and slides rather than prints, and produce much better quality scans than flatbed scanners that provide film adapters. The low-cost yet excellent Konica Minolta DiMAGE Scan Dual IV converts 35mm negatives (both color and black-and-white) and slides to digital form and sends them, via speedy USB 2.0 (also compatible with USB 1.1) interface, directly to your computer. Because negatives and slides are much smaller than prints, film scanners must produce higher resolution. Resolutions from 1,800 dpi to 4,000 dpi are available at prices from under $150 to well over $2,000. The expensive models are often faster and may produce a greater dynamic range—they'll give you more detail in the dark and light areas of the pictures. (Don't buy a film scanner with a dynamic range of less than 3.0.) Canon, Konica Minolta, Nikon, and others offer excellent film scanners.

Some high-end scanners like Konica Minolta's DiMAGE Scan Elite 5400 and Multi PRO, and Nikon's Coolscan V ED and Super Coolscan 5000ED (with prices ranging from $600 to more than $2,000) offer automatic dust-removing capability, which can be a mixed blessing. This feature uses software to find and remove such nasties as dust, fingerprints, and scratches, but also lengthens scanning times and may slightly soften the image.

CAUTION **Watch Out!**

Most of the dynamic range information offered in manufacturers' advertising is little more than wishful thinking. Standards for advertising this number simply do not exist. *Caveat emptor.*

The Konica Minolta DiMAGE Scan Dual IV makes terrific scans from 35mm slides and negatives (and Advanced Photo System negatives, via an optional adapter), and sells for around $300. Its 3,200-dpi maximum optical resolution results in 14-megapixel scans from 35mm negatives and slides.

Editing Your Photos

The most interesting and useful part of digital imaging is what you can do to the original picture once it's in your computer. It is in this area that digital imaging offers a lot to all photographers, whether they record their original images on film or digitally.

Once your images are uploaded to the computer, you can do anything from altering contrast, brightness, and color balance to completely changing an image. You can improve the photos, add special effects, combine two or more pictures into a montage, import the photos into computer-generated documents, and do layouts. Many digital cameras and scanners come with image-editing software that allows you to do basic manipulations, such as adjusting brightness, contrast, color balance, cropping, and so on. More powerful image-editing programs aimed at the family computer–user are also available, as well as high-end pro programs.

Digital imaging can be a lot of fun. You can distort cousin Jimmy's face into hilarious form, transport Aunt Sally to that tropical isle she's always wanted to visit, make Grandpa Arnie's pigs fly What you can do with photos is limited only by your imagination—and your software.

To distort cousin Jimmy's face, you can use one of the filters built into your photo-editing program or use a special distortion program like Kai's Power GOO. To

transport Aunt Sally to that tropical isle, copy her from a photo made locally and paste her into a photo from the tropical isle. To make Grandpa Arnie's pigs fly, copy them from photos made on the ground, paste them into the sky in a nice scenic photo, and add some speed streaks with a special-effects filter. Each editing program has easy-to-follow instructions that show you how to do lots of fun things with your photos.

For more serious-minded photographers, photo-editing programs allow you to improve your pictures without adding weird effects. And you don't need years of experience to do it. For example, let's say your picture looks too gray, so you want to make the lightest thing in the picture white and the darkest thing black. In the darkroom, you'd have to make a series of test prints to determine the exposure that produced the paper's maximum black in the area you want black and to find the proper contrast grade to make the lightest area white—consuming much time and paper, while you are breathing smelly darkroom chemicals. With a computer and a photo-editing program, you can achieve the desired results with a few keystrokes.

Optimizing Your Digital Images

Many consumer-oriented image-editing programs provide one-click digital optimization. Serious shooters will want to do it themselves, for more control. Here's how I optimize an image using Photoshop (other full-featured image-editing programs provide similar capabilities):

Brightness and Contrast

A good place to start optimizing is with brightness and contrast. Here's a simple way to optimize them.

Open the image and go to Image: Levels. In the middle of the Levels window that then appears is a histogram—a graph of the tones in the image. Dark tones are on the left, light tones on the right, and midtones are in the middle. Below the histogram are three arrows. If you move the left arrow to the left edge of the histogram, it will make the darkest tone in the image black. If you move the right arrow to the right edge of the histogram, it will make the lightest tone in the image white. You might not want a pure black and/or pure white tone in every image, but that's a good place to start. (If the histogram already goes from one end of the graph to the other, that means the image already contains a pure white and a pure black tone.)

The Levels histogram indicates that this image lacks true black and true white tones (A). Moving the left arrow to the left edge of the histogram makes the darkest tone in the image turn black, while moving the right arrow to the right edge of the histogram makes the brightest tone in the image white (B). Don't move the arrows into the histogram beyond its edges. If the histogram starts as just a thin line, that's still part of the histogram; moving the right arrow past the end of that thin line to the main bulk of the histogram will result in blown-out white tones (C).

A

B

Next, use the middle arrow to adjust the midtones to your liking. In Photoshop, moving the middle arrow to the left makes the midtones lighter; moving it to the right makes the midtones darker.

Color Balance

Next, it's time to sort out the color balance. If the colors look right, leave 'em alone. If they don't, there are several ways to fix that. The easiest is to go to Image: Color Balance, and use the sliders there to adjust the amount of red/cyan, green/magenta, and blue/yellow. Just experiment with the sliders, until the image looks right to you.

If there's a neutral tone in your image, you can quickly get a ballpark color balance by using the middle eyedropper at the bottom right of the Levels window. Just click the eyedropper icon, then click on the neutral area of the image. This will neutralize that area and thus theoretically adjust all the colors properly, too.

Once you have the colors the way you want them, click OK to save the color adjustments. Now, go to Image: Hue/Saturation. Moving the Saturation slider to the right increases saturation, moving the slider to the left decreases saturation (moving it all the way to the left results in a monochrome image). Moving the saturation slider to the right past around 30 generally produces unrealistic colors, and always results in increased noise ("graininess").

The color balance sliders pro-vide the easiest way to adjust color.

Dodging and Burning

Next, it's time for dodging and burning. Whereas Levels adjustments are applied to the entire image, you can use the Dodge tool and the Burn tool to lighten or darken just a portion of the image. The Dodge tool lightens the area you drag it over, and the Burn tool darkens the area you drag it over. You can adjust the size of the tool, and its "strength."

The Dodge and Burn tools let you lighten and darken specific areas of the image.

Retouching

Next comes retouching. To remove small dust specks, scratches, or unwanted branches and the like, use the Paintbrush tool. Option-click on a nearby area whose color and density you wish to use to cover the offending item, then "paint" it out with the brush.

For larger areas, use the Clone Stamp tool (the rubber-stamp icon in the tool palette). The Clone Stamp tool copies the area you click, then pastes it onto the new area. You can adjust the size of the sampled/pasted area via the brush-size palette. Photoshop 7 introduced the Healing Brush, which works like the Clone Stamp tool, but instead of copying the whole area you click, it just copies the texture, then blends it with the color and brightness of the new area—very handy for people-pictures. (Note: It's a good idea to zoom the image to 100 percent when retouching.)

If you have an unwanted object in the image, you can use the Clone Stamp tool to remove it, by copying a nearby background area and pasting it over the offending object. Cloning is very simple to do with plain-background images like this one, but you can deal with just about anything with practice.

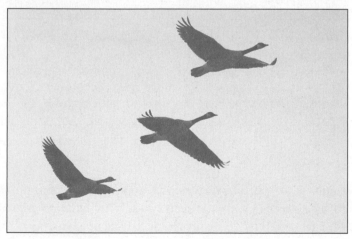

Sharpening

Once you've got the image just the way you want it, the last step is to sharpen it. The best method is the Unsharp Mask filter. Zoom the image to 100 percent and open the Unsharp Mask (Filter: Sharpen: Unsharp Mask). There are three sliders in the Unsharp mask window: Amount, Radius, and Threshold. Start with an amount of 100 percent, a radius of 1.5, and a threshold of 3, and go from there, carefully watching the edges in the image. If they develop a glow or become too grainy, you've overdone the sharpening. It's better to err on the side of too little than too much.

If you see a halo around the subject, you've overdone the Unsharp Mask. Back off on the radius and, if necessary, the amount.

Hot Tip

Never work on the original image. Open the image, then save a copy as an uncompressed TIFF image (with Photoshop, just drag down to Save As, and select TIFF as the file type). That way, you won't accidentally ruin your original image, and won't lose image quality each time you open, change, and save the image (as happens when you work on compressed JPEG image files).

Other Fun Stuff

Of course, you can do more than optimize images with your image-editing software. Most software comes with a variety of special-effects tools, some emulating darkroom effects (posterization, for example), and some providing effects not possible otherwise.

You can have a lot of fun with your image-editing program, even without the hard-earned skills and knowledge of a Photoshop "pro." And the best thing (besides coming up with cool images) is that you can experiment all you want "for free." Try all the filters and settings that appeal to you; if you don't like the result, just hit Undo, and try something else. You'll come up with some really bizarre things, some that work very well, and some that don't work at all. That's how you learn, and it can be a lot of fun as well as enlightening.

The worst thing is that—especially when working with large images on slower computers with limited RAM—some of the effects do take a while to show up on-screen. One way to deal with this is to save a low-resolution copy of your target image and experiment with that; things will happen much more quickly. But bear in mind that some effects—such as Find Edges, which basically converts the image into a line drawing—will be different on small low-resolution images than they are on large full-resolution images. Keep notes as you go, then simply apply the successful steps to a full-size copy of the original image.

Here are some simple ideas to get you started. Again, I use Photoshop, but most image-editing programs provide similar capabilities. One thing to keep in mind: Art is in the eye of the beholder—some viewers will love what you create, some will hate it, and most won't give a darn … so create images that you like, and let the chips fall where they may. But it doesn't hurt to get artistic feedback from photographer friends.

Turning Digital Images into Line Drawings

You can turn a digital photo into a line drawing in any number of ways. One easy way is simply to open the image, save a copy, and then go to Filter: Stylize: Find Edges. You can then go to Image: Adjust: Levels, and increase the contrast if you wish (move the left slider toward the right, and the right slider toward the left). To get a true line effect, you need an image with a plain background. Busy backgrounds will "clutter" the image, but that's not all bad, as shown in the following image of the power line tower.

Another easy method, for a somewhat different effect, is to open the image, then go to Filter: Stylize: Trace Contour, and move the slider until you get an effect you like. Variations include saving the image, then doing Stylize: Trace Contour again, to amplify the effect; posterizing the edges for a more blatant effect (Filter: Artistic: Poster Edges); and reversing the image (Image: Adjust: Invert).

A line-drawing effect can add interest to an everyday image.

Using Colored Filters

Black-and-white photographers often use colored filters to enhance their images. Colored filters for black-and-white? You bet: Although the photos are black-and-white, the subjects are in full color, so colored filters will have an effect. A colored filter transmits light of its own color and blocks light of its complementary color. Thus, it will lighten subjects of its own and similar colors, and darken subjects of complementary colors, in the resulting black-and-white photo. For example, a red filter will lighten red and yellow subjects, and darken blue and green ones. A red No. 25 filter is often used in black-and-white work to darken a blue sky so that white clouds really stand out dramatically. You can also use colored filters to provide contrast between two subjects of different color but similar brightness: An unfiltered black-and-white photo of a green bush with red flowers will show medium gray flowers against a medium gray bush—not very interesting. Use a red filter, and you get light flowers against dark leaves. Use a green filter, and you get dark flowers against lighter leaves. (See the chapter on Filters for more details.)

What does all this have to do with digital, anyway? Well, you can achieve similar effects via the channels in your image-editing program. In Photoshop, the process is pretty simple. Start by opening an RGB color image, then click on the Channels palette. For a red-filter effect, click on the Green channel, then click on the Trash icon at the bottom of the Channels palette and click Yes in the pop-up window to delete it. This now leaves Cyan and Yellow channels showing in palette. Click on the Yellow channel, then click on Trash and click Yes to delete it. Save the image as [imagename]Red.

For a blue-filter effect, open an RGB color image, click on the Channels palette, and click on the Green channel, then click on Trash and click Yes. This now leaves the Cyan and Yellow channels. Click on the Cyan channel, then click on Trash and click Yes. Save the image as [imagename]Blue.

For a green-filter effect, open an RGB color image, click on the Channels palette, and click on the Red channel, then click on Trash and click Yes. This now leaves the Magenta and Yellow channels. Click on the Yellow channel, then click on Trash and click Yes. Save the image as [imagename]Green.

Photoshop's red channel produces the effect of shooting a black-and-white photo through a red filter, rendering reds and yellows lighter and blues darker than in a "straight" shot.

Generally, the green-filter effect produces the most natural-looking black-and-white image, the red-filter effect the most dramatic, and the blue the least real (and grainiest).

Photoshop's blue channel produces the effect of shooting a black-and-white photo through a blue filter, rendering yellows and reds darker and blues lighter than in a "straight" shot.

Eliminating Gray Tones With Threshold Control

Photoshop's Threshold control simply changes all tones brighter than a selected level to white, and all tones darker than the selected level to black. The result is an image containing only black tones and white tones, with no intermediate gray tones.

Photoshop's Threshold control changes all tones brighter than the selected level of white, and all tones darker than the selected level of black.

Open a grayscale or RGB color image. Under the Image menu, drag down to Adjust and select Threshold. Try different settings by dragging the arrow below the histogram, and watch what happens in the preview window. Moving the arrow to the left produces more white tones and fewer black ones, and moving the arrow to the right produces mostly black tones.

Zoom Explosion

One fun photographic special effect is the zoom explosion, produced by zooming a zoom lens throughout its range during a one- or two-second exposure. The problems with this technique are (1) some cameras (including most point-and-shoots) won't let you zoom the lens during an exposure; and (2) the zoom effect thus produced is always centered.

Photoshop's Zoom filter lets you add this effect to any photo, and also lets you position the effect anywhere in the image. To do it, under the Filter menu, drag down to Blur and select Radial Blur. In the window that appears, choose Zoom under Blur Method, start with an Amount of 80, and click in the Blur Center window where you want the effect's center to appear. Then just click OK, and watch the result.

This effect works best with subjects that contain strong color contrast, or good light/dark contrast—it's not very effective with low-contrast images. As with other digital effects, if you don't like a result, just Undo it, and try something different.

Photoshop's Zoom filter lets you create "zoom explosion" effects quickly and easily (as shown on the following page), originating anywhere in the image.

(Renee Chodor)

Storage

Digital pictures take up space on your computer's hard drive. After a while, you'll start to run out of room on your hard drive. Serious digital photographers use removable storage media to store their digital photos so they don't fill up the hard drive.

The best method is on a CD. Having a service bureau (or photofinisher, via Photo CD) do it gets expensive if you have lots of photos to store. Most computers come with built-in CD burners (or even DVD burners) today, and you can buy an external CD burner for under $100. It will let you store 650MB worth of images on a recordable CD that costs less than a quarter. DVD disks cost more than CDs, but will hold lots more photos. Several types of recordable DVDs are available, a more costly but excellent option for storing vast quantities of images.

These storage devices can be used to store more than just photos. You can store all that stuff that's got your hard drive overflowing, too.

Photo Fact

There are two kinds of recordable CDs: CD-R (CD recordable) and CD-RW (CD rewritable). The rewritable ones can be used over and over, but cost a little more, offer less reliable storage over time, and when it comes right down to it, are unnecessary for storing photos. Stick with CD-R. DVDs also come in rewritable and nonrewritable versions; again, for archiving images, stick to the nonrewritable ones.

Getting the Photos Back Out of Your Computer

Once you've manipulated your photo into just what you want, you can print it on your computer printer, or e-mail it to a number of services to have it made into a photographic print or transparency.

Home Printers

You can buy a photo-quality inkjet printer for under $100. Canon and Epson make very good photo-quality printers. Olympus, Hi-Touch, and Sony offer good dye-sublimation photo printers, but these are more costly than inkjets. With any photo printer, the big cost is not the device itself, but the inks and paper. Photo inkjet printers use extra color inks to produce smoother photo-looking tones. For example, where a standard color printer has black, magenta, yellow, and cyan inks, a photo printer might add light magenta and light cyan to the mix. Some printers put all the color inks in a single color ink cartridge; others utilize a separate ink cartridge for each colored ink. The former gives you

Photo Fact

Printing photos uses more ink and takes more time than printer manufacturers' specs indicate. The print times and number of prints per ink-tank set in the specs are generally based on low-resolution prints, not photo-quality prints.

fewer cartridges to buy and keep track of, the latter lets you replace just the needed color should one color run low. All the brand-name photo printers produce good results; check them out at your local computer or camera store and examine samples of their output.

If you don't have a printer, or want your digital images output as transparencies or true photo prints, you can take or e-mail your digital image files to a service bureau for output. You can also deliver the images to most service bureaus on CD or other media—check with the bureau you're going to use to see what media it accepts.

This Epson Stylus Photo R300M inkjet printer can make prints with or without a computer (you can just insert the memory card containing the images into the printer's card slot, and view the image on the printer's LCD monitor), and will print directly onto inkjet-compatible CDs and DVDs, as well as papers up to letter size.

The Least You Need to Know

- ◆ You don't need to do digital imaging if you don't want to, but it's taking over in many areas of photography.

- ◆ Digital imaging lets you create pictures that would be impossible to create otherwise.

- ◆ All you need besides your computer is a $50 software program … but there are lots of other things that are nice to have.

- ◆ There are several ways to get your pictures into the computer and several ways to get them back out.

A

Buying Photo Equipment

One advantage of working for a photography magazine is that I don't have to buy a lot of photo equipment because the manufacturers are always sending us the latest cameras, lenses, and other gear to test for our User Reports. Of course, we don't get to keep the equipment—just about the time we start feeling comfortable with an item, we have to send it back and go through the learning process all over again with the next batch of test gear. So we always get to play with the latest and greatest, but we always have to learn new equipment, which keeps us on our toes.

I have bought equipment from local camera stores and discount stores, as well as by mail order. Buying photo equipment can be a great experience or a not-so-great one. Here are some tips to keep it positive.

Your Local Camera Store

At your local camera store, you'll generally find knowledgeable salespeople who can demonstrate the equipment you are considering and answer your questions about it and your photographic needs. You'll be able to hold the equipment to see how it feels in your hands. This is an important consideration—if a piece of equipment feels awkward in your hands, you'll probably relegate it to a closet before long instead of taking pictures with it. And you can take the camera home with you—you don't have to wait for it to arrive in the mail. Your local camera shop is probably the most efficient place to buy a camera, although it's usually more expensive than the alternatives.

If you don't know much about photo equipment, your local camera store is probably the best place for you to buy—you're more likely to get the right stuff.

Discount Stores

If you know specifically what camera or other photo equipment you want and don't need to see how it feels or ask questions about it, you'll probably save some money by buying at a high-volume discount store. But you'll get little or no after-sale service or advice, and you might not get a U.S. warranty for your purchase (if a store doesn't offer one, walk out).

Mail Order

Mail-order buying (typically, really *phone*-order buying) can offer three big advantages: lower prices, convenience (you can do it from home), and a wide selection of equipment. But there are disadvantages. You don't get to hold the camera or ask questions (those 800 numbers generally are for orders only, although some stores will answer questions if you call their regular toll number). You have to pay shipping, handling, and insurance costs, which, with some stores, add up quickly, cutting into the savings you thought you were getting. You have to wait for your equipment to be delivered (in some cases, this can take weeks if the product isn't in stock when you order it). And you might be getting gray-market merchandise.

Online

Many of the "retail mail order" stores (and even "brick-and-mortar" camera stores) have websites, and you can order camera gear using these. You can click on the appropriate link to get more information about a specific product, which beats trying to get a telephone order-taker to divulge data. As with mail order, you have to pay shipping and insurance costs, and wait for the gear to arrive, and can't ask questions. But often the online price is lower than the walk-in or phone-order price. I'm still a bit leery about sending my credit card number over the Internet, but if you trust the security, ordering online can be a viable alternative to mail-order/phone-order shopping.

Gray-Market Goods

Gray-market goods are brought into the United States by means other than through the equipment manufacturer's official U.S. distributor. This doesn't mean gray-market goods are inherently inferior; it just means they weren't meant to be sold in the United States and thus don't carry the manufacturer's U.S. warranty or qualify for U.S. rebates. Gray-market goods come with an international warranty, which is not honored in the United States. Some stores advertise such goods as having a "U.S. warranty," but it's the store's own U.S. warranty, not the equipment manufacturer's. This means that if something goes wrong with the camera, you have to return it to the store for warranty service because the manufacturer's official U.S. repair stations won't do your warranty work.

Sometimes, gray-market cameras have different model designations, and these can reduce their resale and trade-in value should you later wish to get a different camera. For example,

a U.S. camera store (and a knowledgeable private buyer in the United States) will give you more for a Nikon N80 (the U.S. version of this fine camera) than for an F80 (the non-U.S. version).

Some stores are upfront about gray-market goods. B&H, for example, lists prices for both U.S. and "imported" goods in their ads. (I've bought U.S. products from them and would do so again.) But some stores are, well, not so upfront. Make sure you know what you are getting when you place your order.

Shopping Tips

Mail-order shopping can be both convenient and economical, but it can also be aggravating. It depends on the store you're dealing with. Here are a few tips to make your next purchase easier:

◆ Always pay by credit card. It's easier to deal with transactions gone badly that way, and you don't have to wait for your out-of-state check to clear before your merchandise can be shipped.

◆ Don't give your credit card number (or your name and address, for that matter) until you've established that the store will provide the items you want at the advertised price and in a reasonable timeframe.

◆ Know exactly what product you intend to purchase through the mail. Write down the brand, model number, and price before you pick up the phone to place the order.

◆ If a store tells you that the advertised item you called to order is out of stock or inferior, but they have something "better," politely decline. (This is the old "bait and switch" technique.) If they try to pressure you into accepting alternate items, hang up and try another store.

◆ When you place the order, confirm that the prices match the prices quoted in the ad and that the merchandise has the same brand and model designation.

◆ Ask them to tell you the total cost of your bill, including merchandise, tax, shipping, handling, and insurance. If you buy from an out-of-state store, you probably won't have to pay your state's sales tax. But shipping, handling, and insurance can be quite high with some stores, in some cases driving the total cost up to what you could buy the gear for at your local camera store.

◆ Request an order number, the phone number, and a specific person to call about your order should it become necessary.

◆ Be aware that with most stores, the customer service number is not a toll-free number, and if you have to call to check on an order that didn't arrive as promised, you might spend a long time on hold, at *your* expense.

◆ As mentioned earlier, check whether the product is covered by the official U.S. distributor's U.S. warranty. Some stores offering gray-market merchandise provide their own "U.S. warranty." This means the store, not the camera's official U.S. distributor, will be providing warranty work. Be sure you know what you're getting.

- As a rule, avoid buying a store's extended warranty on photo equipment. It's generally not cost-effective.

- Inquire about the expected delivery date. If the equipment isn't shipped by the agreed-upon date, you should be allowed to cancel your order with no charges. (If there is a charge to cancel an order that is not delivered as promised, I'd try another store.) Again, ask for an order number, a phone number, and the name of a person to call if your order doesn't arrive as promised.

- Ask about the store's refund and return policy. If your order doesn't meet your expectations, it's important to know how long you have to return the items and what charges will be incurred for doing so. Most stores charge a restocking fee (generally 5 percent, but much higher with some stores). Shipping, handling, and insurance are rarely refundable. And you have to get a return authorization number, which generally requires you to make a toll call at your expense.

- The store may not always have in stock the product you ordered. Remember to ask that question when phoning in your order. If it's a hard-to-get item, you can consider being placed on back-order for the product. But being the impatient type, I'd call some other stores to see if they have the item in stock and ready to ship before I'd go on back-order.

- Don't fill out or lose the warranty card or throw away the packaging until you're sure you're keeping the equipment. You won't be allowed to return merchandise if you've filled out the warranty card or lost (or damaged) the packaging.

- Always retain the paperwork for your purchases until the transaction is complete and you are a fully satisfied customer.

- You'll often see items in ads that do not list a price, but rather say, "in stock" or "call for price." This is often the case for new products, where pricing may vary. It means you'll have to call several stores to comparison shop. Don't let the first store you call high-pressure you into buying without checking other stores' total costs. And be sure to ask what is included in the "low price"—such as body only, with battery and strap, or complete kit.

- Beware of "kits" that include a brand-name camera body plus a lens and a flash unit from manufacturers you've never heard of. These off-brand items are generally not as good as those from the camera manufacturer or the major independent lens and flash manufacturers. Some stores will advertise a kit with the camera manufacturer's lenses and flash, then try to tell you they have better items to substitute when you call to order it. If these "better" items were a better deal for you, the store would have advertised them instead of the items you called about—after all, the purpose of the ad is to get you to call.

- Check with the Better Business Bureau and on the Internet for others' experiences with the stores you're considering using. If a store has lots of complaints, you might want to avoid it. Remember, though, that not all complaints (or raves) are created equal. If you're checking a website where anyone with a computer and a modem can post a message, you'll have to weigh how credible and informed people sound before giving their opinions too much credence.

- Visit the store's website if it has one—there you'll find the most up-to-date prices and other useful information. But for the best credit card security, place your order by phone, not over the Internet.

Further Reading

There are lots of great photo books out there, both detailed how-to books on just about any area of photography you could imagine and beautiful coffee-table picture books. Check them out in the book section at your local camera store and the photography section of your local bookstore. Here are some of my favorites. (Some of these are out-of-print; if so, you should be able to find them in the library or at used-book stores.)

Adams, Ansel. *Examples: The Making of 40 Photographs*. Boston, Little, Brown and Company, 1983. Ansel tells how 40 of his best photographs came about.

Bidner, Jenni. *The Lighting Cookbook*. New York: Amphoto, 1997. Secrets of lighting just about anything, clearly explained and illustrated.

Doeffinger, Derek. *The Art of Seeing*. The Kodak Workshop Series, Silver Pixel Press. You'll shoot better pictures after reading this book.

Eastman Kodak (the editors). *The Joy of Photography*. Silver Pixel Press. Beautiful photos and clear how-to information for all audiences.

Fitzharris, Tim. *Nature Photography: National Audubon Society Guide*. Buffalo, NY: Firefly Books, 1998. A fine introduction to nature photography with great photos and tips. All of Fitzharris's books are excellent.

Garnett, William. *William Garnett: Aerial Photographs*. Berkeley, CA: University of California Press, 1995. Blending fragments of earth, water, sky, light, and time, this master creates extraordinary landscapes from his light plane and brings the beauty he sees back for all to enjoy.

Patterson, Freeman. *Photography and the Art of Seeing*. New York: Van Nostrand Reinhold, 1979. How to find the hidden beauty in nature—and capture it on

film. This book lets you in on more of the thinking behind the photos. And another photo-book author whose works are all excellent.

Peterson, B. Moose. *Moose Petersen's Guide to Wildlife Photography*. New York: Lark Books, 2003. Great tips from a pro who isn't afraid to give away his secrets.

Peterson, Bryan. *Learning to See Creatively*. New York: Amphoto, 2003. A pro who knows how to see creatively shows you how.

Petersen's PHOTOgraphic Magazine. Published monthly, available on newsstands and by subscription (www.photographic.com). Lots of how-to articles and user reports on the latest photo equipment.

Rowell, Galen. *Mountain Light*. San Francisco, CA: Sierra Club Books, 1986. The first of Rowell's many books, this magnificent how-to book is my favorite, dealing with both the "nuts and bolts" and the thought behind the shot—and these spectacular outdoor photographs were shot with 35mm cameras!

Schaefer, John P. *The Ansel Adams Guide: Basic Techniques of Photography, Book 1* (rev. ed.). Boston, MA: Little, Brown and Company, 1999. Serious stuff for the serious photo enthusiast, explained clearly.

———. *The Ansel Adams Guide: Basic Techniques of Photography, Book 2*. Boston, MA: Little, Brown and Company, 1999. If you didn't get enough in Book 1, here's more, from "old-time" processes to digital techniques.

Index